CHARLES HARRISON

AN INTRODUCTION TO
ART

YALE UNIVERSITY PRESS · NEW HAVEN AND LONDON

Designed by Gillian Malpass

Printed in China

Library of Congress Cataloging-in-Publication Data
Harrison, Charles, 1942–2009
 An introduction to art / Charles Harrison.
 p. cm.
 Includes bibliographical references and index.
 ISBN 978-0-300-10915-3 (pbk. : alk. paper)
 1. Art. 1. Title.

 N7425.H37 2009
 700–dc22

 2009032797

A catalogue record for this book is available from
The British Library

Frontispiece Richard Serra, *The Matter of Time*, 2005,
Guggenheim Museum, Bilbao (detail of pl. 237)

AN INTRODUCTION TO

ART

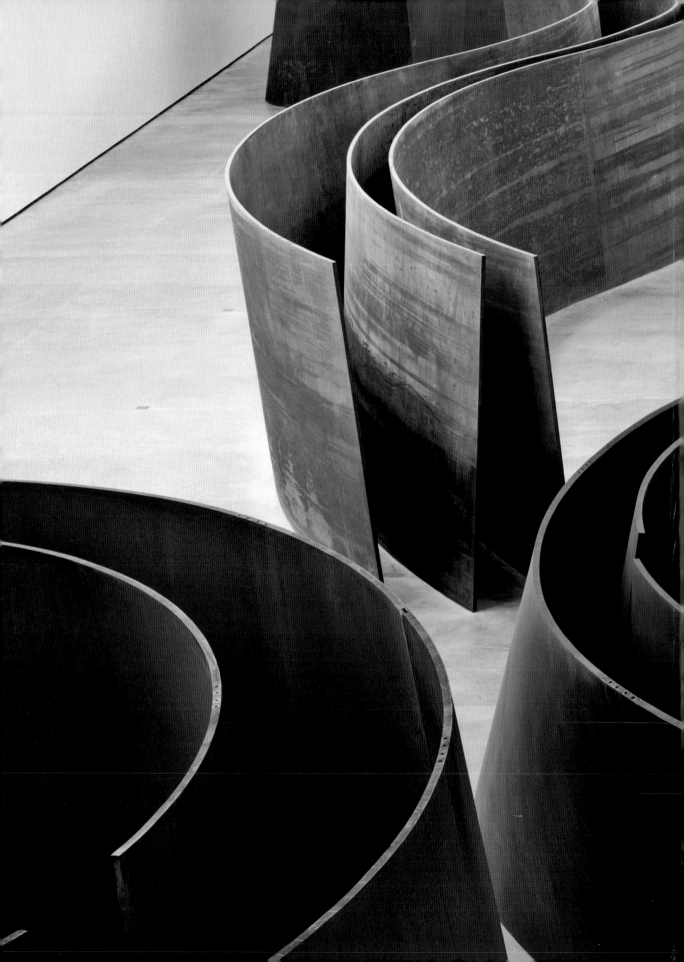

CONTENTS

FOREWORD *by Trish Evans*

IN JANUARY 2008, MY LATE HUSBAND, Charles Harrison, was diagnosed with terminal cancer and given a prognosis of less than two years. Within days of this diagnosis he set to work on producing *An Introduction to Art*, a book he had been intending to write ever since I first met him in 1981. He worked consistently during the following months – writing, checking, correcting – through all the debilitating effects of radical chemotherapy treatment and cancer trial drugs, with a concentration that I found astonishing even for him – and I had many years' experience of his intense commitment to his work. The first draft was completed by the autumn of that same year, a mere nine months in the writing, but it would be another year before the book would be available in its final form. Throughout this whole period the question of whether he would live to see the book to publication hovered unspoken over the entire enterprise.

However, although when he finally came to writing this book he worked so quickly and steadily, the period of its gestation covers many years. Charles loved nothing better than to walk round an art gallery or museum with someone and talk about the works of art on display. In particular he enjoyed doing this with people who had not previously seen art as something they could get any purchase on. For many years I taught students on a multidisciplinary course with the Open University and when we came to the Art History section I would ask him to take us all on a visit to the Ashmolean Museum in Oxford. These were adult students who were new to study and many of them had never been inside an art museum before. Had they done so, they would have felt baffled and out of place, even put down by it. Charles would invite them to stand in front of a painting and really look at it, then to ask questions about it and to puzzle at its possible meaning or significance until they felt they had made some sense of it. He always responded patiently to whichever questions or comments were made and always spoke of the art without mystification or obscurity. By the end of a two-hour visit, my previously sceptical students would be walking round independently, talking to each other about the works and curious to know more.

Whenever I have encountered these students in later years they have always told me that what they recall most vividly about that course was not my patient instruction in essay writing or even my careful induction into the beauties of literature or music, but this trip to the Ashmolean. For the first time they had learned that art could be accessible to them, that it is was not something reserved for the privileged few.

Charles gave them the confidence to look at works of art critically for themselves and to take possession of its possible meanings. That was a genuine gift and one that he bestowed with real generosity and pleasure on anyone who showed an interest. People who saw themselves as highly sophisticated consumers of art would frequently find that looking at works alongside Charles could make them see more and think differently.

Nothing can replace actually standing in front of a painting and talking to Charles about it – everyone who knew him, whether students, colleagues, friends or family, will remember how exhilarating that experience could be. But that gift was lost when he died just a few months before the final publication of this book. In the weeks leading up to his death almost the entire focus of his energy went into finalising the details of the illustrations and the layout. He was correcting the final proofs just a few days before he died, and when he realised that his time was drawing to a close, his one regret was that it had come before he could see this book – the product of a lifetime's inspired teaching, talking and thinking about art – in its completed form.

In this respect, then, *An Introduction to Art* represents for me a poignant fusion of sadness and triumph. It stands as a testimony to Charles's commitment to art in all its multifarious forms and to the importance of making this available to as many people as possible. Crucially also, it embodies a belief that the experience of art should be one of pleasure – both intellectual and aesthetic – and ideally that it should be shared with others. Anybody who has ever found themselves walking round an art gallery with Charles Harrison will recognise in this book his inimitable teaching style and will remember him at his most animated and enthusiastic. I can think of no more fitting legacy for this aspect of his life's work.

INTRODUCTION

I HAVE BEEN MOVED TO WRITE THIS BOOK by a belief that, for all the publications on art already available, there is a real need for a work independent of the interests of any specific institution that offers an introductory guide, not just to modern art, but to art conceived as a broad and open field. It is not my aim to establish a short cut to armchair knowledge, but rather to provide an incentive and accompaniment to first-hand engagement with works of art of diverse kinds. While the illustrations in this book are intended to provide suitable reference and accompaniment to the text, one of the strongest convictions by which I have been motivated is that there is no substitute for acquaintance with the objects themselves.

Works of art have traditionally been associated with vivid and abiding experiences and memories. This is clear evidence that they serve as complex repositories of meaning and content. But just how that meaning and content are recovered is a matter that is rarely free from controversy. There is continual debate in art criticism and art history and in philosophical aesthetics about different methods and principles of interpretation. That debate necessarily addresses the kinds of terms and concepts – the language – in which our responses and interpretations are expressed. It is therefore important that an introductory work such as this should offer some guidance on a relevant and workable vocabulary – guidance that is clearly linked to discussion of the examples illustrated. Questions of definition and categorisation assume a central importance, since they bear on the kinds of assumptions and expectations that we bring to our encounters with art.

The outer limits of the field to be covered in this book are set by the overarching category of visual art, as seen from the perspective of modern western culture. But within that field the reader will find the majority of attention is devoted to the sub-categories of painting and sculpture, conceived as fine arts, with a subsidiary emphasis on artists' prints. The last part is devoted mainly to the various new media that expanded in the twentieth century, as various challenges were offered to the traditional categories of fine art. This priority accorded painting and sculpture has meant

that some related areas of interest are neglected. I have not attempted to give accounts either of architecture or of photographic media, though the first has provided far from passive conditions for the development and installation of both painting and sculpture throughout their history; while as to photography, since its invention in the early nineteenth century its development in both still and moving forms has so far overlapped with that of painting as to threaten to overwhelm it altogether. Each is deserving of an introductory study on its own, which it is well beyond the scope of this book – and this author – to provide.

I have adopted slightly different principles in my manner of treating painting and sculpture respectively. Painting is discussed from the point of view of a European and latterly transatlantic tradition extending from the fourteenth century to the present. I also treat it as an art capable of a degree of self-contextualisation, particularly in the portable form of the so-called 'easel painting'. What I mean by this is that paintings have a certain power to restrict attention to their forms and colours and to what these represent. This power comes by virtue of their traditional containment within the limits of the frame. It also follows from their ability to establish imaginary worlds that extend into their own represented depths rather than outwards through the actual spaces that surround them. I have done what I can to explain the practical means by which this power is generated, to discuss the various types of picture and different manners in which it is exercised, and to consider the psychological part played by the spectator in response.

To the extent that painting involves the marking of flat surfaces, all paintings are similar as objects. The difference between one sculpture and another, on the other hand, can be the difference between two distinct types of object. Where painting is generally contained, sculpture is always encountered within a surrounding space. It is often physically inseparable from a given setting and is rarely easy to divorce entirely from the circumstances in which it is seen, even when free-standing. As an artistic medium it is much more liable than painting to overlap with such other categories as architectural decoration and domestic or other utensils.

As a means to establish some practical limits I have concentrated on sculpture of the human figure. In this case, though, it has seemed both appropriate and desirable to connect the European tradition to a much wider sense of the art, one extending both to the ancient and classical antecedents of that tradition and to the various so-called 'primitive' artefacts that had so marked an effect on developments in the twentieth century. My account of sculpture is therefore far more wide-ranging than my account of painting and is more concerned with considerations of context, with the significance of different materials and processes, and with

problems of interpretation and response. Readers will find fewer detailed discussions of the kind I have provided for some individual paintings. I suggest, though, that the nature of sculpture is such that detailed discussion of this kind has less exemplary potential. Description of sculpture is generally harder to contain than description of painting. This is one of the paradoxical grounds of its fascination.

I have aimed to make the best of this difference between the two major art forms. The contrast of approaches between their respective parts is intended not simply as a means of distinguishing the characters of their subjects but as a way of demonstrating slightly different emphases and priorities in writing about art. Neither of these is intended to exclude the other, however. While I have at various points made a kind of strategic distinction between 'aesthetic' and 'historical' approaches, I have not done so because I believe that the distinction is easily made in connection with any worthwhile experience of a work of art. On the contrary: my concern has been rather to make the consequences of the distinction explicit, so that its more damaging effects can be avoided.

My manner of proceeding follows from a conviction – born of long experience teaching in art schools, universities and museums – that any introductory work must aim to bridge the gap that has formed between what have become widely contrasted approaches, one involving a weak version of the aesthetic, the other involving an over-specialised sense of the contextual and the historical. The first approach is the one generally taken in the literature and industry of art appreciation, a category filled at best by works of sophisticated connoisseurship and at worst by gushing publications more or less indistinguishable from press releases. It is usually associated with generous quantities of attractive illustration and with enthusiastic descriptions of relevant works. The problem with publications of this kind is that they tend to take on the character of guides for consumers. However well intentioned, they rarely leave the reader equipped with sufficient practical and historical insight to think independently and critically about the art they introduce. This tendency has been aggravated by a massive and continuing growth in the numbers of artists, galleries and museums, by the marked and growing commercialisation of a world and culture of art that had for a long time previously been of limited access and popularity, and by the increasing application of business methods and principles to virtually all matters concerned with the exhibition, distribution and publication of art. Temporary exhibitions are now major opportunities for museums to market their own brand together with other related products, with publications high among them. It is unquestionably good that barriers to the experience and critical enjoyment of art should be removed, be those barriers financial, social or educational. But

it is a poor kind of emancipation that turns potential learners into the passive consumers both of spectacle and of interpretation.

The second approach is the one that characterises academic publications in art history, which take the form of learned catalogues accompanying exhibitions, independent studies of movements or groups of work and monographs on individual artists. Although these may be well informed by specialised study and historical research, they are often unsuitable to serve as introductions for those without much experience of academic methods, who come to the art in question seeking guidance on its practical character. The academic study of art history has developed massively since the mid-twentieth century, with professional conferences attended by thousands, yet not everyone who wants to learn about art wants to become an art historian.

Polarisation between these two types of publication increased markedly during the 1960s and 1970s. Since then much academic art history has been engaged with sophisticated types of semiological and cultural theory that have made its findings hard for more populist authors to assimilate. Over the same period the teaching of art appreciation fell out of favour among academic art historians, who suspected, among other things, that it leads to reinforcement of the very canons that they have seen themselves as working to question and to revise. This polarisation has not been to the advantage of studies in art history, which have largely missed the practical experience and intelligibility that was sometimes brought to the subject by an earlier generation of scholar connoisseurs.

In fact, if appreciation and engagement in inquiry are inseparable – as I shall argue throughout this book that they are – a polarisation between aesthetic and historical approaches, or between connoisseurship and art history, must be damaging to both sides. My intention, then, is to try to bridge the gap by drawing not only on the study and teaching of art and art history but also on practical experience of a wide range of works of art, and on what I have been able to learn in the studio of my artist colleagues. I would like to think that this book might perform a role similar to the one I have most enjoyed in all my encounters with students: that of discussing works of art in their actual presence in galleries and museums, and of opening them up to inquiry, criticism and enjoyment.

It is my strong hope that the book will serve both to broaden and to stimulate the curiosity of its readers where works of art are concerned, and to increase their pleasure in the first-hand encounter. I also hope that it will serve to make clear that pleasure in art and learning about art are potentially indistinguishable. I believe that it is precisely in the combination of appreciation with inquiry that connections between people and works of art are most effectively established. These are the conditions

under which works of art may be understood not as objects for the exercise of consumer choices, but as complex vehicles for empathy with minds and cultures other than our own.

My final aim for this book is that it should help to offset a tendency for interest in the art of the modern period and the present to lead to neglect of the art of the past, and for the significance of traditions to be consequently neglected or misunderstood. The majority of my professional work on art has been concerned with the period from the late nineteenth century to the present and with the specific problems of its evaluation and interpretation. Some of these problems are discussed in the concluding part of the book. The art of the late twentieth century and the present can sometimes be hard to explain in simple terms. The necessarily specialised nature of some of the issues at stake means that this chpater is likely to be slightly more demanding of readers than what has gone before. It has always been my experience, however, that consideration of those issues makes the art of the past – however remote – appear all the more relevant and interesting. Rather than another book on modern art, it has been my aim to produce a book about art in general that is informed by a direct engagement with the art of the present.

For any extended discussion of individual works of art I shall refer only to those I have been able to see at first hand in original locations, in museums, in temporary exhibitions and in private collections. While I will necessarily make use of what may be established about works and sites of which I have no direct experience, I shall generally avoid referring to these in support of any conclusions of my own. I have avoided loading the book with an apparatus of notes and acknowledgements, not wanting to produce a work with the appearance of an academic text. I have also wanted to avoid appeals to authority. Readers can nevertheless take it for granted that I am heavily indebted to the work of other writers, especially to those listed at the end of the book in recommendations for further reading.

This book has been planned for many years, and during the time I have been thinking about it I have benefited greatly from my work with students of various institutions in England and the United States, most particularly with those attached to the Open University. Their expectations and responses have done much to form the character of this book. Over the far shorter time in which the text was written I have been very fortunate in those who have given criticism, commentary and advice at every stage of the draft: these are my wife, Trish Evans, who has supported me throughout, not least by taking the side of my potential readers; the philosophers John Hyman and Jason Gaiger, who in their several ways have done their considerable best to correct my lapses of argument; and

my colleagues Michael Baldwin and Mel Ramsden, the artists whose work is issued in the name of Art & Language, who have approached the demanding task of correcting and extending my work as an act of positive and continuing collaboration. I am also grateful to Sharon Harrison and Orlando Harrison (a.k.a. The Spirit), for their critical comments and suggestions on some early material, and to Tom Mitchell for a timely suggestion regarding the concluding section. Hollis Clayson, Christopher Heuer, Matthew Jesse Jackson and Michael Schreyach read the draft text and offered valuable criticisms, comments and advice. Gillian Malpass of Yale University Press has provided prompt and full encouragement at every stage and has shown a continual faith in the project for which I have every reason to feel grateful.

PART I

WHERE IS ART?

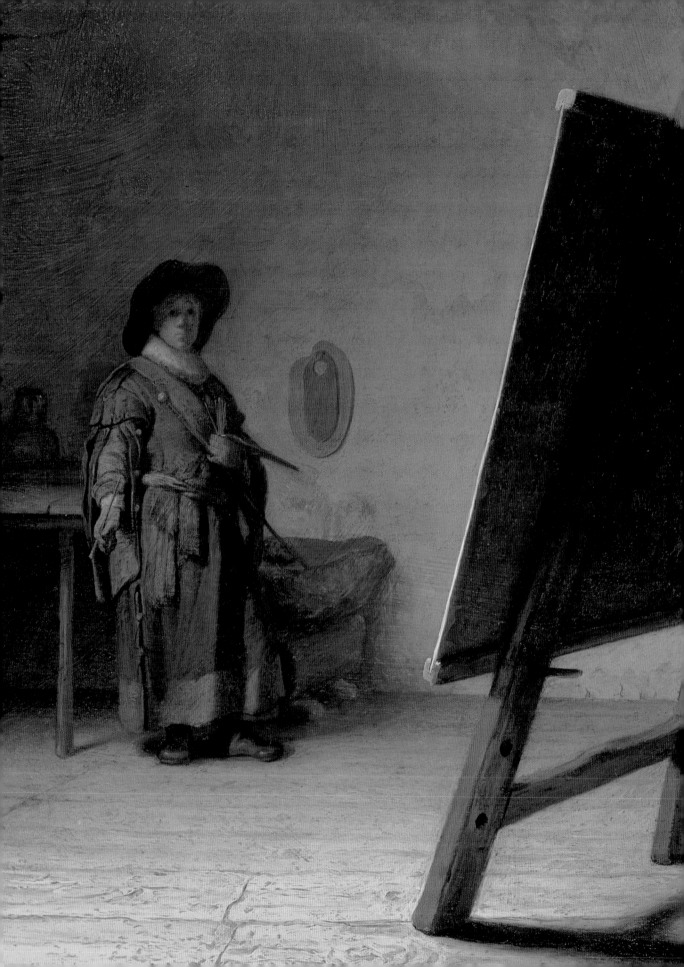

1.1 LOOKING AND SEEING

The aim of this book is to provide an introduction to art – to looking at art and thinking and talking about it but also to studying it. To those for whom art is more or less unknown territory, it offers an introduction to the main kinds of object that might be found in a relatively large art museum – from the most ancient objects to the most modern – and to the different ways in which they can be approached. For those already interested in art, it provides information and suggestions intended to deepen and intensify the pleasures to be gained from viewing works of different kinds.

Among those different kinds, the art of painting has occupied a central place in the development of visual representation over many centuries, particularly in the west. Painting in the European and western tradition will be given early attention in this book, though an equal amount of attention will in due course be devoted to sculpture. The first plate shows a small painting by one of the most widely celebrated of all painters, the Dutch Rembrandt van Rijn, who lived in the seventeenth century. He has painted himself, at the age of about twenty-three, standing before an easel in his studio (pl. 1). Apparently simple as this picture is, there are a number of matters it invites us to consider, from such straightforward questions as where the light is coming from, to more open-ended issues that require us to exercise some imagination. What or whom might the artist be looking at? Do we imagine some person looking back? What might be depicted on the unseen painting within the painting? What relationship might it have with the painting we are actually looking at?

I want to show how absorbing such works can be when enough attention is paid to them and how much they have to offer in bringing their history alive. It is one of the reasons for the abiding fascination of painting that pictures have the capacity to create imaginative worlds and to provide rich material for interpretation. This is a kind of content that many paintings have by virtue of the things and people and scenes they represent. I use the term represent here rather than depict, since it covers a wider range of ways in which works of art may evoke or refer to their subjects. Although the hidden painting in Rembrandt's picture is not depicted, for

facing page Rembrandt van Rijn, *The Artist in his Studio*, detail of pl. 1

1 Rembrandt van Rijn,
The Artist in his Studio, c.1629,
oil on panel, 24.8 × 31.7 cm,
Museum of Fine Arts, Boston

This painting makes an early
and modest contribution to a
type of subject that attracted
important works from many
painters between the early
seventeenth century and the
late twentieth. Notable
contributors to the theme of
the 'artist's studio' include
Vermeer, Velázquez, Courbet,
Matisse and Picasso. These
paintings are revealing about
the materials from which art
is made, about the physical
and social conditions of
artistic practice and about the
nature of relations between
artist and model, artist and
spectator and spectator and
painting. Here Rembrandt sets
himself well back in a space
furnished only with a large
easel, a stone for grinding
pigments, bottles presumably
containing oil and turpentine
and a pair of palettes hanging
on a nail. Much of the allure
of the painting depends on
the relationship between
these mundane elements and
the hidden surface of the
painting on the easel, glowing
as it must be with the light
that falls on it from a window
outside the represented space
of the picture. The artist is
not looking at his canvas,
however, but out towards the
position of an imagined
spectator. (For Rembrandt see
also pls 66 and 114.)

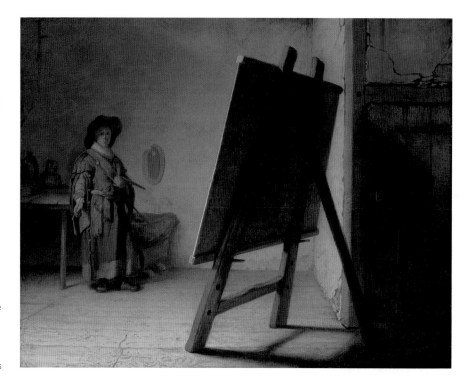

instance, one might say that it is represented in the sense that it is part of
that picture's imagined content. Taken as a whole the picture might be
understood as a representation of the art of painting. As will be seen, the
use of symbolism is another means by which themes or motifs or objects
may be referred to so as to extend a work's depicted content. Both paint-
ing and sculpture have this potential for representational content in
common with literature. Art depicts in a way that literature does not, but
both art and literature can be said to represent. Their ability to refer in
this way to themes of historical, mythical and actual life is the principal
reason why these 'fine' arts have generally been accorded such high status.

This does not mean, though, that representational content of this kind
is entirely necessary to painting or to any of the other visual arts. Even
those works that appear high in both depicted and representational
content, like the picture by Rembrandt, may actually achieve much of their
effect as a consequence not so much of what is shown, but rather of how
the various constituents are made and put together. An abstract painting
or sculpture that has no evident resemblance to things or people may still
hold our attention because it presents an original or compelling combina-
tion of forms and surfaces and colours (pl. 2). The same goes for excep-
tional works of ceramics (pottery and porcelain) and for many of the other
kinds of object to be found in museums (pl. 3).

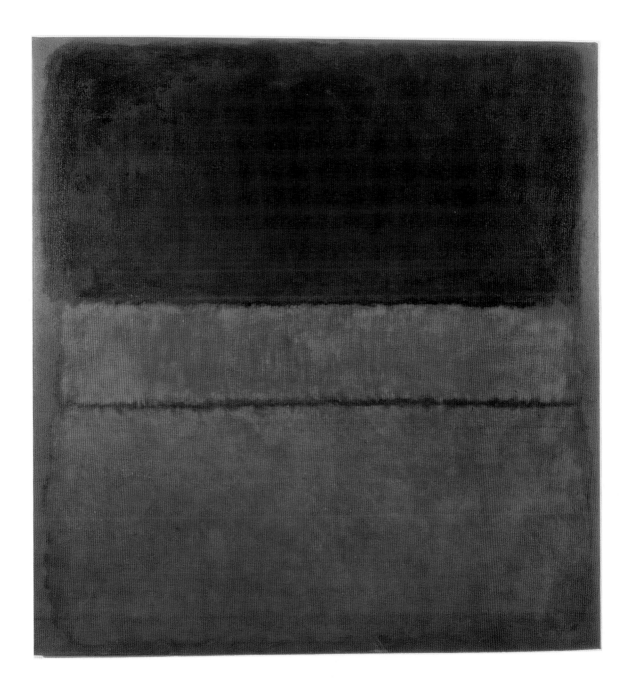

2 Mark Rothko, *Untitled*, 1959, oil on canvas, 144.7 × 139.7 cm, private collection

Rothko was one of a generation of painters who emerged to prominence in New York after the Second World War. His large paintings are composed of overlapping veils of colour that create an illusion of indefinite depth, inviting the viewer to look into their surfaces. The artist conceived of the relationship between painting and spectator as a kind of intimate emotional exchange.

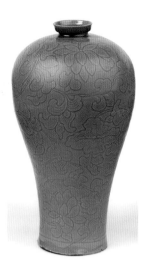

3　Vase with celadon glaze
and incised decoration, Korea,
Koryu dynasty, 12th century,
h. 34.2 cm, Victoria and Albert
Museum, London

The decoration on this vase
was made by carving a
pattern into the clay when it
was leather-hard, before
glazing and firing. Its glaze is
made from feldspathic earth
or rock fused with a natural
flux such as lime or potash.
This requires firing at a very
high temperature. The willow-
green colour known as
celadon was particularly
sought after for its
resemblance to jade. It was
produced by the addition of
iron to the glaze and by
reducing the supply of air to
the kiln. Some of the finest of
all ceramics were made in
Korea during this period.

As distinct from the works of literature and music that we read or listen
to, a work of visual art as traditionally defined is one that we need to look
at to enjoy and make sense of. Since it is designed 'for the eyes', the com-
position of a painting or sculpture does not usually unfold over time like
the structure of a novel or even a poem. However long we may need to
take in its various components and its detail, it is all there from the start
without the need to turn pages and follow a sequence. This is a crucial
factor to bear in mind when we think about how it is that works of art
have meaning and value. That works of art are things presented to us in
this way means that there is something distinctive about the kinds of
response they invite.

The skills at work in such things can be highly developed and highly
sophisticated. The aim of this book is to help the reader to see and to
understand what it is that makes these works of art worth attending to.
Some of what follows may seem elementary. I make no apologies for this.
Although learning to read and write are foundational to all educational
systems, we are not generally taught how to look and to see, let alone how
to understand visual representation. While it is self-evident that no one
can appreciate a poem or novel who cannot understand the language in
which it is written, and that no one can read such things for themselves
who has not learned to read, we normally assume that someone who
manages not to bump into things is fully equipped not only to make dis-
criminations in the ordinary field of vision but also to find their way
around visual representations. Yet this is clearly not the case. If it were,
the museums of the world would not be as full as I suspect they are of
people feeling slightly disappointed that the things they stop to look at
mean so little to them – or working to persuade themselves that what they
think they ought to be feeling is what they actually are feeling. In his *Letter
on the Blind*, published in 1749, the French critic Denis Diderot wrote, 'It
is perhaps necessary that the eye learns to see as the tongue learns to
speak.'

Learning about works of art has much in common with the means by
which we extend our experience of the natural world; that is to say, it
involves a simultaneous process of learning to make distinctions and
employing and extending a vocabulary. The vocabularies of most speak-
ers of English will include the words 'robin' and 'sparrow' and 'oak' and
'beech' but not everyone who looks at a group of birds or trees can connect
these names appropriately to the different objects they refer to. To see a
small brown bird as a sparrow and a same-sized bird with a red breast as
a robin is both to be able to use those names with confidence and to inhabit
a world in which the relevant differences are significant, and which is more
complex and richer as a result. Even the smallest such increases in one's

knowledge invite the making of further discriminations, with further extensions to one's usable vocabulary and to the pleasure to be taken in nature.

The realm of art can hardly be more complex than the natural world. Just as with our understanding of nature, we can advance a considerable way in our understanding of works of art by starting with easily observable and easily learned differences, such as those between a landscape painting and a still life, or between a sculpture that has been modelled and one that has been carved. My own experience tells me that art is inexhaustibly interesting and enjoyable and that there is no end to the process of learning about it. It follows that absolute knowledge and understanding of art is no more possible than it is in the case of the natural world. No one need be ashamed of the limits on their knowledge and experience, particularly not anyone who might be reading this book as a first step in gaining acquaintance with the wide field that it is designed to introduce. In fact, there are plenty of well-read specialists in the art of the modern period who would be unable to tell the difference between a painting by Cimabue and a painting by Giotto, and there are plenty of specialists in the art of the Italian Renaissance who would be hard pressed to distinguish between a Manet and a Monet. This book is not intended to make experts of its readers; it is designed to give graspable meaning and reference to a wide range of artistic categories and labels and technical terms and artists' names, and thus to help its readers to progress from looking to seeing.

It may be asked what is the difference between one and the other. Does seeing simply imply a slower and more attentive process than looking, or does it involve the application of specialist knowledge and understanding? These are questions that this book as a whole is designed to consider and to answer. One conclusion may be anticipated: where art is concerned, seeing certainly entails a richer and potentially more pleasurable experience than mere looking.

In discussing some basic questions of composition and interpretation, I shall look to the art of painting for initial case studies, as I have suggested. First, however, I mean to devote some thought to the kinds of context in which art is encountered, to the different kinds of approach that these may encourage and to the various problems involved, including the problem of how art is to be defined in the first place.

❏ ❏ ❏

4 Cimabue, *Virgin with Angels*, c.1280, tempera on wood, 424 × 267 cm, Musée du Louvre, Paris

This large panel was made for the church of San Francesco in Pisa, by one of the most highly regarded artists of his period. In 1811 it was bought from among the property of suppressed religious houses of Tuscany for a mere five francs. The purchaser was Baron Vivant Denon, the curator of the Louvre appointed under Napoleon Bonaparte. After the fall of Napoleon, many works acquired during his regime were returned to their places of origin. The commissioners from Florence regarded Cimabue's altarpiece as a primitive thing of no value, however, and it was left in the Louvre. Now priceless, it serves as a reminder of the consequences of changes in taste and fashion.

6 (*facing page, right*) Clara Peters, *Still Life of Flowers and Dried Fruit*, 1611, oil on panel, 73 × 52 cm, Museo del Prado, Madrid

Clara Peters worked in Antwerp and specialised in the kinds of table pieces and 'breakfast still lifes' that record the life-style of the prosperous Flemish bourgeoisie.

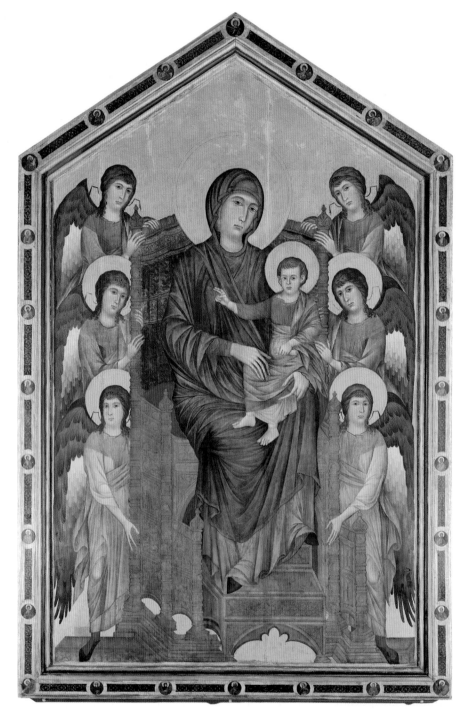

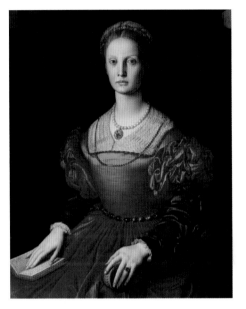

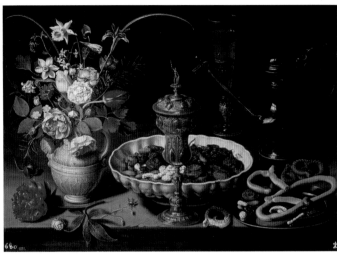

I.2 MUSEUMS AND SITES

The book is written with two particular points in mind: on the one hand, it is museums of various kinds that provide most people with their principal opportunities for first-hand encounters with art; on the other, it is easy for visitors to be frustrated or misled by the appearance of works of art in museum settings, since few of the works were produced with such settings in mind, at least until the twentieth century. In fact it is only since the second half of the last century that significant numbers of works of art have been made with museums as their proposed destinations. The greater part of what we find collected in them was made with widely different locations in view and often with other purposes than to entertain and educate a broad public. Large religious paintings might be made with religious congregations in mind, while smaller easel paintings were for the most part destined for individual patrons. Indeed it is only since the late eighteenth century that the general public has been conceived of as a potential audience for paintings. Among the works present in the major galleries we might expect to find an altarpiece painted to hang in an Italian church (pl. 4), a portrait of a woman painted for her husband (pl. 5) or a still life that may once have hung over a Dutch merchant's dining table (pl. 6). Among the portable sculptures now in museums, a high proportion of those that originated in the cultures of India, Java, Nepal, Tibet and China are images of the Buddha in his various incarnations, made for religious purposes, to assist in acts of public or private observance, as offerings to

5 (*above left*) Agnolo di Cosimo, known as Bronzino, *Lucrezia Panciatichi*, c.1540, oil on panel, 101 × 82.8 cm, Galleria degli Uffizi, Florence

This elegant portrait forms a pair with Bronzino's portrait of the sitter's husband, a member of the Medici's Florentine academy who was presumably responsible for commissioning both works. Details serve to assert Lucrezia's piety and fidelity. She holds a prayer book, while the words on her outer necklace read *Amour Dure Sans Fin* ('love lasts for ever').

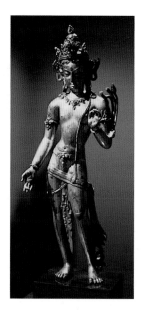

7 *Bodhisattva*, Nepal, 13th century, gilt copper alloy with semi-precious stones, 60.3 × 19.1 cm, Norton Simon Art Foundation, Pasadena

Buddhism originated with the historical figure Gautama Siddhartha. Brought up as a Hindu prince in the sixth century BCE, he developed a distinct philosophy based on the search for enlightenment through elimination of earthly desire, leading to release from the endless cycle of reincarnation. According to the teachings that circulated after his death, bodhisattvas are compassionate devotees who have reached the stage of enlightenment but have delayed the final release so as to assist others in attaining the same state. Their princely dress and ornaments serve to distinguish them from images of the Buddha, who is usually represented as a more ascetic figure.

temples or as mementos of pilgrimages to holy sites (pl. 7). There are sensuously beautiful figure sculptures, some preserved in museums in California, New York, London and elsewhere, that are images of Hindu deities made in India from the tenth to thirteenth centuries for use in religious rituals and for devotional worship (pl. 8). Even such impressive non-religious images as were originally made for public display were more likely to have been designed as demonstrations of political power and authority than for purposes of education or entertainment.

A high proportion of the ancient artefacts now to be found exhibited in museums has been furnished by excavations. This is to say that the objects have been unearthed at sites covered over by the passage of time or by natural disasters or acts of partial destruction in the past, or where material has been deliberately buried. Such excavations may originally have been carried out by collectors and their agents in search of buried antiquities, by opportunists looking for valuables to sell or by scholars engaged in archaeological research. Even where excavation has been done in the name of scholarly furtherance of knowledge about the past, the prevailing tendency over the centuries has been for artefacts of particular artistic value and interest to be removed. In some cases whole tombs, temples and architectural complexes have been dismantled and transported to museums far from their original locations. While this may have ensured the preservation of the artefacts and monuments, and perhaps made them more available to public view, it has often involved losses both to the integrity of the sites and to the potential for understanding the original meaning and function of the artefacts themselves. In the museums of Europe and North America there are many examples of figures in stone and even of wall paintings that have at some point been detached from the facades and interiors of monuments in Egypt, in India or elsewhere. Which is the preferable outcome: that a carved figure or painted decoration should be preserved in a museum, where it can be protected and made available for viewing under comfortable conditions; or that it should be left attached in its original location to the building where it composes part of a sculptured or painted ensemble, where it may perhaps be subject to damage from the elements, from pollution, from acts of religious iconoclasm or from random acts of vandalism? Clearly, there are arguments to be mounted on both sides.

There were limits, however, to what even the imperial powers of the nineteenth century were able to dismount and transport to their burgeoning collections. Many of the world's great archaeological and architectural sites are themselves now preserved as kinds of open-air museums, from which vulnerable items are removed only when necessary for their protection and conservation: in Egypt, the temples of Abu Simbel (pl. 9),

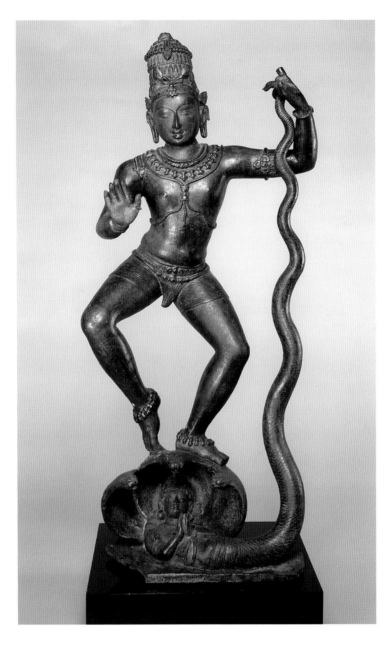

8 *Krishna dancing on Kaliya*, Chola period, 11th century, bronze, h. 87.6 cm, Asia Society, New York, Collection of Mr and Mrs John D. Rockefeller III

Krishna is a hero of Hindu legend, both a pastoral god and a divine lover. He is also sometimes represented as an incarnation of Vishnu (see pl. 180). Here he is shown having subjugated the serpent demon Kaliya, in an episode symbolic of the victory of heavenly over earthly powers. The gesture of the right hand signifies protection and benediction. This sculpture was cast in solid form using the lost-wax process (described in section 4.7).

Luxor and Karnak; in Italy the Roman cities of Pompeii and Herculaneum, buried by a volcanic eruption in 79 CE and still in process of excavation (pl. 10); in Peru the Inca city of Machu Picchu; in Cambodia the temple complex of Angkor Wat; and many, many more.

Much of what we now count as art has thus still to be visited *in situ* if it is to be seen at all at first hand, rather than in reproduction or on film.

9 (*right*) Temple of Abu Simbel, with colossal figures of Rameses II, 1279–1213 BCE, Lower Nubia, Egypt

Rameses is shown in four-fold image in the guise of the god Osiris. Each of the figures cut from the solid rock is some 22 metres high. The smaller figures in front of the throne and between Rameses' legs represent his chief wife, his mother and his children. The doorway in the centre of the facade leads in to a large temple with several chambers, cut from the rock and richly ornamented with carved reliefs. A smaller rock-cut temple to the side is dedicated to the goddess Hathor and to Nefertari, Rameses' queen of twenty years (see pl. 11). The entire temple complex was dismantled and rebuilt on higher ground in the 1960s after the building of the Aswan Dam and the creation of Lake Nasser.

10 (*right*) House of the Mysteries, detail of wall paintings, c.60–50 BCE, fresco, Pompeii, Naples

The complete suite of paintings surrounds one room in what was originally a wealthy suburban villa. Altogether twenty-nine life-sized figures are included. The painted scenes show episodes from the mythology of the Greek God Dionysus and moments from the rituals, 'mysteries' and revels associated with his cult. Also known as Bacchus, he was the god of wine and of inspiration.

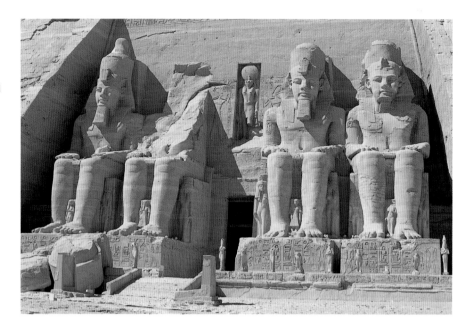

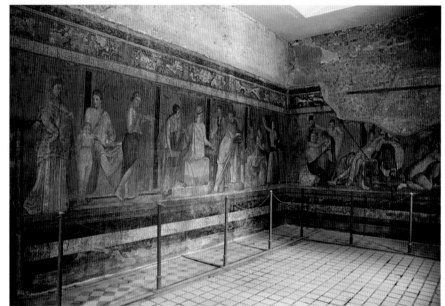

I shall continue to refer to such places as 'sites' rather than museums but it should be clear that the distinction is not a hard and fast one. We generally think of museums as large buildings to which objects are brought and in which they are enclosed, while many sites are visited for their architectural interest and include large areas out of doors. Yet there are enclosed places, from churches to civic buildings, where works of art can be seen

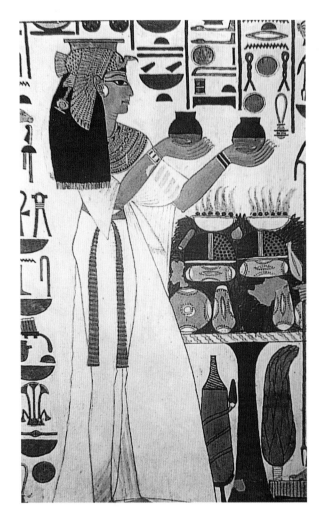

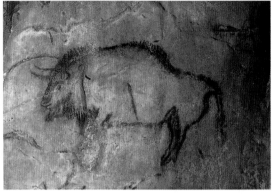

11 Tomb of Nefertari, detail of wall paintings, c.1200 BCE, Valley of the Queens, Luxor

Nefertari was the favourite queen of the Pharaoh Rameses II (see pl. 9). Her tomb was discovered in 1904. The decorations are painted into a layer of plaster that was applied to the limestone walls and then carved in shallow relief. They show the queen making offerings to the gods and journeying from earthly to eternal life. The paintings were the subject of an extensive restoration project in 1986–92.

12 (above) Cave painting, Magdalenian culture, c.18,000–10,000 BCE, Grotte de Niaux, south-west France

It is easy to forget that the 30,000-year span of what we call cave art comprises some seventy per cent of the entire time known to the history of art. The majority of surviving examples have been found in France. Pictures such as this were painted using charcoal and manganese dioxide, with light probably provided by lamps burning animal fat. There are no signs of ordinary habitation at the terminal point deep into the caves at Niaux where the drawings are found, suggesting that such spaces were reserved for purposes specifically associated with the decorations, possibly involving ceremony of some kind, though there is no convincing agreement about what this might have been. Such fluent and accurate drawings could only have been made by accomplished artists who were capable of carrying faithful images of the animals in their minds

in original locations and many of these operate much like museums. Not all of what is involved can simply be categorised as architectural decoration. There are prehistoric paintings of great sophistication and vitality hidden deep in cave complexes in south-western France, where at the time they were made they could only ever have been visible to members of small communities by the light of fires (pl. 12). The surviving monuments in Egypt include giant statues and deep temples ornamented with sculptured reliefs, carved out of solid rock, and tombs covered with still brilliant wall paintings (pl. 11). From more recent times there are European churches and chapels decorated with carvings and some, like the Arena chapel in Padua in Italy where the artist Giotto worked in the early fourteenth century (pl. 13), in which entire programmes of painted decoration survive more or less intact.

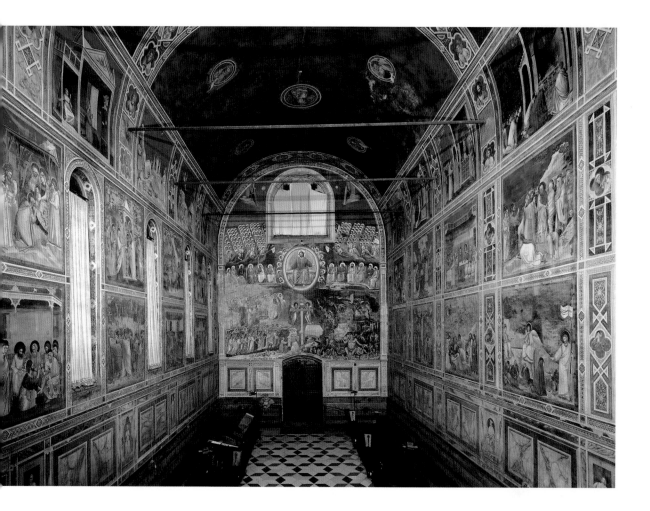

The Arena chapel was designed as a funerary monument to the merchant Enrico Scrovegni who commissioned and paid for it (thus it is also known as the Scrovegni chapel). In the Christian cultures of Europe many of the prosperous and powerful ensured their commemoration by conspicuous displays above ground and by endowing chapels to celebrate masses for their departed souls. Some of the finest decorations in Italy are to be seen in surviving funerary chapels. A notable later example is the New Sacristy in the church of San Lorenzo in Florence, designed by Michelangelo early in the sixteenth century and ornamented with figures carved in marble (pl. 14). Throughout the world, surviving religious buildings and monuments still provide some of the richest opportunities to view works of painting and sculpture in their original locations.

Other instances where art can be visited *in situ* are those artists' studios or working spaces that have been preserved, together with such work as

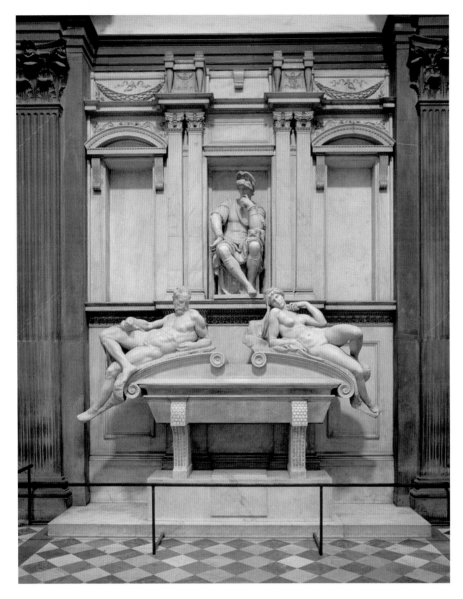

13 (*facing page*) Giotto, Arena Chapel, view of the nave towards west end, 1304–13, fresco, overall dimensions h. 12.8 m, l. 20.82 m, w. 8.42 m, Padua

The work of Giotto occupies a central place in the tradition of western pictorial art. The Arena Chapel is decorated with thirty-six consecutive narrative scenes commencing with the story of Joachim and Anna, the parents of the Virgin Mary, and ending with Christ's resurrection and the inspiration of the apostles at the feast of Pentecost. The west wall is painted with a large scene of the Last Judgement, at the base of which the patron, Enrico Scrovegni, is shown donating the chapel in the hope of his own admission to heaven. Fresco involves painting directly with liquid pigments into a freshly applied layer of fine plaster.

14 (*above*) Michelangelo, New Sacristy of San Lorenzo, showing tomb of Lorenzo de' Medici, 1519–33, marble, Florence

The New Sacristy was designed as a funerary chapel to house the remains of four members of the Medici family. Michelangelo was responsible for the architecture, the design of the tombs and the sculptures that were included. The work was subject to various interruptions and the project remained incomplete when Michelangelo left for Rome in 1534. This illustration shows the tomb of Lorenzo de' Medici, with a sculpture of the duke dressed in Roman military uniform and allegorical figures of Dusk and Dawn, all carved in marble. (For Michelangelo see also pls 138, 156 and 217.)

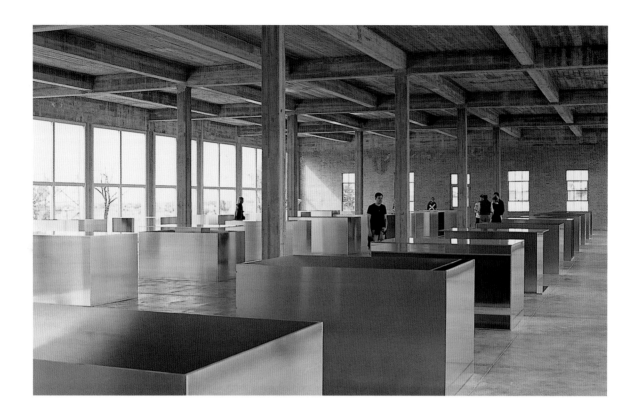

15 Donald Judd, *Installation of 100 works in mill aluminium*, partial view, 1982–6, each unit 104.2 × 129.5 × 183 cm, Chinati Foundation, Marfa, Texas

The complete work of which a detail is shown here occupies two converted artillery sheds at a former military base taken over by the artist with the assistance of the DIA Art Foundation. This and other buildings at the base and in the nearby town of Marfa were adapted in conformity with Judd's plain and rational style so as to serve as permanent settings for his own work and that of other artists. (For Judd see also pl. 107.)

may have been left unfinished, or kept by the artist for other reasons, or been re-assembled posthumously. For the most part these are enterprises of the modern period. Museums devoted to the painter Gustave Moreau and the sculptor Auguste Rodin were both opened in Paris early in the twentieth century in buildings they occupied at the end of their lives. The English sculptors Henry Moore and Barbara Hepworth both left their homes, gardens and studios to serve as museums of their work, the one in Much Hadham in Hertfordshire, the other in St Ives in Cornwall. One of the most ambitious complexes is to be found in the remote small town of Marfa, Texas, where the house and studio of the artist Donald Judd are preserved, while ambitious displays of his own three-dimensional work and of the work of fellow artists are housed in the converted buildings of a former military base nearby (pl. 15).

❑ ❑ ❑

1.3 HISTORY AND AESTHETICS

Even where carvings and paintings have survived on the walls of caves, shrines, temples or churches, we may be separated by hundreds if not thousands of years from the conditions of their production and first use, as we are from the cave paintings in the Grotte de Niaux (see pl. 12), the massive sculptures at Abu Simbel (see pl. 9), or the paintings in the tomb of Nefertari (see pl. 11). Where objects have been removed from their original locations and placed on view in museums there is often a still wider gap to be bridged. Even in the case of contemporary works, the ordinary museum visitor is likely to be glad of some assistance in linking the objects exhibited to the world of ideas inhabited by the artists. It is principally for this reason that museum displays tend to be accompanied by lengthy labels or explanatory texts. The purpose of these is to help bridge the gaps: to guide the imagination of the viewer so that the materials on view can be reconnected in thought to their original locations, cultures and functions.

Researching and providing the relevant information is the specialised work of the art historian and museum curator. The ordinary interested viewer of art is likely to have to take this work largely on trust. A potential problem arises as a result. It can sometimes seem as though the visitor is faced with a choice between alternative priorities or patterns of behaviour. For the sake of clarity I shall exaggerate these alternatives, associating each with a different type of viewer. Sam likes to spend as much time as possible absorbing the information on offer, gaining some understanding of the objects on view and perhaps coming to appreciate their original function. I shall call this the 'historical approach'. In doing so I mean the history of an object to be understood in the broadest terms, so that it covers not simply that object's date of origin and subsequent life but the practical purpose, if any, that it was designed to fulfil and the part it may have played in the beliefs and values of a given society or social group. In the historical approach, the significance of the object in view is in part due to its value as a piece of evidence or record or document – something that will make sense when it is placed in context and that may in turn help to fill out our understanding of that context. It is history in this sense – a body of knowledge that the work of art serves to illustrate and enrich – in which Sam is really interested. The considerable advantage of this approach is that it serves to direct attention onto the specific purposes and values that may have shaped the work, so that its particular representational character can be understood by reference to the social world and period of its origin. One risk is that, rather than treating the work itself as a means to knowledge, Sam may take the background information as adequate for understanding and interpretation and thus fail to

register the work's actual individuality, which may reside in some exceptional technical character, in a content that once went against the grain of contemporary values, or both.

Val is more inclined to give priority to the objects on display and to ignore most of the accompanying information. There may then be more time available to look at more objects and to concentrate more fully on their diverse appearance, though at the risk of gaining little understanding of their original function and meaning. I shall call this the 'aesthetic approach'. The term aesthetic is derived from a Greek word meaning 'perceptive' but it has come to mean concerned with beauty and with its appreciation. There are of course different kinds of beauty. Given the problems posed for the notion by the art of the modern period, which often seems deliberately unbeautiful, it may be safer to think of the aesthetic approach as implying an interest in things for their own sakes – for what they are, rather than what they may have been used for or may be worth in financial terms or even in the scenes and events that they may represent. (It is a notorious paradox that what may be unbearable or repulsive in real life can serve as material for art with a high aesthetic value. Many of the most celebrated works of Christian art show a man dying a terrible death on a cross (pl. 16).) Val's interest is less in the specific social function of the work of art than in the particular solution it offers to a problem common to all art: how representational and emotional content are to be sensed and understood by reference to the marks and forms of which the work is made. Due to the priority it accords to those marks and forms, Val's type of approach is often labelled 'formalist'. The advantage of this tendency is that it allows the work of art to be experienced less as an object that requires interpretation in the light of other events than as if it were a specific event in its own right. The risk is that it will be used to justify merely personal kinds of interpretation in the face of contradictory historical evidence.

Throughout this book there will be various occasions on which to reconsider the possible tension between these two approaches, and I shall suggest various means by which that tension may be resolved. I do not mean to suggest that there is anything wrong either with working to acquire whatever information may be provided or with enjoying art without knowing much about it. Most of the time we probably combine the two approaches happily enough, without any conscious sense that that is what we are doing. An aesthetic approach to an object may well stimulate historical inquiry into the circumstances of its production, just as information about historical context may provide insight into an object's aesthetic value. If there is reason for argument here it is merely about which way of proceeding is most likely to keep the object fully in view.

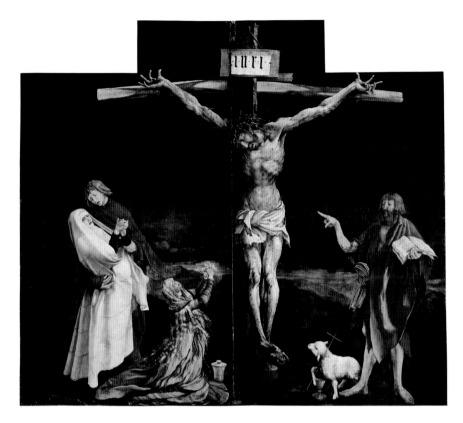

16 Matthias Grünewald, *Crucifixion*, from the Isenheim altarpiece, c.1512–15, oil on wood, 269 × 307 cm, Musée d'Unterlinden, Colmar

This scene of crucifixion forms the central part of a large composite altarpiece. Christ's flayed figure on the cross is flanked on the left by the kneeling Mary Magdalene and the grieving Madonna comforted by St John the Apostle and on the right by St John the Baptist, accompanied by a lamb holding a cross, the symbol of the Lamb of God sacrificed to redeem the sins of the world. The work was originally commissioned for the hospital chapel of a monastic order charged with care over the sick and dying. This helps to explain the concentration on images of intense suffering.

The real problem occurs when the respective priorities seem to be in competition with one another, for example when taking in all the accompanying information provided in museum displays threatens to use up the time available to look at the exhibits themselves. A familiar stereotype illustrates the issues at stake: the couple on holiday visiting a museum or foreign town, the husband (usually) with his nose in the guidebook, the wife impatient to get on and look at what is there to see. It is not simply in the experience of the visitor that these priorities may sometimes seem to conflict. With limited funds to spend on new acquisitions, the curators and trustees of major museums sometimes have to decide whether to commit a substantial sum to a single expensive 'masterpiece' – an item supposedly high in aesthetic value – or to opt for a number of less spectacular objects, the principal attraction of which is that they offer unique evidence about the social world and moment of their production.

It can sometimes appear that these differences in priority are reflected both in the different types of art museum that have been established in the modern world and in the two principal means by which many of the world's largest museums organise their displays. Just how a given institu-

tion maintains and exhibits its holdings is likely to depend on the terms of its initial foundation, on the principal bequests and acquisitions that have established its character and on the role it is given to play by its trustees and by whatever authority they may represent, whether national, local, educational or 'independent'.

For the sake of clarity I shall simplify the available categories, reducing them to three basic types. There are museums – call them type A – that serve mainly to illustrate and to document such matters as the development of social and domestic life and that contain pots and tools and clothes and so forth. They may include picturesque reconstructions of former occupations and environments. There are very different kinds of museum – type B – that specialise in the collection and display of 'fine art', as opposed to the 'applied' arts of design or craft. Many of the best-known of these are principally devoted to the art of painting. Prominent examples include the Uffizi in Florence, the National Gallery in London, the National Gallery of Art in Washington and the Prado in Madrid. While such museums tend to adopt a broadly chronological principle in their displays, a high priority is given to ensuring that individual 'masterpieces' can be viewed as single items under optimal conditions, so that there is generally a stronger incentive to adopt an aesthetic than a strictly historical approach. Finally there are type C museums, both large and small, that may contain both pots and paintings, encyclopaedic museums that aim to provide as wide as possible a survey of artefacts from all ages and cultures and that usually supplement their displays with plenty of other kinds of information, giving a high priority to the demands of education.

The distinction between historical and aesthetic approaches and priorities, such as it is, seems to bear differently on the three types of museum. There is likely to be less emphasis on aesthetic criteria in the type A museum and more in type B. However, it would be wrong to assume that A and B are built on the basis of a distinction between aesthetic and historical priorities or that they somehow enforce a division between them. The type C museum, which offers ample encouragement to both historical and aesthetic approaches, may serve to demonstrate how hard it actually is to keep the respective priorities apart. This last category includes some of the world's major museums, such as the Metropolitan in New York and the Victoria and Albert in London. In such institutions it is normal for the aesthetic and historical approaches to be combined: certain central galleries are devoted to the display of fine examples of painting, sculpture, ceramics, metalwork and so on, singled out and displayed to best individual effect against bare walls and in well-lit display cases; but there are also suites of galleries in which varied items – furniture, carpets, ornaments, pictures and so on – are grouped together in successions of

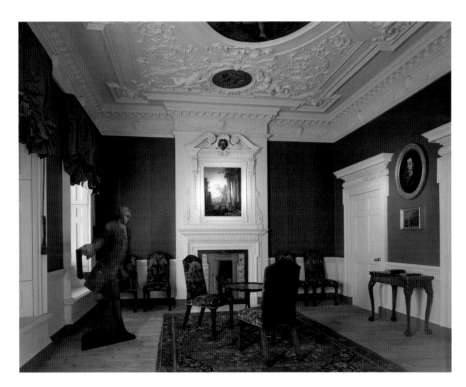

17 Eighteenth-century period room, Victoria and Albert Museum, London

'period rooms' designed to recreate the typical appearance of interiors from different times and places (pl. 17).

More extensive period displays are often to be found in the various palaces and so-called stately homes of Europe that are open to the public. These are among the other places where works of art can be seen *in situ*. Dating variously from the sixteenth to the nineteenth centuries, they are the former and occasionally continuing residences of wealthy and landed families, preserved with as much of their opulent furnishings and decorations as may have survived the generally declining fortunes of the families in question. In Britain many of these are now managed by the National Trust. Like expanded versions of the period rooms to be found in some of the larger museums, they provide evidence of changing tastes and fashions, varying according to the different dates of their foundation and of their periods of maximum prosperity. There are also instances in which more recently occupied houses have been left, suitably endowed, with their former owners' collections in place and intact. Some of these, like Upton House near Banbury in England, are effectively maintained as galleries with distinctive collections of paintings (pl. 18). A notable example in America is the Barnes Foundation in Philadelphia, which has for long been housed in the former residence of Alfred Barnes, who assembled a remark-

18 Pieter Jansz Saendredam, *The Interior of the Church of St Catherine, Utrecht*, 1660s, oil on panel, 116.8 × 96 cm, National Trust, Upton House, Warwickshire

Saendredam was a specialist in the art of perspective composition, concentrating on paintings such as this that show the interiors of Dutch churches. The figures may have been added by another painter.

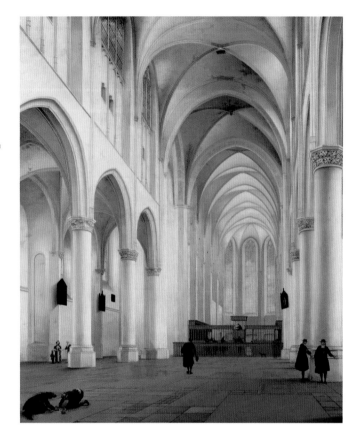

able collection of modern French painting during the first half of the twentieth century (pl. 19). (At the time of writing, a decision has been made to move the collection to a different location, where the works will be displayed in a more conventional type of museum setting.)

Such exceptions apart, however, it is noticeable that where paintings and sculptures are shown in period rooms and in the collections of stately homes, they are not usually displayed so as to be easily viewed in isolation and have rather to be regarded as decorative components in an overall scheme. Not surprisingly, where the larger museums are concerned, the works included in such installations are normally drawn from among the less important examples of the type in question or of the relevant artist's work. We would not expect Leonardo da Vinci's *Mona Lisa* to be hung as part of the decorative scheme in a period room – for all that it may originally have been hung in just the kind of interior that such schemes aim to recreate.

There are clearly hierarchies at work, some that reflect traditional distinctions between 'fine' and 'applied' arts and others that operate to single out certain works as deserving particular attention relative to others of the

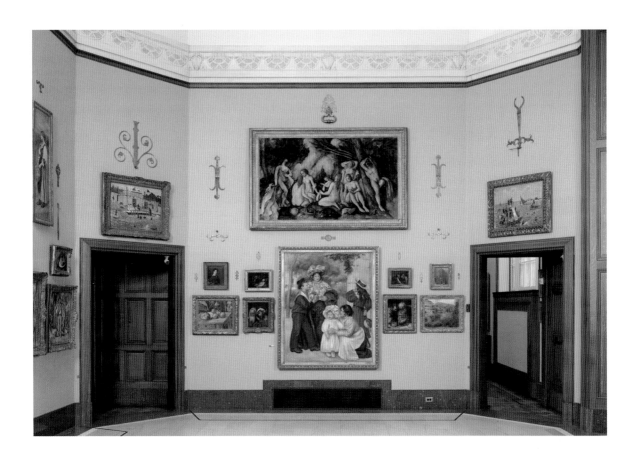

same type. Of the various fine arts, painting is usually the most highly privileged, at least as regards the western art of the last seven hundred years or so. However, neither type of hierarchy is entirely secure. While the standing of certain artists and works of art may have remained stable over long periods of time, the fortunes of others have varied greatly with changes in fashion, in attribution and in scholarship. Largely thanks to the work done in recent decades by women art historians, for example, the work of some formerly neglected female artists has become more visible in museum collections. As to the distinction between fine and applied arts, while this tends inevitably to be maintained in museums devoted to the display of painting, it is intentionally blurred in those broadly based institutions, such as the British Museum in London, where a much larger part in the acquisition, managing and display of material is accorded to the study of human cultures in general. In the various disciplines devoted to such study – archaeology, anthropology and ethnography – questions of aesthetic value are generally treated as secondary, if they are entertained at all, except, perhaps, when it comes to deciding which materials to put on display.

19 Interter with paintings by Cézanne and Renoir, Barnes Foundation, Merion, Philadelphia

Alfred Barnes was a chemist who made his money from the discovery of a popular drug. During the early twentieth century he amassed a collection that included some 175 works by Renoir, 66 by Cézanne and 65 by Matisse. He opened the Barnes Foundation as an educational institution in 1925, with works hung for overall decorative effect. the two lae paintings shown here are Cézanne's *Bathers* of 1895–1906 and Renoir's *Family of the Artist* of 1896.

I do not mean to argue for one type of collection or one type of art over another but rather to assist the reader to derive enjoyment and instruction from artistic work of all and any kinds, wherever it may be encountered. It is a basic premise of my enterprise that works of art are things worth looking at for their own sakes. It does not follow, however, that I mean to favour an aesthetic over a historical approach or that I think looking at an object for its own sake precludes considering it as evidence for historical or other types of inquiry. I mean rather to demonstrate how the various approaches can be reconciled, not only in visits to museums or art galleries but also in the larger context of encounters with art in all its diversity. Of course it would be impossible in one book to provide relevant historical information for all the world's art. (The most recent English-language publication with any such aspirations, the *Grove Dictionary of Art*, runs to thirty-four volumes, each of some nine hundred pages.) I mean instead to provide guidance on the kinds of consideration it may be relevant to bear in mind when viewing works of art – enough guidance to direct the imagination of the reader in ways appropriate to works from many different cultures and periods and in many different media. In this way I hope to show not only that learning about art is a means to increase aesthetic enjoyment but also that enjoying art can in itself be a means of learning. So long as our sense of history is sufficiently broad and our sense of what may be worth looking at for its own sake sufficiently open-minded, historical and aesthetic priorities need not actually conflict. I suggest that the objects most deserving in aesthetic terms may be among the richest sources of evidence regarding the human past and, in the case of contemporary work, regarding the nature of life in the present.

1.4 WHAT IS 'ART'? PART I

Any introductory book on art must face a number of difficult problems, of which the first is raised by the very term that declares its subject matter: Art. The reader is entitled to ask how this subject matter is defined, what are its limits and how they are established. In other words, what is to count as art and why; why some things are singled out as works of art and others not.

It is hard to know where to start in addressing that question. A great many books have been written in the attempt to answer it. One way I might begin is with the earliest surviving evidence of human creative activity. At the time of writing, the oldest object in the British Museum is a

lump of stone that was shaped by a human hand some million and a half years ago so as to make it suitable for use as a cutting tool. The museum does not actually suggest that this should be considered a work of art, but a more clearly worked stone was among the oldest objects included in an exhibition of the art of the African continent, held at the Royal Academy in London in 1995. This was a hand axe, made some 600,000 years ago by flaking away at a lump of banded ironstone (pl. 20). In the catalogue accompanying the exhibition it was argued that the workmanship of such objects 'goes well beyond functional requirements', indicating the development of 'an aesthetic sense' within the culture of the period. The suggestion, then, is that the hand axe is indeed deserving of consideration in its own right and not simply for its effectiveness as a tool.

Given that a carefully crafted hand axe is considered a work of art, does it follow that any product of a human culture may qualify if it is well enough made and if it survives for long enough – not just tools and weapons, pots and pans, but clothes, toys and consumer goods? If we accept that this may be so, and that the distinction between art and not-art will be eroded over time, then the distinction between museum and art museum may seem in the end to be insecure. It certainly appears that modern societies have an increasing tendency to preserve objects and ephemera of all kinds – as though almost anything might in the end prove to be of value in historical or aesthetic terms, or both.

It would not be helpful, however, to leave ourselves in the present with no means of distinguishing between works of art and well-made consumer goods. In fact, though we may get aesthetic pleasure from the well made, there are many well-made things such as high-performance cars and computers that we do not normally classify as works of art, while there are many works of art in museums – particularly in museums of modern art – that are far from well made according to our ordinary understanding of what this means. So 'well madeness' may not be a necessary or even a sufficient criterion for seeing something as a work of art. Is it rather the case that by calling some object a work of art we mean to recognise its membership of a distinct category of exceptional things? If we accept this position we may still need museums of art in which certain special objects can be safeguarded and made available to view. Could it reasonably be said that, whatever its intended use may have been, if the hand axe is a work of art it is not just because it is well made but because it is distinguished by some other essential quality common to all objects that are works of art and absent from all those, including other hand axes, that are not, whenever they may have been made?

Around a hundred years ago the English critic Clive Bell asked himself that last question and came up with an answer that proved both influen-

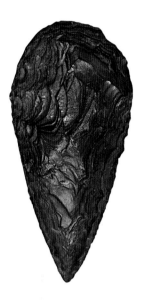

20 Hand axe, c.600,000 BCE, banded ironstone, South Africa, 23 × 11.4 cm, McGregor Museum, Kimberley

Hand axes such as this were widely used during the early Stone Age. This example comes from an area at the edge of the Kalahari desert, where a small excavation yielded more than a hundred thousand stone tools.

tial and controversial. (His book, boldly titled *Art*, was published in 1914. It was continually reprinted during the 1920s and 1930s and new editions were issued in 1949 and 1987.) Bell started from the assumption that works of art are things that provoke 'the personal experience of a peculiar emotion . . . called the aesthetic emotion' (pp. 6–7). He then asked what it was that all these things had in common, 'the quality that distinguishes works of art from all other classes of objects' (p. 7). His answer was that 'In each, lines and colours combined in a particular way, certain forms and relations of forms, stir our aesthetic emotions.' To these aesthetically moving combinations he gave the name 'Significant form'. This then, was 'the one quality common to all works of visual art' (p. 8). Form is a crucial concept in talking about works of art and one that can be surprisingly hard to grasp. A painting of a group of objects on a table may represent the forms of those objects, but in considering the picture's own form what we are really talking about is the way in which the different shapes are related on the flat surface, the pattern they make in the process and the way in which these shapes are made to seem more or less solid within the illusory space of the picture. To consider the form of a work is to see how it is composed – how its particular identity is established against the background of the world at large. What made such form significant in Bell's view was that it conveyed a particular kind of intention: the intention to make something good *in itself*. If we follow his argument, to see the hand axe as a work of art is to set aside its great antiquity and its intended function and to respond instead to the exceptional refinement of its form, a refinement due not just to the particular skill and care with which its maker chipped away at the hard lump of stone but to something more: its investment with the potential to stir emotion.

Where this is the preferred approach to the problem of identifying art, the visitor to a large museum is presumably more likely to favour the 'aesthetic' over the 'historical approach': to look without reading rather than reading to gain information. I cannot imagine that Clive Bell would have spent much of his life studying labels in museums. 'I care very little when things were made, or why they were made', he wrote; 'I care about their emotional significance to us' (pp. 99–100). 'To appreciate a work of art we need bring with us nothing but a sense of form and colour and a knowledge of three-dimensional space' (p. 27).

As the title of his book suggested, Bell's aim was to provide an all-encompassing definition, but attempts at defining art are always liable to be coloured by the particular controversies of the time. This one was no exception. As a determined supporter of the modern tendency in art, Bell was responding to the example of the avant-garde French painters of the late nineteenth century, who had generally rejected those techniques suit-

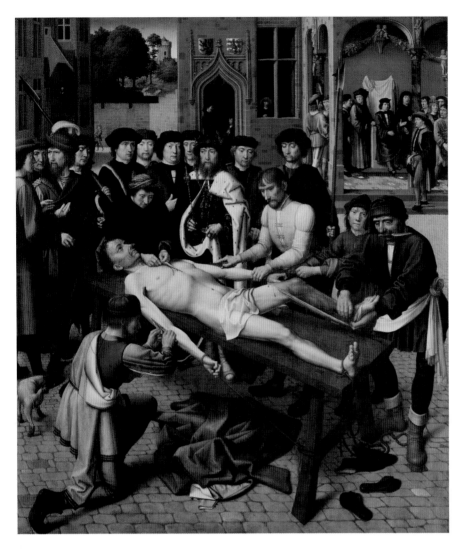

21 Gerard David, *The Judgement of Cambyses*, 1498, oil on panel, one of two, 318.6 × 182.3 cm overall, Groeningemuseum, Bruges

The picture illustrates an episode recorded by the Greek historian Herodotus, regarding the punishment meted out by King Cambyses of Egypt to Sisamnes, a judge accused of taking a bribe. It shows the culprit being skinned alive. In the inset scene at the top right the judge's son, appointed in his place, is pictured seated in a chair draped with his father's skin. The pair of this panel shows Sisamnes's arrest.

able for depicting literary, historical and mythical content that had been developed in the academies of art since the seventeenth century. He wanted to make clear that what decided the aesthetic value of a work of art was not the significance of those forms it might illustrate – its religious or literary or other subject matter – but rather its own distinctive colours and shapes and textures. While he was certainly successful in directing attention to the purely compositional and formal properties of art, he underestimated the part that represented subject matter necessarily plays in the effect of works of art in general – as though in viewing a picture of some horrific act we could somehow set our feelings of revulsion entirely aside (pl. 21).

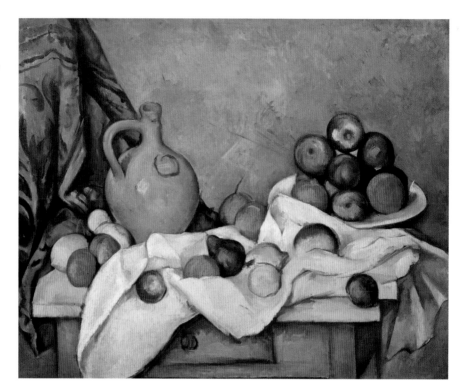

In fact, Bell's secondary aim was to provide a critical platform for appreciation of the work of the French painter Paul Cézanne, in which the combination of forms and relations of forms was certainly remarkable (pl. 22). It is also notable that the publication of *Art* in the second decade of the twentieth century coincided with the first emergence of abstract painting, in which it seemed that there was nothing but forms and relations of forms to be appreciated (pl. 23). The immediate success of Bell's concept of significant form may have been due less to its usefulness as a guide to the one essential property of all art than to its apparent application to the advanced art of the time – advanced, that is to say, in terms of its evident difference from the relatively unchanging art of the academic tradition. It could also be said that the development of abstract art served to encourage close attention to the formal properties of works of art and that that attention generally proved rewarding. There is indeed much to be gained by analysis of the way in which a given composition has been organised, of the means the artist has used to create effects of modelling and of spatial depth, and of the distinctive use of colour and tone – particularly, as I mean to show, where the art of painting is concerned.

Regarded as a more general means of distinguishing works of art, however, Bell's theory of significant form was vulnerable on several counts.

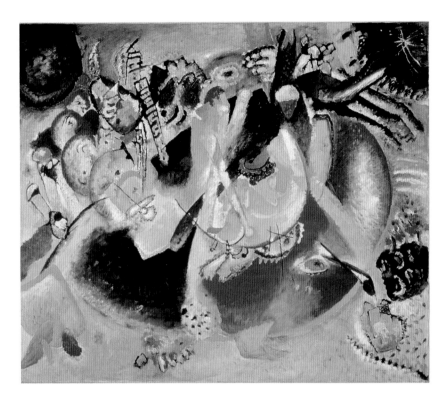

23 Wassily Kandinsky, *Improvisation of Cold Forms*, 1914, oil on canvas, 199 × 139 cm, Tretyakov Gallery, Moscow

Like a number of artists at the turn of the nineteenth and twentieth centuries, Kandinsky was motivated by a belief that what distinguishes works of art is their possession of a certain spiritual value, independent of the natural forms they may represent. His first fully abstract works were painted in 1913–14.

The most obvious point is that it is circular; that is to say, if we enquire into any of the component definitions – 'work of art', 'aesthetic emotion', 'significant form' – it simply throws us back onto one of the others. What is significant form? It is the property in works of art that produces aesthetic emotion. What is aesthetic emotion? It is the feeling produced by works of art. What is a work of art? It is something with significant form. Much rests on Bell's initial assumption that aesthetic emotion is a specific category of experience only to be felt in the presence of works of art. While we cannot rescue his argument from circularity, we may nevertheless want to ask if there really is such a special category of experience, as Bell believed there is, which is distinguishable from just liking the look of something, from religious ecstasy, from love for another person or from the pleasure to be taken in natural effects such as picturesque views or dramatic sunsets. If not, then we may have to abandon the idea that we can look to our emotional experience for guidance to what is and is not a work of art.

Bell's theory was also vulnerable to the criticism that he had really decided in advance what was and was not a work of art and that he was being highly selective regarding the type of object that qualified for his consideration. Despite his apparent catholicity, it might be argued that it

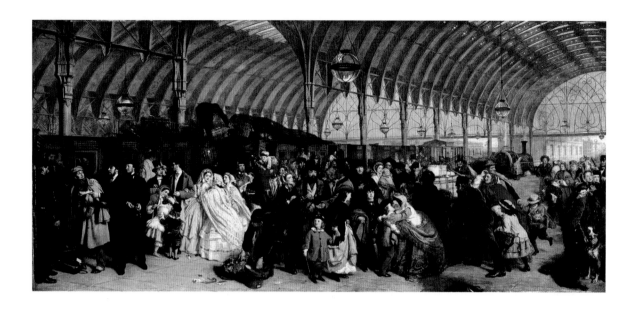

24 William Powell Frith, *The Railway Station*, 1862, oil on canvas, 116.7 × 256.2 cm, Royal Holloway College, University of London

Frith is known for highly detailed paintings, each with a cast of carefully described characters representative of the modern life of the time. He first made his reputation with the painting *Life at the Seaside, Ramsgate Sands*, which was bought from the Royal Academy by Queen Victoria in 1854.

was the well-established media of painting and sculpture that he was really interested in, and that in considering these he had been strongly guided by his personal taste for works which, while not necessarily abstract, possessed strong abstract qualities – such as the paintings of Cézanne – and by his distaste for such highly illustrative works as William Powell Frith's *The Railway Station* (pl. 24). Of the latter he wrote that it 'is not a work of art; it is an interesting and amusing document' (p. 18). On the whole, and so far, while not accepting Bell's outright dismissal of works such as *The Railway Station*, the majority of professional opinion has supported his judgement on the relative merits of Cézanne's work and Frith's – an opinion reflected in far more widespread representation of the former in museums internationally, in higher prices at auction, in higher numbers of relevant publications and so on. Yet, is this because Cézanne's painting has more significant form than Frith's or is objectively better in some other way; or is it because the relative judgements reflect a still powerful influence on the part of that modernist critical tendency to which Bell contributed? It is certainly true that judgements about works of art can often feel like moral commandments – 'You ought to like the work of art I like' or 'You ought not to like that because I don't'. This is more likely to be the case where some authority is already attached to the speaker or writer.

One thing seems clear. Those who defend their decisions about what is and is not a good work of art simply by referring to their emotional responses are always liable to face ripostes from others who find themselves unmoved before the things selected for approval. Such ripostes may take the form, 'But that's just a lump of stone/a primitive tool/an acci-

dental survival from among countless numbers of similar utilitarian objects', or 'To me, Cézanne's painting looks clumsy and devoid of content, whereas Frith's is evidently skilful and full of interest. And why should an interesting document not be a work of art, whether it takes the form of a highly detailed picture, or a photograph or, say, a political cartoon?'

Given the taint of elitism and snobbery that has historically been associated with the idea of 'good taste', it is not surprising that people unaccustomed to making aesthetic judgements or who lack confidence in making them should feel somewhat defensive, or that arguments between opposed positions should sometimes take on the character of class conflicts. What is at issue is the relationship between aesthetic judgement – or taste – and authority. If we think that it is indeed true that the work of Cézanne is better than the work of Frith in some objective sense, then those who prefer Frith's painting risk being seen as lacking in judgement, where that judgement or taste will carry authority for us. If, however, we think there is no such thing as an objective measure of artistic quality, whether in terms of significant form or on any other basis, and that what is called taste is simply a set of preferences associated with a certain social power, then the greater prestige attaching to Cézanne's work must still reflect that power as a kind of authority – an authority by which those who may happen to prefer Frith are liable to feel disadvantaged.

1.5 WHAT IS 'ART'? PART 2

In view of such conclusions it is perhaps inevitable that there should be other ways of addressing the question, 'what is (and is not) a work of art?' than the one advanced by Bell and others. During the latter part of the twentieth century the prevailing tendency to rely on emotional responses was widely challenged by what has been called the 'institutional theory of art'. This is the view that it is not as a consequence of any perceivable formal properties – the specific shapes and colours and textures – that works of art are distinguished from other things. Rather, 'art' is a kind of honorific title that is conferred on some objects rather than others by the institutions of an art world, whether those institutions are personified in influential critics and curators or identified with museums, galleries and journals. This process applies as much to objects from the past or from alien cultures as it does to the most recent products of today's artists. From this point of view, if the hand axe counts as a work of art, it is not by virtue of some describable properties but because that is the role it is given

25 Marcel Duchamp, *Fountain*, 1917, porcelain, 45.7 × 38.1 × 30.4 cm, replica, Sidney Janis Gallery, New York

The following statement appeared in an unsigned contemporary publication for which Duchamp was no doubt responsible. 'Whether Mr Mutt with his own hands made the fountain or not has no importance. He CHOSE it. He took an ordinary article of life, placed it so that its useful significance disappeared under the new title and point of view – created a new thought for that object.' The original of Duchamp's ready-made survives only in an accompanying photograph taken at the time by Alfred Stieglitz.

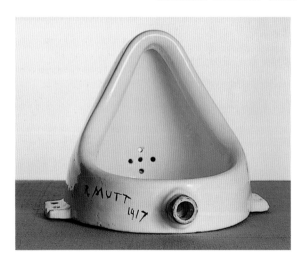

to play in an influential exhibition and in a particular set of ideas about the development of human culture. In a historically ambitious survey of the art of a continent, it gets the ball rolling, as it were, to see the hand axe as something that was intended to be art.

This approach to the question of how art is defined has one clear advantage. Rather than assuming some mysterious property that provokes emotional responses and compels recognition, it places all the emphasis on the matter of who it is that is doing the responding and judging and on why they are doing it. It also encourages us to think about the relations between disparate value systems – the different ways in which the concept of art may be applied, not only within our own culture but in cultures other than our own. In place of Bell's privileged universal aesthete – the responsive individual who goes through the world's cultures picking out things with significant form and rejecting the rest – we are prompted to imagine groups with different interests, in different periods and cultures, for each of whom 'art' may be associated with the satisfaction of certain specific needs. The museum visitor who is persuaded by the institutional theory of art will presumably find less apparent reason to favour the established high-art media of painting and sculpture, or unduly to respect the barriers and distinctions between these and other forms of cultural production. Bell's approach associates art with aesthetic experience. At least in principle, the institutional theory does not.

There is an important reservation to be borne in mind. Just as Bell's theory of significant form appealed because it seemed to apply to the advanced art of its time, so institutional theories proved particularly well adapted to specific developments that followed shortly after in the art of the twentieth century. In 1917 the expatriate French artist Marcel Duchamp called the bluff of the Society of Independent Artists in New York, which, at his own prompting, had advertised a jury-free exhibition open to work of every kind. His submission took the form of a ready-made porcelain urinal, which he signed 'R. Mutt' and titled *Fountain* (pl. 25). This was duly refused entry, as Duchamp had no doubt meant that it should be, providing him with an opportunity to advance the argument that what mattered was not whether or not Mr Mutt had made the object but rather the fact that he had chosen it – that is to say, intended it to be 'art'. The more substantial effect of Duchamp's gesture was to bring home the problems that followed the emergence of Cubism and abstract

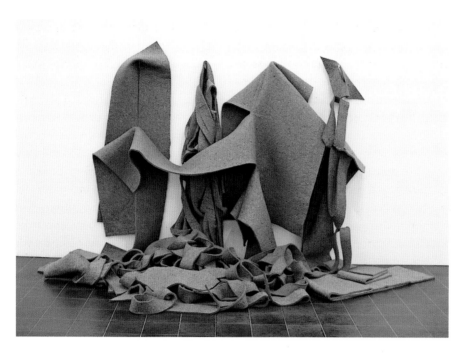

art and the abandonment of any sense of likeness to nature as a criterion of success in painting and sculpture. If art was no longer to be measured in terms that were significantly connected to its life-likeness or truth to nature, and thus to the traditional skills associated with painting pictures and making sculptures, then perhaps the distinction between art and not-art was not a matter of differences in appearance but was merely a matter of the success or failure of any given object to serve as a talking-point within the art world.

Duchamp presented a number of other 'ready-mades' as works of art. These were issued between 1915 and 1923. The original items have almost all been lost, but they survive in modern art museums throughout the world in the form of replicas produced with Duchamp's co-operation during the 1960s. This was a time when his reputation was in the ascendant and when a later generation of avant-garde artists in America looked to his example in questioning the traditional limits of painting and sculpture and the connection between art and manual craft. Many of the artists in question were presenting as works of art things to which conventional means of formal analysis seemed simply irrelevant,

SOMETHING WHICH IS VERY NEAR IN PLACE AND TIME, BUT NOT YET KNOWN TO ME.
ROBERT BARRY, 2 AUG 1969

either because the work could take on any one of a wide range of possible forms or because there was virtually no physical manifestation to be analysed (pls 26 and 27). It was around this time that the institutional theory of art received its actual formulation in the writings of philosophers, though it had been Duchamp's original ready-mades that had supplied the basic idea in practice.

While such theories help to emphasise the vulnerability of all-embracing definitions of art such as Bell's, it seems that they are themselves open to criticism not only on the grounds that they are based in specific artistic tendencies but also that they are not entirely sufficient as explanations. We might accept that an object acquires the status of art as a consequence of some conversation within the art world or some particular theory of human development, yet we can still ask why it was that that object rather than another attracted attention in the first place and what the properties were that allowed it to sustain that attention. Duchamp's urinal may have looked just like a thousand others – the crucial signature apart – but none of those others has been talked of as a work of art. The distinction between art and not-art may not always be made in terms of one single basic criterion, as Bell wanted to believe, but it does not follow that the differences between some objects and others can altogether be reduced to the interests of those making the comparisons. It was its very unpredictability that made Duchamp's *Fountain* effective – not just its ready-made character but the fact of its being a urinal. The gesture would not have been quite thinkable without a background of painting as the business-as-normal of 'visual' art. The problem with the institutional theory is that it tends to reduce the meaning of works of art to the values of the systems that produce or represent them. But our sense of the individuality of some works of art is not always so easily explained away. That a work of art may be like nothing else in our experience is one of the most important reasons we have for bothering with it. (There will be reason to revisit some of the problems involved in defining art, both in discussing sculpture in section 4.2 and in considering the art of the late twentieth century in sections 5.1–2.)

1.6 TAKING OPPORTUNITIES

I hope that what I have said so far will help to explain why, in an introductory book about art written in the early twenty-first century, it seems necessary to take the institutional representation of art as a starting point or organising principle. As a first step in examining the individual work, it helps to be aware of how and why it is made present to us in the first

place. Then, in considering the problems of categorisation and public presentation with which such institutions as museums have to deal, we are inevitably alerted to the characteristically dual aspect of the work of art: as an object that provides evidence for the study of human culture and history but also as something that may attract attention in its own right.

This is not a book about museums, however. I am simply using some major types of art museum as ways of introducing a degree of order to the potential wealth of subject matter conjured up by the word 'art'. In past ages the storage of information and memory in the mind was conceived by analogy with the kind of tiered theatre in which Shakespeare's plays were originally performed. The idea was that if you could identify certain memories with specific compartments in the imagined auditorium, you could then locate and retrieve them at will like data from a filing system. In a similar manner we can think of the different types of museum, and the departments and galleries of which they are composed, as providing virtual compartments into which diverse kinds of art can be separated and categorised, so as to be the more easily concentrated on and recalled and compared. To consider the floor plans of a large museum of type C, like the Louvre in Paris, is to get one diagrammatic view of the ways in which the diverse types and materials and ages of art have been classified (pl. 28). (Large institutions of this type may be referred to as 'Encyclopaedic' or 'Universal Survey Museums'.)

It does not follow, though, that these classifications are sacrosanct. I have already referred to the work of feminist scholars in trying to over-

28 Floor plan of the Louvre

The Louvre opened as a museum in 1793 following the French Revolution, with certain rooms from the former palace of King Louis XIV designated as the Musée Central des Arts. Over the next two hundred years it gradually spread as various public offices vacated the larger complex of buildings on the right bank of the Seine. The project for a 'Grand Louvre' was initiated in 1981 and completed in 1989, though expansion of the galleries and collections continues. Its Asian collections were moved in 1945 into the separate Musée Guimet, while works from 1848 to about 1910 went to the Musée d'Orsay, opened in 1986. The illustration shows the layout of one floor of the museum's four principal levels.

30 (*facing page, top*) Nimba mask, Baga tribe, Guinea, late 19th or early 20th century, wood, h. 126 cm, Musée Picasso, Paris

The man who carried a heavy mask of this type would be hidden beneath a long attached skirt of raffia. He would look out through eyeholes carved between the breasts. Other notable examples of Nimba masks are to be found in the Metropolitan Museum in New York, the British Museum in London and the Musée du Quai Branly in Paris.

come the long-term effects of patriarchy in inhibiting and depreciating the artistic production of women. Museums are inevitably shaped by the cultural priorities, perspectives and prejudices they inherit and represent; they also reflect the revisions of those priorities, perspectives and prejudices that result from shifts in political and economic power, from changes in intellectual fashion and from processes of critical review. As perspectives change with time, with differences in national and cultural viewpoint and with developments in scholarship and technology, controversy inevitably attends on the question of how collections should be represented and what objects and materials should be acquired to supplement them. The current tendency is for large museums to be run like multi-national corporations, with commensurate pressures to expand and diversify. While these conditions are favourable to the spread of 'blockbuster' exhibitions, they are not always conducive to the scholarly priorities that were traditionally associated with curatorship.

In some cases there may be awkward questions to be faced about how objects were acquired in the first place, about how they are to be categorised and about whether the institutions in question are their rightful guardians. In the case of a work by the English artist John Constable (pl. 29), it seems clear enough that we are dealing with a work of art, that it

29 John Constable, *Flatford Mill; Scene on a Navigable River*, 1816–17, oil on canvas, 101.6 × 127 cm, Tate Britain, London

This is one of the last substantial paintings that Constable made where he had grown up, in East Bergholt in Suffolk, before he moved to London. Intimately acquainted though he was with the scene he was representing, the painting shows signs of careful and deliberate planning and construction, in such matters as the treatment of light and shade, the distribution of detail and the depiction of the sky. The picture was largely worked on out-of-doors.

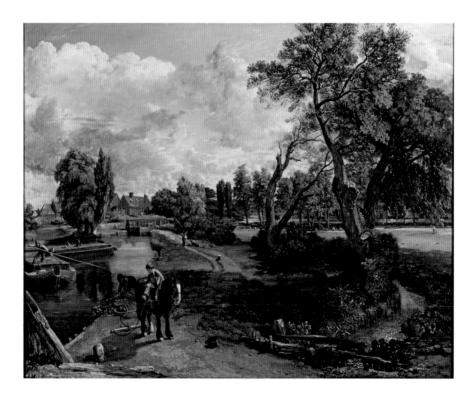

belongs in the category of painting and that a British national collection is an appropriate place for it to be preserved and displayed. But what of a mask carved in Africa during the nineteenth century for use in a specific tribal ritual? The large Nimba mask illustrated here (pl. 30) was made for use by the Northern Baga tribe in north-west Africa in ceremonies intended to ensure the fertility of cereal crops. The artist Pablo Picasso acquired it in the 1920s and it is now to be found in the museum in Paris that is principally devoted to the collection he maintained of his own work. It could be argued that such things have come to be seen as works of art largely because they aroused the interest of artists like Picasso, who themselves adopted what were called 'primitive' styles in the early twentieth century in a spirit of opposition to prevailing notions of civilisation (pl. 31). Are such things best appreciated in the context of modernist European art works such as Picasso's or does appreciation of this kind involve prising the mask loose from the specific culture, beliefs and rituals that gave it meaning in the first place – as a curator of Sam's persuasion might argue? Might it be better preserved alongside other artefacts from West Africa in a department of ethnography or in a specialised institution such as the recently established Musée Quai Branly in Paris – that is to say, one devoted to the study of different human cultures? Or, as Val might

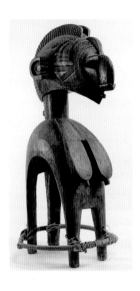

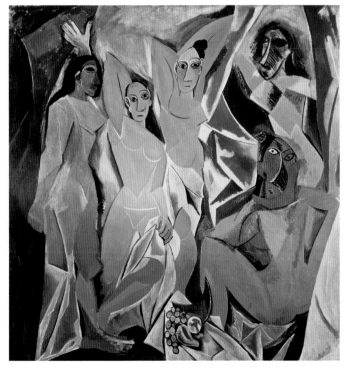

31 Pablo Picasso, *Demoiselles d'Avignon*, 1907, oil on canvas, 243.9 × 233.7 cm, Museum of Modern Art, New York

The outcome of several hundred preparatory sketches, this painting represents five prostitutes in a brothel. The inconsistency in the treatment of the figures is due to the manner in which the painting evolved as Picasso worked on it and as he absorbed the effects of his first exposure to African art. The beginnings of Cubism date from the point at which he finished work on this painting. Although it was seen by a few fellow artists, it was not publicly exhibited until 1916. It was acquired by the Museum of Modern Art in 1939.

32 Fragments from the pediment of the Parthenon, 447–432 BCE, marble, British Museum, London

Periods of Greek art are divided into the Archaic, c.700–c.480, Classical, c.480–323, and Hellenistic, 323–31 (the last dates being marked respectively by the death of Alexander the Great and the defeat of Cleopatra and Mark Antony by Octavian). The sculptures from the Parthenon temple were carved in the Classical period. These figures represent Leto, Artemis and Aphrodite. They would originally have formed part of the decorations in the west pediment or gable of the Parthenon in Athens. Among the causes of damage to the sculptures now in the British Museum are alterations made to the building when it was converted into a Christian church in the sixth century CE, its further conversion into a mosque in the early 1460s and an explosion that occurred in 1687 as a consequence of bombard-ment by Venetian artillery while the Parthenon was being used as an ammunition store by Ottoman forces. The sculptures removed by Lord Elgin in 1806 were sold to the British Museum ten years later, following public hearings as to their worth at which opinions were solicited from a number of artists, among them Antonio Canova (see pl. 170) and Benjamin West, then President of the Royal Academy. (For the Parthenon marbles see also pl. 133.)

respond, would that imply some demotion of its status as an individual work of art – a demotion consistent with the kind of patronising mind-set that led nineteenth-century colonisers to class such things as 'primitive' in the first place, convinced as they still were that standards of civilisation and sophistication in art were set by the highly representational sculptures of classical Greece and Rome?

To mention the connection between colonialism and concepts of the primitive is to raise awkward questions about rightful ownership. What if a claim to the Nimba mask were made by the government of Guinea on behalf of the Baga people, on the grounds that it is a significant part of their heritage, looted under a colonial regime or appropriated for a mere fraction of its true worth? Such issues are not easily settled. The richer and more various their collections, the more evidence the world's great museums inevitably provide regarding those inequalities in the national and personal divisions of power, wealth, education and development that have supported acquisition throughout history. Were liberal principles now to prevail, and were those responsible for the resulting collections to redress the balance by returning any items not acquired in fair and equal exchange, most major museums would be left severely denuded. For some time now, the government of Greece has laid claim to the so-called Elgin Marbles, a major feature in the collections of the British Museum (pl. 32). These are some of the remaining fragments of sculptures made in the fifth century BCE to decorate the Parthenon temple in Athens. They were stripped from the ruins of that building early in the nineteenth century on the orders of the Earl of Elgin, who had obtained consent from the Turkish governor responsible at the time. Eventually they were purchased from Elgin by the British government. Given the nationalist tendency of modern politics, we may be little surprised that the Greeks should want them back.

With this and similar claims no doubt in mind, the director of the British Museum has been prominent in arguing that the obligations of institutions such as his are now not national but global and that they serve as respon-sible repositories for the great variety of human cultures. In fulfilling this function they are not so much capitalising on the legacies of empire as maintaining the enlightened humanism of the late eighteenth century, the period when many of the major European museums were founded. Rather than restoring all expropriated objects to their country of origin – where they might in any case become vulnerable to inadequacies in curatorial facilities and care, or to the destructive effects of local changes in politi-cal regime or religious authority – the course favoured by the British Museum's trustees is to pursue a policy of temporary exchanges of objects and collections between national institutions, to the potential benefit of all involved.

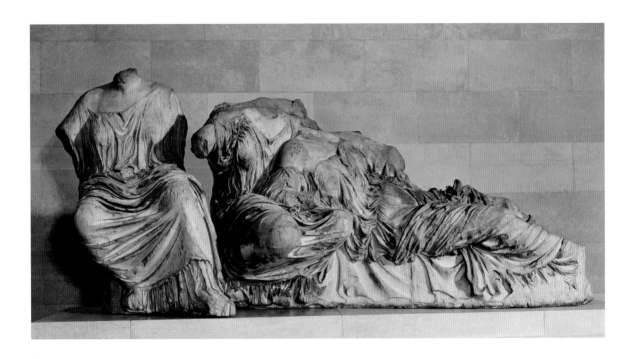

Given the widespread tendency to supplement permanent collections with temporary exhibitions and exchanges, it is clear that those who live within range of any of the world's major museums are nowadays provided with unparalleled opportunities for first-hand encounter with works of art of many kinds and from many ages and cultures. The important question that remains is this: what does one need to know – and know how to do – in order to be able to enjoy this wealth of material and to learn from it? Is it the case, as Clive Bell believed, that all we need is 'a sense of form and colour and a knowledge of three-dimensional space'? Or are there different or additional techniques and skills one can acquire and develop with a view to deepening pleasure and increasing understanding? I believe that there are, if only because neither the sense of form and colour nor the knowledge of three-dimensional space are entirely simple matters, at least where what is at issue is their development for the purposes of art. I also believe that Bell was wrong to treat the emotional enjoyment of works of art as a matter entirely divorced from considerations of when and why those works were made. He did have one valid point to make, however. We should not be intimidated by 'experts' or anyone else into thinking that we cannot look and see for ourselves.

PART 2

SEEING PAINTINGS

2.1 THE THING ON THE WALL

The enjoyment of a work of art involves a certain effort. It requires not only a commitment of time but also a degree of determination to set aside distracting concerns and to concentrate. Concentration can be hard to achieve, particularly in public places, but there are certain techniques that may help. In the scenario that follows I imagine that the object in view is a painting hanging on the wall in a gallery or museum. The aim is to take account of the environment in which the work is seen, and of factors liable to affect its presentation, the better to isolate the work itself. What I propose is a kind of itemised procedure designed gradually to focus attention on the individual painting. Spelt out on the page the procedure will no doubt seem a bit fussy but in practice it reduces to a kind of checklist that can be run through in a few moments.

I should make clear that in imagining an encounter in a museum I also have in mind a tradition of paintings as discrete transportable objects designed to hang on walls – a long tradition of what are called easel paintings. My objective is to provide suggestions about how such works may be enjoyed and understood. I do not presume, though, either that the tradition in question is binding on the present production of pictorial art – in which photographic techniques have come to play a large part – or that the kinds of procedure I recommend will be as appropriate to the art of the present as I believe they are to much of the art of the past. The aim of enjoying and learning from the art of the past commits us to the enterprise of seeing with a 'period eye'. This involves putting ourselves so far as we can in the position of the kind of spectator for whom a given work was originally envisaged. Historical information is of course likely to help in this enterprise but it is at least as important to respond with imagination to such cues as the work itself may provide. I shall make some suggestions about how these are to be recognised and responded to. When it comes to the art of our own time there may be different demands to be faced and different procedures to be adopted, but there will still be a kind of 'period eye' to be acquired, and it may take a degree of work and concentration. In all cases the effort will be well repaid, however, since there is no better way to reconcile the different priorities of historical and aesthetic approaches.

facing page Louise Moillon, *Still Life with a Bowl of Curaçao Oranges* (detail of pl. 86)

With that reservation entered, I suggest that the first important factor to take into account is lighting. This will have a considerable effect on how a painting appears, not just the level of illumination but whether the light is natural or artificial or some mixture of the two. The tungsten light cast by standard electric bulbs is generally warmer than daylight and will tend to strengthen the warm colours – the reds, oranges, browns and yellows. It will normally favour the kinds of painting that were intended to be seen in dark churches by the light of oil lamps and candles, the earliest of them often decorated with gold leaf and painted in brilliant colours. Cooler daylight is more likely to strengthen the blues and greens and is particularly favourable to the kinds of naturalistic landscape composition that were painted largely out of doors, notably by the French Impressionists during the last third of the nineteenth century. Getting a feel for the quality of light in a gallery makes one more responsive to the different ways in which paintings are made of patches of colours.

I still remember a telling demonstration from my days as a student, when a tutor stood us before a landscape by Cézanne and told us to pay attention. At four p.m. precisely the lights in the gallery were switched on to compensate for the falling level of daylight. As this happened, the painting changed utterly, the balance between warmer and cooler colours transformed. Yet the effect lasted only for an instant, since the eyes immediately adjusted to the new conditions and the impression of the painting's previous appearance faded rapidly. Two things were made clear: that paintings feel widely different under different lighting conditions and that visual impressions can be hard to retain, particularly when they are overlaid by others.

We should not assume that the brightest light is always the best. In the case of works on paper, low light levels are usually maintained for reasons of conservation but, such reasons apart, it is always possible to kill a painting with excessive light, turning a delicate surface into one that appears hard and reflective, particularly in the case of works that have been varnished. The painter Mark Rothko stipulated that lighting levels should be kept low where his large abstract canvases were shown, encouraging the spectator to look carefully into the veils of colour of which they were composed (see pls 2 and 105). Some years ago in Madrid, I found myself in front of a small painting of a boat drawn up on the seashore before dawn, painted by the German artist Caspar David Friedrich probably towards the end of his life, which was so dark that its content was at first all but indiscernible. It took several moments of careful adjustment and concentration gradually to make out first the faint beads of light that picked out the profile of the boat and then the shadowy forms nearer the viewpoint. Flooding such a picture with light might allow one to recover its detail far

33 Caspar David Friedrich,
Seashore in Fog, c. 1807,
oil on canvas, 34.2 × 50.2 cm,
Österreichische Galerie
Belvedere, Vienna

Friedrich was the most
important painter in the
German Romantic movement
of the late eighteenth and
early nineteenth centuries.
His paintings are remarkable
for their ability to instil a
sense of mood and
atmosphere through carefully
controlled effects of tone,
colour and pictorial space.
(For Friedrich see also pl. 60.)

more quickly, but one would then miss that sense of slow and assiduous straining for vision through which the moment of approaching dawn is made real in the imagination. Much of the effect of Friedrich's work depends on a similar kind of striving for focus that it requires of the spectator; see, for instance, plate 33.

Moving in on the imagined painting on the gallery wall, the second factor to take into account is the colour and texture of the wall itself and its suitability as a background to the work in question. Like the quality of light, this is likely to have an effect on your response to the work itself and on the way in which you read its composition. If a very dark painting is hung on a white wall it may appear simply as an inpenetrable rectangle, with little power to attract the viewer to its detail. For this reason those 'old master' paintings that tend to be relatively dark in tone are often hung against deeper coloured and sometimes richly patterned backgrounds. New York's Museum of Modern Art, by contrast, is notable for its policy of using plain white-painted walls as foils for its major collection of twentieth-century paintings. Such decisions are not simply matters of aesthetic judgement about how the works in question are seen to best effect. They also involve an element of historical interpretation: a suggestion of the kind of life in relation to which such works make sense; a life of courts and country houses on the one hand, perhaps, and of penthouse apartments and airy offices on the other.

34 Gentile da Fabriano,
Adoration of the Magi, 1423,
tempera on panel,
300 × 283 cm, Galleria degli
Uffizi, Florence

This sumptuous altarpiece in
late Gothic style was
commissioned by a member
of the wealthy Strozzi family
for the sacristy of the church
of Santa Trinita in Florence.
Unlike many works from this
period it is intact in all its
various parts, including the
predella, which is composed
of the small painted panels at
the base.

The third factor to be taken into account is framing. The kinds of paint-
ings that end up in museums tend to be valuable and there is an often
unspoken assumption that that value should be complemented with an
opulent frame. In Italy in the fourteenth and fifteenth centuries, major
altarpieces were often complex combinations of painting and carpentry,
with as much paid to the carpenter and as much spent on gold leaf as was
earned by the painter for his time and skill (pl. 34). An individual painted
panel cut out of such an ensemble (as many have been) is deprived of a
context that was meant to contribute significantly to its meaning and
effect. Nevertheless, it is a more open question whether, say, a nineteenth-
century landscape in oil on canvas is improved by being surrounded with
several inches of gilded carving or plasterwork, particularly where the
effect of overhead lighting on a projecting frame is to cast a wavy band
of shadow across the top two or three inches of the composition. For the

majority of twentieth-century works, particularly for abstract paintings, plain and shallow frames in muted colours are often far less intrusive. A window-like frame may be entirely suitable for an old master painting with a perspective structure and a deep pictorial space, whereas all that many a twentieth-century abstract painting requires is some simple means by which the painted surface is delimited from the wall. It is significant that a number of painters during the latter part of the nineteenth century took the trouble to design and make their own frames, with the aim of ensuring that the colours and compositional effects of their works were suitably complemented. The notion that expensive paintings deserve expensive frames persists nevertheless and it is quite common to see even abstract paintings encumbered with heavy antique surrounds. Conventions of framing have differed over time and between different countries and it is rarely easy to decide when a certain work was given the frame it now occupies, or whether the artist might have played a part in choosing it. Yet trying to work out whether a frame properly complements the painting it surrounds is one way to concentrate some relevant attention on the work itself.

Framing leads on to the matter of glazing. Of the various experiences galleries have to offer, few are as frustrating as finding that the painting you particularly want to look at has been rendered all but invisible by a combination of poor lighting and mirror-like reflections. The availability of non-reflective glass has done much to solve the problem, but it can still be a source of vexation in some older and less well endowed collections. Even where reflections are eliminated and lighting well adjusted, a sheet of glass is a physical barrier between you and the picture surface. Paintings are highly vulnerable to deliberate attack and careless handling – not to mention acts of thoughtless prodding – and it is easy enough to understand why those responsible for them should want to ensure their protection. Rare as it tends nowadays to be, the encounter with an exceptional painting, in good condition and still unglazed, is always a welcome opportunity.

With ambient lighting, background decoration, framing and glazing taken into account, what remains is exactly how to address the object on the wall – where to position oneself in relation to it. Watching the behaviour of visitors in galleries of paintings, one might be forgiven for thinking that there is some kind of prohibition against getting too close to any painting for too long. The normal motion is one of drifting edgily round the gallery, keeping a safe distance, politely avoiding blocking the view of other visitors, with occasional darting forays up close, usually to read a label, sometimes to examine a detail. Few people seem to stand four-square in front of any individual work for more than a few seconds, if at all. In

35 Claude Monet,
Waterlilies, after 1916,
oil on canvas, 200 × 427 cm,
National Gallery, London

This is one of a series of
large works that Monet made
towards the end of his life, in
a studio overlooking the lily
ponds in his garden at
Giverny. It was probably
painted during the First
World War, within sound of
the guns at the front. (For
Monet see also pl. 38.)

a crowded museum such reticence is understandable. All things being equal, though, the best position from which to view a painting is of course to stand centrally before it. I also suggest that the distance at which to start is not the normal two or three metres away, but rather the place where the painted surface entirely fills your visual field; where, so far as manageable, you see all the painting and only the painting. This will be much closer than you expect – a distance of no more than about a metre from a picture the size of Monet's *Waterlilies* in Tate Modern, which is more than four metres wide (pl. 35), while for a small and detailed painting like Ford Madox Brown's *Hayfield* (pl. 36) you will find that you have your nose virtually pressed up against the surface, probably closer than any nearby attendant will want to let you stand.

This is not simply a matter of relative proportions. It connects to the very conditions under which each painting was made, by an artist facing the marked surface head-on and evaluating it as the work proceeded. That artist, we should bear in mind, was the painting's first and most influential spectator. The Monet and the Madox Brown are widely different examples chosen to make a point. Most paintings will fall somewhere between these two extremes. What matters is that one be able to gain some insight into the physical character of the different working procedures. The artist who paints every leaf and blade of grass is using the point of a very small brush and controlling its movements with the finger joints. That artist will be working close to the surface of the painting. This is where the picture's effects will principally have been inscribed. For Monet, on the other hand, the liquid atmospheric effects he sought were achieved

with quite broad movements of an outstretched arm and a long paint-laden brush. These movements came not from the fingers but from the shoulder. Although the artist would have moved closer to apply those individual dabs of colour that mark the petals of the lilies, and though he would at times have stepped back to assess the overall effect, we can imagine that his principal working distance was about a metre from the canvas – coincidentally the same distance at which the finished painting fills one's visual field.

I do not mean to suggest that there is always only one distance from which a painting can be seen to best effect, or that there are many types of painting in which the size and scale of brushstrokes remain entirely uniform. Furthermore there are many notable paintings made under conditions such that it was never expected or intended that a close view would be possible – for instance where they serve to decorate high ceilings, such as the one in the Sistine Chapel in Rome that was worked on in fresco by Michelangelo. None the less I do firmly believe that what we might call the artist's main working distance is usually the place at which the technical character of a painting is most clearly revealed. At least as regards European easel painting from the early sixteenth century onwards, this will normally be the point where a kind of equilibrium is reached between overall composition and figurative detail. It can even be said, I think, that achieving that equilibrium came increasingly to be felt as a positive measure of competence in painting at the point in the nineteenth century when the old academic and the new modernist tendencies began clearly to diverge. In the late 1870s and early 1880s certain Impressionist painters in France developed a technique whereby separate small strokes and dabs of colour would mix optically in the eye of the spectator who stood back from the canvas. We may indeed need to stand back to experience this effect but unless we also stand close we are unlikely to appreciate the unusual brilliance of the surface that produces it.

A comparison will serve to demonstrate the difference between two approaches on the part of painters at the time. Frank Boggs was an American painter working in Paris. In 1882 he sent to the official French Salon a panoramic picture of the Place de la Bastille, some two and a half metres in width (pl. 37). It was evidently intended for public display and was successful in attracting a purchase from the French state. The painting was included in an exhibition *Landscapes of France* shown in London and Boston in 1995–6. Boggs was working in a relatively traditional style, with

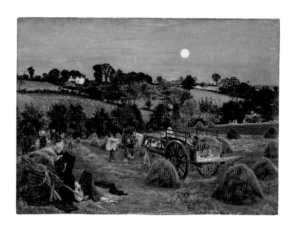

36 Ford Madox Brown, *The Hayfield*, 1855, oil on wood, 24.1 × 33.3 cm, Tate Britain, London

An associate of the Pre-Raphaelite Brotherhood, Brown is best known for larger paintings with themes of a literary, historical, religious or social character. The small landscapes he painted in the 1850s are nevertheless among his most attractive works.

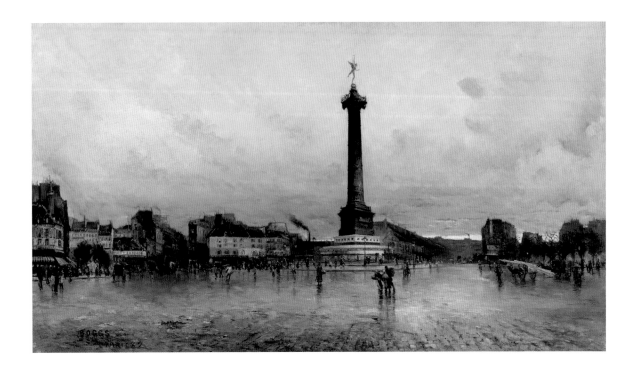

37 Frank Boggs, *Place de la Bastille in 1882*, Salon of 1882, oil on canvas, 140 × 250 cm. Musée Nationale de la Coopération Franco-Americaine, Blérancourt

restrained colours, though he used a sketchy touch for the details of his picture. From the position at which this painting filled my visual field, the composition registered in all its marked effects of contrast and depth. However, at that distance much of the detail remained unreadable, the busy activity of the street reduced to a blurry, flickering texture. When I stepped closer to the surface, the texture resolved into a complex pattern of figures and incidents, into which I felt drawn as though by some contemporary narrative of life on the city streets. But there was a price to pay. At that distance I lost the sense of an overall composition and of the formal relations by means of which those details could be made to work together. It seemed that, in this case at least, the *what* of detail and the *how* of formal composition were pulling in different directions.

Shown in the same exhibition, Monet's picture of the River Seine at Lavacour was painted two years earlier (pl. 38). Although smaller than Boggs's work, at a metre and a half wide it is still large for an Impressionist painting of the period. What seemed remarkable about this work was that when I stood at the position where all the painting and only the painting was visible, there was no sense of separation between composition and detail. Each brushstroke registered, contributing its portion of colour both to the vivid representation of the scene observed and to the

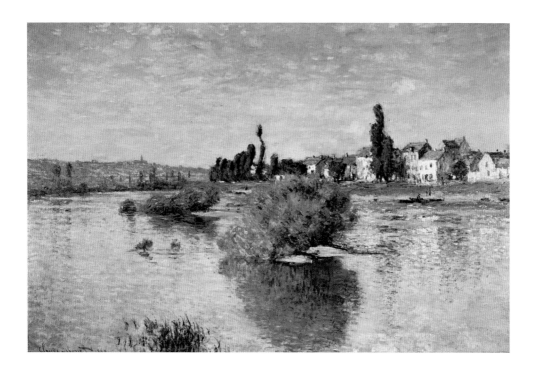

38 Claude Monet, *Lavacour*, 1880, oil on canvas, 98 × 149 cm, Dallas Museum of Art

(For Monet see also pl. 35.)

weaving together of the overall picture surface. To concentrate on a particular passage of painting, say the group of figures sketched in before the brightly lit house at the right, was still to feel the balancing effect of other parts of the motif, like the dark-toned poplar trees seen on the river bank at the left. This seemed like painting for the eyes *par excellence*.

Boggs may well have intended that his work should require two or more viewing positions and may have regarded the variety involved as a satisfactory outcome. I am not arguing that paintings ought to have only one optimal viewing point. I mean rather to point to the difference between different aesthetic regimes and priorities, and to suggest ways in which these can be identified and responded to. Different types of painting give one different kinds of work to do. The trick is to adjust one's expectations and viewing behaviour to the particular character of each.

So far the procedure of this section has been to encourage concentration on the autonomous character of the painting – its identity as a self-contained and self-sufficient thing, isolated not just from its physical surroundings but also to a certain extent from its place in a larger history. The procedures I have described are intended to help us see better what is there to be seen. But we do not approach works of art as though our minds were blank tablets, innocent of any prior experience or knowledge, nor need we aspire to do any such thing. Artists have always had to rely

39 Georges Braque, *Still Life with Harp and Violin*, 1912, oil on canvas, 116 × 81 cm, Kunstsammlung Nordrhein-Westfalen, Düsseldorf

Musical instruments appear in a number of Cubist paintings. Their attraction to the painters lay in their status as traditional components of still-life paintings, in the complex shapes they present to the eye and in the analogies they suggest with musical forms of composition. This picture was painted at the point of greatest complexity in the development of Cubist painting. (For Braque see also pl. 59.)

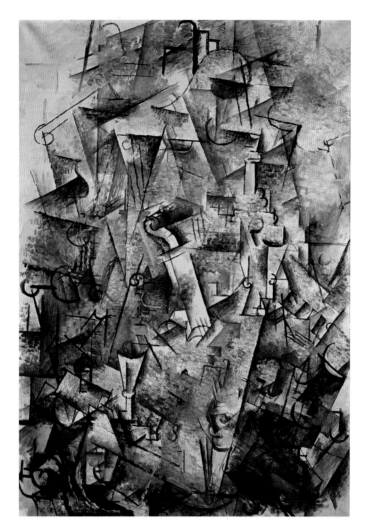

largely on viewers being able to bring their relevant knowledge and experience to bear and of course that will include knowledge and experience of the kinds of things that paintings picture.

In many cases what is depicted in paintings is recognised easily enough, the more so with practice and some exercise of imagination. Yet there will always be cases where it is not clear just what it is that the forms in a painting are meant to represent. One may be able to see the painting well enough but not easily interpret what it seems to picture. I am not just referring to such things as the Cubist paintings made by Picasso and Georges Braque before the First World War, which can sometimes be hard to relate to the ordinary appearances of the world (pl. 39), let alone those abstract works that are not intended as likenesses at all. I am thinking more par-

ticularly of pictures that contain obscure symbolism, that illustrate unfamiliar myths and stories, that contain characters engaged in unaccountable activities or that present effects of colour and delineation for which there is no apparent rationale. Many examples are to be found among those works of art, both paintings and sculptures, which were made to fulfil a primarily religious function (see pl. 94). In such cases it may feel as though the possibility of aesthetic enjoyment is restricted; that one cannot maintain an interest without the kind of knowledge that a more historically informed approach might provide. There may then be good reason to be grateful for the extensive label or the book that explains what it is one is looking at and indicates what one should look *for*.

However, recalling the husband with his nose in the guidebook, there can sometimes be a kind of loss in having too much of the work done for one in advance. There may be cases where some additional exertion will serve to clarify what initially appeared obscure and where the work of interpretation is revealed as a part of the pleasure that a work of art has to offer. I shall take up this theme in due course, when I come to discuss the question of how one might decide, faced with an unfamiliar work of art, just what is relevant and necessary to know about it. My point for now is that simply by giving works of art a sufficient and appropriate degree of attention, one can often get further in understanding them than might at first have seemed possible. The process of working for that understanding can in itself be rewarding – more so, in many cases, than having all the information given in advance by a label or a book.

To that end I have a compelling demonstration to propose – for those who are not put off by the potential for some public embarrassment. It requires that you provide yourself with two fat 'L' shapes cut from grey cardboard, say about 10 centimetres (4 inches) long on each side and about 2.5 (1 inch) wide. These can be put together to make a variable frame, adjustable to the exact proportions of any composition with a rectangular or square format. For your ensuing gallery visit, you might want to conscript a friend to provide some moral support. Duly equipped, select a painting, preferably one with a relatively deep pictorial space, such as a landscape or city view. Particularly effective types of work from which to start are the classical landscapes of Nicolas Poussin (pl. 40) and Claude Lorrain, the topographical pictures of Antonio Canaletto (pl. 41) and Bernardo Bellotto or the naturalistic landscapes of Constable (see pl. 29), but almost any competently painted picture will offer some dividend. Place yourself squarely before the picture at the viewing point already suggested (reminding yourself that this will usually be closer than you first think), hold your apparatus up to one eye with the other closed and adjust it so that it exactly encloses the composition but with background wall and

40 Nicolas Poussin,
Landscape with a Calm, 1651,
oil on canvas, 97 × 131.5 cm,
John Paul Getty Museum, Los
Angeles

The evocation of a sense of
mood was crucial to the
character of Poussin's
landscapes. Their spaces are
carefully organised by the
distribution of light and shade
and by the placing of incident
and detail. A contrasting
pendant to this picture shows
a landscape with a storm
(Musée des Beaux-Arts,
Rouen). (For Poussin see also
pls 77 and 78.)

41 Antonio Canaletto, *The Stonemason's Yard*, 1727–8, oil on canvas, 123.8 × 162.9 cm, National Gallery, London

Canaletto's highly skilful paintings of Venice were in great demand among aristocratic patrons throughout Europe in the first part of the eighteenth century, though this work may have been made for a local patron. It shows a view from a temporary mason's yard across the Grand Canal to the church of Santa Maria della Carità.

frame eliminated. Then look hard into the picture. If you perform this operation correctly, you may be surprised by what you see: by the way in which the pictorial space opens up, detail is rendered visible and colour palpable and your imagination is drawn into the represented world. If nothing else, the exercise should help to make clear some of the advantages of seeing paintings at first hand as against studying them in reproduction. Looking at a painting in this way may not serve to clarify any unfamiliar symbolism but you will be seeing it to maximum visual effect, devoid of distractions, with the results of the painter's craft allowed to register in full. By this means, perhaps, we can make our best guess as to how the picture was originally imagined and intended – and not only when it was intended for the context, such as a church, in which it may even now be being viewed.

2.2 MAKING SPACE

To reiterate a previous point, it is an important difference between verbal language and pictures that they carry their meanings in different ways. Linguistic texts are organised sequentially in a conventional order, distributed in time as well as space. Seeing a page is not the same as reading it. A single pictorial image, on the other hand is distributed in space so that its constituents can in principle be apprehended simultaneously. This fact is central to the distinctive ways in which pictures are composed and used. While they may not be well employed in conveying information that needs to be absorbed sequentially, like narratives and reports, they are highly suitable for showing appearances and for representing qualities and relations. There is another important difference to be observed. In modern languages, letters and words are signs connected to their objects by convention. Pictures, in contrast, are connected by kinds of likeness, however tenuous the resemblance may become. While the word 'cat' does not look like a cat, a picture of a cat does, even if we have to learn how it does. Of course not all paintings are pictures in this sense, but even abstract painting depends for its effect on a tradition of picturing, particularly on the kinds of imaginative activity on the part of spectators that pictures have traditionally encouraged. The paper you write on remains a flat surface. The paper you draw on becomes an imaginative world. It might be said that the very first condition of making a picture is not the composing of an image, however basic. What comes first is the idea that an image is something a flat surface can be made to contain.

fig. 1

fig. 2

A simple exercise will serve to make a basic point about the transformation of flat surface into pictorial world. First I draw a circle two or three centimetres in diameter on a clean sheet of paper (fig. 1). Next I shade the left-hand side of the circle, adding tone to imply a source of light falling on the circle from the right (fig. 2). What I have effectively done is to model the circle so that it is possible to see it as a sphere. In other words, I have supplied the appearance of a three-dimensional object on which light is falling, so that it has a dark side and a brightly lit side. There is another important consequence of my action: it is not just that the circle has ceased to be like a capital O and become like a sphere. Something has happened to the sheet of paper. While there is no problem with a flat sheet containing a letter O, it cannot by definition contain a sphere. If the shaded circle can be seen as a sphere, it must follow that it is now possible to see – to imagine – the surrounding paper as having a depth sufficient to contain it; or rather it must be possible to see the ground on which the shaded O is drawn not as a sheet of paper at all, but as if it were a spatial volume sufficient to contain a sphere. We still know that it is a sheet of paper and that it is flat but in so far as we do 'see' a sphere, the implied space to accommodate it comes along naturally too. This is an occurrence – a kind of seeing – about which we can mostly agree.

Of course most paintings are far more complex to look at than a shaded circle but I suggest that our capacity to agree about this kind of seeing is a basic condition required to make representation do its work in painting. I would go further and suggest that this agreement is a significant starting point for art considered as a social exchange, an exchange between the artist who furnishes material for the exercise of imagination and the spectator willing to undertake the relevant activity. It is the kind of exchange that depends on a relationship of mutual recognition and collaboration for which the work of art provides the occasion. To put the point another way, a work of art is like a game – often a serious game – that is set in play when the spectator's imagination engages according to some set of

42 John Russell, *The Face of the Moon*, c.1795, pastel on paper, 64.14 × 46.99 cm, City Museum and Art Gallery, Birmingham

Russell was both an accomplished astronomer and a specialist in the use of pastel. According to his own testimony, the poor quality of contemporary maps of the moon 'led me to conclude I could produce a drawing in some measure corresponding to the feelings I had upon first sight of the gibbous moon through a telescope.'

rules. Once those rules come into effect, endless possibilities are opened up for enriching representation, for the consequent enlargement of art's field of reference and indeed for the transformation of the rules themselves.

The next plate shows a slightly more complex picture of an illuminated sphere (pl. 42). Although it may look at first glance like a photograph, it was actually made in pastel – a soft, chalky drawing medium – some decades before the invention of photography, by an artist who was presumably using a telescope to look at the moon. This is a work driven by a spirit of scientific observation and curiosity, where the need for accuracy of visual information was crucial to the procedure. There is a point to be noted here. It is not simply the power of illusion that the spectator assents to or agrees to entertain. It is not just the apparent transformation of the sheet of paper into a space with a sphere in it that holds our attention in the case of Russell's picture. Rather, what is intriguing is the seemingly paradoxical experience of seeing the paper as both literally flat and imaginatively fathomless. What the art of easel painting caters for – and this is as true of abstract painting as it is of the most highly figurative – is our pleasure in this, the relationship between the seeing of the flat painted surface and the seeing of that surface as something else, something much more, something that has been made to be as it is. The viewer whose pleasure is aroused by what a painting pictures – a beautiful woman, a handsome man, an elegant horse, a sumptuous meal, an inviting landscape – is still enjoying a representation, not the thing itself, and at the least has a sense of whether the picturing has been well or badly done.

Like my shaded sphere, Russell's picture demonstrates a basic figure–ground relationship. Such relations involve seeing some object both as distinct and as located in a context by which its meaning and identity are established. A black stain on a white sheet draws attention to itself as a stain precisely because of its difference from the surrounding area. In a picture with spatial depth, a figure will be made to stand out from its ground by means of modelling or contrast of colours. In Boggs's painting (see pl. 37), the figure–ground relations are stark, in Monet's *Waterlilies* they are deliberately subdued (see pl. 35). These may seem like purely formal matters but they are central to the ways in which attention is

43 Arthur Devis, *The James Family*, 1751, oil on canvas, 98.4 × 124.5 cm, Tate Britain, London

Robert James was for some years the secretary to the East India Company (referred to in section 4.4). The painting shows him at the age of 51.

directed and also to the means by which a sense of relative value is conveyed. Figure–ground relations are necessarily involved in the ways in which we isolate objects of attention and attach meaning to them accordingly.

Clear cases of how such relations convey meaning and value in painting are to be found in the art of portraiture. In Arthur Devis's picture of the James family, the patriarch and his wife and daughters are made to stand out as distinct figures against the ground of the painting's more distant elements (pl. 43). In this case that ground depicts a landscaped English park. It would be easy to take this backdrop as merely conventional, like the kind of ready-made staging that Victorian photographers provided for their clients. But an important part of the job the portrait painter does for his client is to imply that the apparent relationship between figures and ground is just as it should be, that Mr James is the entirely appropriate occupant of a landed estate, complete with the kind of architectural elements and details that suggest history, culture and tradition. Devis achieves this by making the strictly formal and the illustrative aspects of the painting work harmoniously together. By contrast, those persons who question a man's 'background' are usually suggesting that he fails to fit.

44 Barnett Newman, *Untitled* (*The Void*), 1946, ink on paper, 61 × 45.7 cm, Louisiana Museum of Modern Art, Humlebæk, Denmark

Newman was a member of the generation of American painters known as the Abstract Expressionists, a contemporary and associate of Mark Rothko (see pl. 2).

In the case of the shaded spheres, it is clear enough which part of the picture serves as the figure and which the ground (the term background would not be appropriate here, since the imagined spatial grounds extend both behind and in front of the spheres). But figure–ground relations appear in many different ways in art. A drawing in ink on paper by the American artist Barnett Newman seems at first sight to show another sphere (pl. 44). In this case, however, the round shape actually represents the rim of a void (*The Void* is a title that has sometimes been attached to the work). It is important that the void is sphere-shaped, or rather it is significant that the artist has deliberately both aroused and reversed our normal expectations of figure–ground effects, according to which a 'ground' will normally surround a 'figure'. It is the shock of this reversal that produces the effect of the picture. The void in place of a sphere implies that the medium of seeing – light – comes before there is any actual object to illuminate. The reference, I think, is to the opening of the Biblical book of Genesis. 'God created the heaven and the earth. And the earth was without form and void, and darkness was upon the face of the deep.' As an artist working in the mid-twentieth century, Newman shared with many other modernists an interest in the idea of going back to the 'beginning', to the origins of creative activity. What his work suggests is that, for the painter, creation begins not with formless matter but with the command 'Let there be light'. Once there is light, we can begin to make out figures against grounds and to find order out of chaos.

I referred to the shading of my sphere as the addition of tone. Tone is a measure of darkness or lightness and as such an indispensable element in painting's potential for emotional effect. In painting and drawing the use of tone is inseparable from the implication of a source of light, and therefore from modelling, which is to say the business of making shapes look three-dimensional. A life drawing of a man by Paul Cézanne has been shaded so as to make the figure look solid, with the light presumed to be falling from the left (pl. 45). The Italian term *chiaroscuro* – literally 'light-dark' – refers to the distribution of light and shade in a picture. It was normal practice until the nineteenth century for pictorial compositions to be worked out initially in terms of their chiaroscuro, which is to say on a tonal basis. Brueghel's painting of the Death of the Virgin is an example of a finished painting that has been constructed almost entirely in this way, with colour restricted to a few warm points of light (pl. 46). It is what is known as a grisaille.

45 (*right*)　Paul Cézanne, *Academic Study of a Nude Male Model*, c.1865, black chalk on paper with white highlights, 31 × 49 cm, Fitzwilliam Museum, Cambridge

'Life study' from the nude was central to academic training in the nineteenth century. Made not long after Cézanne first arrived in Paris from Provence, this drawing is distinguished from others of the type by the vigour of its execution. It was probably made at the Académie Suisse, a studio where artists could work for a monthly fee, with a model provided. (For Cézanne see also pls 22 and 58.)

46　Pieter Brueghel the Elder, *Dormition of the Virgin*, c.1564, oil on oak panel, 36.8 × 55.5 cm, National Trust, Upton House, Warwickshire

This night scene shows the death of the Virgin Mary. Light is provided by the taper placed in her hands by St Peter, by the fire burning in the hearth, by two small torches placed near the ceiling and by a small candle on the table in the foreground. The figure sleeping by the fireside probably represents St John the Evangelist, the author of an apocryphal book containing a visionary account of the Virgin's death. Brueghel may have intended to suggest that it is this vision that we are seeing. An engraving was made from the picture in 1574 and the monochrome technique may have been used so as to aid the engraver's work. The painting was once owned by the painter Peter Paul Rubens.

The tonal range of a painting is a scale that runs from its whitest white to its blackest black. One of the key differences between Boggs's painting and Monet's picture of *Lavacour* (see pl. 38) is that while the former is composed with a dramatically wide tonal range, far more of the work in Monet's painting is done by colour, with no pure black used at all, so that the overall tonal range is far lighter, while the darker colours appear more intense. The difference is between a work largely organised on a tonal basis and one in which a high priority is given to the saturation of colour; that is to say, to the redness of red, the greenness of green and so on. Generally speaking in figurative painting, the use of strong tonal contrasts and emphatic modelling will tend to mean that colours are kept at a relatively low level of saturation. In Impressionist painting such as Monet's, on the other hand, the aim is to convey a sense of natural light and atmosphere by increasing the brilliance and saturation of colour. As a consequence, individual effects of modelling tend to be subordinated to a sense of gradual progression through the pictorial space. This contrast may be related to a conventional distinction that is often made in art history between 'linear' and 'painterly' styles.

47 Jan van Eyck, *Virgin and Child in a Church*, oil on panel, 32 × 14 cm, c.1430–40, Gemäldegalerie, Berlin

Van Eyck was one of the most accomplished of a number of painters who worked in the Netherlands in the early fifteenth century, best known for his work on the Ghent Altarpiece begun by his brother Hubert. His fine oil-painting technique involved coloured underpainting covered with up to six layers of translucent glazes. Here the height of the Virgin's figure relative to the architecture is not a failure of realism but rather a means of conveying her symbolic presence as a personification of the Church.

2.3 PERSPECTIVE

If a picture is conceived as a device for representing the three-dimensional world on a two-dimensional surface, it is clear that some procedures or techniques will be required to deal with those spatial relations that can no longer be accommodated. Some system will be needed so that certain priorities can be maintained and, crucially, so that viewers will be able to find their way about the resulting image. As a means of achieving this, perspective has been understood in one form or another since antiquity. There were always certain common-sense principles which artists could adopt and which obey a basic logic of perspective. They could make the assumption that any picture will represent a fixed viewpoint, that from that viewpoint objects in the foreground will occlude objects in the background and that the latter can therefore be left out. (The Cubist painters' abandonment of this principle was one reason for the shock their work caused among the majority of viewers. What they did was allow their pictures to include references to objects and details that might be known to be there, even though they were 'behind' other things.) Another common-sense principle was to make the assumption that objects near at hand will always appear larger than the same-sized objects further away. Straightforward as this last may initially seem, it is actually in conflict with the so-called

'social perspective' adopted in pictorial art in ancient Egypt and in West Africa, whereby an individual's depicted size depends on their status (see pls 9 and 188). Such variations set aside, however, even a fairly unsophisticated painter equipped with these two principles could produce a readable picture of, say, a simple landscape – one that the viewer could relate somehow to the real world. All that is required of the viewer is that he or she should not confuse a pictured object that looks small because it is far away – say, a cow on a distant hill – with a miniature version of the same object that is set near at hand, such as a toy cow on a table.

The real problems are posed not by those surfaces that offer a frontal view to the spectator, like the facade of a house, but by those surfaces and planes that recede into depth, like the side walls of the same house that extend at right angles to the viewpoint. By an early age most children will have acquired the ability to draw a house seen full-on with windows and door, and perhaps a lollipop tree or two. It is a considerable step from there to the point where one can put the side walls in so that they look 'right', let alone, say, add a porch or a dormer window. These are the elements that will benefit from some learned system by which the two-dimensional surface can be made somehow to 'contain' those things that appear solid and plastic in three.

Even without such a system, practised artists can achieve high levels of life-likeness in representing complex forms in space. In Roman times artists responsible for the wall decorations in prosperous villas were capable of considerable sophistication in representing solid-looking buildings and other complex objects, using ruled lines drawn into wet plaster. In the early fifteenth century certain painters in the Netherlands produced highly detailed pictures with complex pictorial spaces and with intricate architectural settings represented in an apparently consistent and rational manner (pl. 47). However, it was in Italy during this period that artists actually evolved a geometrical method that would serve systematically to translate three dimensions into two: it would determine exactly which objects would occlude others over a given depth of space, it would

48 Unknown artist, six-fold screen with scenes from *The Tale of Genji*, 1677, Japan, ink, and colours on gilded paper, one of a pair, 170.2 × 348 cm, Isabella Stewart Gardner Museum, Boston

The Tale of Genji is one of the major works of Japanese literature, a long novel written by Lady Murasaki at the Heian court in the early eleventh century. The painting of paper screens was a major art form in Japan from the fifteenth to the nineteenth century.

give consistency to the apparent diminution in size of like-sized objects – such as people – and it would translate receding planes in the real world into sensibly related areas of the picture surface.

This system is known as linear perspective. Although its invention is credited to the architect and sculptor Filippo Brunelleschi around 1412, it was first codified by another architect, Leon Battista Alberti, who published a treatise called *De pictura* (*On Painting*) in 1435–6. They were members of a generation of artist scholars and theoreticians who helped to transform the status of art at the time in Florence. It is no coincidence that both were avid students of Roman architecture, much of which was still visible in Italy in the form of standing monuments and ruins. A refinement to the principles of linear perspective was noted by Leonardo da Vinci, who observed that the representation of depth in painting required an 'aerial perspective', according to which colour would appear to be moderated and softened by distance.

The theory and practice of perspective has since been the subject of countless demonstrations, treatises and instruction books and it remains an indispensable element in architectural planning, in the teaching of technical illustration and in the design of animations such as those that feature in computer games. This is the case even in those eastern and Far Eastern cultures where pictorial space in painting has generally been organised on a different basis. (In traditional Chinese and Japanese art the system of perspective most commonly used is orthogonal, in which receding parallel lines are represented as actual parallels, set at an angle to the viewpoint, rather than converging on a single vanishing point in the depth of

fig. 3 fig. 4 fig. 5

the picture space (pl. 48).) The study of perspective can easily become a highly complex business. I shall try to cover some of the essentials, starting from simple problems of representation in depth, and I shall devote some space to a particularly impressive early demonstration of the skills involved.

Let us say that having made my shaded sphere I now want to include another on the same sheet, the same size as the first but further away. I might produce something like figure 3. It is quite likely, however, that someone will see this not as a picture of two same-sized spheres, with one further away than the other, but as a larger and smaller sphere, each the same distance from the viewer. This spectator is regarding the two spheres as located on the same vertical plane – a plane which is parallel to the literal surface of the paper – as represented in figure 4. What I need to do is change this spectator's angle of vision, so that the two spheres are understood as lying along a plane that recedes into the depth of the picture. So I add some different cues, like those in figure 5. Although the pair of spheres is drawn in exactly the same way as in the other pictures, the effect of my basic perspective is to direct the spectator's vision so that it appears as though the sphere on the left is seen first as the eye travels into the picture space. It seems we may after all need sequence in the reading of pictures, but it is sequence of a kind that leads *into* an imaginary space rather than across the paper's literal surface.

During the fifteenth century in Italy the great majority of paintings were devoted to religious themes and were commissioned for religious purposes (pls 49 and 50). Both of these examples are painted in tempera on wood, a medium widely used in Italy before the introduction of oil paints. It involves mixing the pigments – the substances giving the colour – not with oil but with egg, with the white being used for lighter colours and trans-

49 Giovanni di Paolo, *St John the Baptist going into the Wilderness*, c.1450, tempera on panel, 31 × 38 cm, National Gallery, London

fig. 6

parent effects and the yolk to add density and warmth. Tempera is a less fluid and less flexible medium than oil. It dries faster and demands an even application and a light touch. In the hands of skilled technicians it can be used to produce coloured surfaces of great clarity and brilliance. These two pictures offer representations of considerable spatial depth but, while one uses informal and partly inconsistent means of doing so, the other shows all the advantages of a rigorously applied system of geometrical perspective.

Giovanni di Paolo's picture of St John the Baptist going into the wilderness is a predella panel; that is, it originally formed part of a small series of pictures, representing episodes from the life of the saint, that would have been set below the main subject of a much larger altarpiece (such as that in pl. 34). From our modern point of view it seems that Giovanni had a problem, whether he was aware of it or not. For most of the picture he has used a basic perspective to suggest gradually increasing depth of space. Thus the small pink-painted buildings beyond the patchwork fields in the

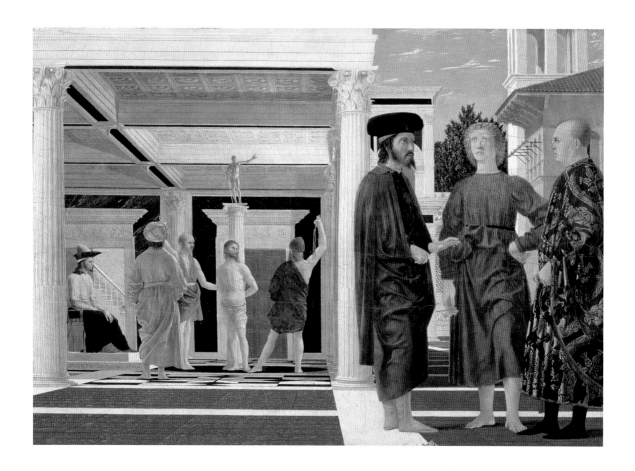

50 Piero della Francesca, *Flagellation of Christ*, c.1460, tempera on panel, 58 × 81 cm, Galleria Nazionale delle Marche, Palazzo Ducale, Urbino

Various attempts have been made to interpret this painting and to link the three figures at the right – a Byzantine, an unearthly youth and a contemporary Italian in formal dress – to the scene of flagellation set back in space and time. According to one theory, its purpose was to encourage support for a crusade against the Turks who were then in occupation of Constantinople, the historical centre of the eastern Church, with the sufferings of Christ serving to symbolise the sufferings of the Church. It

remains possible that at the time the picture was painted its message was understood by no more than three people: the man who commissioned it, the person it was to be given to and the artist who painted it.

centre appear much further 'in' than the one that St John the Baptist is leaving at the left. Yet the artist also wanted to make the point that the saint has left home and travelled into the mountains, so he showed him twice, after the manner of a strip cartoon. Further, in order that we know that we are seeing the same person both times, he gave him the same pose and literal dimensions. The result is that we are faced with two mutually inconsistent cues for measuring the depth of the pictorial space by means of the relative sizes of the objects within it. Clearly the 'second' Baptist would have a severe problem if he tried entering either of the buildings in the middle distance. To return to the diagrams, it is as if I had drawn two spheres literally the same size, while also suggesting that one was further away than the other (fig. 6).

To turn now to the *Flagellation* by Piero della Francesca (pl. 50) is to find all in order, at least in terms of the coherence of its pictorial space. The painting shows Christ being whipped in a classical loggia in the presence of the enthroned Pontius Pilate. In his concern accurately to represent the style of Roman architecture in the first century CE, Piero is likely to have been assisted by his friendship with Alberti. Outside, and in the world of fifteenth-century Italy, three figures stand in the foreground apparently involved in some conversation about the meaning of the event. Where Giovanni di Paolo conveyed the sense of distance by dramatic changes of scale and by delicate atmospheric effects, Piero creates the illusion of a measured progress into depth across a level urban space. This space is complicated by the presence of a series of buildings. They are so clearly delineated that you might assume the artist had drawn them from life. In fact it is more likely that he designed them for the purposes of his picture. It is worth considering for a moment what this means. If Piero did not actually make models of these buildings, he must certainly have imagined them as an architect might have done, no doubt using a ground plan to help him work out their placing and proportions so that they would look right from the intended viewpoint.

The scene is set in a level Italian-style piazza, with a pavement of red terracotta tiles interspersed with white marble strips. The piazza is bounded at the back of the picture space by a high decorated wall. Piero has left a single sight-line open between the legs of two of the figures at the right, so that we can see the full extent of the pavement at the point where it meets the wall (pl. 54). Whenever I have asked groups of students how far away they take that wall to be from the spectator's imagined viewpoint, I have received a surprising range of answers – from about two metres to fifty. What this demonstrates, I think, is that we have most of us lost the skill and taste for reading perspective – the relevant 'period eye' – that Piero was encouraging his contemporary audience to practise. For

the point is that the answer can actually be worked out (though for a really accurate result one needs to have the painting clearly in view in a good light).

Piero shows us that the width of each terracotta tile is about equivalent to the length of a grown man's foot, say a bit more than 30 centimetres. Each square of 64 tiles is enclosed within a broad white marble band. As a rough rule of thumb, then, we can say that each white band running parallel to the picture surface marks about 3 metres travelled into the depth of the picture space. Counting in on that basis down the sight-line as it runs into shadow, I reach 24 metres at the point where a band that must be running across the others appears brightly lit. Where is this light coming from? The sharp shadow in the bell tower at the top right tells me that the sun is high and to the left. It follows that there is a considerable gap between the back of Pilate's loggia at the left and the near side of the building that frames the left-hand figure in the group of three at the right, and that it is through this gap that the light is falling. That building in turn casts a band of shadow that appears near the base of the wall and it can be assumed to extend back some distance. I may not be able to go on counting the marble bands as the space between them contracts but what I can tell is that I should at least treble my 24 metres in order to arrive at the distance to the base of the wall.

There are two basic principles of perspective at work here. The first concerns those lines and planes that run parallel with each other away from the viewpoint and at right angles to the picture, like the three partially seen white marble strips running from front to back, the roof line and windows of the building at the right, and the large roof beam with black inlay in Pilate's loggia. These planes are drawn so that they would converge on a single point on the horizon at the deepest extreme of the picture space, known as the vanishing point. The same will go for any points of equal height that might be located on such a plane. The second principle concerns those lines and planes that run parallel to the picture. Where the real intervals between these are regular, like the white marble strips I have been counting into the space of the *Flagellation*, in the picture they will appear to compress at an even and increasing rate as they recede into depth. In a properly worked perspective, like Piero's, the rate of compression will match the rate of convergence of the parallel lines that recede towards the vanishing point. A simple diagram should make this clear (fig. 7). Piero may well have used just such a grid in order to help plan his composition. Its potential usefulness as a way of measuring out the picture space is reflected in the pattern of tiles that provides the floor of his picture. It is no coincidence that of those various other paintings that provide particularly impressive demonstrations of skill in the art of perspective, many

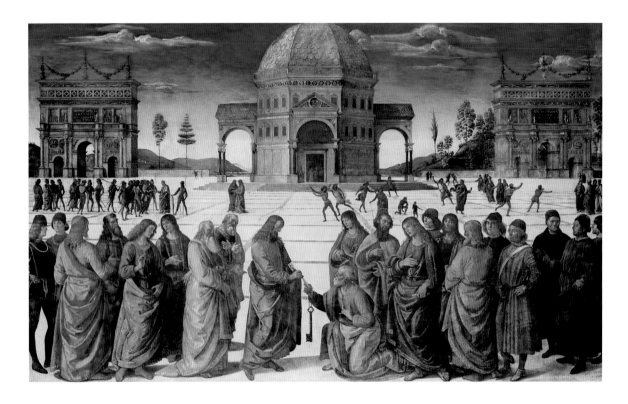

51 Pietro Perugino, *Christ handing the Keys to St Peter*, 1481–2, fresco, 335 × 550 cm, Sistine Chapel, Vatican, Rome

This is one of a series of large pictures painted in fresco around the walls of the Sistine Chapel. The project engaged a number of the most successful artists of the time.

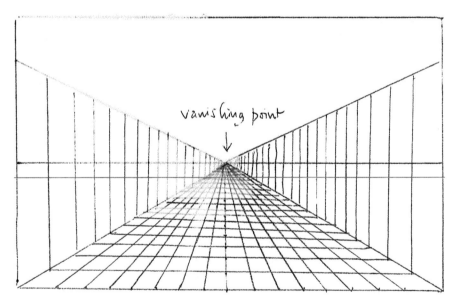

vanishing point

fig. 7

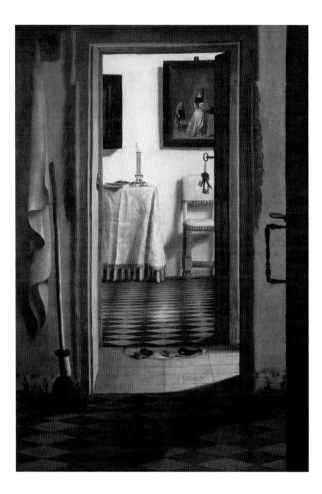

52 Samuel van Hoogstraten, *Interior viewed through a Doorway ('The Slippers'),* c.1657, oil on canvas, 103 × 70 cm, Musée du Louvre, Paris

Van Hoogstraten's picture is typical of the interior scenes painted in the Protestant Dutch Republic during the mid-seventeenth century. Works such as this that celebrate the sober elegance of bourgeois life have their counterpart in scenes of less orderly life in the servants' quarters.

also include conspicuously tiled floors, whether in the paved piazzas and loggias of the Italians (pl. 51) or in the domestic interiors pictured by Dutch artists in the seventeenth century (pl. 52).

As an artist well versed in mathematics and geometry, a friend of the architect Alberti and himself the author of a treatise on perspective, Piero della Francesca was providing a conspicuous demonstration of what were still relatively advanced skills, exercised at the highest artistic level. He was painting in this case for a very small audience, clearly one that could be put on its mettle in the attempt not only to fathom the depth of the picture but also to translate the black-and-white marks on the floor round the figure of Christ into the pattern of tiling that they represent and to trace back the lines of shadow in the coffered ceiling above so as to locate the unearthly light source that must be concealed between the pillars at the centre (pl. 54). To engage with these visual puzzles is to recover some of the fascination that Piero's advanced skills must have exerted for his

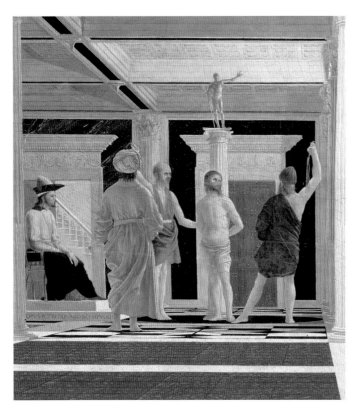

53 Piero della Francesca,
Flagellation of Christ
(detail of pl. 50)

contemporaries – particularly for the patron who commissioned the work, almost certainly identifiable as the man represented at the extreme right of the picture.

The *Flagellation* also conveys a kind of hidden message, only to be understood by those who could properly connect the conversation taking place in the fifteenth-century here and now at the right to the vision of the flagellation at the left – for a vision is what it is, set back in another and more ancient time, lit by an unearthly light and framed in Piero's remarkably accurate version of Roman architecture from the time of Christ. Where Giovanni di Paolo offered us two sequential episodes from the same narrative, Piero's more sophisticated type of pictorial space allowed him to represent two diverse moments as interrelated across time and space. He used a particular formal device to underscore this relationship. As the turbaned witness with his back to us stands relative to the three figures of the flagellation, so the imagined spectator of the picture – in this case ourselves – is placed relative to the trio at the right. It is as though the witness were the actual spectator's representative at the flagellation, an avatar projected back in time, encouraging us to imagine seeing through his eyes. We shall have further cause to explore the strange power exercised over the imagination by those figures that are presumed to look into the spaces of pictures.

There is a final point to be made before we leave the paintings by Giovanni and Piero. Although the two pictures were probably painted within about ten years of each other, Piero was using advanced mathematical and geometrical techniques that Giovanni almost certainly did not possess. In the mid-fifteenth century the development of such techniques was of great interest to some painters and patrons in Italy but not to all. By giving their pictures the look of systematic organisation and truth to appearances, artists such as Piero della Francesca and Leonardo da Vinci were able to raise the intellectual content of painting in the eyes of those to whom that content was of interest. What their work seemed to show was that their

art depended on a degree of theoretical knowledge and understanding, not simply on the practising of craft skills and techniques. If a painting could be seen as something worked out in the mind like a poem or a logical problem, and not simply made in the hand, then it was more likely to attract the attention of those, in such lively urban centres as fifteenth-century Florence, who prided themselves on their own literacy and sophistication. In this sense we might say that Piero's work represents a more advanced state of technical development than Giovanni's or even that it was somehow more 'modern' at the time. Giovanni himself was based in the more conservative centre of Siena and he seems to have worked exclusively on religious commissions of a relatively standard type. The comparison between the two paintings suggests an analogy between the development of perspective and the emergence of polyphony in music. While polyphony was generally welcomed for the great increase it brought to the potential for complexity and 'depth' in music, it was at first not universally favoured for use in religious services, since it led to a 'mixing up' of the religious text which the single melodic line had formerly carried, making it harder to follow.

54 Piero della Francesca, *Flagellation of Christ* (detail of pl. 50)

I do not think that it follows from these observations that Piero's is necessarily a better painting than Giovanni's in aesthetic terms. The intellectual achievements of Piero's work are certainly impressive but they do nothing to disqualify the decorative charm, narrative clarity and imaginativeness of Giovanni's. There is no reason to assume that a particular technical or intellectual development must involve an increase in the aesthetic merit of artistic work. A form of organised and systematic 'truth to appearances' is one characteristic a painting may have. Decorative charm and individuality is another. These two characteristics may go together but there is no reason why they should. Art-historical treatments of the art of the Italian Renaissance have tended to stress the development of perspective systems, rightly enough, since these developments played a crucial part in shaping the course of art over the next four hundred years. As painters demonstrated increasing skill in representing figures and objects in con-

55 Henri Rousseau, 'le Douanier', *Carnival* Evening, 1886, oil on canvas, 117.3 × 89.5 cm, Philadelphia Art Museum

Rousseau was the first artist in modern times to be celebrated for his apparent naivety. The admiration for his work among modernist artists and writers was of a piece with their enthusiasm for the art of so-called 'primitive' peoples. Picasso gave a banquet in his honour in 1908 and the Surrealists claimed him as an important precursor.

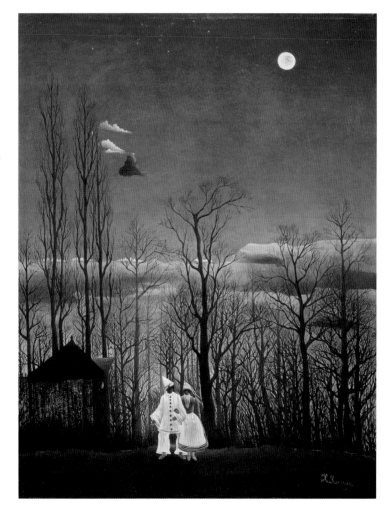

sistent pictorial spaces, so the value of paintings came to be associated less with the price of materials – the gold leaf and expensive pigments that had been used in their manufacture – and more with the achievement of kinds of life-likeness. By the late fifteenth century the ability to work out an orthodox perspective scheme was more or less common to ambitious painters in Italy. As tends to happen with new technical resources in art, no sooner were the basic geometrical principles established than artists began to seek variant effects with eccentric or multiple vanishing points, mutually contradictory systems and so on. During the late sixteenth and early seventeenth centuries, ever more ambitious schemes of fictional architecture were tried out in the decoration of large interiors and on the ceilings of churches and palaces. These certainly testify to a range of impressive technical, intellectual and organisational skills that the devel-

56 Alfred Wallis, *The Hold House, Port Mear Square, Island, Port Mear Beach,* c.1932, oil on cardboard, 30.5 × 38.7 cm, Tate Britain, London

Wallis's paintings were seen by the artists Ben Nicholson and Christopher Wood on a visit to St Ives in Cornwall in 1928. They were subsequently circulated among the small English avant-garde of the time. Made using ships' paints on scraps of wood and cut-out cardboard, they mostly depict scenes from Wallis's earlier life as a mariner and places that were familiar to him, all painted from memory rather than direct observation. This work shows features of the town of St Ives around the cottage where Wallis lived near Porthmeor Square.

opment of perspective encouraged. It does not follow, however, that we need disparage the virtues of work such as Giovanni's – the vividness and homeliness of its detail, the evocative quality of its atmosphere and its forthright way of showing the passage of time.

In fact, early in the twentieth century 'primitive' paintings such as Giovanni's came to be widely preferred to more sophisticated pictures like Piero's, on the grounds that they were more richly endowed with the kind of significant form identified by Clive Bell. The idea gained ground that technical sophistication might be inhibiting to a certain 'purity' of vision and that it was to the latter rather than the former that one should look for aesthetic virtue. This was the time when serious interest was first shown in the art of children and of the mentally ill. In Paris in the early 1900s, the art of the untaught Henri Rousseau was celebrated by a group of avant-garde artists, Picasso among them (pl. 55). In England, a similar enthusiasm was shown for the remarkable pictures of Alfred Wallis, a retired Cornish mariner who began painting in the late 1920s at the age of 70 – 'for company' after his wife died – and whose ability to represent the world as three-dimensional had not progressed much beyond the cardboard-house-and-lollipop-tree stage (pl. 56). Indispensable as the skills of perspective construction have remained for such purposes as technical illustration, their most distinctive uses in the art of the twentieth

century were in structuring the dream-like spaces of the Surrealist painters, and of Salvador Dalí in particular. Such demonstrations apart, modern painters from late in the nineteenth century onwards have tended to associate linear perspective with technical conservatism.

<div style="text-align: right">

2.4 THE PICTURE PLANE

</div>

I have at various points mentioned imaginary viewpoints and imaginary spectators. Both are crucial to the ways in which paintings work and they deserve some further consideration. To make clear what is involved I return to a kind of starting point – the artist faced with a blank canvas. Let us say that what is to appear on that canvas is a portrait of a man. The artist's task will be to produce a convincing likeness that is also successful as a work of art. An exceptionally able artist (a Titian or a Rembrandt) may do something more, may endow that likeness with apparent personality and consciousness, properties that pieces of painted canvas cannot possess literally (pl. 57). In this and the following section I want to explore how such effects are achieved.

The practical point from which the picture commences occurs when the artist regards the literal flat surface – the tangible surface of the canvas – and begins to work on it. As the first mark is made on the canvas, the imagination of a virtual world is invited – a world within which the content of the picture is to be located. The picture plane is established as that world is defined. It marks the separation between the world of the painting's spectator, as it were on this side, and the world beyond in which the painting's subject matter – a pictured person, say, or a landscape – is to be situated. Everything located behind that plane, then, will be part of the painting's content. As long as traditional painting techniques are maintained, no painted objects will be able to break the picture plane and enter the spectator's world, any more than characters in a film can step through the screen into the audience. The picture plane will tend to coincide with the literal surface but, unlike that surface, it cannot be touched. Imagine a painting of a life-sized figure, with arm outstretched and with a pointing finger that reaches out to the very nearest point of the picture's represented space. If you could reach out in turn, the picture plane is where your fingers would meet. Of course all you would actually touch is the flat surface of the canvas and at that moment the power of the illusion would be broken. We can perhaps now begin better to understand the strange fascination of painting's dual aspect: the simultaneous experience of the flat surface on the one hand and of its imagined depth on the other. For

57 Titian, *Ranuccio Farnese*,
1543, oil on canvas,
89.7 × 73.6 cm,
National Gallery of Art,
Washington D.C.

Commissioned as a gift for
the boy's mother, Titian's
painting shows the twelve-
year-old member of one of
Italy's most powerful and
wealthy families. The grandson
of Pope Paul III and recipient
of a number of titles and
offices, he was destined for a
career in the church and was
pressed into public life at an
early age. The Maltese cross
on his cloak signifies his
recent appointment as prior
of a religious property
belonging to the Knights of
Malta. (For Titian see also
pl. 95.)

what we are experiencing is the very condition by which the painter's activity is governed: that of addressing a literal surface and marking it with paint, while at the same time assessing that action's contribution to the building up of an imagined picture and range of effects.

Tension between these two aspects can best be understood, I think, at the moment when it reaches crisis. From the seventeenth century to late in the nineteenth the picture plane was for the most part taken for granted in painting. It was not something artists had reason to be self-conscious about or to call attention to – not, at least, unless they were in the business of playing games with illusion. The picture plane was simply an auto-

matic condition of pictorial representation, serving, like the proscenium arch in conventional theatre, to mark the separation of art from life. For the majority of painters during these centuries, that the picture plane permitted a kind of imaginative entry to the world of the picture was a guarantee that all was well with the workings of representation. Things were to change, however. In the first years of the twentieth century, near the end of his life, Cézanne returned to a motif he had painted often some twenty years previously, the view of Mont Sainte-Victoire in Provence. He was deeply committed to the idea that painting entailed the faithful transcription of sensations of nature. He also believed that success was to be measured by the harmony he achieved in his composition and he understood that harmony as a matter of balancing colours and tones dynamically across the surface of his canvas. In the resulting paintings an extraordinary tension is maintained between the painting's illusory and physical properties – between the contribution each brushstroke makes to the impression of space and depth, light and atmosphere, and the obdurate presence of those same brushstrokes as palpable marks on the literal surface (pl. 58). A considerable strain is placed on the picture plane as a consequence. In so far as that plane serves conventionally to mark the

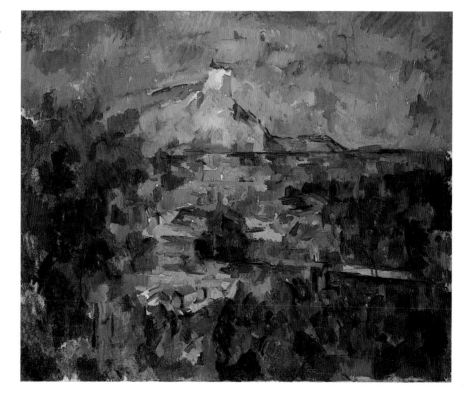

58 Paul Cézanne, *Mont Sainte-Victoire from Les Lauves*, 1904–6, oil on canvas, 60 × 72 cm, Kunstmuseum, Basel

Retiring to Aix-en-Provence in the last years of his life, Cézanne had a studio built on the edge of the town, a short uphill walk from the point at which this view of the mountain could be seen. The effect of his technique is to compress the distance to the mountain while making the intervening space appear dense with visual incident. (For Cézanne see also pls 22 and 45)

59 Georges Braque, *Still Life with Violin*, early 1914, collage with gouache and charcoal on chipboard, 71.8 × 51.8 cm, Cleveland Museum, Ohio

The violin is represented both by the colour and texture of the collaged sheets of paper and by drawing in crayon. A wine glass is sketched in front of the violin at the bottom of the picture. (For Braque see also pl. 39.)

dividing line between 'art' on the one side and 'real life' on the other, the implication is that the line might be in process of shifting.

Only a few years later the Cubist painters Braque and Picasso presented a dramatic challenge to the idea that the picture plane could simply be taken for granted, as though it were a transparent device given to painting. By sticking sheets of printed paper to the actual surfaces of their pictures, they drew a kind of flagrant attention to the relationship between literal and virtual surface. Further, by sometimes drawing shapes *on top* of the collaged sheets, they flouted the rule that said that pictorial content was always on the other side of the picture plane (pl. 59). At least for the purposes of painting, the entire matter of how pictures represent – indeed of whether paintings need to be pictures at all – was called into question. My reason for using these examples to explain the picture plane is that it is to modernism that we largely owe an interest in the plane's role in earlier painting. By modernism I mean to refer to the self-conscious pursuit by certain artists of subjects and techniques distinct from those of the academic tradition, gathering force and recruits in the late nineteenth and early twentieth centuries. I shall fill out this account of modernism in section 2.11. The point to be registered now is that it is in response to

60 Caspar David Friedrich, *Woman at the Window*, 1822, oil on canvas, 44 × 37 cm, Alte Nationalgalerie, Berlin

This picture shows the artist's wife of five years looking out from the window of his studio in Dresden. The presence of the river Elbe below is suggested by the mast and rigging of a ship, while a line of poplars indicates the distance to the further bank. (For Friedrich see also pl. 33.)

61 Henri Matisse, *Portrait of Greta Moll*, 1908, oil on canvas, 93 × 73.5 cm, National Gallery, London

The sitter was a friend and patron of the artist. By placing her image near the front of the picture space Matisse implies a physically close relationship to the imaginary viewer. This sense of physical closeness is complemented by the emotional effects of the woman's relaxed pose and open expression and also by the cursive rhythms and rich colours of the painting overall. (For Matisse see also pls 85 and 100.)

62 Eugène Boudin, *Still Life with Oysters*, oil on canvas, c.1860, 56 × 80.5 cm, Bristol City Museum and Art Gallery

Boudin is best known for small beach scenes painted on the Normandy coast, but he made several still lifes in the 1860s. The projecting knife-handle is a device familiar from Dutch still-life paintings of the seventeenth century.

developments in painting and criticism in the twentieth century that the virtual picture plane has been explicitly considered in its relationship to the painting's literal marked surface. I shall return to the early twentieth century in due course but for now I shall resume discussion of the workings of the picture plane in more traditional painting.

One of the first decisions the artist will make is how close to the plane the subject is to be set. In the case of a portrait or other single-figure composition, to locate the figure well back in the picture space would be to imply a matching distance on this side of the plane and perhaps to create a sense of strangeness or formality between subject and spectator (pl. 60). To bring the figure close, in contrast, would be to presume a spectator near at hand and to establish a potential sense of relationship or even of intimacy (pl. 62). The object seen nearest to the plane as the eye travels into the picture is normally an important element in engaging the spectator with its content. In still-life painting, the inviting knife handle that projects forward towards the picture plane is there to stimulate our imagination, even to trigger our psycho-motor reflexes, as though we might grasp it and set about the pictured meat or fruits (pl. 62).

A further consideration to be decided by the artist is where the horizon of the picture is to be set, since this will decide the spectator's angle of vision into the picture space. Even where they are not particularly evident, both the height at which the horizon is set and the position of the vanishing point are key elements in the organisation of pictorial compositions.

They are among the variables by means of which painters are able to control the spectator's relationship to the scene represented, affecting not only what is seen but also how it feels to be seeing it. While relatively central vanishing points may constitute a kind of norm in painting, moving the vanishing point to left or right, or indeed outside the painting altogether, will have a range of effects on the spectator's response to the resulting picture. *Interior*, by the French painter Edgar Degas, has a vanishing point at the left, where a plainly miserable woman sits bent over in a pool of light (pl. 63). The significance of her pose is brought home by the shadowed male figure who appears tall and unyielding at the extreme right of the picture. It is as though Degas had wanted to suppress the spectator's awareness of his presence until the woman's isolation had been clearly registered.

In the case of Piero's *Flagellation* (see pl. 50) the vanishing point was set centrally on a horizon line that was itself notionally established just below the middle of the picture. The effect was to imply a central viewing position and a gaze that penetrates deep into the picture space. In general we tend to find low horizons used in open landscapes over extensive ground, in seascapes and in any composition where the artist wants the spectator's attention to be directed deep into the space of the picture. A higher horizon usually implies a closer focus and thus makes the spectator feel more directly involved in the content of the picture, as in van Gogh's painting *The Night Café* (pl. 64) where the effect of the high

63 Edgar Degas, *Interior*, *c.*1868–9, oil on canvas, 81.3 × 114.3 cm, Philadelphia Art Museum

Although this picture was for a long time known as *The Rape*, the title was not provided by Degas, who is reported as having said he wanted to make 'a family portrait'. What he clearly meant by this, however, is that he intended to picture the misery and oppression that married life involved for many women at the time, a theme common to the novels of Degas's contemporary Emile Zola. (For Degas see also pls 122 and 204.)

64 Vincent van Gogh, *The Night Café*, Arles, 1888, oil on canvas, 70 × 89 cm, Yale University Art Gallery, New Haven, Conn.

Van Gogh rented a room over the all-night café and stayed up for three nights to paint this picture. His aim was to use colour to convey the atmosphere of a place he called a 'devil's furnace', the last resort for night prowlers and drunks. In a letter to his brother, he wrote 'With red and green I have tried to represent the terrible passions of humanity.' Paul Gauguin came to stay with him soon after and painted his own more congenial version of the same scene (now in the Pushkin Museum of Fine Arts, Moscow).

horizon level and the consequently steep floor plane is to make the spectator feel a part of its enclosed world. (An extreme contrast is provided by an engraving from a famous treatise on perspective published early in the seventeenth century (pl. 65). It shows what happens when the horizon line and the vanishing point are set, unusually, at the very bottom of the picture. The spectator in this case becomes someone looking straight down into the well of a tower.)

65 Hans Vredeman de Vries, engraving from *Perspective*, Leiden, 1604, pl. 39, 17 × 25.5 cm, British Library, London

66 Rembrandt van Rijn, *Self-portrait with Two Circles*, c.1665–9, oil on canvas, 114.3 × 94 cm, English Heritage, Iveagh Bequest, Kenwood House, London

Rembrandt's self-portraits include some forty paintings and thirty-one etchings (see pl. 114), spanning a period from his youth in the 1620s to his death in 1669. This is one of the finest of the pictures from his maturity. The roughly sketched semi-circles in the background may refer to maps in the shape of globes, often used as wall decorations in Dutch houses at the time. (For Rembrandt see also pl. 1.)

For the artist facing the canvas, these various factors – the placing of the main subject relative to the picture plane, the distance from that plane to a nearest feature and the positioning of vanishing point and horizon – are all means to control what the spectator sees and how that spectator sees it. I have said that the artist is always the first spectator of a painting's effects. That statement needs to be qualified. What the artist may also do is stand in for an imagined spectator of the scene represented, in order to see what it is like to look through his or her eyes. Sometimes the eyes are simply the artist's own. In self-portraiture the picture plane will often coincide with the position at which there was a mirror in which the artist

scrutinised his or her own reflected image. Yet even in such cases there may be an element of deliberate estrangement or role-playing. Among the most remarkable paintings ever made are certain late self-portraits by Rembrandt, in which the artist seems to construct his own appearance as though seen through another's eyes. This effect depends on the elimination of any sense of the mirror that must actually have been used to produce the likeness (pl. 66). Just occasionally the artist may imagine a specific kind of spectator, whose point of view will decisively affect how the picture appears. Some of the most distinctive pictures in the history of art depend on what are in effect supreme acts of impersonation on the part of their painters. This may initially seem a strange idea. I shall try to explain it in the next section.

Before we leave the picture plane there is one reservation to be entered. In order to explain the relationship between picture plane and literal surface I have called up an image of the artist working at the canvas or board and marking it with paint so as to produce a kind of imagined content. It is an important component of that image that the marked surface is physically bounded and contained, so that the actual surface and the virtual plane can be viewed as one by a stationary viewer. However, the concept of the picture plane tends to break down where the surface extends beyond the margins of the picture, as it might in a small drawing on a large sheet of paper, or where it is impossible to see the whole image at once from a stationary position, as in those types of Chinese landscape painting that are painted on scrolls, to be gradually unrolled before the viewer (pl. 67).

Unlike the Chinese, painters in the western tradition since the Italian Renaissance have been particularly concerned with the representation of figures and objects as situated within specific spaces. It is partly for this reason that the idea of the picture plane has been so central to that tradition. As I have suggested, it is the use of the picture plane that largely controls the spectator's sense of palpable relationship to those figures and objects. By the same token it often plays an indispensable part in establishing psychological and emotional content. Yet, as the counter-example

67 Gao Ko Ming, *Streams and Hills under Fresh Snow*, detail of handscroll, 1035 CE, ink and colour on silk, 41.2 × 241.2 cm, Metropolitan Museum of Art, New York, John M. Crawford Jnr Collection

Apart from small album leaves, Chinese paintings on paper or on silk were generally kept rolled up. An upright composition could be hung up in order to be viewed in its entirety but a horizontal composition such as this would be carefully unrolled piece by piece, so that the viewer could follow a continuous sequence from right to left, as though moving through the landscape.

of Chinese painting serves to demonstrate, it does not follow that the picture plane is a necessary element in all painting and picture making or that it is the only device by means of which paintings can be made to engage their viewers in psychological and emotional terms.

<div style="text-align:center">

2.5 THE IMAGINED SPECTATOR

</div>

If you were looking at a painting in a gallery and I asked you, 'Who is seeing this?' you might – with some justifiable irritation perhaps – reply, 'I am'. That would of course be true, but say the painting you were looking at was the one reproduced here (pl. 68) and I asked you instead, 'Who is seeing what this painting shows?' You might then be given pause for thought. This second question invites you to identify not just a viewpoint but an actual spectator or type of spectator that the painting presumes or requires. This is an imagined spectator, one who plays a kind of part in the content of the picture, someone who is not represented in it but whose point of view is represented *by* it. The presence of such an imagined spectator may often be suggested, as in Carl Blechen's painting, when a pictured figure gazes out through the picture plane in a manner clearly designed to suggest an answering regard – in this case presumably a disturbing intruder on the bathers' privacy. In such cases we may find ourselves slipping involuntarily into the suggested role and, as it were, entering into the content of the picture. In order to do this, we may have to imagine ourselves as another.

A similar effect is at work when an author adopts a narrative viewpoint or persona in the writing of a novel or short story. This is an imagined identity, often distinct from the author's own, even when he or she appears to speak and write in the first person. In such works of fiction, the narrator is a kind of avatar, established by the author to aid, direct and control the work of invention. To read the resulting story is to see through that character's eyes, to be privy to her thoughts and emotions. What she witnesses or experiences or knows about will decide the content of the story. Events outside her consciousness may be imagined by the reader, but they have no place in the novel or short story itself and are irrelevant to the assessment of its meaning. The imagined narrator can thus be employed by the writer to set a kind of limit to the content of the work and to guarantee the integrity and self-sufficiency of its structure.

The imagined spectator can be thought of as providing the painter's equivalent of the narrative viewpoint and voice. As the painting's first spectator, the artist may assume a specific identity and point of view, both to direct the work of invention and to test the resulting effects. The artist

68 Carl Blechen, *Girls bathing in the Park at Terni*, c.1836, oil on canvas, 105 × 78.5 cm, collection Georg Scholer, Switzerland

The German artist Blechen was much affected by the work of Friedrich (see pls 33 and 60). His success with this composition is confirmed by the existence of four large and five small versions.

who is to represent a woman posed before him will consider not simply how to achieve a likeness but also how the woman is to be seen, whether as an artist's model, as a friend, as a lover or as a wife. Let us imagine a circumstance that was relatively common in Europe from the fifteenth to the nineteenth centuries: a picture to be painted by a male painter who is required to represent a woman as his patron's betrothed (pl. 69). How is he to achieve this? What he may do is imagine the husband-to-be as the one who is looking, the equivalent of the writer's imagined narrator. That is to say, he will look as though through the other man's eyes, so as to try to see the woman as that man sees her – or rather, perhaps, as the man

would like to imagine that she looks when she is looking at him. In build-
ing the resulting image on the other side of the picture plane, the artist
must be careful to give the prospective wife the look that invites the
answering regard of the prospective husband.

I suggested earlier that certain exceptional portrait painters manage to
endow their subjects with the appearance of life and consciousness. It may
now be easier to understand some of the reasons why and means by which
this is done. It depends largely, of course, on the technical ability that
allows these artists to provide compelling likenesses. None the less,
wedded to that is the ability to convey the sense that the pictured person
is being seen, and seen by someone (our imagined spectator) who is
responding not to an image but to another living being. As I suggested, it
was a part of the strange accomplishment of Rembrandt's self-portrait that
he pictured himself as though he were being seen by another – the imag-
ined spectator whose position we are then able to occupy.

Just as the narrator serves to define and to delimit the substance of the
novelist's story, so the imaginary spectator proposes the content of the

picture. What I mean by this is that everything the picture shows is identified with what that spectator is seeing; not only with what the spectator sees but also with how he or she sees it. A notorious example of a picture with an imagined spectator was painted by the French artist Edouard Manet. His *Olympia* was first shown in Paris in 1865, to largely outraged responses from contemporary commentators (pl. 70). It shows the nude figure of a woman (a *demi-mondaine* or woman of doubtful reputation) lying on a bed, in a pose associated with classical representations of Venus, the goddess of love. What made the painting particularly provocative was the unabashed outward stare of the woman, inviting as it did an answering regard from this side of the picture plane. In this case to assume the imagined spectator's role was to find oneself cast as the other party in an alienated exchange of money for sex. I say 'oneself' but of course it is on the whole easier for men to imagine themselves into that role than it is for women. We are reminded that the great majority of paintings in the history of art have been made by male artists and that they have tended to presume a largely male audience. However, the point about the imagined spectator

is that it is a role that the painting itself defines, irrespective of who is looking at it. All the information required for anyone to play the part is provided by what lies behind the picture plane.

There is an important point to be grasped here. It concerns the relationship between 'aesthetic' and 'historical' approaches to paintings. The imagined spectator exists as a creation of the mind of the painter and of the time of the work's production. To put on this imaginary identity – the spectator conceived by the artist in composing the picture – is to enter the time frame of the painting itself and to experience its content as though one were a part of its world. By this means we get a long way to acquiring the 'period eye' mentioned in section 2.1. Painting's potential in this respect is similar to that of the novel. In both cases we are provided with the means to 'take on' a different perspective and to enter a particular world of manners and values, but without actually surrendering our position in the present. My suggestion, then, is that almost all paintings have the capacity to make the past vivid to us in ways that learning about their context may well confirm, inform and even enable, but can never supplant.

That we do not actually surrender our position in the present is a point that needs stressing. I do not mean to suggest that the physical character of the picture disappears when we engage with it in imagination, any more than the novel we become absorbed by loses its dependence on the words on the page. In so far as the enjoyment of art can be distinguished from the enjoyment of fantasy, it is probably the abiding awareness of artifice that marks the difference. *Olympia*'s invocation of her client is not by any means the end of the story. Manet may well have looked through those imagined eyes in order to 'see' the woman and in the process set up a kind of game that the contemporary visitors in the French Salon did not actually want to play in public. Yet as a painter he was also as it were looking over the shoulder of the imagined spectator at the woman on the bed and endowing her with a kind of self-consciousness to which we might think the client would have been blind. Noticing how that expression is made out of paint is part of our experience of the work and it takes place in the here and now. To continue the analogy with the novelist's use of a narrator, while we may need to 'listen' to the narrator to hear the story, we do not entirely lose our sense that he or she is a part of the author's construct.

With this reservation in mind, though, I want to suggest that the idea of the imagined spectator is one that can usefully be applied when viewing virtually any work of art. I do not in this case mean that all artists employ an imagined spectator as a kind of compositional necessity, but that the great majority of artists in the entire history of art have needed to bear in mind the interests of their employers or patrons or of a generalised public.

Clearly, imagining how those interests are to be satisfied – or sometimes deliberately countered – will play a part in measuring the progress of their own work. (The solitary artist working for himself – it has always been he – was almost unheard of until the Romantic movement in the second half of the eighteenth century and all that changed then was that the patron was supposed to pay up without having exercised control over the work.) While paintings with a clearly identifiable role for the imaginary spectator may actually form a small minority, to ask 'Who was imagined in the making of this work?' is almost always to pursue a useful and relevant line of inquiry. It may not always be possible to deduce answers from the work of art itself, but keeping the question in mind ensures that when one does go looking for background information, the practical character of that work stays firmly in view.

A further reason for keeping the idea of the imagined spectator in mind is that it serves as a check on the tendency to subjectivise our responses to art. While I have said that artists depend on our willingness and ability to bring relevant knowledge and experience to bear on works of art, the key word here is relevant. This will almost always involve somewhat more than Clive Bell's 'sense of colour and form and . . . knowledge of three-dimensional space'. Yet our starting point is always the area of human culture that we share with the maker of the work, however broad or narrow that may be. We share a surprising amount – not least our human nature – with those who painted animals on the walls of caves 30,000 years ago. It may sometimes seem harder to see what we share with a contemporary artist whose work is addressed to a specialised art world and who thus in some respects occupies a narrower cultural band. In neither case, however, will we require knowledge and experience that are so strictly personal as to be categorically different from that of anyone else who shares the culture in question. There is usually plenty there, as it were, to keep us busy as spectators of the work – if only we can learn how to get it all properly focused (which is a great part of what is involved in learning about art).

The difficult part may be to prevent personal preferences and prejudices from getting in the way. That I might have had a bad experience of being thrown from a horse is a matter of complete indifference to George Stubbs's *Whistlejacket* (pl. 71). It would be the same if I had recently won a fortune by betting on a chestnut gelding. To step outside the world of my personal experience is to enter another, in which the artist's groundbreaking scientific interest in his subject comes together with an eighteenth-century patron's pride in the racehorse he owned to produce an extraordinary portrait of an exceptional animal. To sense the convergence of those interests in the production of the painting is to get some

feel for the historical moment: on the one hand for the rise of natural-scientific inquiry, on the other for the vital role that horses played in the culture as a whole before the coming of the railways.

There are many works of art that provide useful historical information by virtue of the events and scenes and people that they illustrate. Paintings can preserve for us the former layouts of cities and landscapes, the appearance of long-dead kings and queens and philosophers and poets, the configurations of famous battles and the scenes of terrible disasters. What they can also do is establish for us in imagination the character of certain real circumstances, and the states of mind and conditions of awareness of fellow humans in other ages and in other cultures. The more absorbing the art remains in its power to do this, the greater its potential to bring history alive.

2.6 GENRES

Among the paintings so far discussed there are some I have described respectively as portraits, landscapes and still lifes. Subject matter is only one of the grounds on which paintings can be put into categories but it has distinct advantages. Knowing what kind of painting we are looking at can help adjust our expectations and give us some sense of what to look for. Each of the different kinds tends to be associated with certain conventions and expectations, providing a useful 'comparison class' within which significant departures from those conventions can be registered as challenges to normal expectations. Where we can stick within a certain range of subject matter there are also interesting comparisons to be made between examples from different artists, from different periods and even from different cultures.

This is an appropriate moment to recall a point I made in the previous section, that while not all painters will have been accompanied by an imagined spectator, virtually all works of art are made with some kind of audience or recipient in mind. The use of the term 'genre' is a reminder that works with different subject matters have historically been associated with different kinds of function and audience. Genre is a term of French origin meaning kind or type. Its use reflects the fact that it was within the French Academy in the late seventeenth century that the different categories of subject matter in painting were first explicitly organised into a hierarchy. The Academy had been founded under royal patronage in 1648, following an earlier precedent in Rome. It provided a highly influential model for academies in other countries during the eighteenth century. The

71 George Stubbs, *Whistlejacket*, 1762, oil on canvas, 292 × 246.4 cm, National Gallery, London

Whistlejacket was painted during the ten-year period while Stubbs was working on *The Anatomy of the Horse*. Finally issued in 1766, this remarkable publication was made from the artist's own dissections, drawings and engravings. In his own words it was 'as much as I thought necessary for the study of Painting.' This picture was commissioned by the Marquess of Rockingham, the owner of the horse. The pose supports the tradition that Rockingham originally intended the work to be developed as an equestrian portrait of George III, complete with landscape background, but that he changed his mind for political or aesthetic reasons or for a mixture of both.

72 Nicolas de Largillière (formerly attributed to), *Louis XIV and his heirs*, 1710–15, oil on canvas, 127 × 160 cm, Wallace Collection, London

There is some doubt over the traditional attribution of this painting to one of the most successful French portrait painters of the Sun King's reign. De Largillière maintained a large studio and had several pupils, one of whom may have been responsible for this work.

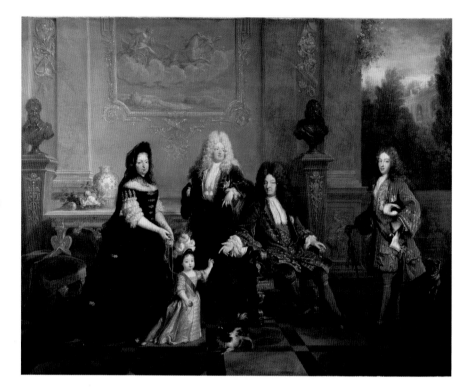

codification of the genres was part of an enterprise, typical of the tendencies of academies in general, to advance the professional status of painting and to establish it on a firm theoretical basis. In effect, those responsible were giving formal recognition to the different functions that the art of painting had by that time come to fulfil in the principal urban centres of Europe and to the different kinds of specialisation that artists had developed in response. In according relative status to the individual genres, the academy was also reflecting the existing stratifications of the social world at a time when the main sources of patronage were the state, the church, the aristocracy and an increasingly independent mercantile class or bourgeoisie. The distribution of power and wealth between these bodies varied among the major European countries, with the character of the majority Christian religion – whether Catholic or Protestant – being an important factor.

The kinds of painting normally sanctioned by the Catholic church and state were those that had clear religious, commemorative or propagandising functions. Initially the term genre referred to the various specialised categories of picture that were distinct from these: still lifes, landscapes, animal paintings and pictures of 'low life' – low, that is to say, in the view of those in the seventeenth and eighteenth centuries who regarded them-

73 Jan Vermeer, *Girl with a Pearl Earring*, c.1665, oil on canvas, 44.5 × 39 cm, Mauritshuis, The Hague

The sitter for this famous painting has never been identified. In fact it was probably not painted as a portrait in the strict sense but rather as a *tronie*, a character study of a head or head and shoulders, usually, as here, in exotic dress. Paintings of this type were easier to sell on an open market than identifiable portraits and were popular among painters in seventeenth-century Holland, Rembrandt included.

selves as proper guardians of a 'high' artistic culture. The status accorded portrait painting tended to vary according to the standing of the subject. A formal record of the monarch with his heirs (pl. 72) was clearly a work of a different order from a head-and-shoulders of an anonymous young woman (pl. 73). For the most part the genres tended to flourish under Protestant regimes, where the grip of the classical tradition was far weaker and where patronage was more widely distributed across society, with an emerging bourgeoisie taking an active part. Elsewhere they were generally accorded a relatively low status. There were certain notable exceptions among painters working in Catholic countries, however. In Italy around 1600 Michelangelo Caravaggio radically narrowed the gap between religious art and low-life subjects by reinterpreting biblical episodes as unglamorised scenes from contemporary life (pl. 74). In Catholic Spain the young Diego Velázquez painted some remarkable pictures of 'low' kitchen and tavern scenes, endowing them with the kind of gravity normally reserved for historical or religious subjects (pl. 75).

While both still-life subjects and landscapes had featured among the decorative wall paintings in Roman villas, and while still-life elements and landscape backgrounds had appeared in paintings of various kinds since the Middle Ages, neither of these genres had emerged as a distinct spe-

74 Michelangelo Merisi da Caravaggio, *The Supper at Emmaus*, 1601, oil and egg tempera on canvas, 141 × 196.2 cm, National Gallery, London

The subject is taken from the New Testament Gospel of St Luke, chapter 24 verses 30–31. The resurrected Christ joins two of his disciples on the road to Emmaus, but only when he blesses the bread at supper do they recognise him. It is this moment of recognition that the painting pictures. Caravaggio uses various devices to engage the viewer, among them the barely arrested movement of the disciple at the left, the basket of fruit almost overhanging the table in the centre and the outstretched hand of the disciple at the right, which extends to the nearest point of the picture space. The artist painted a second version of the picture five years later (now in the Pinacoteca di Brera, Milan).

cialisation until about the beginning of the seventeenth century. Still life in particular was seen as subject matter fit only for domestic consumption. In the traditional language of the art school and the studio, a painting 'from life' is one that depends on the study of an object that the artist has available to view, such as a model posed for the purpose. In contrast, a still subject is one that can be counted on not to move (indeed the French term for still life is *nature morte*, literally 'dead nature'). A typical still life is a picture showing a range of domestic objects and materials that we assume to have been real and present to the painter. The major development in the genre took place during the course of the seventeenth century largely in the Dutch republic, where ready buyers for modestly sized, well-made paintings were to be found among prosperous mercantile communities. In the surviving inventories of wealthy Dutch families from the period it is not unusual to find references to collections of more than a hundred pictures. A further significant group of still-life painters developed in the early part of the seventeenth century within the small Protestant community in Paris, composed of French Huguenots and expatriates from the Low Countries and elsewhere. I shall return to discussion of still life in the following section.

Landscape also developed into a considerable genre during the seventeenth century but its status was variable. A kind of true-to-life rural landscape was developed by the Dutch painters. This attracted a similar kind

75 Diego Velázquez, *Two Young Men eating at a Humble Table*, c.1617–19, oil on canvas, 70 × 112.2 cm, Apsley House, London

This work was probably painted when Velázquez was no older than 20, a few years before he entered the service of Philip IV of Spain. It belongs to the Spanish category of *bodegon*, a name referring to a low public eating place. The term was used to designate still-life paintings showing food and drink, genre pictures containing the kinds of people who might be customers and kitchen scenes in general.

of market to still-life painting and was in general held in low esteem by the French Academy. However great might be the technical skills demonstrated by a painter such as Jacob van Ruisdael, from the point of view of the Academy the scenes he depicted were devoid of intellectual significance (pl. 76). The very life-likeness of such pictures – the vivid evocation of light and atmosphere, the concentration on ordinary occupations and the careful balancing of realistic detail with an impression of distance and extent – was associated with lack of inventive ambition.

There was, however, another kind of landscape painting that the professionals and theorists of the Academy wholeheartedly approved, that they regarded, in fact, as a measure of what painting should aspire to. This was classical landscape as practised by the French painters Nicolas Poussin and Claude Lorrain among others (pl. 77). Poussin's work was held in particularly high esteem. There are various ways in which his painting can be distinguished from that of Ruisdael. In so far as Poussin based his scenes on particular observed landscapes, he found these not in northern Europe but in the countryside around Rome, where he lived and worked for the greater part of his life. Yet his completed paintings make no pretence to be pictures of actual landscape scenery. Rather they are self-consciously organised according to principles of order and harmony similar to those that might have been applied to a musical composition at the time. In correspondence, Poussin himself used the primarily musical concept of 'mode' to refer to the different ways in which a picture might be organised so as to produce appropriate emotional effects on the viewer.

76 Jacob van Ruisdael, *River Landscape*, 1649, oil on canvas, 134 × 193 cm, University of Edinburgh, on loan to National Gallery of Scotland, Edinburgh

Ruisdael was particularly adept at using effects of light and weather to instil his landscapes with mood and emotion. It was common practice in Dutch painting at the time for the figures in landscapes and architectural pictures to be executed by other artists who specialised in that department (see also pl. 18). The figures in this case have been attributed to Nicholas Berchem or Philips Wouwerman.

77 Nicolas Poussin, *Landscape with the Ashes of Phocion collected by his Widow*, 1648, oil on canvas, 116.5 × 178.5 cm, Walker Art Gallery, Liverpool

The theme is taken from the *Life of Phocion* by the Latin author Plutarch. Phocion, an Athenian general, was condemned to death by his enemies and forced to commit suicide. Refused burial within the city walls, his body was cremated on the outskirts of the town of Megara. In the foreground of the picture Phocion's widow and a maidservant are shown gathering up his ashes to take them back to Athens, where he was in the end given an honourable burial. (For Poussin see also pls 40 and 78.)

In fact, Ruisdael's scenes were also composed, with varying degrees of reference to specific places, but what he offered his spectators was a sense of the world in the present. This meant that from an academic viewpoint his pictures were regarded as mere copies of nature. The time Poussin's paintings represent, in contrast, is always an imagined past, a past which is evoked as much by the unreal formality of his compositions as by the

classical buildings that are depicted in many of them. They are thus land-scapes only in a limited sense. First and foremost they are settings for episodes from classical history and mythology or from the Bible, acted out by human figures whose presence is always crucial, however few they may be and however small a proportion of the represented space they may actually occupy. For the aspiring professionals of the French Academy, Poussin provided an important example of the 'learned painter', one whose practice could be seen as distinct from that of the guild members responsible for work in the more lowly genres.

By virtue of their literary and mythological content, Poussin's classical landscapes were thus raised above the genres to the status of 'history painting', a category normally applied to types of picture, including many of Poussin's own, in which human figures were given a more prominent role (pl. 78). History painting was widely regarded as the highest of the professional categories. It referred to those types of painting that were intended for a public function, as altarpieces or mural decorations for churches, as records of state occasions or as contributions to the require-

78 Nicolas Poussin, *The Testament of Eudamidas*, c.1645–50, oil on canvas, 110.5 × 138.5 cm, Statens Museum for Kunst, Copenhagen

Poussin took his subject from the Latin author Lucian. Its theme is the importance of friendship relative to wealth. Lying on his deathbed, the impoverished Eudamidas dictates a will making his two closest friends responsible for the care of his mother and daughter. Despite public ridicule, the survivor of the two friends honours the obligation in full. The painting shows the dying Eudamidas accompanied by a doctor and a notary, with his grieving mother and daughter at the foot of the bed. With its frieze-like design and muted colouring, this is one of Poussin's most impressively austere paintings. (For Poussin see also pls 40 and 77.)

79 Jacques-Louis David, *J. Brutus first consul, on his return home after condemning his two sons who had joined the Tarquins and conspired against Roman liberty: Lictors bring in their bodies for burial*, 1789, oil on canvas, 325 × 423 cm, Musée du Louvre, Paris

David's emergence as a painter of highly evocative history pictures followed an academic training at the Ecole des Beaux-Arts in Paris. This work was shown in the French Salon in 1789, the year of the French Revolution. Its theme is a commitment to the principle of political freedom that supervenes even family ties – a theme complicated by the evident tragedy to which this commitment leads. This is not Marcus Brutus, the assassin of Julius Caesar, but Lucius Junius Brutus, credited by the Roman historian Livy with a decisive role in ending the rule of the Tarquins and establishing the Republic. David broke with the normal techniques for directing attention in a painting by placing the figure of Brutus in shadow at the extreme edge of the picture, while setting the grieving chorus of wife and daughters in full light.

ments of moral and historical education as conceived by the representatives of the state. The term 'history' derives from the Italian *istoria*. At a time when the great majority of painting was still devoted to religious themes, the term was used to refer not to the representation of the past specifically but to the story-telling or moral content of painting in general. It was in its capacity for such content, and in the elevated style or 'grand manner' by which that content was depicted, that the importance of history painting was supposed to lie. By demonstrating an ability to treat of mythological and moral themes – those represented in classical or religious texts – the artist could claim status as a dealer in ideas, along with the poet, the dramatist and the philosopher. Furthermore, in so far as the ethical content of these ideas was made comprehensible and vivid to the painting's audience, the artist could be seen as contributing to the spiritual well-being of society.

There was a further reason for the supreme status accorded to history painting. In line with its potential public function and display, it was generally conceived on a larger scale than any of the genres. There was more space to fill and generally a wider and more highly populated range of motifs with which to fill it. The history painter thus needed to be equipped with a full range of painterly skills: in the construction of deep represented spaces and consistent perspectives; in the organisation of tone and colour across a potentially broad spectrum; in the convincing imagination and realisation of appropriate landscapes and architecture; in the selection and depiction of still-life elements; in the representation of figures in action; and in the suggestion of a variety of emotions through movement, gesture and facial expression. Until well into the nineteenth century, the aspiring student aiming to graduate from any one of the academy schools throughout Europe and North America faced a key test of professional competence: the ability to work up a convincing composition on a historical theme set by those established professionals who performed the role of teachers. For the ambitious French painter trained in the academic tradition, the production of a successful and topical history painting remained a measure of the highest achievement and the best means of attracting public attention in the official Salon (pl. 79).

Given the high status of history painting, the painting of low life appears as a kind of opposite – the other side, as it were, of a social coin. Confusingly, work of this order is often referred to simply as 'genre painting'. Its typical subject matter is the lives of those who are not counted among the makers of history or the fit subjects of literary mythology. When painting of this type offers moral content, it normally takes the form of a sermon against the kinds of behaviour it illustrates. Works in this category include pictures of the picturesque poor in Italian cities and in the surrounding countryside, Dutch and Flemish tavern scenes with peasants

carousing, fighting, gambling, flirting and occasionally urinating (pl. 80), kitchen scenes with servants demonstrating the consequences of distraction and, particularly in the French painting of the eighteenth century, many images suggestive of virtue and virginity lost or under threat (pl. 81). It is clear that those classes of people who were generally represented in such pictures were unlikely to be among their purchasers. The audience for such pictures is likely rather to have included travellers who enjoyed scenes of picturesque urchins among classical ruins, puritans who liked to remind themselves and others of the dangers of drink, and employers concerned both for the morals of their servants and for the evidence of their own respectability.

This is to imply a highly stratified society, which the pictured content of the art serves to reinforce. No doubt there were those who were attracted to such paintings for the distance they could imagine between the low lives depicted and their own, but we should not over-simplify.

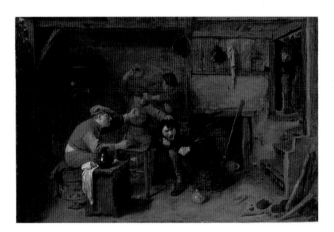

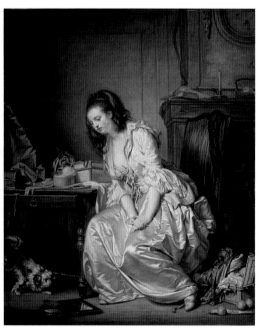

80 Adriaen Brouwer, *Fight over Cards*, c.1631–5, oil on panel, 33 × 49 cm, Bayerische Staatsgemäldesammlungen, Alte Pinakothek, Munich

The Flemish painter Brouwer specialised in small unsentimental scenes of peasant life, often set in taverns. Many of his paintings have an obvious moralising theme with regard to the effects of drinking, though they humanise their subjects by concentrating on the representation of extreme emotions that was unusual in the art of the time. He died in his early 30s, almost certainly in poverty.

Paintings in this category are rarely solemn. The very contrast with history painting's elevated themes endows the painting of low life with a certain subversive power. Many of the pictures of tavern life show scenes of evident celebration and fellowship. Some of the most attractive of these were painted by Jan Steen, who for some of his career was also a part-time tavern-keeper and who used himself and his family as models for scenes of debauchery and of respectable entertainment alike. Where the prosperous, the professional and the puritanical make their appearances, it is usually as the butt of a joke that the picture serves to play on them. The painting, in other words, is as likely to be on the side of those apparently being moralised about as it is of the moralists themselves. Pretentious doctors failing properly to diagnose the condition of lovelorn and sometimes pregnant young women were a favourite target, as were old men with young wives. In one picture in Apsley House in London, Steen manages to score off all three at once (pl. 82). While the doctor pronounces on the evidently lovesick young woman's supposed ailment, her husband is shown in the background, as we might imagine counting his money. It is to the imagined spectator that the 'truth' of this scenario is revealed and to us as we take on that spectator's position. This is the position of someone for whom incompetent doctors, miserly old husbands and unfaithful young wives are all regarded as fit subjects for scepticism and ridicule.

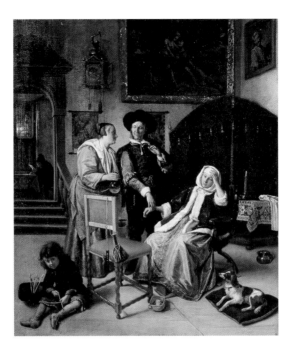

82 Jan Steen, *The Doctor's Visit*, 1658–62, oil on canvas, 49 × 42 cm, Apsley House, London

(For Steen see also pl. 84.)

It is significant also that the margins of the 'low life' category are fuzzy. Where the work of the seventeenth-century Dutch painters is concerned, though scenes below stairs are usually clearly distinguishable from those set in the floors above, servants and masters appear in paintings with similar kinds of pictorial set-up and architecture, while the eighteenth-century French painter Chardin used evidently bourgeois young ladies and young men as often as he did servants in paintings suggestive of the vulnerability of virtue (pl. 83). There are also works that make play with the supposed disparity between history painting and scenes of low life. In a marvellous painting in Pasadena, Steen takes the biblical theme of the Marriage at Cana – a thoroughly fit subject for a proper history painting – and renders it into a riotous party, with a plump figure in his own image taking a central role, upstaging Christ himself (pl. 84).

The potential for artistic ambition that each genre represents varies with time, with developments in artists' techniques and interests and with changes in the audience and the market for art. From late in the eighteenth century to the end of the nineteenth, landscape was associated with major technical and theoretical developments in painting, from the naturalistic scenes and quasi-scientific cloud studies of John Constable in England to the work of the Impressionists in France. This development led in turn to a revaluation of the Dutch landscapes of the seventeenth century. Constable was a great admirer of both Poussin and Ruisdael. After 1900, as

81 (*facing page, right*) Jean-Baptiste Greuze, *The Broken Mirror*, Salon of 1763, oil on canvas, 56 × 46 cm, Wallace Collection, London

Here the broken mirror is clearly a symbol of the loss of virginity. Greuze had achieved great success two years previously with his painting *The Marriage Contract*, in which he treated a genre subject as material for a substantial multi-figure composition.

83 Jean-Siméon Chardin, *The House of Cards*, 1737, oil on canvas, 60 × 72 cm, National Gallery, London

The precarious house of cards is employed to suggest the moral vulnerability of the young adolescent.

84 (*facing page*) Jan Steen, *The Marriage at Cana*, 1676, oil on canvas, 79.7 × 109.2 cm, Norton Simon Art Foundation, Pasadena

The subject is taken from the New Testament Gospel of St John, chapter 2, verses 1–11, recording Christ's first miracle, performed at a wedding feast in Cana. The wine having run out, he asked for six stone jars to be filled with water. When tasted, they were found to contain the finest wine. The jars are pictured at the front left, Christ with halo is shown standing against a pillar beyond, while the bride is seated at a table at the far right. Steen's own likeness appears in the portly figure in the foreground to the left of centre, portrayed, perhaps, as a self-satisfied master of ceremonies. This is one of six paintings he made of the subject. (For Steen see also pl. 82.)

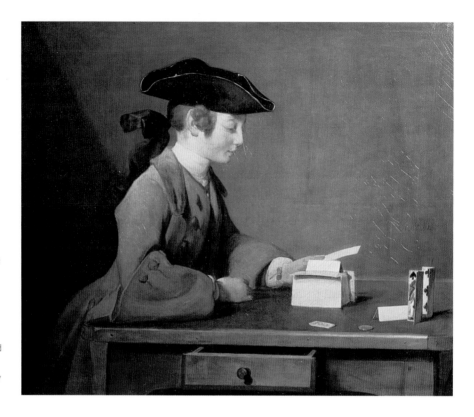

academic traditions rapidly lost ground to the advance of modernism, the idea of history painting ceased to be central to professional training except where it was imposed on political grounds, as it was in Eastern Europe under Soviet control. Its memory persists, however, as long as the combination of largeness of scale with breadth of content serves as a measure of ambition and public purpose – as it does even in the wall-sized abstract painting of the mid-twentieth century. (I shall return to this last point in section 2.12.) Throughout the period the genre of still life proves highly adaptable. Perhaps because its traditional subject matter predisposes towards formal and decorative rather than narrative treatments, it provides an appropriate basis both for some of the most complex Cubist work in the years immediately before the First World War (see pls 39 and 59) and for paintings by Henri Matisse and others in which juxtaposition of saturated colours is given priority over the effects of gradual modelling and tone (pl. 85).

While many paintings made between 1600 and 1950 will be found to fit comfortably into one or other of the genres discussed here, there will be some that appear to evade them all, others that combine aspects of two or more. There are nude studies that are neither low-life scenes nor por-

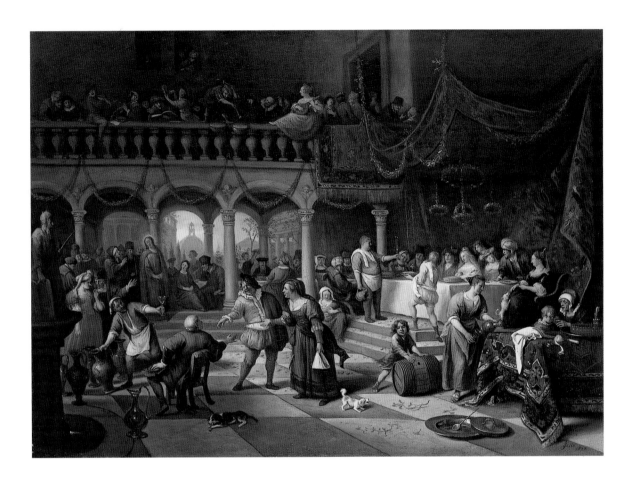

traits, kitchen scenes that are largely still lifes, portraits where the land-scape seems as prominent as the figures it contains and, particularly from early in the nineteenth century onwards, there are scenes of contemporary life accorded all the scale and breadth of content that were expected of history paintings. The hierarchy of the genres nevertheless serves as a useful reminder of certain practical considerations: the various kinds of function and audience that paintings were historically designed to satisfy; the traditional bases of the painter's training; and the different kinds of working limit that were available for artists to set themselves and to play with.

With abstract art there came a shift in the sense of what it is to be an artist. In the early twentieth century there was a tendency for artists and their supporters to ignore the practical considerations associated with the genres and to represent painting as a 'pure' pursuit, its outcomes fashioned by intuition and its development impelled not by any shifts in the com-position and interests of a market but by a kind of internal impulse or

85 Henri Matisse, *Tulips and Oysters on a Black Background*, 1943, oil on canvas, 61 × 73 cm, Oeffentliche Kunstsammlung Basel, Kunstmuseum

Despite the bright colours and apparently simple components of this picture, it is animated by a considerable tension and spatial ambiguity in its structure. The table-top set parallel to the picture plane implies a viewpoint looking down, while the vase of tulips and bottle are seen in profile, as though by a spectator looking straight into the picture space. If we take our directional cues from the vase and bottle, the black background will tend to read as a section of patterned wall behind the still life; but if we follow the viewpoint established by the table-top, it can also read as a tiled floor, dramaticaly changing our sense of how we relate to what's pictured. Although the contrast between background and white tulips gives the painting the widest of tonal ranges, Matisse has eschewed modelling in favour of effects of rich and saturated colour. The work was painted in Nice during the Second World War and was formerly owned by Picasso. (For Matisse see also pls 61 and 100.)

necessity. Rather than accept outright this modernistic view of the development of art, however, it may be more helpful to take the opposite position and ask what kind of genre is abstract painting; how is it learned and who is it for? I shall return to these questions in section 2.12.

2.7 TWO STILL LIFES, PART I: DESCRIPTION

To get the most from a work of art we should be in a position to provide a relevant and adequate description of it. By relevant I mean checkable so far as possible against the observable character of the thing and against the experience it offers as a work of art. Adequacy is harder to define. It might help to set yourself the imaginary task of describing the work to someone who has not seen it. What would you have to mention and in what order and what might you leave out? While a painting may set the imagination going by virtue of some narrative potential in its subject matter, working for a description means holding back the weaving out of a story until you are sure you have the visible components that matter identified and in place. Suppose you were describing Chardin's *House of Cards* (see pl. 83). It might be tempting to concentrate on what is happening in the painting, perhaps on the imminent collapse of the card house, so as to bring out a kind of 'human' content. Yet what about the open drawer right at the front of the picture space and the plain background, which occupies a large proportion of the picture surface? How much attention would you give to the colour scheme or to the brushwork? Thinking

about what contributes to the effect of the work can be a good way of getting to know it better.

Faced with a single work of art it can sometimes be difficult to tune in to its specific character and to find ways adequately to describe it to oneself. It is often helpful to start with a comparison of two works that have some elements in common, so that by noticing the differences between them one can learn more about the individual aspects of each. The compare-and-contrast exercise is a basic tool in the study of art history. It can be tedious when restricted to the analysis of style but it has its uses. In this section I shall compare two examples from the genre of still life, so as to further my discussion of the relative advantages of different approaches.

The two paintings were both made in France. The first was painted by a twenty-four-year old woman in 1634 (pl. 86). Louise Moillon was a member of the community of Huguenots living and working in the Saint-Germain-des-Prés district of Paris in the early seventeenth century. The great majority of paintings ascribed to her are still lifes and were made when she was in her twenties. After that she made what would have been considered a good marriage and with a few exceptions datable to her thirties seems virtually to have given up painting, though she lived to be eighty-six. A more or less prosperous married woman would certainly not have been expected to pursue a career as a painter. For this and other reasons it was difficult and unusual for a woman to achieve the status of a professional artist in the seventeenth century, as it remained until the 1970s, when male-dominated workshop practices were largely replaced by other means of making art. As a surviving work by a woman artist, Moillon's picture would be exceptional even if it did not have much else to commend it. The second painting was made by Gustave Courbet in 1871 or early 1872 when he was some fifty-two years old (pl. 87). More than any other single artist during the nineteenth century, Courbet was responsible for promoting the idea of a Realist art, free from the idealism and pomposity of academic history painting and dedicated to recording what he called 'the manners, ideas and aspect of the age'.

I start with the common features. Both paintings show displays of fruit in a ceramic container on a table-top or shelf. In both cases some of the fruit has been placed directly on the flat surface as though there was too much of it for the respective containers and in both cases the background is dark and indefinite. These are all statements about what is pictured. There are also similarities in how these elements are made to work in the two paintings. In each case the subject is seen at an angle that suggests a viewpoint slightly above and close to, so that we have a downward–slanting angle of vision. The fruit is also pictured close to the picture plane

86 Louise Moillon, *Still Life with a Bowl of Curaçao Oranges*, 1634, oil on panel, 46 × 64 cm, Norton Simon Art Foundation, Pasadena

or 'front' of both compositions, as if within reach, while much is made of its colour and texture. In both paintings there is an external light source directed at the fruit from the left foreground, conforming to a seemingly natural tendency to read 'into' compositions from left to right, while the dark background serves to set the various objects into relief. There is a relatively wide tonal range in both pictures, though it is considerably wider in the Moillon than the Courbet, the effect of the external light source being more muted in the latter. To consider in this way how the picturing is done is to focus on the paintings' effects – the ways in which we as spectators are drawn to respond to the subject. The imaginative activity that our response triggers is not free-ranging. Each composition has been organised so that specific feelings – of nearness, of concentration and of stimulation of the sense of touch – are the effects that were intended and that will be produced in the viewer.

To note these aspects that the paintings have in common is to get a sense of the tradition the artists shared and of those conventions that remained

relatively stable in still-life painting over the course of some two and a half centuries. We are now in a better position to attach meaning to the differences. Moillon's painting shows a collection of exotic fruits in a porcelain bowl – oranges from the island of Curaçao in the Dutch West Indies with branches of deep green leaves still attached, together with a single lemon. The bowl itself is of some significance. Fine porcelain like this was not made in Europe until early in the next century. The bowl is an expensive import from China, datable to a period shortly before the completion of the painting. Chinese porcelain of this period (the reign of Wan Li) was often featured in still-life paintings by French and Dutch artists. This particular bowl appears in other still lifes by Moillon. If she owned it herself it would have been a treasured item. It is more likely, perhaps, that she borrowed it from one of the dealers in antiques and other exotic items who formed part of the community she inhabited around Saint-Germain-des-Prés, alongside the painters, copyists and forgers who also made their living there.

87 Gustave Courbet,
Still Life with Apples and Pomegranate, 1871,
oil on canvas, 44.5 × 61 cm,
National Gallery, London

Courbet's painting, in contrast, shows a shallow dish piled with apples and a single pomegranate at the left front of the pile. The dish is a piece of rustic pottery, its glaze chipped with use, and, though the apples are glowing with colour, they are also scabby and bruised – windfalls, perhaps, or fruit that is at best no better than the common fare of the time. Where Moillon restricts herself to one principal type of motif, Courbet includes a pewter jug and a glass with some liquid (probably wine) further back at the left. That the jug is of dull pewter rather than shiny silver is consistent with the subdued aspect of the work as a whole. Moillon sets her nearest objects close to the picture plane, the spectator's regard drawn in by the detail of the single pip, the exposed flesh of the bisected fruit and the leaf arranged so as to curl over the edge of the shelf. It is noticeable that she shows us the front edge of that shelf, and inscribes her name and the date of the painting along it at the right so as to include them in the represented content of the composition. In Courbet's painting, however, though the nearest fruit is set slightly further back, the table surface continues forward right up to the picture plane, so that we can imagine it extending into our own space. Yet his signature stands proud of that surface and conspicuously partakes of the painting's colour scheme, as though marking the convergence of the picture plane with the literal marked surface of the canvas.

Differences in the way the picturing is done take us into matters of style and technique. The fineness of Moillon's fruit and bowl is in part conveyed by a refined manner of painting. Everything is evenly and carefully delineated, with attention to detail and to the subtle gradations of surface and texture. The gradual transition from light to shade on the oranges is crucial to the sense of their solidity as the picture conveys it. Although various textures are represented in the painting, its actual surface retains a glassy smoothness overall. By contrast, Courbet's picture has a rougher and more variegated surface, although the painter uses a much narrower range of colours than Moillon. The brushwork on the apples, in particular, looks casual and sketchy.

Certain differences in effect follow from these differences in the ways in which the picturing has been done. So, while Moillon's finer technique creates the effect of a sharp light on the fruit and of an even focus on the part of the spectator, the effect of Courbet's glowing colours and more blurred manner is to make it seem as though the apples themselves were radiating warmth and subdued light. Combined with the differences already noted in angle of vision and in the relationship between shelf or table-top and picture plane, these factors lead to differences in the emotional or expressive qualities that we find in the two paintings. Although I believe that these are the most important differences of all, they are also

the hardest to describe. They are difficult to put into words because the qualities in question are precisely those that painting as a form of art conveys in ways that can seem to escape language. Emotional quality is defined not simply in the relationship between the spectator and the objects pictured but also in the ways in which the paintings go beyond mere picturing to suggest and to define a position for the spectator. I say position because I want to refer to a sense of physical placing, as if it were the actual spectator that was the person within touching distance. More importantly, each painting also defines something like a disposition or inclination on the part of its imagined spectator. Perhaps the best way to capture this difference between the two paintings is to say that the person we imagine sitting before Moillon's shelf is a different kind of person from the one we imagine sitting at Courbet's table. It is of course the same actual spectator – you or I – who is considering both paintings. Yet when we experience Moillon's work it is as though we were one person, complete with one potential range of physical and social interests and attributes, whereas when we experience the Courbet it is as though we were another. This is to say that each painting solicits a different possibility regarding ourselves.

2.8 TWO STILL LIFES, PART 2: INTERPRETATION

So far I have discussed these paintings as though all we need to know can be seen in them and as though a full enough description of each will suffice to get at its meaning – in other words to serve as an interpretation. I want to emphasise that description is the best place to start in any process of interpretation and also that we should beware of any interpretation of a work of art that seems not to match what we can see directly when we look at it. Nevertheless, between description and interpretation there is no clear line of demarcation, no place at which we can say with confidence that we have moved from the one to the other. Interpretation is part of seeing from the start. We would normally 'see' a smiling face before we saw a sphere with a curved line on it. In any event, as I mentioned at the beginning of this book, works of art normally come accompanied by other types of information than those that are directly visible or that can be inferred from what we are able to see, particularly when they are displayed in museums. I have already furnished a considerable amount of such information in naming the artists who painted the two still lifes under discussion and in giving the dates at which they were made.

It would clearly be impossible to ignore this information, for instance when considering such matters as the kind of person each painting seems to presuppose as its spectator – particularly given the point I stressed earlier, that the artist is always the first spectator of the emerging work. Our knowledge that the artists were of different sexes and widely different ages is bound to have some influence over how we see the pictures and how we interpret them. Information of this kind may also lead us to notice or to look for other forms of difference than those I have noted so far. For instance, we might go back to the paintings and find delicacy in one and something like machismo in the other. But in proceeding like this we would actually risk reducing the relations between the two paintings to a set of contrasting stereotypes or clichés. These might well turn out to be less revealing – and of far less relevance to the actual paintings – than the observations already made without bringing considerations of gender and age to bear.

This is not to say that considerations of a painter's sex or age are necessarily irrelevant, or that when we come to interpret a work of art we should always set aside such information as we may have gained from reading about it or about the artist who produced it. The point is rather that we need to ask how such considerations contribute to our understanding of the work in question, relative to other things we know or can see. For instance, to accept that difference of gender must be so important as fully to account for the difference between the two paintings might be to rule out or to underestimate the potential importance of the 250-year gap in dates or the thirty-two-year gap in age between the artists.

What we can certainly do is to use the kind of data that might be supplied in a caption or accompanying label or in some other background information in order to check our observations and to fill them out. Given the point that the artist is the person on whom the effects of the work are first tried out, we can say that the *Still Life with a Bowl of Curaçao Oranges* is not only a picture of fruit in a bowl; it is also a representation both of the content and character of a specific young woman painter's visual and social experience and of her ideas about how she wanted her work to look. By the same token, Courbet's painting shows us not only what Courbet was once looking at; it is also revealing to some extent about the form and character of the painter's seeing. The seeing involved is not just an automatic process of forming images in the mind. Artists are not simple mirrors of reality, any more than the rest of us. They naturally make discriminations within the visual field and think about what they see as they see it. As they look, their habits and emotions and appetites are in play. The objects of their vision are continually charged with desire or dis-

appointment, with affection or antipathy – in fact with meanings. What a man in his fifties with a history of political activism desires and dislikes may not be what a young unmarried woman desires and dislikes. How those habits and emotions and desires and dislikes are expressed in their art will depend on different technical abilities and interests in the handling of the painting medium that are partly attributable to differences in training, in practical development, in physical character and so on. All other factors being equal, we may expect that the pictures they produce will indeed be different, though not necessarily in ways that would allow us to tell which was painted by the man and which by the woman.

Of course, in this case the 'other factors' are considerable. On the one hand there is the artists' sharing of a convention, a set of implicit rules and expectations that suggest what is and is not appropriate for a work in the still-life genre. For instance, it was a normal assumption that the appropriate way to paint one's subject was as though it were seen on a table or shelf, close to, with clearly illuminated forms against a dark background. The persistence of this assumption in practice largely explains the similarities already observed between Courbet's painting and Moillon's. On the other hand there is the gap in time of some 250 years. This factor may account for all kinds of difference and change. Yet even when these factors are taken into account, what we can say is that the emotional differences observable between the two paintings are consistent and compatible with what we now know about the differences between their respective authors. To that extent each could be said to be of its author. It might be fanciful to take the next step along this path and say that, in so far as it expresses a distinct personality, each is like a portrait of the artist. This is to take a kind of individualistic approach, at the opposite extreme to one that would accord priority to the kinds of social relations within which the works were produced. But to consider the paintings in these terms is a not inappropriate way of drawing attention to their differences, and indeed of accounting for some of them, as long as we remember that it is the paintings with which we have to connect our responses and not the artists themselves.

Taking a lead from this idea, we can perhaps proceed from the contrast between the two paintings further to explore some general questions of meaning and interpretation in works of art. We have considered what is represented in the pictures by Moillon and Courbet and also how that representing is done. What remains to be asked is why – for what reasons and with what intended meanings – the objects are painted in that particular manner and with those particular qualities. In the case of Moillon's still life it is hard, I think, to get much beyond the kind of circular answer that says: 'In order to produce a painting that looks like this.' But I do not

think that the circularity of the answer is in any way damaging to her work. Here is why. I have already mentioned that Moillon's painting shows unusual fruit in a bowl of imported Chinese porcelain. The exoticism of the subject matter is clearly meant to contribute to the appeal of the painting, and I suspect that that appeal was originally intended for a prospective purchaser who belonged to a higher class than Moillon's own – someone, for instance, who might have been able to afford a fine porcelain bowl imported from China. What I find particularly remarkable about the work is the combination of this exoticism in the objects pictured with the careful and unsensational character of the style. Although she conveys a powerful sense of delight in the objects depicted, Moillon refuses either to dramatise her subjects beyond their intrinsic appeal or to hint at any covert meaning that might be intended by their selection or arrangement. Like all the works of hers that I have seen, the *Still Life with a Bowl of Curaçao Oranges* is marked by the clarity of its composition, by its assiduous and confident pictorial decorum and by an evident trust in what can be made straightforwardly visible to the spectator.

In the case of Courbet's picture, in contrast, we might ask why such clearly humble objects? Why apples redolent of the country orchard and the long grass rather than the dining table or the sideboard? Why fruit that have the signs of decay about them, for all their roundness and rich colour? Why a single pomegranate? Why a chipped piece of rustic earthenware rather than some more splendid container? Why these forms shown as though glowing with their own light in the near darkness rather than more clearly lit by the conventional source from outside?

The questions perhaps matter more than the answers, for they serve in themselves to indicate what makes Courbet's painting distinctive as a painting – that is, as an object whose meaning is largely derived from its relationship to other paintings. In fact, to ask such questions is already to show some recognition of what it means to work within a tradition and a genre, for they imply some understanding of what kinds of decision it was relevant for the painter to make. If we assume that the properties I have called attention to are properties the painting was intended to have, we are really saying that the effect we have already experienced *is* the painting's meaning, hard as this effect may be to put into words.

If we do go beyond what can be learned by looking closely at the painting, however, we might be able to proceed a little further in explaining why Courbet should have made a painting that looked like this. There are two points to be made, one relevant to the still-life genre as a whole, the other to Courbet in particular. The first point, implied earlier, is that the genre of still life has traditionally been associated with a specific kind of philosophical and moral content. If you look at plates 88 and 89, you may

be able to see why. Steenwyck's picture features a skull, a large vessel, an empty shell, a watch, a smoking taper, a Japanese sword in a lacquer scabbard (at the time an exotic imported item on a par with Moillon's bowl), a lute placed face down, a book and the bell of a trumpet. It may not be immediately clear how these objects are linked together but if one takes the skull for a principal cue, then all the other objects can be interpreted as reminders of the brevity of life and of the transience of human possessions, powers, pleasures and achievements. This type of still-life painting is known as a *memento mori* (meaning 'remember death') or 'Vanitas'. As the full title of Steenwyck's painting suggests, the reference of the latter term is to the emptiness or futility of worldly values and attachments, as expounded in the Book of Ecclesiastes from the Old Testament, a text that achieved wide currency during the seventeenth century, particularly in Protestant countries. 'Then shall the dust return to the earth as it was; and the spirit shall return unto God who gave it. Vanity of vanities, saith the Preacher; all is vanity.'

The picture by Jan Davidsz de Heem, in contrast, is full of objects suggestive of luxury and sensory enjoyment. Painted in Antwerp, it seems to convey exactly the opposite message to Steenwyck's work: 'Get what you can and enjoy it while it lasts', perhaps. Of course that might be regarded as just another way of acknowledging the transience of consumable stuff. In any event, once the still-life tradition has been associated with the content of paintings such as Steenwyck's, enjoyment of displays such as de Heem's will be unavoidably stalked by the consciousness of mortality. Both paintings can thus be seen as stimulating philosophical reflection. One achieves this through an encouragement to abstinence and thoughtfulness, the other through a concentration on perishable foodstuffs and momentary pleasures. Yet, given that it is art we are talking about, no con-

88 (*above left*) Harmen Steenwyck, *Still Life: An Allegory of the Vanities of Human Life*, *c*.1640, oil on oak panel, 39.2 × 50.7 cm, National Gallery, London

Born in Delft, Steenwyck trained in Leyden, where the university was a stronghold of Dutch Calvinism, a form of Protestantism that was particularly opposed to worldly values.

89 (*above right*) Jan Davidsz de Heem, *Still Life*, 1640, oil on canvas, 149 × 203 cm, Musée du Louvre, Paris

De Heem was largely responsible for introducing the type of sumptuous still life that became prevalent in painting in Holland and Flanders in the mid-seventeenth century. He was among the most financially successful painters of the period.

tradition is involved in saying that both were also made to be enjoyed as conspicuous demonstrations of the painter's skill.

It is a feature of the genre of still life, then, that it is often used to suggest deliberation on the meaning and the finiteness of life. This is not really surprising given the two principal conditions that tend to define the genre: first a type of pictorial set-up that suggests solitary and sedentary concentration; second an emphasis on the play of the senses. In the typical composition of the seventeenth century, the accomplished painter worked to stimulate a sense of sensory self-awareness and in doing so to demonstrate a high level of skill in the representation of complex visual effects: the sense of touch is evoked by emphasising rounded volumes and complex textures; flowers or smoking pipes and tapers evoke the sense of smell; succulent fruit and meats, the charred flesh of grilled fish, beakers of wine and pearly oysters evoke the sense of taste; musical instruments the sense of hearing; and of course the decorative and illusory effects of painting itself provide exercise for the faculty of sight.

Such connotations are given in the very business of pictorial representation and in the kinds of demand that paintings make naturally on the spectator's imagination. Pictured elements may be endowed with further potential as symbols through association with literary, moralising or philosophical texts and contexts and conventions. Those associations stick more strongly and more consistently to some objects than others. A skull inescapably symbolises death, while a flower that evokes transience in one context may have quite a different meaning in another. To call a work such as Steenwyck's an allegory is to say that an entire group of potential symbols is organised systematically so as to assign them a meaning beyond their literal appearance. The still life by Jacques Linard, a French artist of the seventeenth century, actually takes as its subject the relationship between the five senses (sight, taste, touch, smell and hearing) and the four elements (earth, air, fire and water (pl. 90)). Another painting takes this allegorising tendency to an extreme (pl. 91). In a landscape setting that combines the effects of the four seasons (spring, summer, autumn and winter), human figures are variously characterised so as to represent the four ages of man (childhood, youth, maturity and old age). These are in turn occupied in ways that represent the actions of the five senses. Other components of the picture serve to evoke the four elements.

Moillon's tendency as a still-life painter, I suggest, stands at the opposite pole to works such as this. The effect of her apparent trust in the straightforward power of her medium and her technique is to make such complex allegories seem arch and somehow unpainterly. But might Courbet's painting, with its more complex range of pictured objects, be appropriately considered as an allegory of some kind?

I mentioned two points relevant to Courbet's picture. The second concerns the conditions under which his still life was painted. He came of peasant stock from the mountainous country near Besançon in eastern France and he retained a strong sense of identification with his background. As a life-long supporter of political radicalism, he had been involved with the Paris Commune. The Commune was founded in March 1871 following the fall of the Second Empire the previous autumn and in opposition to the right-wing National Assembly established during the ensuing Third Republic. After the bloody suppression of the Commune, Courbet was tried, fined a large sum for his supposed part in the destruction of the Vendôme Column and confined for six months in the Sainte Pélagie prison in Paris. (The column was a Roman monument erected in Paris, surmounted by a sculpture of Napoleon I, which the Communards viewed as a symbol of oppressive authority.) Our still life is mentioned in a list of the pictures Courbet painted during the period of his imprisonment, at a time when his health was poor and he was saddled with debt.

Given the two points I have offered, it is perhaps not difficult to conceive of Courbet's painting both as a kind of *memento mori* and as an obstinate assertion of his identity, and thus, by extension, as a kind of self-portrait; not just a picture by, but in a metaphorical sense a picture of someone crippled by the powers he had always opposed, yet with the self-image of an honest countryman still in full possession of his senses. Where Moillon's picture was probably painted to cater to the tastes of a customer from a different class than hers, the materials of Courbet's painting are drawn from the class he still claimed both to belong to and to represent. The apples are a Realist's apples. Paintings are not verbal statements and they are not open to being tested for truth or falsehood in the same way. However, someone who had concluded that Courbet's painting was a

90 (*above, left*) Jacques Linard, *Allegory of the Five Senses and the Four Elements; with objects bearing the arms of the Richelieu Family*, 1627, oil on canvas, 105 × 153 cm, Musée du Louvre, Paris

Like Moillon, Linard lived in the Saint-Germain-des-Prés district of Paris. Among the objects his picture includes are a bouquet of flowers (smell), a mirror (sight), fruit and a box of sweets (taste), a lute, a recorder and a music book (hearing), playing cards (touch), root vegetables (earth), an exotic bird heading into the open sky (air), a miniature stove (fire) and an iris in a vase (water).

91 (*above right*) Simon de Vos, *Allegory of the Four Seasons and Human Ages*, 1635, oil on canvas, 49 × 64 cm,, National Gallery, Prague

De Vos was a Flemish painter with a tendency to cram his paintings with figures and incidental detail.

joyful celebration of the fruitfulness of autumn could find themselves a bit troubled by the biographical information. They might either have to change their view of the picture or add a get-out clause to their interpretation: 'And yet, despite everything, the artist's love of life shines through'.

2.9 RELEVANCE AND OPENNESS

There is one important caution to be entered here. Had you been able to start with the information I have given you, you might well have arrived at a meaning for Courbet's painting, an interpretation of it, by a much quicker route than the one I have taken. However, you would, I think, have been less likely to do the kind of work the painting invites you to do; less likely, that is to say, to exert yourself to see it. Further, the more interesting and potentially relevant the information about Courbet seems, the stronger will be the temptation to use it as a key to the appearance of the painting, whether it actually fits or not. If it were not actually true that Courbet's picture was painted when he was in prison, beset by financial obligations and in ill health, would the meaning of the painting change? You might feel that it would and yet nothing would have been altered in the painting's form. It might be best to say that the meaning for you would be affected. Yet that suggests that its meaning for you is somehow independent of, or separate from, how the painting actually looks. If we conceive of works of art as forms endowed with meaning, then presumably we want to accord their appearance some authority in deciding what to take into account and to trust when it comes to interpreting them.

Suppose I offer the following anecdote concerning a painting by one of Courbet's French contemporaries, Jean-François Millet, a work known as *The Winnower* (pl. 92). It appears to represent a farmer engaged in the heavy task of separating the grain from the chaff by tossing them together in flat basket, the chaff being blown away by the light breeze at the door of a barn. This painting is now in the collection of the National Gallery in London. When a responsible institution such as this spends public money on a work of art, it will want to be assured that that work is the authentic and if possible unaltered product of the artist's hand. The safest way to establish this is by provenance, an ideally unbroken chain of recorded ownership that securely connects the work in the present to a first documented appearance in the artist's studio or in an exhibition. A painting by Millet with the title *Le Vanneur* (*The Winnower*) was indeed recorded in the French Salon in 1848, the year of a revolution. It was purchased by the Minister of the Interior. After that, however, it was lost for

some 125 years, when it reappeared in America. Despite this considerable break in the painting's provenance, the National Gallery was convinced on various grounds that it was indeed the original work that had been exhibited in 1848 and further that it was superior in quality to two later versions by Millet of the same subject.

Now suppose I were to say that around the same date the artist had painted a picture illustrating a story by a friend about a peasant rewarded for his honest toil by the gift of a miraculous shower of gold and that this, not *The Winnower*, is the painting purchased by the National Gallery. Among the evidence to be adduced is a contemporary review of the work in the 1848 Salon which mentions 'a column of gold dust'. The potential effect of this information is to encourage a perception of the painting that would be consistent with a different title, such as *The Gift of the Miraculous Shower of Gold*. In fact the information is false but it is not unlike the kinds of claim that are sometimes made as the result of art-historical research where the true origins and subjects of paintings are open to question.

92 Jean-François Millet, *The Winnower*, 1848, oil on canvas, 100.5 × 71 cm, National Gallery, London

Born of peasant stock, Millet belonged to a generation of French painters preceding the Impressionists. The realism of his scenes of peasant life was moderated by the predominantly religious aspect under which they were represented.

My point is that the work itself can often be trusted to make you alert to misinformation, if you give sufficient weight to its visible properties. In this case the peasant's evidently strained posture, his gnarled hands, his lack not just of an expression of joyful surprise but of any visible expression at all, are not to be cancelled out by a mere change of caption. Painted in the year of revolution, this is a powerful image of the peasantry as a potential political force. With his red cap, white shirt and blue protecting cloth round his knees, he is even draped in a form of the French flag, the tricolour. Comfortably sentimentalised images of the peasantry were plentiful enough in the art of the eighteenth and nineteenth centuries, but Millet's winnower offered no such reassurance. His presence was a sign that the social forces and tensions by which the modern world was being shaped were emerging closer to the surface of art.

The principal moral of this anecdote is that you should not always be guided in your interpretations of works of art by the titles they are given. In this case the National Gallery's title is entirely justified, but there are

many others where the titles by which paintings are known are those given them by dealers in order to make pictures easier to sell or by collectors who thereby impose their own interpretations on future viewers. Degas's *Interior* of about 1868–9 (see pl. 63), for instance, was for some while known as *The Rape*, as noted before. The scenario the artist painted is one in which an act of rape may indeed seem imaginable, but to fix the meaning of the painting in this way is actually to rob it of the subtlety and complexity that leads us to explore and to speculate about what it is we are seeing.

Biographical information about the artist can be particularly tempting when it seems to offer a key to the meaning of a given work of art. However, we need to bear in mind that the formal and physical characteristics of the work are there to be perceived independently of what that information may suggest. Its relevance is best treated as an open question. Open questions are questions that are relevant and useful to bear in mind but not necessarily possible or even desirable to resolve. One such question is this: is the meaning of a work of art to be identified with the specific form it acquired through the intentional activity of the artist (which might lead us, for instance, to pay particular attention to biographical information); or is what we refer to as a work of art something that has meaning by virtue of the multiple and potentially infinite interpretations that spectators are able to bring to it? On the one hand we cannot sensibly separate the meaning of Courbet's still life from what he may have intended and thought and done in painting it. On the other hand there is no denying that works of art can be brought to life for us by the various interpretations offered by other viewers, even – perhaps especially – if there is a degree of conflict between them.

2.10 ICONOGRAPHY

There is one further matter to be discussed before we finally leave Courbet's painting. It concerns his choice of fruit, in particular the inclusion of the pomegranate. There is a deceptively simple way in which this might be explained. If you were to consult a dictionary of signs and symbols you would find that the pomegranate has a particular meaning in the classical tradition. Being packed full of seeds it was taken as a symbol of fertility, of life and of the rebirth of nature. Within the Christian tradition it came subsequently to be regarded as a symbol of resurrection, particularly when paired with the apple, which stands as a symbol of temptation, of the Fall of Man, and of death. Countless European pictures show Eve tempting Adam with an apple-like fruit, supposedly leading him

into sin and bringing about their expulsion from the Garden of Eden. In a work with a Christian theme, then, a pomegranate may be understood as a symbol serving to remind the viewer of God's forgiveness and of the promise of everlasting life. This is how it appears, for instance, in Botticelli's *Madonna and Child with Pomegranate* (pl. 93).

In the traditions of art, it is as though certain forms acquire lives of their own, carrying a parcel of meaning and reference with them, like the upturned lute in Steenwyck's Vanitas still life (see pl. 88). This tendency of pictorial forms to convey symbolic meanings is one of the factors that allows works of art to deal with complex themes and ideas. Iconography is the term for the study of such symbolic meanings and of the ways in which they change and develop – derived from the Greek word *eikon* which means an image or likeness. As I have already suggested, where paintings depend heavily on such symbolic forms of meaning, the viewer may need specific kinds of knowledge in order to 'read' them. A painting made by the Italian Carlo Crivelli in 1486 illustrates just this point. The

93 Sandro Botticelli, *Madonna and Child with Pomegranate*, c.1487, tempera on panel, diameter 143.5 cm, Galleria degli Uffizi, Florence

Botticelli was one of the most successful painters in Florence in the late fifteenth century, enjoying the patronage of the Medici. He was among the contributors to the frescoes on the side walls of the Sistine Chapel (see pl. 51). His reputation waned in the sixteenth century, however, and was not revived until the second half of the nineteenth.

subject of the painting is the Annunciation (pl. 94). This is the moment
from the Gospel of St Luke at which Mary is informed by the archangel
Gabriel that she is to be the mother of Christ. The virgin's impregnation
by the Holy Spirit is signified by the ray of light descending from heaven,
which finds its way to her head through a convenient gap in the architec-
ture. The closed-off passage into depth at the left of the picture is a con-
ventional reference to Mary's virginity, as is the flask of pure water on a
high shelf in her bedroom. Right in the foreground, as it were under the
viewer's nose, an apple is juxtaposed with a cucumber. The apple performs
its conventional role as a reference to the Fall and to human mortality.
The cucumber, being packed full of seeds, carries the same symbolic sig-
nificance as the pomegranate. It conveys the promise of resurrection and
redemption. This promise is underlined by the inclusion of a peacock. Due
to the superstitious belief that its flesh never decayed, the bird stood as a
further symbol of immortal life.

These are just some of the pictorial devices by which Crivelli sought to
make clear the Christian meaning attached to the Annunciation. There are
other symbolic elements of the painting that can only really be understood
when one knows the circumstances under which the work was made, and
for that we need to reconnect it to its original location, from which it was
removed before the end of the eighteenth century. The painting was com-
missioned as an altarpiece for the Church of the Holy Annunciation in the
town of Ascoli Piceno in the Kingdom of Naples, to celebrate the receipt
of good news on the feast of the Annunciation in 1482. At that time the
reigning pope granted the citizens of the town certain rights of self-
government (*libertas*) under the general control of the Catholic Church
(*ecclestiastica*). These rights were likely to have included a degree of
freedom from rigid controls over money-lending and investment and thus
to have promised a degree of expansion and potential prosperity for the
town, possibilities which the opulent setting of the picture may have been
intended to suggest. Each year a commemorative procession was held to
celebrate the occasion, ending up in the church before this altarpiece, com-
pleted four years later, where the various meanings of the two forms of
good news – the religious message of redemption and the promise of civic
benefits – were woven together in a single picture. The unusual figure
accompanying the archangel is St Emidius, the patron saint of Ascoli. He
carries a model of the town as though to demonstrate his exemplary per-
formance of his role.

This is a clear case of a work with a complicated iconographical pro-
gramme – one that is largely indecipherable without the kind of informa-
tion to be looked for in a dictionary of symbols and a well-researched
catalogue. You might now feel that had I given you the information about

the apple and the pomegranate it would have been clear that Courbet's painting also had a hidden religious theme referring to death and resurrection in explicitly Christian terms. However, at this point I want to pull back from what begins to look like an exercise in translation (apple = fall; pomegranate = resurrection; the beaker full of liquid = communion wine perhaps). No interpretation of a work of art should be allowed to stand unchallenged if it fails to do justice to the way in which the work appeals to the senses. What holds my attention in Courbet's picture is the substance, colour and texture of the fruit and I suspect that it was this sense of substantiality that the painter meant to convey. Courbet called himself a Realist, meaning that he aimed to show life as he believed it was, not as it was supposed to be in the kind of art that might be approved in academic circles. Also, he never painted a properly religious picture in his life.

The moral is this: if a pomegranate symbolises resurrection in one painting, it does not follow that every pomegranate in every painting is there to serve as a symbol of resurrection or that every apple must signify sin and death. While Courbet was in prison he was dependent on his sister, who brought him flowers and fruit to paint. It was probably she who chose the pomegranate. In the end we cannot know whether the artist was even aware of its potential meaning as a symbol. The most we can say is that in so far as the meaning was established in other circumstances it may still cling to any representation of the fruit. Some works of art, like Crivelli's, are organised as complex allegories that clearly invite us to regard their pictured objects as decipherable symbols. Other paintings may make use of similar objects but in ways that require no such deciphering. In one case the clues may point in one way, in another case in another. There is no clear line dividing the one type of work from the other and no hard and fast rule that will tell us what to do in any given case. In the absence of documentary evidence, the best we can do is respond to the clues.

2.11 MODERNISM

I have at various points referred to modern art and modern artists, implying some kind of difference or departure from a continuing tradition. It is time to give some thought to what the term might mean – and to what it is that the modern is being contrasted with. One seemingly straightforward way in which that point might be answered is to say that while traditional kinds of art bear some clear relationship to how things look and are arranged in the world, works of modern art are often unconcerned to establish correspondence of this kind. At a certain point in the development of western culture, there seems to have been a relaxation of the prin-

ciples by which the appearances of works of art were connected to the appearances of the world. Many artists no longer wished to picture the world according to traditional principles while others seemed not to want to picture the world at all. Among the typical symptoms of this change are a tendency for the shapes, colours and materials of art to lead a life of their own, forming strange combinations, offering distorted or exaggerated versions of the natural world, and in some cases losing all obvious connection to the ordinary objects of our visual experience. The works of art in which these symptoms were first made inescapably clear were produced by artists working in a number of major European cities in the first decade and a half of the twentieth century. It was the development of Cubism in the years after 1907 that seemed most clearly to mark a decisive break with previous styles. With the emergence of abstract art soon after, the differences began to look irreconcilable. Consider plates 31, 39 and 23.

The belief that what had emerged was indeed a distinctive artistic culture was given institutional recognition with the founding of the first museums explicitly devoted to the acquisition and display of modern art. An early precedent was set by a group of wealthy collectors in America in 1929. New York's Museum of Modern Art was originally intended for the temporary display of mostly European work but by 1939 it had evolved into a permanent collection housed in a large building in mid-town Manhattan designed in a 'modernist' architectural style. Developments in Europe were interrupted by the Second World War but in Paris a Musée d'Art Moderne was opened in 1961, its display including a single room of 'foreign schools' as complement to its survey of the development of art in France since the late nineteenth century. Many more museums of modern art were established during the last third of the twentieth century in major cities throughout the world. In London throughout the twentieth century responsibility for the acquisition and exhibition of recent art from abroad was vested in the Tate Gallery at Millbank, which had been founded primarily to provide a historical collection of British painting. This awkward division of responsibilities was finally resolved at the millennium when Tate Modern opened on Bankside as Britain's first museum devoted exclusively to modern art, with 1900 being temporarily set as the art-historical cut-off point dividing its collections from those of the established National Gallery.

It seems there are good reasons, then, for thinking of modern art as a phenomenon of the twentieth century. But before we get too carried away with the idea of a break with the past occurring around 1900, there are two questions to be addressed. The first is just how far what was involved in the move away from naturalistic appearances really was a break with

95 Titian, *The Flaying of Marsyas*, c.1570–76,
oil on canvas, 212 × 207 cm, State Museum, Kromeréz, Czech Republic

The episode to which the picture refers is recorded in the *Metamorphoses* of the Roman poet Ovid. The suspended figure of the satyr Marsyas occupies the centre, attended at the left by two executioners. His panpipes are suspended from the tree at the top left. Apollo may be represented by the figure at the far left playing a form of viol. The thoughtful seated figure at the right represents King Midas, one of the judges of the musical contest. Having decided in favour of Marsyas, Midas was rewarded by Apollo with asses' ears. Various observers have identified this last figure as a self-portrait. (For Titian see also pl. 57.)

tradition rather than, say, a change of direction or even a kind of recapitulation. The second is why that move should have been made when it was. The two issues are connected.

On the first point, if we survey the development of western painting from the discovery of linear perspective in the early 1400s until the mid-nineteenth century, it is possible to observe what may look like a gradual increase in the ability of artists to produce life-like scenes and images. Yet that sense of progress depends on a relatively selective review of the evidence. While the ability to produce convincing and life-like images was something that artists themselves tended to advertise, and while it was consistently valued within the academic tradition, it was by no means the only skill that painters sought or that their audiences valued. Titian's *Flaying of Marsyas* was painted in the 1570s (pl. 95). It illustrates an episode from classical mythology: the satyr Marsyas dared to challenge the god Apollo to a musical contest, which he lost. His punishment was to be skinned alive. The expressive power of Titian's painting lies less in its convincing depiction of the various figures involved than in the agitated surface of brushmarks that covers the surface of the canvas – and in the association the artist forges between that surface and the soft pelt of the suspended victim at the centre. Over our specified period of four and a half centuries, there were certainly artists who had reason to develop skills in perspective and in systematic visual description, but there were also others, like Titian, whose work was valued more for the richness of their colouring and for the appearance of spontaneity in their handling of paint. Even if we allow that the period in question shows a steady growth in one particular range of skills, we would still have to recognise that, in the larger scheme of things, that entire development forms a relatively limited episode in the art of just one part of the world.

What we may have in view, I suggest, is not so much a radical break with the past, occurring at the end of the nineteenth century, as a moment of loss of value in a particular range of techniques that had been developed for ensuring life-likeness. It seemed, I think, that the potential of such techniques to generate new types of picture had finally been exhausted, with the consequence that younger artists submitted to traditional training felt that their imaginative activities were being increasingly restricted. As a consequence, considerable interest was shown in other ways of connecting art to the world and to the spectator than those that depended on achieving naturalistic resemblance. These alternatives included a recourse to symbolism, which had generally been ruled out in those types of painting that aimed to represent the world in realist or naturalist modes, and a renewed emphasis on the kinds of decorative properties – independent effects of colour, pattern and rhythm – that had also needed

96 Paul Gauguin, *Ancestors of Tehamana*, 1893, oil on canvas, 76.3 × 54.3 cm, Art Institute of Chicago

This picture was painted at the end of Gauguin's first visit to the island of Tahiti, which lasted two years. His departure from France was motivated by a conviction that the west was in a state of decay and by a mistaken belief that he would discover an innocent primitivism among the Tahitians. The sitter was a thirteen-year-old Polynesian girl with whom the artist lived and had a child. She is seen against the background of a frieze of idols, above which abstract shapes suggest a kind of exotic writing. The words at the bottom left translate as 'Tehamana has many parents.' (For Gauguin see also pl. 227.)

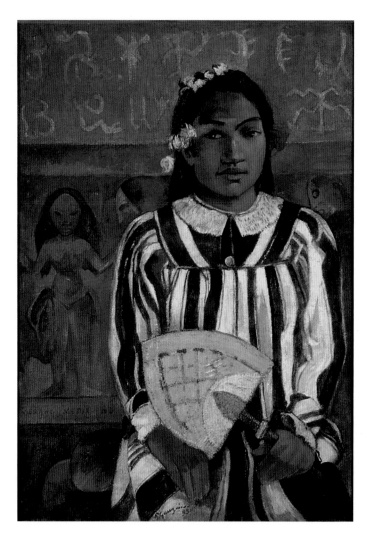

to be played down where the priority was to achieve faithful likeness (pl. 96). Artists also looked increasingly to the example of music, as an art form in which pictorial kinds of resemblance were altogether ruled out, but which nevertheless possessed a capacity to engage its audiences and to move them emotionally.

 In seeking to explain the advent of modernism, then, there are various factors we might take into account. One is certainly the apparent decline in the value accorded those practised skills of hand and eye co-ordination that were required to achieve convincing likenesses and that formed an essential part of academic training. A clear part in accelerating that decline was played by a major new technical discovery, the invention of photography at the end of the 1830s. In so far as the camera served to auto-

mate the process of capturing faithful images, it would clearly compete on highly advantageous terms with the painter's pencil and brush in any market for the supply of pictures, at least wherever it was primarily likeness that a picture was required to provide – in portrait painting, in topographical views, in the recording of natural-scientific specimens and so on. If the hand-made picture was not to be judged a relatively expensive commodity, it now stood in need of some other justification than its ability to provide likenesses. A part of Clive Bell's argument against Frith's meticulously painted picture of Paddington Station was that, for all the industry involved in its making, it was no better than a hand-painted photograph, devoid of the emotional effects produced by 'significant form'.

Bell was an associate of the highly influential English critic Roger Fry, who published an 'Essay in Aesthetics' in 1909, drawing on some of the theories that had accompanied the development of painting in France over the previous forty years. In his conclusion, Fry stated, 'We may . . . dispense once for all with the idea of likeness to Nature, of correctness or incorrectness as a test, and consider only whether the emotional elements in natural form are adequately discovered'. Art was not now primarily to be measured against the appearances of the world. Critical attention would fall rather on the achievement of emotional effects, even in the case of such figurative paintings as those of Cézanne and Matisse, which Fry greatly admired. One of the tendencies that modernism thus most clearly defines is an increasing shift of priorities from subjects to means – from the what to the how of representation. In the photography of the late nineteenth century we find images of dramatic unpopulated landscapes increasingly supplanted by scenes of busy city life. Yet for the painter, however much the experience of modernity might seem to be shaped by the appearances of the industrialised world and its expanding populations, it would not be what was pictured that established the modernism of the work of art. It would be the way in which the medium was put to use and the self-sufficiency of the 'world' that the work brought into effect.

A further consequence of the development of photography was that it provided massive impetus to the reproduction and publication of art of all kinds. Before the invention of the camera, those who wanted to refer to works of art that were not immediately to hand were largely dependent on their ability to obtain engravings. In 1836, when Constable was invited to lecture on landscape painting at the Royal Institution in London, he was dependent for his illustrations on drawings, painted copies and the mostly black-and-white prints he could assemble and put before his audience. It was no coincidence that the rapid development of art history as an academic discipline went hand in hand with the development of increasingly sophisticated techniques of photographic reproduction. By the end

97 (*above*) *Mask*, Central Africa, Fang, late 19th century, carved and painted wood, 42 × 28.5 × 14.7 cm, Musée National d'Art Moderne, Centre Pompidou, Paris

This mask was bought by the painter Maurice de Vlaminck in Paris in 1905 and sold by him to his fellow artist André Derain, a close friend of Picasso at the time.

98 (*right*) *Male and female figures*, West Africa, Azande, late 19th century, wood, h. 80 cm and 52.6 cm, British Museum, London

The Azande or Zande occupy the borderlands of Zaire, the southern Sudan and the Central African Republic. These two figures may have been made to represent a pair of ancestors. They were collected in the 1920s.

of the nineteenth century artists and others interested in the development of art had access to a vastly wider range of images, drawn from a much wider range of traditions and cultures, than had their predecessors. For those who had reason to feel frustrated with the teachings of the academic tradition, it became far easier to argue that these were based on a restricted view of art and of its meaning and value in human societies. One powerful form of argument was connected to the critique of capitalism that had been advanced by socialists since the mid-nineteenth century, as well as to certain developments in psychology. It was based on the idea

that where no demand for self-conscious reflection was made of the spectator, what attractive likenesses offered was simply a kind of substitute possession and consumption, and thus a reinforcement of the material values that governed bourgeois life. One implication drawn from this argument was that what was required was a reawakening of art's commitment to the 'pure' spiritual values associated with earlier epochs and with less sophisticated cultures.

Among the newly accessible works of non-European cultures, none were to have a more decisive effect on the development of modern art than the carved masks and statues from Africa that ethnographers began to collect at the end of the nineteenth century and that artists first became aware of in the early years of the twentieth (pls 97 and 98). From the perspective of the academic tradition, these were 'primitive' artefacts, produced by savages and devoid of aesthetic merit. But to those for whom that tradition now represented an exhausted artistic culture, the expressive force and vitality of African carvings offered a powerful kind of confirmation. On the one hand they could be seen as having elements in common with other supposedly primitive types of art, such as the works of those early Italian artists who had not yet submitted to the discipline of perspective; on the other they seemed to confirm the avant-garde artists in their conviction that the traditional demand for descriptive accuracy had come to stand in the way of art's potential for expressive, emotional effects. Among the supporters of modern art, 'primitive' now became a term of unqualified approval. At the same time groups of artists earned the label of 'Expressionists' for their use of bright, saturated colours, simplified forms and emphatic brushmarks (pl. 99).

In 1908 Henri Matisse paid a kind of eloquent farewell to the idea that art's appeal to the spectator might be dependent on the achievement of likenesses. 'Expression, for me, does not reside in passions glowing in a human face . . . The entire arrangement of my picture is expressive . . . Composition is the art of arranging in a decorative manner the diverse elements at the painter's command to express his feelings.' Two years later

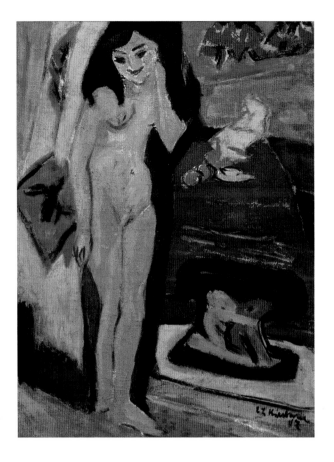

99 Ludwig Kirchner, *Nude behind Curtain (Franzi)*, 1910, oil on canvas, 120 × 90 cm, Stedelijk Museum, Amsterdam

Kirchner was a founder member of the German group Die Brücke (the Bridge), founded in Dresden in 1905. Their programme spoke of the need for 'freedom of life and movement against the long-established older forces', and for 'directness and authenticity' in creative work. Besides brightly coloured Expressionist paintings, Kirchner also made wood carvings in a consciously primitive style.

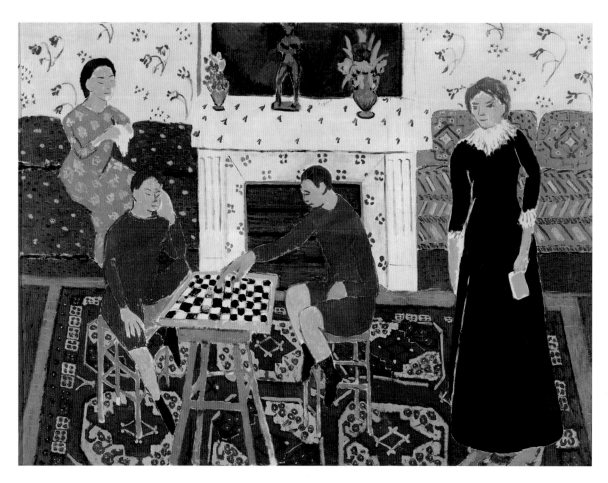

100 (*above*) Henri Matisse,
The Painter's Family, spring
1911, oil on canvas,
143 × 194 cm, Hermitage
Museum, St Petersburg

This picture was painted
about seven months after
Matisse's visit to the
exhibition of Islamic art in
Munich. The combination of
relatively flattened pictorial
space, with dense patterning
and a wide range of colours,
was prompted by the textiles
and painted miniatures he
saw on that occasion (see
pl. 101). (For Matisse see also
pls 61 and 85.)

he travelled to Munich to see a major exhibition of Islamic art, finding his own interest in an art of bright colour and decorative organisation confirmed and encouraged by the textiles, carpets and miniature paintings of the Middle East, designed as these were according to different priorities from those by which the European tradition had largely been governed since the fifteenth century (pls 100 and 101).

2.12 ABSTRACT ART

Given the developments discussed in the previous section, it was perhaps not surprising that the possibility of an entirely abstract art should have begun to preoccupy certain painters at the forefront of new developments, notable among them the Russian artists Wassily Kandinsky (see pl. 23) and Kasimir Malevich and the Dutch painter Piet Mondrian. Landscape compositions featured among the early works of each of these, which is to say that they each had experience of a genre suitable for the private interior and of a type of picture that invited the imagination of an extensive space. The question they confronted was whether it was necessary for a painting actually to picture anything at all in order to count as a work of art. This question needs to be considered with some care. What is at issue is the distinction between a painting and a pattern or, to make the point clearer, a mere pattern. Decorative pattern-making may be carried to the highest levels of aesthetic achievement – as it is, for instance, in the ceramic tiling of certain Islamic mosques and shrines – without requiring the specific kinds of intellectual and emotional engagement on the part of the spectator that have traditionally been associated with paintings. It was that potential for engagement that the first abstract painters hoped somehow to preserve, while at the same time, as they saw it, 'liberating' form from its material associations.

In order to achieve this they needed to keep hold of two of painting's crucial defining properties – whatever else they might abandon. The first was the containment of the image within its traditional format. The abstract work needed first and foremost to be seen as though it might be a picture, so that the expectation of content and engagement would be generated in ways that it is not by a continuous surface of decoration. The second, connected to the first, was the imagination of a picture plane; so that however the canvas surface was marked, those marks would establish an imaginative presence as it were on the other side of that surface, where the representational content of painting had traditionally been located. In its most reduced form – as it appears in Kasimir Malevich's

101 (*facing page, bottom*) Kamal-udin Bihzad, *Harun al-Rashid at the Barbers (A Public Bath)*, 1494, manuscript illumination from the *Khamseh* of Nizami, watercolour on paper, British Museum, London

Bihzad was born in Herat in Khorasan (Afghanistan), where he worked at the Safavid court between 1486 and 1495, before being appointed director of the Royal Library in Tabriz. As a teacher he had considerable influence over the development of painting not only in Iran but also in India and Turkey, where several of his pupils were employed. Nizami was an Azerbaijani poet living in the late twelfth century.

102 Kasimir Malevich, *Black
Square*, 1923 version of 1915
original, oil on canvas,
106 × 106 cm, State Russian
Museum, St Petersburg

The first version of Malevich's
Black Square was shown in an
exhibition in St Petersburg in
December 1915. In an
accompanying pamphlet he
claimed that 'the artist can be
a creator only when the
forms in his picture have
nothing in common with
nature' and that, once
everything has vanished, 'there
remains a mass of material,
from which the new forms
will be built'. He subsequently
claimed that the Suprematist
movement he had initiated
was the artistic counterpart
to the Russian Revolution of
1917. The condition of the
original *Black Square* has
deteriorated; this illustration
shows one of the several
later versions painted by the
artist.

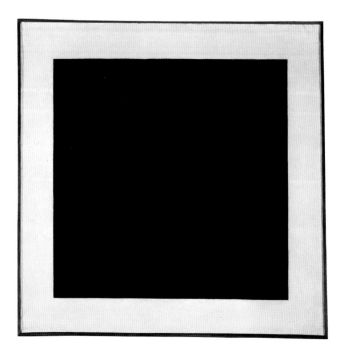

Black Square (pl. 102) – the abstract painting offers no more than a simple
figure–ground relationship, with the consequent suggestion of an isolated
spatial plane, and a containing margin round the object that serves to dis-
tinguish it from the background against which it is placed.

The first of several versions of Malevich's work was painted during the
build-up to the Russian Revolution of 1917 and it marked – certainly in
the painter's own mind – a kind of *tabula rasa* or fresh start from which
a new language of increasingly complex forms could be developed.
Throughout the 1920s and early 1930s the idea of a 'new art for a new
world' exercised a considerable hold over the imaginations of artists, archi-
tects and designers of an increasingly international modern movement,
driven in large part by the promise of progressive change that the Revo-
lution seemed to hold out. Many surviving works of abstract art from that
period bear witness to a poignant belief in the power of art to project and
to model a new and well-ordered world, so that the distinction between
art and design might be rendered irrelevant (pl. 103).

In the event, however, that utopian belief became increasingly hard to
sustain in the face of mounting evidence of the betrayal of the Revolution
in Russia, of the rise of Fascism in Germany, Italy and Spain and of the
suppression of abstract art under each of the relevant regimes. What fol-
lowed was not that the justification for abstract art was entirely removed
but rather that its potential came to be understood in far different terms

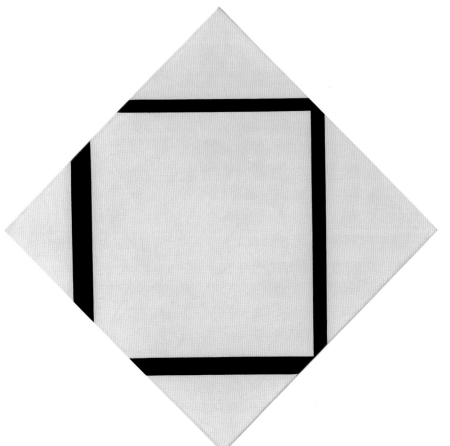

103 Piet Mondrian, *Composition IA*, 1930, oil on canvas, 75.2 × 75.2 cm, vertical axis 102.5 cm, Solomon R. Guggenheim Museum, New York

Mondrian referred to his art as new or neo-plasticism. ('Plasticism' translates the Dutch term *beelding*, which carries connotations of forming and making that are absent from the more basically material sense of 'plastic'.) His assumption was that an underlying harmony between human beings and nature could be expressed through the 'pure' and essential relationships between basic forms and colours. This would lead to the unity of all the arts, to the breaking down of distinctions between art, architecture and design and finally 'to the end of art as a thing separated from our surrounding environment, which is the actual plastic reality'.

by a subsequent generation of painters, artists working during the Second World War and its aftermath, not in Europe but in America. Unable to repose faith in the prospect of a better-ordered social world, the generation of painters known as the Abstract Expressionists came to conceive of art as essentially a mode of self-assertion and to imagine an audience composed of isolated individuals.

The career of Jackson Pollock was exemplary. In 1936 he had arrived in New York from the American West, encouraged by what he had seen of the art of revolutionary Mexican mural painters to imagine working on large-scale public projects with socially relevant themes. However, the works for which he is now best known – and which made him the first American 'celebrity' artist – are large-sized abstract paintings, made between 1947 and 1950 by pouring, dripping and spattering liquid paint on canvases laid on the studio floor (pl. 104). What is remarkable about these paintings is that they appear contained, for all their scale and often

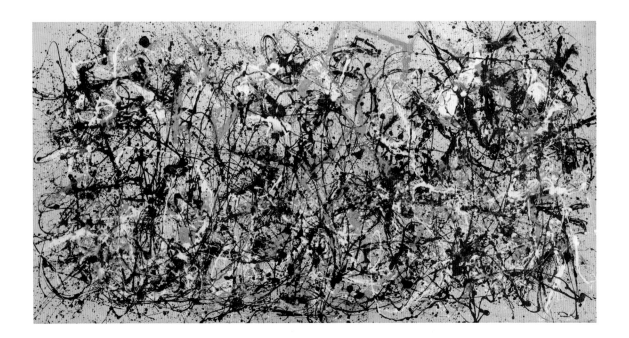

unusual proportions, and that, for all their highly charged surfaces, they retain some sense of a picture plane behind which a shallow impression of depth extends, promising pictorial content of a kind. It was Pollock's belief that the process he adopted would allow him to circumvent the normal processes of censorship in the civilised mind and to reach a deeper and less self-conscious level of suggestion and meaning, which would be preserved in the finished work. But it does not follow that his technique was arbitrary. His periods of rapid activity were interspersed with long moments of reflection on the work in progress, while he addressed the twin problems faced by all painters of abstract works: whether what he had so far produced was a painting rather than a (mere) piece of decoration; and what further action, if any, was required to improve it. Like each of the painters before him who had succeeded in making individual works of abstract art, Pollock had to learn what kind of a thing his own painting was and what were the conditions of its success or failure.

For two of the other American painters, Mark Rothko and Barnett Newman, sheer size was important in a way it had not been for the first generation of abstract painters. As they conceived the painting, it was necessary that it confront the spectator as it were on physically equal terms, so that an exchange between the two could be imagined that was both mutual and intimate. It was a condition of that exchange that there be no represented object that the spectator might mistake for the content of the painting itself. The procedures I recommended at the very beginning of

this discussion of painting are of particular relevance to works such as Rothko's. Before one of his typical paintings from the 1950s it will pay dividends to position yourself at the point where the painting fills your visual field – where you see all the painting and only the painting, so that the distractions of the surroundings are minimised. You will find that this puts you at what feels like a social distance in relation to the painting: that is, it is equivalent to the distance at which it feels comfortable to stand in relation to another person with whom you are at ease. A relationship to a painting conceived in these terms is clearly different from one in which what we are looking at is a contained portable object. It is as though we were ascribing to the painting the possibility of a kind of moral character and autonomy, as we might to another person.

Just how a painting by Rothko is lit will have a considerable effect on its appearance. The lighting levels that favour these works – and those the artist himself prescribed – are much lower than those normally maintained in galleries of modern paintings. The canvases are painted with thin layers of overlapping colours, applied in such a way that the figure–ground relations are rendered fluid and ambiguous. A hard reflecting light generally renders the resulting surfaces opaque, whereas a more muted light encourages us to look into the areas of colour and to become increasingly absorbed by their textures and variations.

In the late 1950s and early 1960s Rothko painted a number of works that were intended to be seen grouped together in spaces specially devoted to them. One such ensemble survives at Tate Modern in London (pl. 105). These are works that make strong claims for themselves. They aspire to the status of high art – to the kind of high genre that had previously been associated with history painting – in a way that the first generation of abstract painters would perhaps have considered inappropriate. Of course they are not history paintings, but they are certainly intended to be seen as serious and to invite consideration alongside the major genres of the other arts: tragic drama, epic poetry, music on a symphonic scale. A degree of romanticism is required for ambition of this order – an ethos widely different from the socially constructive purpose that invested the earlier abstract art of Malevich or Mondrian.

One of the questions that is often asked of art – especially of modern art – is 'whatever next'? On the one hand the very idea of art presumes continuity. Art is unthinkable without some sense of a tradition to which each new enterprise can be attached, however tenuously, if only to ensure that it is as 'art' that the results are seen. If there had been no tradition into which they could be inserted, however provocatively, there would have been no means by which any of Marcel Duchamp's chosen ready-mades could have laid claim to an aesthetic regard (see pl. 25). On the

104 Jackson Pollock, *Autumn Rhythm (No. 30 1950)*, 1950, oil and enamel on canvas, 270.5 × 528 cm, Metropolitan Museum of Art, New York

This is one of a series of large abstract paintings included in a solo exhibition in New York in 1950. In statements written three years earlier Pollock had said, 'I intend to paint large movable pictures which will function between the easel and the mural . . . I believe the easel picture to be a dying form, and the tendency of modern feeling is towards the wall picture or mural.' And, 'When I am *in* my painting, I'm not aware of what I'm doing. It is only after a sort of "get acquainted" period that I see what I have been about. I have no fears about making changes, destroying the image, etc., because the painting has a life of its own. I try to let it come through . . . The source of my painting is the unconscious.' Paintings such as this usually began with loose drawing in fluid enamel that suggested imagery of some kind, though any recognisable shapes became overlaid as the work progressed.

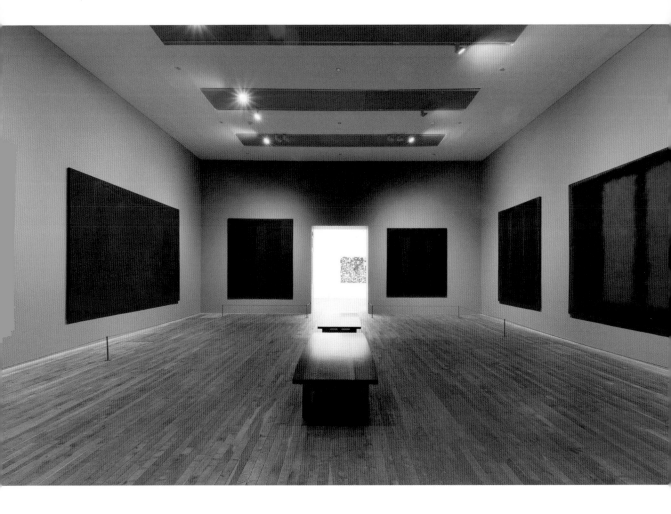

105 Mark Rothko, *Seagram Murals*, 1958–9, oil on canvas, various dimensions, Tate Modern, London

The paintings now housed at Tate Modern in London were selected as a group and donated by the artist from some forty canvases he painted after accepting a commission to decorate the Four Seasons restaurant in the Seagram Building in New York. In June 1959, near the end of his period of work on the series, Rothko visited Pompeii and was particularly impressed by the murals in the House of the Mysteries (see pl. 10), where he found 'the same feeling and broad expanses of somber color' that he was seeking to achieve. As the project developed, Rothko was increasingly attracted to the idea of a 'place' that would be defined in terms of the effects the paintings created. However, it became clear that the kind of place he had in mind could hardly be reconciled with a restaurant where 'the richest bastards in New York will come to feed and show off' (Rothko's reported words on visiting the restaurant after its opening in July 1959). The commission was duly abandoned. (For Rothko see also pl. 2.)

106 Yves Klein, *White Monochrome*, 1958, dry pigment, synthetic resin and plaster on coated canvas, 100 × 50 × 2 cm, Musée National d'Art Moderne, Centre Pompidou, Paris

Once the idea had taken hold that painting developed through a process of gradual reduction in its figurative and material aspects, a number of avant-garde artists tried to establish an end point to the process. In the year in which this work was made, Klein staged an exhibition of an empty white-painted gallery. The following year he gave a lecture in Paris on 'The Evolution of Art towards the Immaterial'.

other hand there seems to be some connection between modern art and novelty. The very idea of modernism places a high premium on originality, on doing that which has not been done before. So far as the development of abstract painting was concerned, the question the modernists faced was, if painting can survive – can even match up to the highest genres of art – without its traditional figurative content, what else might turn out to be dispensable? Colour? Internal detail? Variety of form?

It is characteristic of the modernist tendency to maintain a continual critical reflection on the art of the immediate past, and once such questions are asked, they will sooner or later be answered in practice. At a certain point the blank canvas – all white or all black – seemed to represent an irresistible terminus of sorts; a point beyond which there could be no proceeding but only a kind of turning back. Near-blank canvases were indeed painted by a number of artists around 1960, miniscule differences in colour or traces of texture serving to forestall the final step (pl. 106). Yet it was not these that really put the further development of painting into serious question. Rather it was a range of works that deliberately assailed the two basic conventions by which I have suggested that the integrity of painting has traditionally been assured, whether figurative or abstract: the containing edge and the picture plane. I have in mind objects such as the untitled relief of the early 1960s by Donald Judd, who was shortly after to advocate 'three-dimensional work' as a new category of art, virtually replacing both painting and sculpture (pl. 107). What such works seemed to demonstrate was that if the edges at right angles to the surface were made to appear integral to the object on the wall, then that object would be a literal thing and it would no longer be possible to conceive of a discrete content on the surface which that edge merely bordered

107 Donald Judd, *Untitled*, 1961, asphaltum and gesso on composition board mounted on wood, with inset aluminium pan, 122.2 × 91.8 × 10.2 cm, Museum of Modern Art, New York

Judd began his career as a painter. This is one of a number of transitional wall-mounted objects prefiguring the 'three-dimensional work' that he advocated in the mid-1960s and made from then until his death in 1994. In an influential essay published in 1965, he began with the claim, 'Half or more of the best new work in the last few years has been neither painting nor sculpture.' (For Judd see also pl. 15.)

or contained. As to the picture plane, works such as this ruled out the very possibility of a virtual plane somehow detached from the literal surface, both by rendering that surface altogether opaque and by subjecting it to actual physical interruptions. The effect of these moves was finally to proclaim the severance of the connection between abstract painting and a tradition of pictorial representation.

It might be asked why an artist should want to eliminate just those aspects of the medium of painting that had traditionally served to underwrite its imaginative content. The answer, I think, is that Judd conceived of the work of art as something of value not because of any virtual content that might be 'seen in' it but rather because of a sense of rightness conveyed by its physical presence, and by its relation to its surroundings. It might be thought that such work would run the same risk as the very first abstract art: that it would be dismissed as mere design. Yet conditions had changed greatly in the intervening half century. In the art world of the 1960s the new genre of 'three-dimensional work' found ready acceptance as 'art' among those who had come to regard painting as a limiting technical category.

2.13 PAINTING AND THE POST-MODERN

During the 1970s, the idea that modernism was somehow exhausted or at an end gained considerable impetus among writers of art criticism and theory, partly prompted by developments such as those mentioned at the end of the previous section. I do not mean to suggest that the making of one new type of art has the power automatically to put a stop to others. Throughout the 1960s and 1970s, a number of modernist artists continued resolutely to produce large brightly coloured abstract canvases. Nevertheless, enterprises that are noticed within the art world do unquestionably change the climate of expectation, and their implications tend to resonate in the air of art schools and studios. During the same period the idea that painting was 'over' – that it had become a traditional but culturally irrelevant craft medium like stained glass – gained considerable currency among certain avant-garde artists and their supporters.

I have deliberately couched this account of the 'demise' of painting in terms that assume a single dominant tendency and that are in that sense consistent with the modernist idea that there is a mainstream in art to which major developments conform. However, there are other ways in which the development in question might be described. For instance, what we may actually be considering is not the decline of painting as a medium but the more limited rise and fall of abstract painting – a distinctly twentieth-century genre or range of genres of great interest but with now-limited potential. In the late 1950s and 1960s a considerable number of artists in Europe and America made paintings using already processed imagery, much of it taken from the mass media. Among the most interesting of these were works by Andy Warhol in New York, made in the early 1960s, in which photographs taken from police files, from publicity and from the press (often the *National Enquirer*) were transferred to canvas by means of a casually applied silkcreen process (pl. 108).

It is my personal view that while there are abstract paintings that can stand comparison on aesthetic terms with the major figurative pictures of the past, abstract art has indeed for some time been a narrowing seam. Yet it does not follow that we can go back to 1900 and resume a tradi-

108 Andy Warhol, *Orange Car Crash 14 Times*, 1963, silkscreen ink on synthetic polymer paint on two canvases, overall 268.9 × 416.9 cm, Museum of Modern Art, New York

Works such as this were produced in a studio Warhol called The Factory, where topical and violent images such as this were transferred to canvas by the use of silkscreens, in numerous variations and increasingly with the use of assistants. (The silkscreen technique is discussed in section 3.5. For Warhol see also pl. 125.)

tion of picture-making as though nothing had changed. The contained, hand-made, figurative painting with an active picture plane may well be an item that can only now succeed in a conservative market. Whatever resources painting may or may not now be able to draw on, it will certainly not be practised as a modern art without some coming-to-terms with the sheer availability of pictorial imagery by other means; with the consequences of more than a century and a half of development of photographic techniques, and of the developments in film and video technology that have followed, not to mention the continuing advances of computer technology in facilitating the production, transmission and capture of pictures of all kinds. Given that paintings, like much else, tend to be consumed as images, there can be no sloughing off the implication that a painting, whatever its technical character, also potentially exists in a photographic and digital form. Nor can it be assumed, in the twenty-first century, that the line dividing the visual arts from verbal language can be drawn in the same place as it might have been a hundred or so years ago. During the late 1960s and early 1970s, artists involved in the Conceptual Art movement placed texts of various kinds on gallery walls in the place of paintings, as though to suggest that whether or not painting had a future, it could not be allowed to depend on a merely customary division between the spectator and the reader.

If we ask whether painting is still a practically viable medium, the evidence might nevertheless seem to suggest a thoroughly affirmative answer. At the time of writing there are undoubtedly more paintings to be seen in more commercial galleries throughout the world than at any previous time in history. The harder question, perhaps, is whether the medium of painting as traditionally conceived can still be looked to for new art of real complexity and depth.

It might be argued, though, that even this is a modernist kind of demand to make of art and as such is either internally unsustainable or otherwise inappropriate to the present age. Underlying such arguments is the view that modernism should be regarded as an influential but limited narrative of modern art; one which charts a particular line of development leading to the abstract work of the twentieth century, which identifies a 'mainstream' of the supposedly most original and most important painting and sculpture and which proposes a particular set of priorities for the making of critical judgements. In the art world of the last three decades of the twentieth century there was widespread interest in the idea of post-modernism in art. What this implied was not simply that the modernist narrative had lost its credibility and that it was no longer appropriate to think in terms of a single mainstream of development, but also that no one set of priorities could now be assumed sufficient or appropriate for

the making of critical judgements. According to this point of view, to look for complexity and depth is always to look for particular kinds of complexity and depth and thus to risk ignoring or marginalising artistic practices and works that may be responsive to other commitments and interests.

This shift in viewpoints effected a marked change in the curatorial policies and practices of many of the world's museums of modern art. Until late in the twentieth century, the great majority of permanent collections were presented along lines designed to demonstrate relationships between chronological developments and national schools. Around the time of the millennium many of these collections were reorganised so as to suggest thematic links and contrasts across wide ranges of work from different locations and from different phases of the modern period. Curators responsible for acquisitions have in recent years deliberately sought out work of types that the modernist narrative tended to ignore or to disparage: art produced outside the major metropolitan centres of Paris and New York, art that falls between or outside the established categories of painting and sculpture and art that represents the meanings of those excluded from the dominant culture (pl. 109).

In the latter part of the twentieth century the visitor to the Museum of Modern Art in New York could proceed through a succession of rooms, each stocked with celebrated examples of modern painting and sculpture, and could absorb a powerful account of the development of art from the

109 Chéri Samba, *March in Support of the Campaign on AIDS*, 1988, oil and sequins on prepared canvas, 136 × 200 cm, Musée National d'Art Moderne, Centre Pompidou, Paris

Born in 1956, Chéri Samba is a painter from the Democratic Republic of Congo, who works in Kinshasa and now also in Paris. The work for which he became known outside his native country addresses topical themes specific to African culture. He is also represented in the Museum of Modern Art in New York.

primarily French Post-Impressionism of the late nineteenth century to the large-scale abstract painting produced in America in the 1950s and 60s. This was the modernist account made manifest. Now, a visitor to the newly enlarged Museum of Modern Art may find elements of that account illustrated with a chronology of works up to the mid-twentieth century, albeit with the line of development blurred by the addition of more various kinds of work and by deliberately staged contrasts and confrontations. From that point on, however, the impression the display is likely to create is of a clamour of voices, each seeking to be heard and each requiring us tune to a different register. While some of the works in this display may be paintings, it is clear that no particular privilege now attaches to the medium. It is an open question, perhaps, whether what this circumstance betokens is a real gain in the cultural range and social relevance of art or a weakening of the human values associated with the very idea of aesthetic experience, or both.

PART 3

PRINTED PICTURES

3.1 REPRODUCTIONS AND PRINTS

There are paintings that exist in several versions, sometimes all from the hand of one artist, sometimes as the work of studio assistants, sometimes in the form of later copies. Yet each generally exists as a separate hand-made thing. On the other hand, while most readers of this book will be at least occasional visitors to museums and galleries, familiarity with works of art still comes in the great majority of cases through printed reproductions, such as those in this book. Such images depend on an initial photographic process, either photo-mechanical or digital, by which the original work is captured. The history of reproduction of this kind thus begins with the invention of photography in the late 1830s. Before that, those who wished to obtain reduced and relatively inexpensive versions of original pictures were dependent on skilled artisans working with a range of techniques for the production of repeatable images – prints. The oldest of these, the woodcut, was in use in Europe for making simple pictorial images by the end of the fourteenth century. I mentioned earlier that engravings were among the resources that the painter John Constable used to illustrate his lectures on landscape painting. The engraving of metal plates was first developed in Germany around 1430. The closely related technique of etching was developed later, around 1500. From early in the sixteenth century until well into the nineteenth, engraving was the most widely used method of producing multiple copies of pictorial images. Lithography was developed at the very end of the eighteenth century and screenprinting or silkscreen in the twentieth. (Each of these techniques will be discussed below.) All these print-making techniques depend on the exercise of a degree of craft skill and all are still in use by artists. The aim of this section is to allow readers to distinguish between works in the different print media, to gain some understanding of the processes involved and the effects that may result and to draw attention to some representative examples from different periods.

It might be asked why anyone should nowadays want or need to have recourse to print-making techniques, given that photographic and scanning technologies are available for producing high-resolution copies of pictorial images. The answer is that each of the techniques listed – with the

facing page Ando Hiroshige, *Mishima, Morning Mist,* from *Fifty-Three Stations of the Tokaido* (detail of pl. 120)

partial exception of screenprinting – allows the artist or the artist's assis-
tant to inscribe the surface from which the print is made through direct
physical contact. He or she thus controls a range of effects that may be of
aesthetic interest in themselves, relatively independent of any other image
that the print may be intended to reproduce. To talk of 'prints' is thus to
refer to works that are not actually reproductions, or not just reproduc-
tions, even in the case of those that were made with reproduction of a cel-
ebrated image as their intended function. A small black-and-white
engraving that reproduces the composition of a large oil painting is clearly
an item in a somewhat different category. In the techniques required to
derive the one from the other there is considerable room for variety and
for invention. A print, in this sense, is a work of art that exists in multi-
ple copies, each of which is as much an 'original' as any of the others.
During the period from the early sixteenth century until the middle of the
nineteenth, many of those who collected prints did so because they pro-
vided images of paintings by celebrated artists, but prints by skilled
engravers were also valued as works of art in their own right.

Since the late fifteenth century many artists have made their own prints,
but there have also been cases where successful and highly esteemed
painters have maintained professional relations with specialist print-
makers whose output has served to publicise their work. As late as the
mid-nineteenth century, the majority of the money that William Powell
Frith earned from his painting *The Railway Station* came through his share
of the sales of engravings. More than three centuries earlier, at the begin-
ning of the sixteenth century, the engraver Marcantonio Raimondi entered
a collaborative relationship with the young Raphael, who maintained a
highly successful workshop in Rome designing frescoes for the pope and
for other demanding patrons. Many of Marcantonio's numerous surviv-
ing prints record compositions and drawings by Raphael, in some cases
providing the only complete evidence of lost works. The high reputation
that Raphael's work maintained among painters and connoisseurs over
the next four hundred years ensured a continuing demand for engravings
of his work. Both as a consequence of this connection and by virtue of
Marcantonio's great skills as a print-maker, early impressions of his
engravings have remained in consistently high demand among collectors
(pl. 110).

❑ ❑ ❑

GALATEA
*Dum ferri gaudet Siculas Galatea per undas,
Haud notum incautis spectantibus excitat ignem.*

110 Marcantonio Raimondi, after Raphael, *Galatea*, c.1515, engraving, 40.2 × 28.6, British Museum, London

Many of Marcantonio's prints after Raphael show some variety from the finished paintings, suggesting that he worked from preliminary drawings or that he was afforded considerable liberty of interpretation or both. This work is exceptional in offering an accurate account of the fresco on which it is based, painted by Raphael in the Villa Farnesina in Rome. The widespread dissemination of the painter's style was largely due to the circulation of prints such as this. (For Marcantonio see also pls 117 and 158.)

3.2 RELIEF PRINTING

An impression is the printed image made from an inked plate. Why is it that 'early impressions' specifically are sought after by collectors? Because the worked plates will wear with use, though at different rates for different types. To consider how and why this happens is to begin to explore the nature of the print medium. Until the invention of lithography – a means of printing from a flat surface – there were two principal processes by which repeatable images could be made: by working in relief, where the print is taken from a projecting design, or by working in intaglio, where the design is incised in some manner. Both depend on the availability of a sufficiently smooth, stable and durable surface to receive the printed impression, which is to say they depend on a ready supply of paper. In China, fine paper was available by the second century CE and printed paper images were made from as early as the seventh century from low

111 Illustration to the Bizangquam commentary on the Buddhist *Tripitaka*, woodcut, China, Northern Sung Dynasty, printed 1108, h. 22.6 cm, Arthur M. Sackler Museum, Harvard University Art Museums, Cambridge, Mass., Louis H. Daly, Anon. and Alpheus Hyatt Funds

The *Tripitaka* is an important Buddhist canon of scriptures. This woodcut was used to illustrate a scroll containing a printed commentary.

reliefs cut in stone and wood (pl. 111). The development of relief printing techniques came much later to the west, however. This was in large part because it took centuries for the invention of paper to spread through the Islamic world to North Africa and thence to Europe, where its manufacture and use were slowed by prejudice against all things associated with Muslim civilisations and by restrictions on the transmission of the paper-maker's craft. It was not until late in the thirteenth century that the first European paper mill was established in Italy and not until early in the fifteenth that relief printing emerged as a significant artistic medium in the west with the refinement of woodcutting techniques.

For a typical woodcut, the process involved is as follows. First a carpenter supplies a plank of close-grained wood – usually fruit-wood of some kind that is easily worked with the block-cutter's tools – of approximately the same dimensions as the intended picture, with the face carefully smoothed. For a simple composition the artist might draw directly onto the wood in ink but for a fine picture a finished drawing on paper would be made and pasted onto the plank face down – so that the image would appear the right way round when printed – and then oiled to render it transparent. A skilled block-cutter would then gouge out the white areas of the composition with a chisel and sharp knife, leaving a detailed relief pattern corresponding to the ink drawing, which would be destroyed in the process. (The cutter was rarely the author of the drawing but where the enterprise was financed by a publisher he would be at least as well if not better rewarded.) To take an impression, the relief areas would be covered with ink, with care taken to prevent run-down into the gouged-out areas, and the block would be pressed firmly onto a sheet of dampened paper.

Simple woodcut blocks had been used in the Middle Ages to produce patterned textiles, playing cards and devotional images of various kinds, but it was with the rapid expansion of book publishing in the second half of the fifteenth century that the medium received its crucial impetus. With typefaces being also cut from wood, a pictorial woodblock could easily be bound into the same form for printing of an entire sheet. The improvements in paper quality and paper supply required by book publishing provided further grounds for the development of artists' prints. In Europe the high point of the development of the woodcut was achieved by artists working in the Rhineland area around 1500. Among these was Albrecht Dürer, who besides his career as a painter was responsible for remarkable prints in both the relief and intaglio media. He received a part of his training in a workshop that supplied images for book printing and was himself a skilled block-cutter. By 1498, however, when he designed his first major publication, the *Apocalypse*, he had largely delegated the demanding work of block-cutting to others (pl. 112). Much of the attraction of these works derives from the fine balance struck by artist and block-cutter between the inked areas and the white sheet, the denseness and intricacy of pattern relieved by the carefully preserved flow of space and light around the composition.

A carefully maintained woodblock may yield impressions running into four figures before signs of wear are apparent through deterioration of the quality of the printed image. None the less, there are limits to the fineness of detail and the complexity of texture that even the most highly skilled block-cutter can reproduce. That limit was effectively reached early in the sixteenth century. Although the woodcut remained in use for illustrations, vignettes and broadsheets, engraving had by then become the preferred medium for producing repeatable pictures.

3.3 INTAGLIO PRINTING

Engraving is an intaglio process, that is, the image is produced from lines and textures incised into a metal plate. The printed picture emerges from the residue left in these incisions when the plate is inked, wiped and put through a press with a sheet of dampened paper. Far greater pressure is required to print an engraving, which tends to show in an indented plate mark left in the paper round the borders of the image. The metal most frequently used is copper, which is soft enough to be easily engraved with a burin, a pointed steel tool with a *v*-section.

113 (*right*) Andrea Mantegna, *Virgin and Child*, c.1490, engraving and drypoint, 25 × 21 cm, British Museum, London

The relief-like effect of this fine print testifies to a degree of cross-fertilisation between print-making and sculpture in Italy during the late fifteenth century. Mantegna may have been specifically affected by the bronze reliefs of Donatello.

112 (*facing page*) Albrecht Dürer, *The Whore of Babylon*, from *Apocalypse*, 1498, woodcut, 39.5 × 28.6 cm, British Museum, London

Dürer's edition of the visionary *Apocalypse of St John* was the publication that made his name. The fifteen large woodcuts were presented not simply as illustrations to the text, which was printed in both Latin and German versions, but as powerful interpretations in their own right. This image is taken from the Book of Revelation, chapters 17–19, an allegorical account of earthly excesses and of their punishment. The Whore of Babylon is described in chapter 17 verses 3–4: 'And I saw a woman sit upon a scarlet-coloured beast, full of names of blasphemy, having seven heads and ten horns. And the woman was arrayed in purple and scarlet colour, and decked with gold, and precious stones, and pearls, having a golden cup in her hand full of abominations and filthiness of her fornication.' The town of Babylon is seen in flames at the top right, the descending armies of heaven at the top left, led by the Knight Faithful-and-True.

Remarkable engravings were made in the late fifteenth and early sixteenth centuries as original images by artists who also worked as painters, Dürer again among them. One of the rarest and most beautiful of all prints is an image of the Virgin and Child engraved by the Italian artist Andrea Mantegna using both a burin and a kind of steel needle known as a drypoint, a tool which the burin largely replaced (pl. 113). From the start such images as these had a status almost equivalent to that of original drawings, which patrons were just beginning to see as worth preserving and collecting. That few copies of this particular print survive suggests both that few were ever printed and circulated and also that the plate was destroyed or lost soon after its completion.

The intaglio technique of etching was developed from processes originally used to make designs in steel armour. Instead of engraving directly into the copper plate, the etcher draws with a stylus into a thin covering layer of wax or resin. The plate is then dipped into a bath of acid, which etches the design into the metal plate where its surface has been exposed. The plate can then be cleaned, inked and printed just like an engraving. Etching allows for more fluent and rapid movements of the hand and for a greater variety of engraving tools, resulting in a wider range of textures and effects. It also permits corrections and revisions to be more easily made

114 Rembrandt van Rijn,
Self-Portrait drawing at a Window, 1648, etching, drypoint and burin,
16 × 13 cm, second state of seven extant, British Museum, London

This is one of thirty-one self-portraits that Rembrandt made as prints. In later states he increased the contrast between the lit and shadowed areas of the image. (For Rembrandt see also pls 1 and 66.)

115 (*facing page, left*) Wallerant Vaillant, *The Fruit Peeler*, c.1670, mezzotint, 24.8 × 30.5 cm, author's collection

Vaillant was of French birth but worked mainly in Amsterdam. He was the first professional artist to work in mezzotint, making more than 200 prints in the medium. The majority of his designs, including this, were taken from his own paintings.

before the plate is dipped. In the seventeenth-century graphic work of Rembrandt the subtleties of line, texture and chiaroscuro that etching enables were deployed in some of the most absorbing and highly prized of all printed images (pl. 114). Many such prints by Rembrandt and others are known in different 'states'. These refer to trial printings the artist-print-maker makes to assess progress at any stage prior to completion of the plate. Some may record only minute variations, while others preserve early versions of compositions that have been radically reworked.

Two further varieties of engraving were developed in the seventeenth and eighteenth centuries respectively. The first, mezzotint, involves the use of spiked steel rockers in place of or in addition to the burin. In the hands of a skilled print-maker this produces a more velvety texture with a greater potential for exploiting subtle gradations and contrasts of tone (pl. 115). The second, aquatint, was designed to reproduce the effects of wash drawings and watercolours and was much used in England from late in the eighteenth century, when the art of drawing in watercolour was brought to a high level of sophistication in the study of landscape. It involved the use of various methods for producing the effect of a soft grain or wash, either by covering the plate before dipping in acid with fine particles of resin or by brushing acid directly onto the plate. The process cannot be used to produce lines, so it is usually combined with normal etching and engraving techniques. A late high point in the use of aquatint was reached

A caza de dientes.

in the series of prints issued by the Spanish artist Francisco de Goya, notably his *Caprichos* of 1799 and *Disasters of War* of about 1810–20 (pl. 116).

Where sheer quantity is the issue, copper plates are at a disadvantage relative to woodblocks, since they tend to wear faster, the quality of each succeeding impression being the more likely to deteriorate the finer and more detailed the lines and textures. The more celebrated an individual print, of course, the greater will be the demand for copies and the longer that demand will persist. A plate engraved early in the sixteenth century might still be in use three centuries later, but by that time the impressions produced would almost certainly be poor relations of those printed during the print-maker's lifetime and possibly under his supervision – and that is if the plate has not been re-engraved to strengthen lines that have worn and grown weak (pl. 117). Many valuable prints have also been much copied by subsequent print-makers, either in emulation or with the intention of cashing in on a ready market, or both. As early as about 1508 Marcantonio purchased a set of Dürer's woodcuts of the Life of the Virgin, which were for sale in Venice, and made careful copies of them by engraving the designs on copper plates. Partly to guard against pirating and to guarantee against deterioration in large editions, print-makers from the late nineteenth century onwards adopted the practice of signing and numbering a limited number of fine impressions – usually anywhere between

116 Francisco de Goya, *A caza de dientes* (collecting teeth), from *Caprichos*, first edition, 1799, plate 12, etching and aquatint, 21.5 × 15.2 cm, author's collection

The complete series of *Caprichos* comprises eighty prints, based on work in two sketchbooks of 1796–7. This collection offers vivid and ironic comment on the patterns of private and social life in Spain at the time, with enigmatic references to witchcraft and the threat of madness. Only twenty-seven sets had been sold before the *Caprichos* were withdrawn from sale, possibly as a result of complaints at their content. The present image refers to a superstition that the teeth of hanged men are efficacious in making spells and love potions.

117 Marcantonio Raimondi, after Raphael, *Galatea*, engraving, late impression, 38.3 × 28.6 cm, author's collection

Compare with pl. 110. This is an impression taken from a heavily worn plate, probably in the nineteenth century, by which time much of its detail and subtlety had been lost. The image has also been trimmed slightly at the bottom. (For Marcantonio see also pl. 158.)

25 and 250, depending on the medium – before cancelling the plate by scoring through it. In the case of highly esteemed print-makers, such as Degas, dealers have occasionally produced posthumous editions from cancelled plates to supplement the few surviving lifetime impressions.

3.4 THE JAPANESE WOODBLOCK PRINT

I mentioned earlier that a limit to the quality of woodblock cutting was reached in the early sixteenth century, with the implication that scope for extension of the woodcut medium was restricted thereafter. The one area in which there was significant further development was in the use of multiple blocks to print images in two, three or four colours, with the white of the paper normally being used for the highlights. During the sixteenth century a considerable number of 'chiaroscuro woodcuts' were produced

118 Katsushika Utamaro,
Lovers in an Upstairs Room
from *Poem of the Pillow*
(*Utamakura*), 1788,
woodblock print,
24.5 × 37.3 cm, published by
Tsutaya Juzaburo, Victoria and
Albert Museum, London

Among the artists providing
designs for woodblock prints
in the late eighteenth century,
Utamaro was one of the
most accomplished and
popular, specialising in images
of female beauty. The majority
of Japanese artists who
provided designs for prints
also contributed to the
market for erotic illustrated
books and pictures, known as
Shunga ('spring pictures').
This impression is from a *de
luxe* printed book of erotica,
containing twelve images.
The intimacy of the scene is
emphasised by the low
viewpoint, the intertwining of
limbs and fabrics and the
imagined exchange between
the two hidden faces. In
translation, the poem
inscribed on the fan reads:
'Its beak caught firmly/In the
clamshell,/The snipe cannot fly
away/of an autumn evening.'
Utamaro was one
of the first Japanese artists to
be recognised in Europe.

by this means in Germany and Italy. However, it was in Japan, rather than Europe, that the possibilities of the colour woodcut were most fully and most impressively exploited. Japanese prints, as they are popularly known, were first made at the end of the seventeenth century and their last great exponent, Ando or Utagawa Hiroshige, died in 1858.

In Japan the development of woodblock prints was driven by the particular social conditions of the 'floating world' (*ukiyo-e*) and by the type of market that these created. Floating world refers both to a place and a way of life: its centre was the Yoshiwara district of the town of Edo (present-day Tokyo), a 'pleasure quarter' of Kabuki theatres, tea houses and brothels catering to a wealthy merchant class during a period of rapid urban expansion. Based on a tradition of painted screens and scrolls, the prints circulated as more affordable means to advertise the delights of a leisured existence, to illustrate familiar literary themes, to provide images of celebrated actors and scenes from popular dramas and to record the appearances and occupations of fashionable 'beauties', dressed in the latest kimono styles and patterns. Typical examples produced during the eighteenth and early nineteenth centuries combine elegant linear stylisation with deft use of pattern and texture (pl. 118). As the potential of the medium was developed, successful artists supplied designs for extensive portfolios, extending the range of subjects to include detailed scenes of city life, in many cases employing linear perspective in the western style, together with landscape compositions drawing on different seasons and types of scenery.

119 Hokusai, *South Wind,
Clear Dawn* (*The Red Fuji*),
from *Thirty-Six Views of Mount
Fuji*, 1830–32, woodblock
print, 25.6 × 37.7 cm, British
Museum, London

Hokusai was one of the
greatest draughtsmen,
illustrators and print-makers
of the nineteenth century,
responsible for some thirty
thousand identified pictures,
the finest of them produced
in his old age. This celebrated
image is from one of the
most successful of all
portofolios of woodblock
prints, produced when the
artist was about 70.

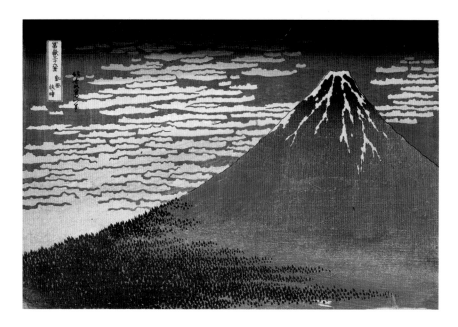

The typical procedure was similar to that by which woodcuts had been produced in Europe in Dürer's time, albeit the process of production and distribution was subject to a more streamlined commercial organisation. A print publisher would commission the artist to provide an original drawing in ink on paper. This would be pasted face down on the woodblock and transferred by a professional block-cutter and a proof impression printed showing the design in black. Until the 1760s any colour would be added by hand. After that time publishers began to issue more expensive editions printed from multiple blocks, sometimes in composite images of two or three sheets. Areas to be coloured would be indicated by the artist and a separate block cut for each colour. After a further proofing stage an edition could be printed, each individual sheet receiving an impression for each colour, with the separate blocks being carefully registered to avoid blurring. A standard first edition was one thousand impressions, though several thousand prints could be taken from a successful block before its quality degenerated noticeably. Sample prints would be displayed for sale by street traders or in publishers' windows, to be purchased in many cases as temporary decorations. Copyright would rest with the publisher. For all the care that went into their production, these were essentially popular productions, ignored by contemporary connoisseurs of fine art at the time and preserved in good condition in only a small minority of cases. That so many have survived at all is a testimony to the vast quantities that were produced. By the early nineteenth century there were

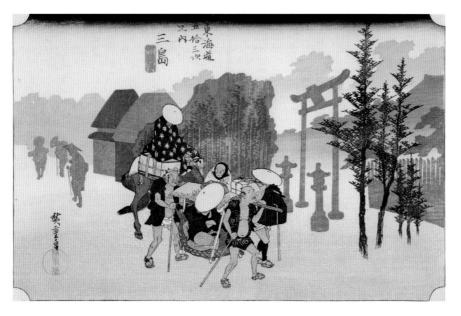

120 Ando Hiroshige, *Mishima, Morning Mist*, from *Fifty-Three Stations of the Tokaido*, 1832–4, woodblock print, 23.7 × 37.3 cm, published by Takenouchi Magohachi, Fitzwilliam Museum, Cambridge

The Tokaido was the imperial road linking the cities of Edo and Kyoto. Hiroshige's fifty-three scenes resulted from a journey he made as an official on a government mission to Kyoto. Their publication made his reputation. The present image is of travellers setting off in mist, one cross-legged in a litter carried by bearers, another asleep on a horse. Figures travelling in the opposite direction are being swallowed up by the mist at the left. Hiroshige was the last great master of the Japanese woodblock print.

many hundreds of publishers in Japan, each issuing prints in editions of several thousand, while an individual artist might be responsible for as many as fifty thousand designs.

As often with printed editions, there tends to be great variation in the quality of different impressions. There can be a world of difference between the appearance of a well-preserved early impression and a late edition carelessly printed from worn or recut blocks, where little control has been exercised over the mixing or registration of colours. As with European woodcuts and engravings, the more popular and successful the print, the more likely it is to have been issued in increasingly degenerate impressions and copies. Seen in their original form, however, portfolios such as Hokusai's *Thirty-Six Views of Mount Fuji* and Hiroshige's *Fifty-Three Stations of the Tokaido* are among the major artistic enterprises of the nineteenth century from any country and in any medium (pls 119 and 120).

Japanese prints were comparatively little known in the west before the second half of the nineteenth century, when they attracted the interest of modernist artists in France, notable among them James McNeill Whistler, Monet, Degas and van Gogh. Their appeal was largely due to two connected factors. At a time when these artists were establishing a deliberate distance from academic norms, Japanese prints presented what seemed new and unconventional ways to conceive of the organisation of pictorial space and the decorative distribution of shapes and colours. And at a

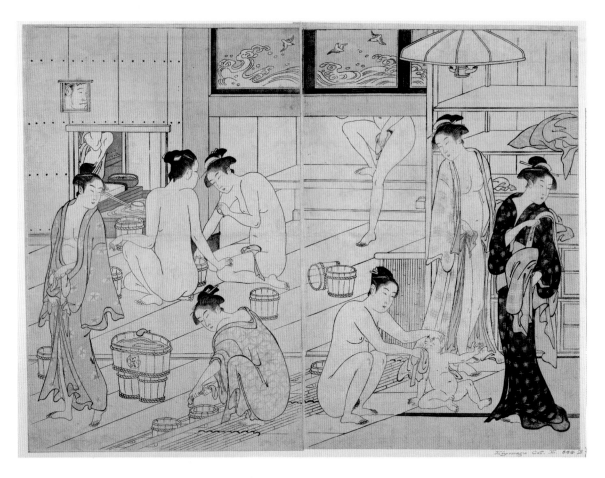

122 (*right*) Edgar Degas,
In the Salon of a Brothel,
*c.*1878–9, monotype print,
ink on paper, 15.9 × 21.5 cm,
Musée Picasso, Paris

This is one of a number of
Degas's brothel monotypes
that were acquired by Pablo
Picasso in the 1940s

moment when Paris, like Edo before it, was seeing the imagery of a specifically modern life established in the work of artists and writers alike, they pictured a world of enticing urban pursuits directed at a rising bourgeoisie (pls 121 and 122). In 1890, a large exhibition of Japanese art was held at the Ecole des Beaux-Arts in Paris, with more than seven hundred woodblock prints among the exhibits.

3.5 PLANOGRAPHIC PROCESSES

Degas's *In the Salon of a Brothel* was made as a monotype, a unique impression made by drawing in ink on a blank plate, then putting this through a press with a sheet of paper to produce a single image. Many of Degas's 150 or so surviving monotypes are of scenes observed in Parisian brothels at the end of the nineteenth century. They are alive with a mixture of sympathetic observation and acid humour, the latter usually at the expense of the male clients.

The monotype is made by a planographic process, that is, it requires neither a relief nor an intaglio image but is printed from the flat inked surface of an unengraved plate. In this case the image is erased in the process. The principal planographic techniques for printing multiple images are lithography and screenprinting. These are both processes capable of considerable variety and sophistication. As a consequence artists employing them have tended to be more reliant on collaboration with specialist technicians than those working as engravers or etchers. Lithography depends on the antipathy of grease and water. The image to be printed is drawn onto the surface – traditionally a smooth slab of porous limestone – with a pen or brush, using a kind of greasy ink mixed with a solvent. This is then bound to the stone with a mix of acid and gum arabic, which also leaves the un-drawn areas resistant to grease and attractive to water. A solvent is then used to remove the pigment, leaving only the grease. To make an impression the stone is sponged with water then rolled with an oil-based ink. The drawn areas attract ink and repel water, while the undrawn areas repel ink and attract water.

The lithographic technique is particularly well suited to reproducing the subtle effects of drawing in soft pencil and crayon and may yield many thousands of faithful impressions. Prints in varied colours can be made by using a different stone for each. The technique was used to fine effect by French print-makers and artists working during the nineteenth century, both to reproduce painted compositions (pl. 123) and to produce original works drawn directly onto the stone (pl. 124).

121 (*facing page, top*) Torii Kiyonaga, *Interior of a Bath-House*, 1787, pair of woodblock prints, ink and colour, 38.7 × 51 cm, Museum of Fine Arts, Boston

Kiyonaga was adept at compositions with several figures, the majority showing scenes of life in the pleasure district of Edo. This work is relatively unusual among Japanese prints in depicting nudes. It is one of a large number of woodblock prints that were owned by the French artist Edgar Degas. An impression was given to him by a Japanese art dealer working in Paris.

123 V. Adan after
Jean-Léopold Boilly, *Entrée du
Théâtre de l'Ambigue-Comique*,
1819, lithograph,
28.7 × 34.4 cm,
author's collection

This early lithograph is based
on a picture by the French
painter Boilly (now in the
Louvre, Paris). It shows the
scrum to gain entry to a free
performance at a popular
theatre.

124 Henri Fantin-Latour,
Etude, 1899, lithograph,
18 × 12 cm, author's
collection

Fantin-Latour is best known
for delicately painted still lifes
of flowers and fruit but he
also made a number of
lithographs. This small print
retains the spontaneous
qualities of an informal life
study drawn in crayon.

Screenprinting was developed in the twentieth century from the use of stencils. It involves using a form of organdie (commonly of silk or of a synthetic fibre) stretched across a frame. Parts of this are blocked out with paper or some opaque medium that adheres to the screen. When ink is wiped across the frame with a squeegee, only the unblocked areas will print on the surface laid underneath. The technique was widely employed in the early twentieth century for printing designs on fabric but was not much used for artists' prints until after the Second World War, when photographic techniques were used in concert with fine screens to produce both subtle half-tone effects and sharp-edged patterns of bright colour. Notable use of silkscreen printing was made by the American artists Robert Rauschenberg and Andy Warhol, who first adopted the technique in 1962, using it to transfer ready-made photographic images onto canvas. Warhol also made a notable series of silkscreen prints on paper based on photographs of Elizabeth Taylor and Marilyn Monroe, his use of colour exaggerating the artificial effects of the film stars' maquillages (pl. 125).

125 Andy Warhol, *Marilyn*, 1967, silkscreen on paper, 91.5 × 91.5 cm, edition of 250, Kunsthalle, Hamburg

This image is taken from a publicity still used in 1953 for the film *Niagara*. Warhol had first used it soon after Monroe's death in 1962, in paintings made by silkscreen printing on canvas. (For Warhol see pl. 108.)

Modern lithographic and silkscreen processes are both capable of yielding many thousands of impressions without deterioration, distinguished from ordinary commercial reproductions only by the quality of ink and paper employed. It follows that when such editions are limited in number and signed by the artist, the motivation is more likely to be the maintenance of a certain rarity value and price level than the need to maintain the integrity of an original design. Where such enterprises are concerned, the line dividing fine-art print from reproduction becomes altogether indistinct. In the case of highly popular artists such as Picasso or Salvador Dalí, photographically reproduced pictures may be offered for sale in huge editions with signatures which are part of the printed image. Rather than bargain prints, these may more appropriately be regarded as very expensive reproductions.

It is to a certain extent the lure of the signature – and of the conventional stereotypes of artistic authenticity – that underwrites the market for such things. A different understanding of the potential for large editions was pursued during the Conceptual Art movement of the late 1960s and 70s, when a number of artists turned to printed media for works that took the form of texts, diagrams and plans and which could therefore in principle be distributed in unlimited numbers. Some of these were printed by

This is one of a series of works the English artist made in 1969 and 1970, at a time when he was proposing that the concepts of artistic object and artistic form should be dissociated from the world of manufactured things and redefined in terms of the structures of psychological experience. In this case the result is a work that has its existence, in Burgin's words, in 'message rather than in materials'. Although the issuing of signed and limited editions of texts such as this was often used as a means of ensuring some financial return for the artist, *Any moment . . .* was given unlimited distribution by being printed on the page of a magazine.

```
0
ANY MOMENT PREVIOUS TO THE PRESENT MOMENT
1
THE PRESENT MOMENT AND ONLY THE PRESENT MOMENT
2
ALL APPARENTLY INDIVIDUAL OBJECTS DIRECTLY EXPERIENCED BY
YOU AT 1
3
AL OF YOUR RECOLLECTION AT 1 OF APPARENTLY INDIVIDUAL
OBJECTS DIRECTLY EXPERIENCED BY YOU AT 0 AND KNOWN TO BE
IDENTICAL WITH 2
4
ALL CRITERIA BY WHICH YOU MIGHT DISTINGUISH BETWEEN
MEMBERS OF 3 AND 2
5
ALL OF YOUR EXTRAPOLATION OF 2 AND 3 CONCERNING THE DIS-
POSITION OF 2 AT 0
6
ALL ASPECTS OF THE DISPOSITION OF YOUR OWN BODY AT 1 WHICH
YOU CONSIDER IN WHOLE OR IN PART STRUCTURALLY ANALOGOUS
WITH THE DISPOSITION OF 2
7
ALL OF YOUR INTENTIONAL BODILY ACTS PERFORMED UPON ANY
MEMBER OF 2
8
ALL OF YOUR BODILY SENSATIONS WHICH YOU CONSIDER CON-
TINGENT UPON YOUR BODILY CONTACT WITH ANY MEMBER OF 2
9
ALL EMOTIONS DIRECTLY EXPERIENCED BY YOU AT 1
10
ALL OF YOUR BODILY SENSATIONS WHICH YOU CONSIDER CON-
TINGENT UPON ANY MEMBER OF 9
11
ALL CRITERIA BY WHICH YOU MIGHT DISTINGUISH BETWEEN
MEMBERS OF 10 AND 8
12
ALL OF YOUR RECOLLECTION AT 1 OTHER THAN 3
13
ALL ASPECTS OF 12 UPON WHICH YOU CONSIDER ANY MEMBER OF
9 TO BE CONTINGENT
```

lithographic techniques and some by the relief medium of letterpress, some in the form of single sheets, some as sequences of individual pages, some as small books. A number used photographs as kinds of 'neutral' picture. Although the initial market for such works was not great, and though most were in fact issued in relatively small numbers, the aim was not so much to establish their rarity value as deliberately to put them outside the category of the autographic.

An autograph work is one validated by the artist's individual touch. Even an engraving from an artist's hand is an autograph work. However, while an original musical score and the manuscript of a novel are both kinds of autograph, neither the enjoyment of a piece of music nor the

The convertible exploded. It went roar thump. The body accelerated upwards, away from the heavier mechanical parts. The roof tore open at the front. The rear axle and part of its subframe assembly caught up with and passed through the rear body, upwards and forwards. The doors and the windshield burst. A few passers-by were injured. Some were deafened by the concussion, others were lacerated by glass.

127 Art & Language, *Hostage LXVI (The Convertible exploded)*, 1990, silkscreen text on paper, glass, oil on canvas on wood, 214 × 142.5 cm, artists' collection

Art & Language was formed in England in 1968 and was central to the original Conceptual Art movement. Since 1976 the name has designated the artistic work of Michael Baldwin and Mel Ramsden alone (with my collaboration on literary projects). This is one of a series of paintings based on an image of a row of poplar trees. Areas of the wet painted surface have been deformed by being pressed from behind against an applied surface of glass. A printed text has then been pasted over the glass like a kind of poster. This refers to an event occurring in a very different world from that of the painted landscape.

reading of a novel depends on access to the work in that form or on the exact repetition of any marks made by composer or writer. The musical performance and the printed novel are allographic forms (in legal terms,

an allograph is a document signed on behalf of another). Given the greatly reduced role that hand and eye had had to play in modernist art, the strategy of Conceptual Art was deliberately to downplay the value of the artist's touch – or rather to suggest that that value was already fatally compromised. If visual art could be treated as a potentially allographic medium, then perhaps less attention might be devoted to stereotypes of artistic authenticity and to the 'aura' of originality associated with the hand-made, and more to the idea content of the works themselves (pl. 126).

During the 1970s, the Conceptual Art movement spread from New York and England to attract adherents across the world. Like many episodes in the history of art, it produced a certain amount of highly original work that was in principle reproducible without loss, and much trivia in printed form. As already suggested, there has actually been no diminution in the amount of new paintings – and of other kinds of exotic autographic objects – that have been ushered into the world since the 1970s. What has changed is that the combination of printed texts with pictures and objects is no longer regarded as though it involved a submission of art to literature (pl. 127).

PART 4

SEEING SCULPTURE

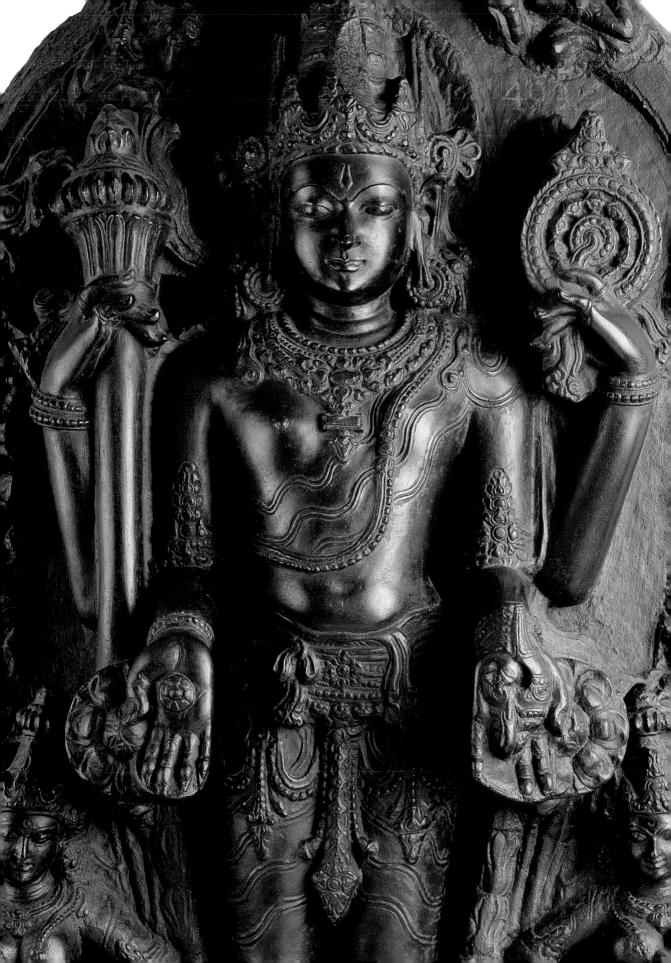

4.1 SOME PROBLEMS WITH SCULPTURE, PART I: THE FIGURE

Our attention so far has principally been directed to works of art painted or printed on flat surfaces. It is time to turn to the consideration of sculpture, an art form that presents a different range both of possibilities and of problems. While it is an art of great antiquity and diversity, it has attracted far less attention from historians and critics. There are many individual works of sculpture that are highly valued and many that have been celebrated over centuries. Yet the evidence suggests that sculpture is harder to write about than painting, harder, at least, to write about with what the American critic Clement Greenberg called 'real relevance'; that is to say 'relevance to the quality of effect'. I shall explore some of the reasons why this might be the case but I also hope to provide the reader with some guidance to the great variety of the art form and to the extraordinary achievements of those who have pursued it.

In 1846 the poet Charles Baudelaire wrote a long review of the French Salon. The sixteenth of his eighteen sections was devoted to sculpture. He titled it 'Why sculpture is so tedious'. This was a low moment in the history of the art, perhaps the very lowest, and Baudelaire was exaggerating for rhetorical effect, but he had two apposite points to make. The first was that, unlike painting, which establishes a single viewpoint 'on its own terms', sculpture suffers from 'a certain vagueness and ambiguity' as a consequence of the myriad faces it presents to the viewer. The second was that once sculpture advances beyond the primitive and the 'carving of fetishes', it becomes subordinate to painting and architecture, being often coloured and incorporated into the schemes of buildings. Baudelaire foresaw, however, that sculpture would effect a kind of return to the primitive. 'At the beginning and the end, it is an isolated art.'

Baudelaire's forecast was indeed fulfilled, as will be seen, albeit it is clear in the light of that fulfilment, and of a far wider survey than he was in a position to make, that sculpture is a far from tedious art. In one respect, however, the finest critic of the nineteenth century had reason on his side. It is difficult to grasp the great potential of sculpture as a form of art without some understanding of the problems it poses, both for the artist

facing page Vishnu, India, West Bengal, Pala period (detail of pl. 180)

and for the spectator. Where a painting generally has the power to distinguish its content from its surroundings, a sculpture is always situated in a surrounding space and world. Furthermore, though a typical painting may be fully before the eyes as a whole, the same is rarely true of a three-dimensional sculpture. At the beginning of this book I referred to works of painting and sculpture as things that are there to be seen all at once. Where sculpture is concerned, that statement needs to be modified. Works modelled or carved in relief may present a single face to the spectator, while a sculpture intended for a place in a niche or on a facade will at the least presuppose a restricted angle of view. A figure made in the round, however, is a thing that is never seen in its entirety from a single viewpoint, for all that it is as fully present as a painting. Either it must be turned – as a small sculpture held in the hand may be – or the viewer must walk round it. This means that our sense of it as a whole will depend to some extent on our memory – and this despite the tendency of sculpture to appeal more or less irresistibly to the actual or imagined sense of touch.

Where sculpture of the human figure is concerned, we do indeed have a strong sense of how a partial view is to be completed. We have the ability to intuit physically what is on the other side of a body that presents itself to the viewer, to sense how its weight is spread and limbs disposed and to feel for the emotion that might be driving a gesture or a facial expression. Perhaps partly for this reason – because we can so readily relate its forms to our own – the variously represented human body, in whole or in part, is by far the commonest subject in all the world's sculpture. In recognition of this preponderance, my discussion of sculpture will be largely concerned with images of the human figure. During the second half of the twentieth century there was a marked shift away from the representation of the human figure as a central preoccupation of sculpture. At that point, however, a kind of complementary emphasis fell on the spectator's own embodied presence as a condition to which the work of art draws a special kind of attention.

Of one thing we can be sure. The ability to make a durable three-dimensional image of the human body is a severe test of the competences of the artist and not simply because the plausibility of the result is a matter on which the audience is likely to have the strongest of opinions. No sculptor who chose the human figure in preference to other possible subjects is likely to have done so because it appeared easy to represent or was well suited on practical grounds to the relevant processes, whether these involved the subtractive activities of carving – commonly in varieties of wood or stone – or the principally additive activities of modelling in clay or plaster. (I shall have more to say about the distinction between subtractive and additive processes in following sections.)

128 (*facing page*) Alberto Giacometti, *Man Pointing*, 1947, bronze cast, h. 178 cm, Tate Modern, London

Giacometti was a Swiss sculptor and painter, connected with the Surrealist movement in the 1930s. After the Second World War he drew the attention of French Existentialist writers and philosophers with his attenuated figures, apparently alone in empty tracts of space. The original of this bronze was modelled in plaster on a metal armature. Giacometti's tendency at the time was to start with a more substantial body of material and gradually to reduce it to a thin and highly textured final form.

At the heart of all sculpture of the human figure, there is a defining paradox. The actual human body has evolved in nature to be strong and adaptable in the face of the demands of life. Its structure of bones, tendons and muscles is both stable and flexible, built to withstand the various stresses of an adventurous existence. In their manifest exhibition of these virtues, young, healthy and athletic bodies exercise a particular appeal. Yet a sculpture of the human figure made in a heavy and unstressed material, like stone, clay, bronze or even wood, while it may be more durable than the actual body, is relatively inflexible and is thus highly vulnerable to accidents and forces which that body is built to withstand. Widely different levels of stress will follow from differences in weight. A figure in clay will weigh half as much again as an actual human body. A figure in stone will weigh many times as much. Even a hollow figure in bronze will be a very heavy item. Considered as a subject for sculpture, the erect figure balances precariously on two long legs with its heaviest component, the head,

perched at the top on the thin stem of the neck, rendering the whole highly unstable. Even a horse or a bull can at least be naturally represented with its weight distributed across four legs. The features of the human figure are complex and detailed, its hair mostly concentrated on the head, tending to idiosyncrasy in arrangement and often untidy. Its spindly arms are liable to project out some distance from their vulnerable points of attachment on the shoulders and they end in fragile fingers (pl. 128).

In view of the problems posed by the standing figure, it might be thought that sculptors would prefer a pose with the body extended on the ground, given that that would be relatively straightforward, physically stable and far less vulnerable to breakage. The supine position tends to be avoided, however, except for the purposes of funerary monuments. This is not just because it offers fewer possibilities for animation but because its default association is indeed with the absence of life (pl. 129). It is not hard to see why the ancient Egyptian sculptors

liked making images of seated cats and why many of these have survived intact where other of their productions have been broken (pl. 130). You know where you are with an image rising gradually from a solid base to a smoothly articulated peak. When complete in all its parts, the live human body is far less likely to present the kind of compact image favoured by the processes of both carving and modelling.

The paradoxical aspect of sculpture of the figure is that for all the problematic difference in materials from the real human body, the medium possesses the potential to represent not only that body's surface properties but also the very structural strength, mobility and expressiveness that are its distinguishing virtues – and to do so in images of enormous variety and appeal. The basis of painting's virtuality lies in the animation of the flat surface – its transformation into the carrier of a distinct kind of content. In the case of sculpture it is the transformation of one body of material into the image of another that holds the attention. This is effected not only in substance but often also in scale; not only marble or bronze so worked as to represent the softness and pliability of flesh but also objects in a full range from the colossal to the miniscule (see pls 9 and 211) endowed with a capacity to reflect us back to ourselves, however radically altered. In a typical painting, a human figure ten centimetres high occupies a world that is scaled down accordingly. The painter has already done much of the work of imaginative adjustment that allows us to relate that figure to the world of our own bodily sensations. In contrast, the miniature figure that stands on my desk occupies the same world as I do and must somehow distinguish itself against the background of the everyday. It does so through its possession of a kind of integrity and self-sufficiency – an appearance of life that elicits a matching sensation from me.

A high price is paid for realisation of this representational potential, however. Whether in carved or in modelled sculpture of the figure, while

the goal of ambitious work may be to achieve the maximum appearance of animation and expressiveness, much of the artist's inventive activity must be directed towards the satisfactory distribution of weight and the minimising of vulnerability to breakage. Such efforts notwithstanding, the sculpture that has survived entirely intact for centuries, let alone millennia, is a great rarity. There could be no more compelling evidence of the sheer unsuitability of the human figure for representation in sculpture than the myriad surviving casualties, testaments to erosion or to accident or to the purposeful activities of iconoclasts: bodies broken at the feet or the knees; bodies missing heads or arms or all of these; faces missing noses and ears; arms missing hands, hands missing fingers and so on.

We have had to make the best of this. In the west, for as long as there has been interest in the art of earlier ages – at least since the Italian Renaissance in the early fifteenth century – the enjoyment of sculpture has been virtually inseparable from an aesthetic of the damaged, the incomplete and the fragmentary, particularly where it is a partial image of the human body that is the object in view. Perhaps sometimes there is a kind of release in the fractional body from the demands on the imagination made by the complete and complex whole. Among the most haunting of fragments from ancient Egypt are a portion of the face of a queen carved out of yellow jasper and a red quartzite torso, believed to be of Queen Nefertiti (pls 131 and 132). Of all fragments surviving from ancient times, however, none have been more widely celebrated and more thoroughly aestheticised than the remaining components of the sculptures from the pediments of the Parthenon, included among the Elgin marbles in the British Museum (pl. 133). This persistent association of sculpture with the damaged and the incomplete was given a kind of self-conscious expression in the modern period. From the end of the nineteenth century onwards it became common practice for sculptors to issue partial images of the body as finished works (pl. 134).

The aesthetic of the fragmentary has generally been pursued in a kind of awkward tension with the urge to restore. This urge may also be prompted by aesthetic considerations; it may spring from a desire on the part of some wealthy connoisseur that the imagined whole figure should be completed or from the dedication of a later craftsman working in a spirit of emulation, or from both in collusion. (In 1550, at the request of Duke Cosimo de' Medici of Florence, the sculptor Benvenuto Cellini added a head, arms, feet and an eagle to a marble torso from ancient Greece.) The urge may be driven by mercenary and fraudulent interests, perhaps by a dealer in antiquities with a gullible collector in mind. It may result from some mixture of these motives. Among the apparently complete sculptures that have survived from ancient times, many have at some point had missing or damaged parts restored, restoration being a process that

130 Seated cat, from Saqqara, Egypt, late period (661–332 BCE), bronze with gold rings and silvered collar, 42 × 13 cm, British Museum, London

Cats were identified in Egypt with the goddess Bastet, whose cult flourished during the late period, especially in the area of the Nile Delta. Mummified cats have been found in special cemeteries, where they were interred as signs of devotion to the goddess.

131 (above) Fragment of the head of a queen, Egypt, 18th dynasty, c.1353–1336 BCE, yellow jasper, l. 14 cm, Metropolitan Museum of Art, New York

Jasper is one of the hardest materials ever to be used for carved sculpture. This elegant fragment is dated to the brief period when the revolutionary Pharaoh Akhenaten moved the base of the royal family from Thebes to Amarna and instituted a new religion based on worship of a single divine force, manifested in the light of the sun. His reign is also associated with a remarkable development in Egyptian sculpture, particularly evident in sensuous and relatively naturalistic images of his queens and daughters. The complete head would once have been attached to the body of a statue. It has been tentatively identified with Queen Tiye.

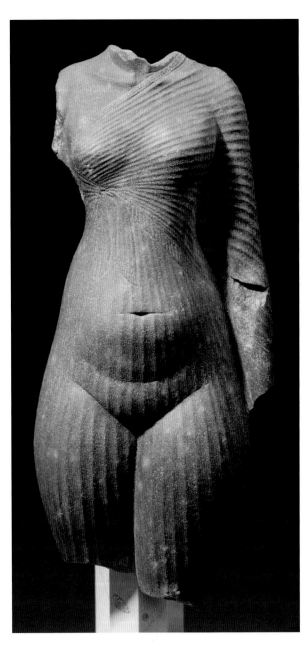

132 Torso of a Princess, Egypt, 18th dynasty, c.1353–1337 BCE, red quartzite, h. 29.4 cm, Musée du Louvre, Paris

Dating from the same period as pl. 131, this torso is thought to represent Akhenaten's chief wife, Queen Nefertiti (meaning 'the Beautiful One is here'). Wide hips and full buttocks propose an ideal of female beauty distinct from that of preceding periods of Egyptian art, though familiar from far more ancient figures. The queen's body is shown as clothed in a thin undergarment of fine pleated linen, over which she wears a fringed shawl of even finer pleats, knotted below the right breast. Here the effect created by the sculpted folds is so compelling that we accept without thought the illusion that these continue over the gap where torso and thighs meet. As this statue demonstrates, balancing the relationship of mass to surface detail is crucial to the success of figurative sculpture.

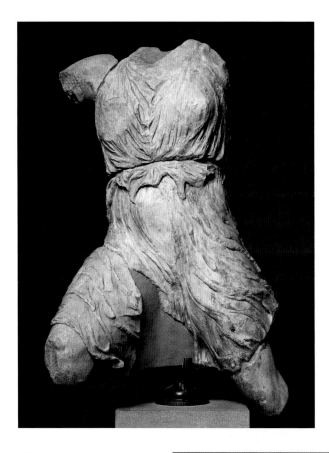

134 (*below*) Auguste Rodin, *Flying Figure No. 1*, 1889–91, bronze cast, 1964, 53 × 78 × 30 cm, Musée Rodin, Paris

It was principally the French sculptor Rodin who was responsible for introducing partial and fragmented figures into the canon of accepted subjects for sculpture. While the largely classical remains to which these refer are complete works that have suffered damage, Rodin's partial figures were either derived from sculptures in the making or were conceived from the start as incomplete bodies. Rather than testifying to the effects of the passage of time, they make finished material from the working processes of figurative sculpture. This work was originally modelled in plaster. (For Rodin see also pl. 210.)

133 (*above*) *Iris*, torso fragment from the Parthenon marbles, 447–432 BCE, marble, British Museum, London

Originally this stood on the east pediment of the Parthenon. In Greek mythology Iris was responsible for carrying messages from the gods. Dressed in thin silk, she was normally represented with wings. (See pl. 32.)

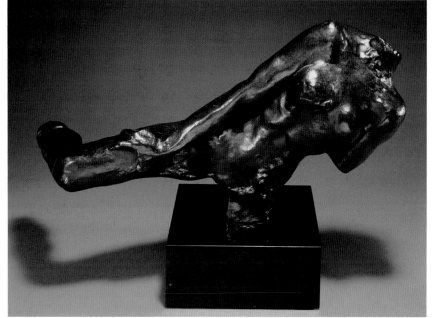

135 (*right*) Statuette of a man, Egypt, late pre-dynastic, Naqada III period, c.3100 BCE, basalt, 39.5 × 10.8 × 7.5 cm, Ashmolean Museum, Oxford

Assembled from three fragments, this figure is believed to have come from a site in Upper Egypt excavated at the end of the nineteenth century. Although its authenticity has been questioned, it is similar to smaller figures in ivory from the pre-dynastic period, which show the same lengthy penis-sheath (broken at the top in the basalt statue). The legs are missing from below the knees.

136 (*far right*) Statue of Amenhotep III (on a sledge), Egypt, c.1350 BCE, purple quartzite, life size, Luxor Museum

Amenhotep III was the father of Akhenaten (see the caption to pl. 131) whose original name was Amenhotep IV. This well-preserved statue was among several found buried under a courtyard in the palace of Luxor during reconstruction works in the late 1980s. An exceptional feature of this figure is the sledge on which it stands. Made of wood, sledges such as this were used in ancient Egypt to tow completed sculptures into place once they were finished. The implication is that the pharaoh is represented as a statue.

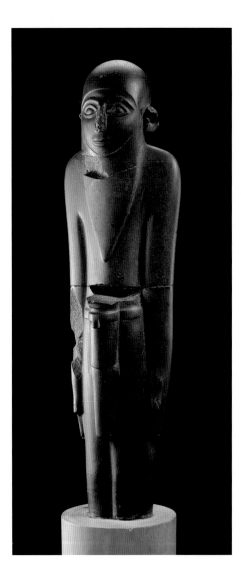

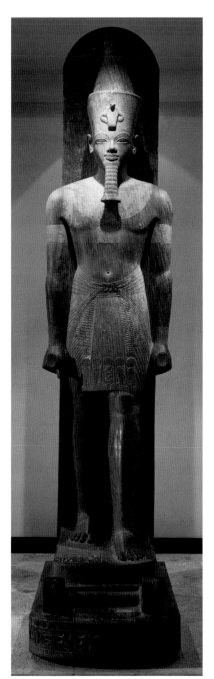

can be carried out with more or less accurate knowledge about a work's likely original state and with more or less skill and care.

Given the problems encountered in the sculptural representation of the human body and given also the relative restriction on horizontal poses, the most easily represented whole image from a technical point of view is the figure standing with feet together and arms at the sides or laid across the breast. Not only does it require no deep undercutting, no penetration of the block of material, no vulnerable projections, it is also the most straightforward in its appeal to the imagination of the spectator (pl. 135). All things being equal, figure sculpture tends to favour a frontal view, concentrating detail and variety on the primary indicators of age, sex and personality. The forward-facing side will provide a strong indication of the appearance of the back – if the back is completed at all. When a figure is intended for a position against a wall or in a niche the unseen reverse side may be left unworked.

Departures from this basic pose are signs of certain kinds of development in sculpture, both chronologically and technically. In Egyptian carvings, the movement forward of one leg is sufficient to moderate the formality of the hieratic standing pose with feet together (pl. 136). In Greek marble sculpture of the fifth century BCE, the slightest shifting of the principal weight of the body towards one leg achieves a further considerable animation of the standing male figure. The philosopher G. W. F. Hegel associated this development with the emergence of a reflexive self-consciousness in the individual: the moment at which the brute body may be said to be animated by a 'soul' (pl. 137). In certain Italian works

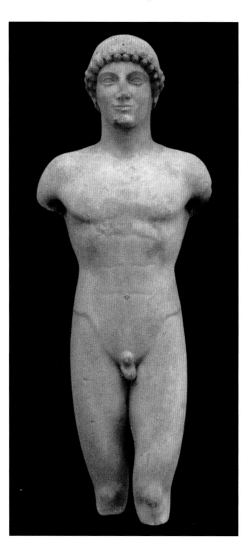

137 Kouros (the 'Strangford Apollo'), said to be from the island of Anapha in the Cyclades, c.500–490 BCE, marble, h. 101 cm, British Museum, London

The Greek word *kouros* means 'youth'. Archaic figures of this type were used as representations of gods or heroes or as grave markers for individuals. They are typically almost symmetrical round the vertical axis, with arms at the sides and slightly smiling features, but with the feet set slightly apart and weight evenly distributed between them. This figure from the very end of the Archaic period shows signs of increased animation, notably in the suggestion of a slightly uneven distribution of weight. It is named after a previous owner, Viscount Strangford. (For periodisation in Greek art see caption to pl. 32.)

138 Michelangelo, *Victory*, c.1520–25, marble, h. 261 cm, Palazzo Vecchio, Florence

Two Italian terms are used to describe the effects employed by Michelangelo to create a sense of suspended movement in sculptures such as this: *contrapposto*, literally meaning 'counterposed', refers to the twisting of the torso so that the shoulders are set at an angle to the hips; *figura serpentinata*, literally 'serpentine figure', refers to a further development in which one or more figures are arranged as though in an upward-turning spiral. (For a notable example of the latter see pl. 146.) The face and neck of the figure of Victory show clear signs of Michelangelo's characteristic use of the claw-chisel to create a surface equivalent to the cross-hatching of a drawing in pen and ink. In more highly finished works such as the *David* (pl. 217) these striations are smoothed away with abrasives. (For Michelangelo see also pls 14 and 156.)

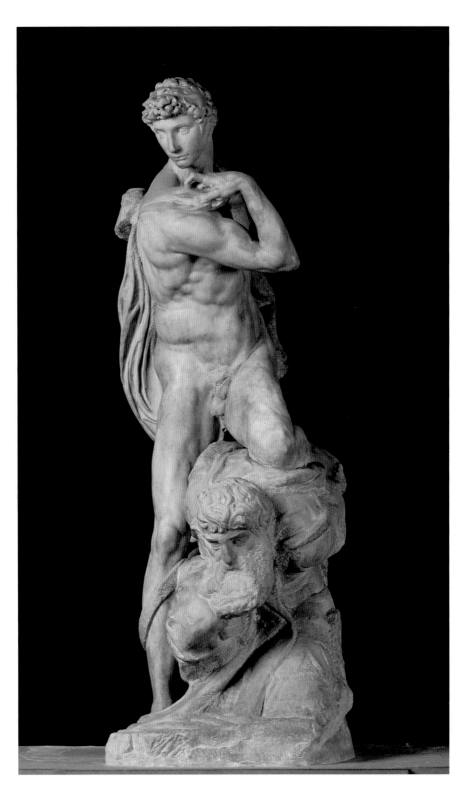

of the sixteenth century, the standing body is turned at the waist, so that the line of the shoulders is at an angle to the line of the hips (pl. 138). The effect of such developments is to endow the figure with a sense of arrested or impending movement and thus to prolong the spectator's apprehension of the whole body. It was at this period that artists came increasingly to conceive of the sculptured figure as one that should present a variety of different configurations according to the changing viewpoint of the spectator.

Where sculpture in stone is concerned, improvements in the materials from which sculptors' tools were made played an important part among the factors by which these developments were enabled. The early Egyptians and archaic Greeks were limited to stone tools and to punches made of bronze – an alloy of copper hardened with an admixture of tin. Being too soft to carve out material with oblique strokes, a bronze point could only be used with a mallet at right-angles to the stone surface and would still require continual resharpening. Surviving unfinished statues show heavily stippled surfaces that would have had to be laboriously smoothed down with abrasives – sand, pumice or emery, the last found in Asia Minor and on the Greek island of Naxos. It was not until after about 500 BCE that the Greeks had recourse to iron tools. By this time a basic range of stone carvers' equipment was established for the next two and a half millennia: besides the punch and bow- or running-drill, pointed and serrated hammers, flat and bull-nosed chisels, a claw-toothed chisel that would carve parallel grooves, rasps and an auger (a drill worked with a crank handle). This basic repertoire was not really increased when steel of high quality became available in the sixteenth century, though improvements in the durability and sharpness of the tools led to considerable extension in the effects that could be achieved, particularly where these involved undercutting or the refinement of detail.

Developments in Greek sculpture after the classical period show an increased interest in the animation of figures and variation of poses. Seated, kneeling and crouching poses all present different aspects from different viewpoints and thus tend to be harder to fix as single images in the mind. Many of the most appealing figure sculptures are those that maximise this effect, where poses have been selected that present different configurations from each viewing angle. The *Crouching Venus* dates from about 1600 and was cast in bronze by Antonio Susini, who worked in Italy (pl. 139). It is based on a model by Giambologna that adopts the pose of a Greek figure known through Roman copies (pl. 140). While the Greek original may be assumed to have been a life-sized figure carved in marble, like the Roman version illustrated, the bronze is small enough to be held and turned in the hand. A strong part of this work's poignant

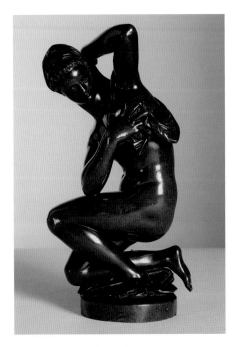

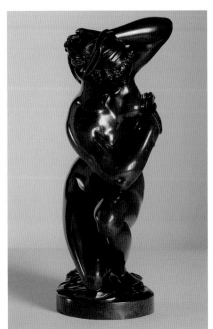

139a and b. Attributed to Antonio Susini, *Crouching Venus* or *Kneeling Woman drying herself*, c.1600, bronze, h. 24.9 cm, after a model by Giambologna, Holburne Museum, Bath

Susini worked as an assistant to the sculptor Giambologna (see pl. 146), as a specialist in the production of bronze statuettes. Many of these, like the present work, were smaller versions of antique statues. After 1600 Susini had his own workshop, though Giambologna continued to supply him with models. His bronzes are distinguished by the high quality of the casting and finishing. This version was formerly in the collection of Louis XIV.

140 *Crouching Venus*, 1st–2nd century Roman copy of Greek original of 2nd or 3rd century BCE, marble, h. 112 cm, British Museum, London, lent by HM Queen Elisabeth II

This is one of several Roman versions of what is assumed to be a lost Greek original (others are in the Louvre in Paris, the Uffizi in Florence and the Museo Nazionale delle Terme in Rome). It was formerly in the collection of Charles I and following his execution was acquired by the painter Sir Peter Lely, re-entering the royal collection after Lely's death. The relatively rough treatment of the back suggests that it may have been made to be set in a niche.

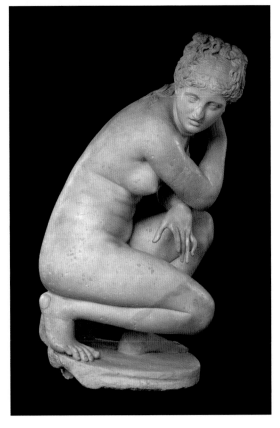

appeal is that any single viewpoint from which one may try to remember it invokes the expectation of others from which its profile will be quite different. Here the strong tendency to favour a forward-facing view is countered by the turning of the head towards the left shoulder, so that the sight of the kneeling woman's face and features coincides, exceptionally, with a side view of her legs and torso. Given the complexity of the pose, each new aspect perceived supplements one's initial impression, providing more material for the memory and imagination to absorb in filling out an image of the whole.

In principle, the experience of viewing a sculptured figure in a photographic reproduction must clearly be even more remote from the first-hand encounter than it is in the case of a painting. A photograph flattens and fixes the image of a sculpture in a single aspect, as seen from one viewing angle, with a given direction and strength of lighting. Yet it is of the essence of the experience of sculpture that we tend to find ourselves in motion in its presence, seeking optimal positions and angles of view, and that different lighting conditions will tend to bring out different aspects and effects. We speak of prints and photographs as 'reproductions' of paintings but properly to reproduce a sculpture we need a three-dimensional equivalent – a copy or a cast. Where a small reproduction of a large painting will still provide access to much of its content, to reduce a life-sized sculpture to the size of a desk-top object is radically to change its nature – a point which confirms the importance of scale in contributing to the virtuality of sculpture.

How light falls can be crucial in the case of the draped figure. Early in the fifteenth century the Italian sculptor Donatello carved a number of life-sized statues of prophets in marble. These were made to occupy niches in the bell tower of the cathedral in Florence and were thus to be seen at some height from the ground against a patterned architectural background – a difficult context if the figures were to register in all their individuality. The sculptor's solution to the problem was to dramatise the relationship between mass and surface and between the draped and undraped portions of each of the figures. In the statue of Jeremiah, the clothing is rendered as an emphatic landscape of ridges and folds and hollows that entirely swathes the prophet's torso, making the contrast all the more marked with his stern Roman-style head, bared shoulder and long right arm (pl. 141). The original carving is now housed indoors for protection, but this was a figure designed to be seen under conditions where the effect of changing light on its strongly projecting edges and receding concavities would have added a continual variation and animation to its appearance. The photographs through which such works become widely known tend, however, to reduce each to a single memorable image.

141 Donatello, *Jeremiah*, *c.*1425–36, marble, h. 191 cm, Museo dell'Opera del Duomo, Florence

The highly decorated bell tower or *campanile* of Florence cathedral was begun by Giotto in 1334. Its design included a number of niches to be filled with statues. Donatello completed the first two of these in 1418 and 1420 and continued to work on the project until the 1430s. The original marble carvings have now been replaced by copies.

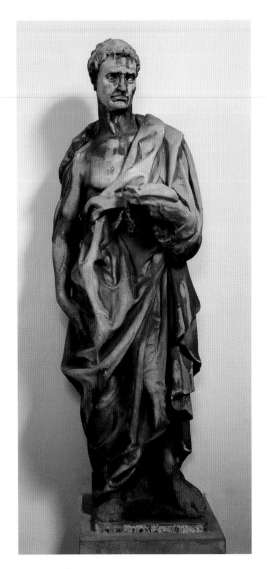

The relative remoteness of the photographic image from the actual work may be one reason why far less is written about sculpture *pro rata* than about painting and why it attracts proportionately fewer publications. It may also help to explain why sculpture seems in general to be regarded as a less accessible art form than painting. Exhibitions of work by celebrated sculptors rarely draw the same levels of attendance as exhibitions of well-known painters. Compared to the number of people that hang reproductions of paintings on their walls, few hang photographs of sculptures – or even devote space on their shelves and tables to the kinds of reproductive casts that can usually be bought from museums. Yet it

remains the case that there are numerous works of sculpture, from diverse periods and cultures, that appear to exercise an abiding power over those who have actually seen them – those, that is, who have experienced their effect at first hand.

4.2 SOME PROBLEMS WITH SCULPTURE, PART 2: THE FRAME OF VIEWING

I observed in the last section that many works of art seen in museums are far removed from their original contexts of use and display. This is a factor of particular consequence where sculpture is concerned. It could be said of easel painting – at least of painting in the European tradition since the fifteenth century – that it has considerable powers of self-contextualisation. The framing edge that marks the boundaries of the image, the picture plane that serves to define the limits of the represented space, the background that both closes off that space and describes a setting for figures or still-life objects, even the rhythmical relations across a flat surface by which abstract works may be rendered coherent, these all contribute to the sense that the painting is a self-sufficient thing, preserving at least a significant aspect of its identity wherever it may be displayed. Even a picture executed in fresco directly on a wall, though it may retain a strong sense of the place and context to which it is adapted, will generally include some kind of depicted framing, so that the virtual space of the representation is clearly demarcated from the literal surface on which it is painted and its integrity thereby assured. Sculptures designed to be seen as independent and self-sufficient images have traditionally been placed on plinths – sculpture's nearest equivalent to the frame that serves to separate the painting from its surrounding environment. Even in such cases, however, free-standing sculpture is generally far less readily insulated than painting from the environments in which it is seen. As already suggested, it occupies a field of view in which other objects and surfaces are bound to appear. In the case of monumental sculpture preserved at religious sites – whether on temples in Egypt, on temples and cave complexes in India and China or on churches in Europe – it may be not merely difficult but perhaps inappropriate to isolate some specific 'work of art' from the display provided by an overall decorative and architectural programme (pls 142 and 143).

In the museums of Europe and America many individual figures and other fragments are nevertheless to be found that have at some point been detached from such programmes. While in some cases they may have been salvaged from ruins, in others the extraction of parts may actually have

142 Carved reliefs, c.1025–50, sandstone, facade of the temple of Kandariya Mahadeva, Khajuraho, Madhya Pradesh, India

The walls of this large Hindu temple contain three horizontal bands of carved statuary, with some 650 individual figures. These represent Shiva in various manifestations, together with consorts and other divinities, some engaged in a variety of sexual acts. Their overall theme evokes the marriage of Shiva and Parvati. The bands of decoration may have functioned to provide the temple with a protective clothing symbolic of fertility and abundance.

143 (facing page) Buddha Group, Tang dynasty, c.725, painted clay, Dunhuang, cave 45 (rear niche), Gansu Province, China

Dunhuang is situated on the northern Silk Road, the artery that connected China with India, Central Asia and the Mediterranean. The many caves carved in tiers out of a cliff face served from the fourth century to the fourteenth as Buddhist temples, monasteries, sanctuaries and libraries. Of nearly 500 surviving caves the majority are highly ornamented with paintings and sculptures on Buddhist themes. Clay was used for many of these sculptures as a consequence of the excessive softness of the rock. In 1900, thousands of manuscripts and scroll paintings were discovered in a cave in Dunhuang that had been sealed in the twelfth century.

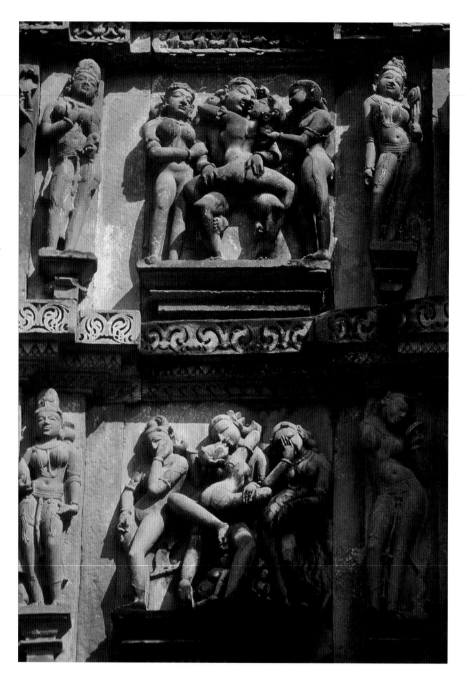

contributed to the ruination of the whole. It was no doubt precisely because the fragments in question offered the potential for isolated aesthetic enjoyment that many of them were selected for salvation or extraction, by collectors who assumed that their religious function had been forgotten or could simply be ignored, by traders who saw a profit in cater-

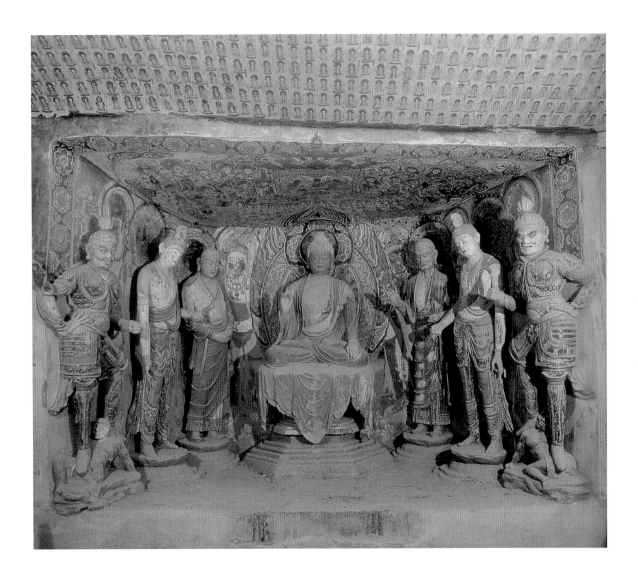

ing to collectors' tastes or by representatives of museums and scholarly institutions who considered that they were acting responsibly by safe-guarding endangered artefacts. An early and notable example of the last instance is provided by the work of Alexandre Lenoir, curator of the Musée des Monuments Français. This was set up in Paris in 1792 to house medieval sculptures and architectural fragments confiscated from the nobility or removed from churches during the French Revolution. For a brief while it drew visitors from all over Europe, encouraging a Roman-tic taste for art outside the classical canon. We are reminded that sculp-tured images of rulers, saints and deities are particularly vulnerable to political changes, religious upheavals and iconoclasm (the breaking of images, usually on the grounds that they are offensive to religious beliefs).

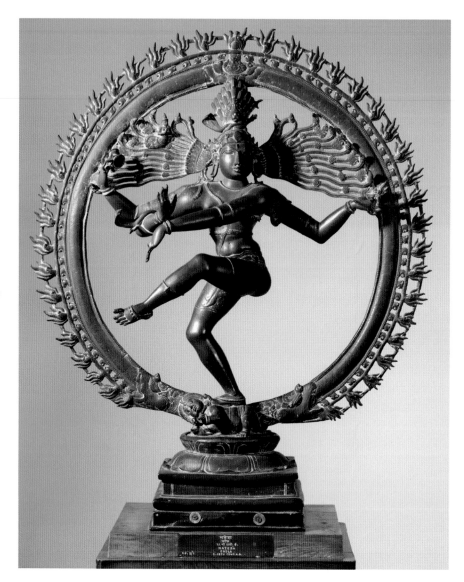

144 *Shiva as Nataraja (Lord of the Dance)*, Chola period, 12th century, bronze, 97 × 83 cm, National Museum of India, New Delhi

The Chola dynasty ruled in south India from the ninth century to the thirteenth. Their patronage led to a great increase in the building and endowment of temples and shrines for Hindu, Buddhist and Jain faiths. The Chola rulers themselves were followers of Shiva and were particularly associated with his incarnation as Nataraja. Bronzes such as this were made by the lost-wax process (see section 4.7) and were paraded annually in rituals that are still performed

Many figures that once had a ceremonial or religious function in their place of origin are to be found in modern museums not because they have been dismounted in modern times but as a consequence of actions taken hundreds or even thousands of years ago. A considerable number of Hindu bronzes of the Chola period from south India have been recovered from sites where they were buried to avoid destruction by Muslim occupiers in the fourteenth century (pl. 144). Either the site of their interment had been forgotten or they had been replaced at some point by newer versions, or both. In 1903, a deep pit was discovered in the temple complex at Luxor

in Egypt, which, among other objects, contained sixteen thousand bronze statuettes of Osiris and some seven hundred stone statues of pharaohs and deities and others, the oldest datable piece being then more than four thousand years old. It is possible that they were buried during the process of restoration of the temple that took place in the second or first century BCE. A further twenty-six well-preserved statues were discovered in 1989 where they had been buried in a *cachette* under the floor of the temple. These are now housed in the museum at Luxor (see pl. 136).

Even in such cases, however, the object now installed in a museum may seem detached from those conditions under which it was once esteemed or found offensive, leaving a sometimes difficult aesthetic appreciation virtually the only mode of access. Faced with such an item in a museum, one is liable to be caught between enjoyment of it in the here and now and frustration at the difficult effort of imagination required to reconnect it to the original context of its creation and display, however much accompanying information may have been provided. Such conditions prevail where much of the world's sculpture is concerned. It is significant in this context that Lenoir's museum was dissolved at the Restoration in 1815, having been subject to the criticism that if works of art could not be maintained in their geographical and spiritual settings, their meaning and value were effectively lost.

In the case of works that were actually made to be self-sufficient, free-standing and movable, it may still be hard not to feel a certain frustration. I have in mind the small desk-top bronzes made in Italy between the fifteenth and early seventeenth centuries, of which Susini's *Crouching Venus* is a distinguished example (see pl. 139). Faced with a priceless painting in a prestigious gallery, we can at least stand before it as its first and most privileged viewers might have stood and can scrutinise it as closely. For as long as we are absorbed in front of it, there is a sense in which it might as well be ours as anyone's, so that questions of original ownership and use are rendered for the moment incidental. The sculpture in a glass case, however, is put permanently out of reach of the visitor to a museum, where its salients, textures and surfaces may be viewed but where their invitation to the sense of touch is one that can never be taken up. To that extent it is alienated from the individual viewer in a way one might think it was not meant to be.

It has to be said, however, that such things were generally always expensive, so that the individual viewers for whom they were conceived were never more than a small minority. In such cases, perhaps, the frustration is one that all but the sculptor's more privileged clients were always liable to feel, in so far as they were even aware of the objects in the first place. The spectatorship of sculpture outside its original context does seem

145 Monumental seated Maitreya Buddha, begun 730, sandstone, Leshan, Sichuan Province, China

Maitreya is a messiah-like figure supposed to appear on earth at some future date as the successor to the Buddha Shakyamuni. He was first mentioned in a text dated to the first century BCE. The position of the hands on the knees, unusual in Buddhist sculpture, is explained by the difficulty of creating projecting features on this scale. Other colossal figures of Maitreya were carved in India and Tibet.

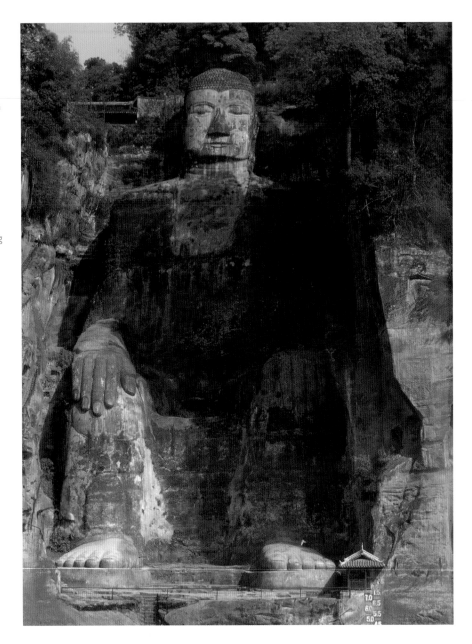

somehow a more exotic, more difficult, more recondite matter than the viewing of painting. It is as though the private aesthetic enjoyment of a sculpture entails a sort of privilege and that this implies some restriction on the validity of the medium.

Perhaps this is because so much of the sculpture that has normally been available to view over the ages was not originally intended for private pos-

session but was made for religious purposes and is integral to the fabric of temples and churches, or was conceived of on other grounds as a contribution to the imagery of social and public life. Religious forms of art are not only to be found adorning the churches, chapels and shrines of the various faiths. Christian images populate many civic buildings and public spaces throughout Europe, while there are representations of the Buddha carved from rock faces in India and China, some many times life-size (see pl. 145). Public forms of sculpture also include those monuments conceived of as commemorative rather than religious – works whose original function was to honour the memory of an individual or, as in the case of war memorials, of the many. What is perhaps the most successful ensemble of sculpture still to be seen in a public place in Europe had no great religious or memorial function. These are the statues that decorate the Piazza della Signoria in Florence – some of them now replicas, while the original works are conserved in nearby museums. They resulted from a series of commissions to outstanding artists, paid for as demonstrations of political power and civic pride. Among those originally responsible for the sculptures displayed in the Piazza were Donatello, Michelangelo, Cellini and Giambologna, four of the finest sculptors working in Europe during the fifteenth and sixteenth centuries – or indeed at any period (pl. 146). While each of the four made objects for private patrons, much of their practical energy was devoted to works like these that would at least be available to view in chapels, on the facades of buildings and in urban spaces.

Much later sculptural work also takes public form as architectural ornament or garden statuary. Look up above street level in any major European city where a high proportion of buildings survive from the eighteenth and nineteenth centuries – in Vienna, say, or Prague – and we find the facades and roof lines heavily populated with gods and goddesses, vestals and cherubs, nymphs and satyrs. On the buildings of the early twentieth century we may find personifications of science, of agriculture or of industry. Walk through almost any park established in the last four hundred years and we are likely to encounter life-sized figures in marble, in bronze or in composite stone, cavorting among the greenery, gesturing against the sky or solemnising on their pedestals. They are so ubiquitous, in fact, that we may have to be alerted by a guidebook or by some professional or academic programme of study if we are to give any of the more remarkable examples more than a passing glance.

Even in the case of small-scale sculptured figures that have no evident public or utilitarian function we cannot often be sure that private aesthetic enjoyment was ever the primary end in view. Where small sculptures have a religious subject, the diminution in scale may signify less the difference

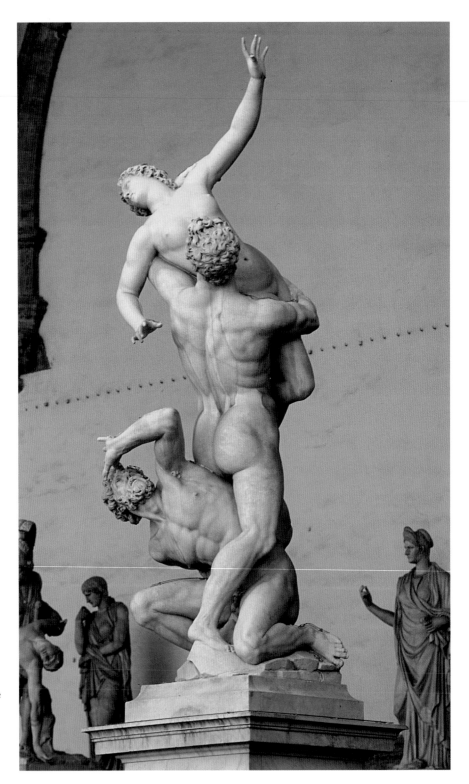

146 Giambologna (Jean Boulogne), *Rape of a Sabine*, 1582, marble, h. c.410 cm, Loggia dei Lanzi, Piazza della Signoria, Florence

Of Flemish origin, Giambologna initially travelled to Italy to study classical and Renaissance sculpture and stayed under Medici patronage in Florence, where he became the dominant sculptor of the generation after Michelangelo. Although his reputation was made by a number of ambitious public statues, his style was disseminated throughout Europe by small bronze reproductions of his work (see pl. 139).

148 (*facing page bottom*) *Mercury*, Roman, c. early 2nd century CE, bronze with copper, silver and niello inlay and gold accessory, 20.3 cm, British Museum, London

Numerous small bronzes were made by the Romans, representing gods, goddesses and emperors. Mercury was seen as the protector of merchants and travellers. This fine work was found in a cave in France in the eighteenth century, when it was acquired by the scholar and connoisseur Richard Payne Knight.

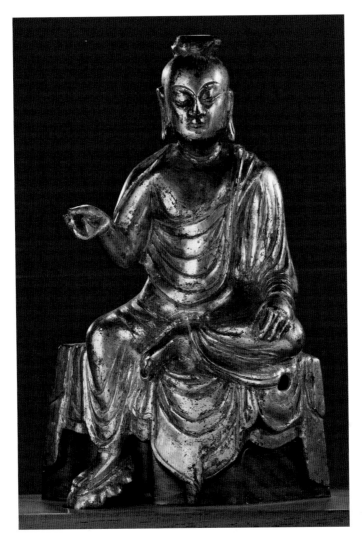

This small bronze would have been made for a wealthy patron as an offering to a temple or as an item of private devotion.

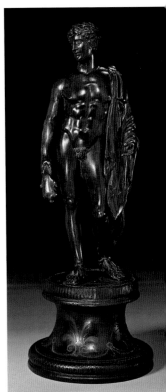

between public function and private possession than the different contexts of public and private devotion, or the contrast between princely and public and modest and private offerings at shrines and temples. Hindu or Buddhist devotees and pilgrims might pay for a small sculpture to bestow as an offering, while if it was acquired to keep, it would not solely be justified as an object valuable in its own right but also as a kind of terminal through which the represented god might be addressed and might in turn communicate (pl. 147). Even the small bronzes cast in Italy during the Renaissance, though largely intended as luxury items without religious value, were made in partial emulation of the miniature gods and goddesses to which the Romans had made offerings in their own homes (pl. 148).

149 Master of the Michle Madonna, *Madonna of Michle*, Brno, c.1340, wood, h. 120 cm, Convent of St Agnes, National Gallery of Prague

This is one of a group of large free-standing sculptures of the Virgin and Child carved in Bohemia in the mid-fourteenth century. Earlier precedents in stone sculpture are suggested by the long parallel folds with which the Virgin's figure is articulated.

150 *(facing page)* *'Venus' of Willendorf*, c.30,000–c.18,000 BCE, limestone, 11 × 5.5 × 4.5 cm, Naturhistorisches Museum, Vienna

Excavated in 1908, this figure is known after the place in Austria where it was found, near but below the site of a large hearth. It was deeply coloured with red ochre. A larger ivory figure was found nearby. Figurines from prehistoric times have been found in Eurasia from Spain to Siberia. Few are identifiable as male. The diversity of types suggests that there can be no single explanation of their function.

This dependence on religious and public context may be one reason why there are far fewer galleries and museums devoted specifically to sculpture as an art form than there are to painting. As mentioned in part 1, there are small museums devoted to individual sculptors, usually formed on the basis of materials left in the studio on the artist's death. There are also localised collections devoted to periods of exceptional production in individual centres. These include a collection of Chola bronzes maintained in the Government Museum in Chennai in India, the Bargello museum in Florence, in which is housed a collection of Italian Renaissance sculpture safeguarded against the elements and against the hazards of public life, and many small museums in Europe, such as the Convent of St Agnes of Bohemia in Prague, where impressive medieval and early Renaissance carved figures can be viewed together with contemporary paintings and artefacts (pl. 149). There are protected sites in Egypt, in China, in India and elsewhere at which some of the world's most ambitious carvings can be seen *in situ*. Anthropological museums too may contain many sculptures among other kinds of material. Yet there are no museums that attempt comprehensively to survey the art of sculpture in the manner that painting is surveyed

by the National Galleries in London and Washington or by the Museo del Prado in Madrid. The Glyptothek in Munich is a partial exception. It is a museum of sculpture exclusively in the classical tradition. As will be seen, this is the exception that helps to prove the rule.

Besides the dependence on context, there are further explanations that might be offered for this absence of comprehensive museums of sculpture. One is that it is generally a more expensive art than painting, potentially more demanding of time, materials and technical resources and that in consequence sculptures are simply rarer than paintings. Another is that sculpture on a large scale has always been harder to transport, even where it is not part of the fabric of a site or building. But perhaps the most important reason is that unless the survey of sculpture is restricted to a particular period or artist or style, it becomes hard to fix any practical boundaries to the material that might come up for consideration. Where a thousand-year-long western tradition of painting can on the whole be sensibly regarded apart from the pictorial art of earlier ages and other cultures, it seems harder to maintain a similar concentration on sculpture.

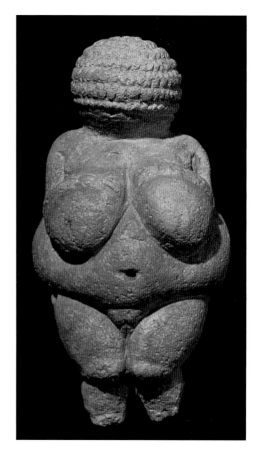

We do not expect to find works from China or Japan among the major collections of painting in the west. Yet works from ancient Egypt, from India, from China, from Japan or from Africa are hard to exclude when it is the art of sculpture that is under consideration and they are generally well represented in the more encyclopaedic museums. Sculpture tends also to be difficult to define as a category distinct from such other things as architectural decorations, monuments, grave markers and so on – objects whose status as art might normally seem to be less clear than something that can confidently be called a 'sculpture'.

It might be thought that a sculpture small enough to be easily transported is both far less likely than an embedded life-sized statue to be dependent on physical or even religious context for the establishment of its significance, and to be less prone to confusion with objects of other kinds. After all, a vast proportion of what we count as sculpture has been made on a small scale and is easily enough accommodated on the kinds of surface found in domestic interiors: private altars, embrasures, table and desk-tops, shelves, mantelpieces and window-sills. Many of the earliest surviving three-dimensional images of the human body are small enough to be held in the hand (pl. 150). But just as the life-sized and over-

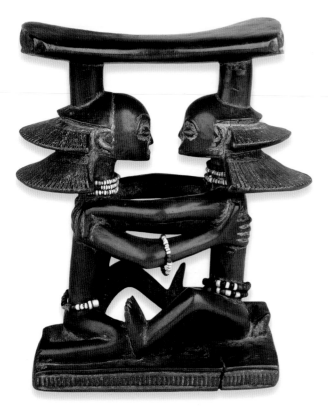

151 Head-rest, Luba, Zaire,
early 20th century, wood,
17 × 13 × 9 cm, British
Museum, London

The function of objects such
as this was in part to protect
the complicated type of hair-
style represented in the two
carved figures. Head-rests
were important pieces of
personal property, accorded
particular value as the
supposed seat of dreams.

life-sized image naturally connects to archi-
tectural spaces, and to the religious and
other occasions of public life, so the minia-
turisation of the figure brings sculpture into
alignment with those other kinds of objects
that can be handled and moved about: with
tools and utensils, knives and spoons,
brushes and combs, pots and cups and jugs
and bowls – objects that may have been
made and decorated by just those techniques
of carving, modelling and casting that are
the preserve of the sculptor. Some of the
most appealing of all figurative carvings
from Africa were made to be used as head-
rests (pl. 151).

To return to a point made in part 1 of this
book, there are galleries that are devoted to
paintings and that appear to invite aesthetic
modes of contemplation, and there are
museums that may contain paintings but
that also contain pots and tools and other
kinds of objects. It is these latter that gener-
ally also include sculpture. Their displays
usually offer more information about their exhibits than are put up on the
walls in painting galleries. They may encourage aesthetic appreciation of
some of the items on display, particularly, perhaps, where it is most clear
that these were made to be seen as works of art, rather than weapons or
tools or whatever. Yet there is normally a much greater likelihood that
works of sculpture will be seen in the context of other made things – some-
times also of objects that are formed naturally such as shells, bones and
pebbles – than there is in the case of paintings. A painting is not often
liable to be taken for something else, but in order to consider a given object
as a sculpture we may sometimes need to be aware that that is indeed what
it is. I mean to draw attention here to the difficulty of securely maintain-
ing a line drawn round sculpture for the sake of exposition, of establish-
ing the art form as a contained and coherent category and of settling on
any one set of guidelines as to how it is to be enjoyed and understood. As
will be seen, such problems of categorisation and exposition gain added
levels of complication when it is the three-dimensional arts of the twenti-
eth and twenty-first centuries that are under consideration.

❑ ❑ ❑

4.3 THE CLASSICAL CANON

As counters to that last point, in this and the following section I shall discuss two different principles on which sculpture has been seen and may be seen as a coherent category. To apply either one is to generate some tension with the other. The first concerns the idea of a classical canon. While there may not be many existing museums or galleries of sculpture, collections of sculpture actually lay at the heart of many early museum foundations, the British Museum among them. The sculpture in question was of a specific type and period. It was Greek and Roman sculpture, with images of the human figure accorded particular prominence. Art history itemises various European renaissances and classical revivals, from the ninth century to the early nineteenth, referring to particular phases when artists and their supporters looked back to Greek and Roman times and deliberately adopted ways of representing that accorded positive authority to classical precedents. We have already seen how artists in fifteenth-century Italy drew on the legacy of Roman culture in developing architectural and pictorial styles ordered on mathematical and geometrical lines. While classical buildings surviving more or less intact or in ruins provided Italian architects with measures of possibility and of ambition, whole or fragmentary classical statues maintained a similar hold over the imaginations of Italian sculptors. Donatello was one of the generation, mentioned in section 2.3, who helped to transform the status of art in Florence. Probably in the 1440s, he matched the technical achievements of Greek and Roman artists by making the first full-size free-standing sculpture of a male nude that had been cast in bronze for a thousand years, using a biblical character as the pretext for a distinctly novel exercise in grace and sensuality (pl. 152).

It was not only in the form of the quantities of monumental Roman architecture and sculpture surviving above ground that the classical legacy was accessible and effective during the intervening periods. Although the Roman Empire collapsed in the west in the fifth century CE, for at least the next millennium, while the eastern church adopted Greek as its official language, Latin remained the principal language of formal and written record and exchange among those throughout western Europe who could read and write. Latin was the virtually exclusive language of the Bible and of religious ceremony until early in the sixteenth century in the countries of northern Europe that underwent Protestant reformation and it remained so into the late twentieth century where the authority of the Catholic Church was maintained.

The art of the Greeks was also substantially represented in Latin texts. Among those that had been preserved from classical times were several that referred to specific Greek artists and to their works: the painters

152 Donatello, *David*,
c.1440, bronze, h. 158 cm,
Museo Nazionale del Bargello,
Florence

The young David is shown
standing on the severed head
of the giant Goliath, whose
sword he holds. This work
was made in response to a
commission from Cosimo I
de' Medici and was originally
installed in the courtyard of
the Palazzo Medici in
Florence. The casting was
delegated to a specialist
foundry. Recent technical
examination of the statue has
shown that details such as
David's hair were originally
gilded.

153 (*facing page*) *Apollo
Belvedere*, Roman, c.120 CE,
believed to be a copy of a
Greek bronze of the 4th
century BCE, marble, h. 224
cm, Belvedere Courtyard,
Vatican Museum, Rome

This statue was probably
discovered in Italy before the
end of the fifteenth century. It
was installed in the specially
designed Belvedere
Courtyard in the Vatican in
the early sixteenth century,
after which it became
celebrated as one of the
greatest works of antiquity
and as an ideal representation
of the youthful male figure. Its
status was affirmed over the
next three hundred years
through casts, smaller copies
and engravings. The possibility
that the statue might be a
Roman copy from an earlier
Greek work was not raised
until the early nineteenth
century. The missing right
forearm and parts of the left
hand were restored in the
1530s.

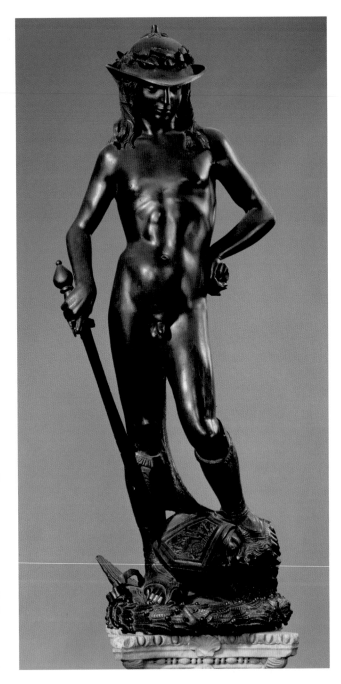

Apelles, Zeuxis, Timanthes and Parrhasius, the sculptors Praxiteles, Phei-
dias, Scopas, Lysippus, Leochares and Heliodorus. Some of these texts,
such as Pliny the Elder's *Natural History*, offered detailed descriptions of
specific works. These were highly influential. It was on Pliny's authority
that Praxiteles was understood to be the author of three notable figures

of Venus, while Pheidias was recorded as the maker of a giant statue of Athene in the Parthenon and was consequently for long assumed to be the author of the Parthenon marbles. The *Natural History* was one of the first classical documents to be made available in a modern printed edition, issued in Venice in 1469. Although there was virtually no remaining Greek painting except on vases, assumptions about its excellence were made on the basis of such texts and of the sculptures that had survived, albeit mostly in the form of Roman copies. In fact it was not until the middle of the eighteenth century that serious attempts were made to distinguish between Greek and Roman art and that historians and archaeologists first began to argue for the superior and definitive virtues of Greek art and architecture of the fifth and fourth centuries BCE. Until that point it was Rome rather than Athens that was seen as the centre of the classical world.

A particular prestige was attached to a number of figure sculptures carved from marble that were excavated in Rome and first put on display in the early sixteenth century. Most of these are now thought to be Roman copies but they were regarded until recent times as Greek originals and in many cases identified with specific statues by artists named in the classical texts. It is not hard to imagine the excitement that

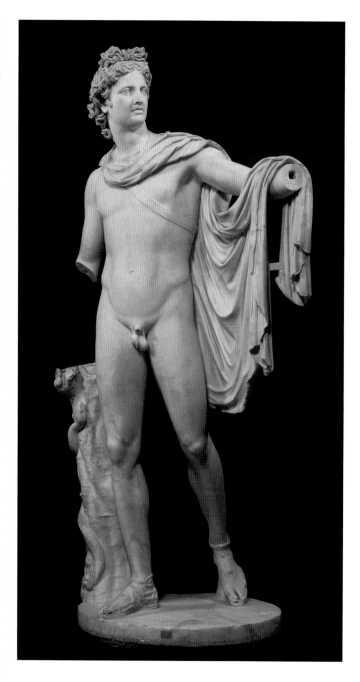

must have been felt when a marble figure was unearthed that appeared to match the account given in Pliny's *Natural History* of an Apollo by Leochares or a Venus by Praxiteles, or the reluctance there would have been to believe that the figure was a copy at best (pls 153, 154, 155). These statues had an immediate effect on both painters and sculptors in Italy, Michelangelo prominent among them. His uncompleted marble carving of

154 *Medici Venus*, Greek or
Roman, 1st century BCE,
perhaps after an earlier
Greek original, marble,
h. 153 cm, Galleria degli Uffizi,
Florence

In the sixteenth century this
statue was in Rome but at
the end of the seventeenth
was sent to Florence and
installed in the Uffizi, where it
was widely regarded as a
model of female beauty. It is
one of the most extensively
copied sculptures of all
cultures and ages. The base is
engraved with the name of
Cleomenes son of
Apollodorus. Although not
original, this may be a copy of
a signature from an earlier
version, possibly a bronze of
the classical period. Both arms
were missing from the statue
before its arrival in Florence,
when they were added by a
local sculptor. The head has
been broken and re-set. A
Venus of a similar type and
pose is in the Capitoline
Museum in Rome.

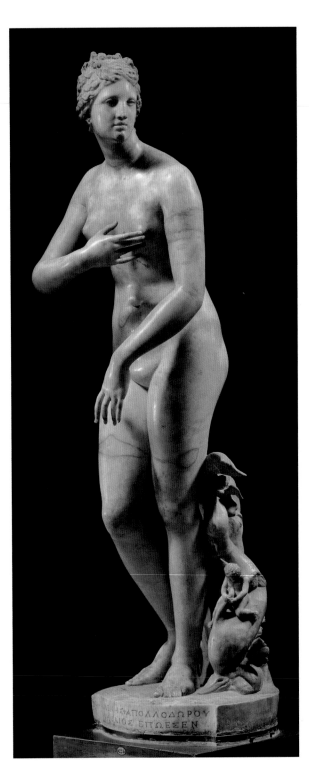

155 (*facing page left*)
Belvedere Torso, Greek,
(?)1st century BCE, marble,
h. 159 cm, Vatican Museum,
Rome

This partial figure is first
recorded in the 1430s. Early
in the sixteenth century it
was installed in the Belvedere
Court in the Vatican. It is one
of the few celebrated antique
statues that remained
unrestored at the time. Over
the next three hundred years
numerous casts and copies
were made. A small terracotta
version dating from the mid-
sixteenth century is in the
Ashmolean Museum in
Oxford. According to Sir
Joshua Reynolds, the first
President of the Royal
Academy in London, 'A mind
elevated to the contemplation
of excellence perceives in this
defaced and shattered
fragment . . . the traces of
superlative genius.' The work
is signed Apollonius, a name
unrecorded among the
various Roman accounts of
classical sculptors.

a caryatid was clearly made with the late Greek Belvedere Torso much in mind (pl. 156).

In the culture of the west from late in the sixteenth century until the end of the nineteenth, it was to a large extent the restricted canon of these classical works that defined what sculpture was and should be, specifically how the human figure was properly represented both in sculpture and in painting. Poses and proportions derived from them reappear constantly in the art of the period from early in the sixteenth century to the nineteenth (pl. 158). The ability to produce images of an ideally proportioned human figure that conformed to the stylistic canon these classical works represented was taken as a crucial measure of accomplishment in sculpture, equivalent to the demand made of painters that they be able to situate plausible scenes and objects in a coherent pictorial space. Surviving figures of Venus were taken for models of the aesthetically pleasing female form, figures of Apollo of the male. During the late seventeenth and eighteenth centuries, acquaintance with these canonical classical statues grew not only as a consequence of the first-hand experience of travellers but also through the distribution of plaster casts and marble copies, through the circulation

156 (*above right*)
Michelangelo, '*Atlas Slave*', c.1520, Carrara marble, h. 278 cm, unfinished, Galleria dell'Accademia, Florence

One of a number of works intended to form part of an ambitious tomb for Pope Julius II to be installed in St Peter's, Rome. The impossibility of completing this project in the face of changing proposals and other demands haunted much of Michelangelo's career. Although the figure has been only partially roughed out, it provides a clear demonstration of the artist's recorded admiration for the *Belvedere Torso*.

157 (*above*) *Venus* (after the *Medici Venus*), Italian *c.*1700, bronze on marble base, h. 42.3 cm, author's collection

Numerous small bronzes such as this were made in Italy after the more celebrated classical statues. The dolphin supporting the leg of the original marble could be ignored when the figure was translated into bronze.

of small bronze versions and through the publication of quantities of engravings (pls 157 and 159).

Apart from the sheer prestige of classical culture, largely conferred on account of surviving texts and monuments, there were two connected reasons for the admiration accorded these works. The first was their life-likeness. Not only were they impressively accurate in modelling physical proportions and poses, musculature, features and so on, but where the figures of Egyptian and pre-classical Greek sculpture had appeared relatively rigid and static (pl. 160), those that had their prototypes in carvings of the fifth and fourth centuries BCE or later were animated by the more dynamic equilibrium of their poses and by an impression of mobility in

158 (*facing page top right*) Marcantonio Raimondi, after Raphael, *The Judgement of Paris*, c.1515–20, engraving, 30 × 44 cm, British Museum, London

This print by Marcantonio is based on a lost drawing by Raphael. It shows Paris judging a beauty contest between the goddesses Athene, Hera and Aphrodite (Venus is her Latin name). He awarded the prize of a golden apple to Aphrodite, who had promised him the love of Helen of Troy. She is shown as the central figure of the three at the left of centre, in a pose that appears partly derived from the *Medici Venus* (see pl. 154). A resemblance to the *Belvedere Torso* (see pl. 155) can be seen in the reclining male 'river-god' figure at the extreme right. (For Marcantonio se also pls 110 and 117.)

160 (*left*) Standing male figure, from Boeotia, central Greece, c.570–560 BCE, marble, h. 77 cm, British Museum, London

Estimated to have been made some seventy years before the Strangford Apollo (see pl. 137), this Archaic kouros is still close in style to standing male figures from Egypt.

159 (*facing page bottom right*) Jan de Bisschop, four views of the *Medici Venus*, from *Signorum veterum icones*, 1668, engravings, each 24 × 8.2 cm, author's collection

Jan de Bisschop was a Dutch draughtsman and etcher, who produced two substantial and influential collections of prints. The *Icones* is composed of a hundred etchings after classical and classicising sculpture, some, as here, shown in multiple views. He was dependent on material available in the Netherlands and many of his prints are based on drawings made by other artists from Roman figures that had been heavily restored. His work played a significant part in the revival of the classical tradition in the Low Countries at the end of the seventeenth century. In the introductions to his publications, he condemned those contemporary Dutch artists who found artistic virtue in 'ugliness', rather than submitting to the 'guiding hand' of antiquity.

their gestures and facial expressions. The second reason was that they appeared not so much as accurate transcriptions made from individual people but as exemplifications of ideal forms – representations of the human in a state of perfect health, life and well-being. They thus permitted a kind of reconciliation of the values of the life-like and the ideal, values that we might normally think of as tending to pull in different directions.

161 *Borghese Gladiator*,
Greek, possibly a copy *c*.100
of a Greek original of the 3rd
century BCE, marble, l. 199 cm,
Musée du Louvre, Paris

This statue was found in
Latium in the seventeenth
century and remained for
two centuries in the Villa
Borghese in Rome, where it
was particularly admired by
Bernini (see pls 167 and 216).
A bronze cast was made for
Charles I (now in Windsor
Castle), while full-size copies
were to be found in many
English and French collections
in the eighteenth century. It
was purchased by Napoleon's
brother-in-law in 1808. The
traditional identification of the
figure as a gladiator is actually
based on a mistaken
restoration. It is signed
Agasius of Ephesus on the
base.

The concept of an 'ideal form' brings together two of the most slippery
terms in talk and writing about art. I shall try to provide some clarifica-
tion. The notion of the ideal derives from the influential theories of the
Greek philosopher Plato. He believed that what allows us to group forms
and objects into categories is the ideal form that is the essence of each.
Rather than identifying a given category by a particular example, the lover
of truth and wisdom will seek to grasp this essence. The notion of the ideal
is thus formed in contrast with the real. Every person I encounter has a
specific physical manifestation – his or her individual appearance. I may
be attracted to some more than others and may classify people as more or
less beautiful, though not necessarily for the same reason that I find them

attractive. If asked to imagine 'beauty' given human form, I may call some real person to mind. However, were that person to be faithfully represented in paint, stone or bronze, the very marks of individuality would always be liable to persist as limits on the power of the resulting image to exemplify physical beauty as a universal or abstract value. To conceive of a representation as ideal is to see it as transcending both the particularities of character and the mere personal preferences of artist or viewer. The notion of the ideal thus carries connotations of detachment or disinterest – the ability to suspend personal loyalties and desires and investments in favour of a standard or model or principle transcending the brute necessities of the real world. The classical statues labelled as Apollo, Bacchus, Hercules, Venus or Niobe were not viewed as portraits of individuals but as personifications of gods and goddesses or of characters from myth. Their forms served as representations of ideas: Art, Pleasure, Strength and Valour, Love, Grief and so on. They were 'beautiful' in so far as they were perfect exemplifications of the physical type that could be associated with these ideas. In the European philosophy of the seventeenth and eighteenth centuries, ideas were generally seen as superior to – or refined from – merely sensory responses or perceptions.

162 Joseph Wright of Derby, *Three Persons viewing the Gladiator*, 1764–5, oil on canvas, 101.6 × 121.9 cm, private collection

Wright of Derby was particularly skilful at candle-lit scenes such as this – a speciality associated with earlier Dutch and Flemish painting and thus not generally approved for painting in the 'grand manner'. He shows three connoisseurs gathered to admire a small copy of the celebrated antique statue, from which one is making a drawing.

The coupling together of 'ideal' and 'form' thus associates beauty with those works of art that, though they may represent human figures or other natural subjects, are seen as somehow transcending or outranking the particular in their proportions, their details and their dispositions, appealing instead to the realm of ideas and to a sense of value abstracted from the everyday. What is required for the appreciation of beauty as thus conceived is a lofty aesthetic sense (pls 161 and 162). This is what we might call the classical aesthetic sensibility: a set of high-cultural attitudes towards art in which the concepts of form, ideal, beauty and disinterest are connected in this way. What happens in practice is that the philosophical authority associated with the pursuit of ideal forms translates into a kind of kudos attaching to the concept of taste; taste ('good' taste) comes in turn to be associated with responsibility – with the obligation and right to take decisions and to act on behalf of others – and thus, of course, with the justifications given for academic values and for aristocracy. The authority of 'good taste' thus comes to function as a kind of cultural equivalent of the temporal power that capital confers on those who control it.

163 (*facing page top*)
Alexander Sarcophagus, view
of long side, 4th century BCE,
marble, h. 1.95 m, frieze
h. 69 cm, from the Royal
Necropolis of Sidon,
Archaeological Museum,
Istanbul

This well-preserved
sarcophagus in the form of a
Greek temple was discovered
in Lebanon in 1887. It is not
the actual tomb of Alexander
the Great but takes its name
from his appearance in action
in a lion headdress on one of
the long carved panels, which
shows Greeks fighting
Persians at the Battle of Issus
in 333 BCE. The date of the
sarcophagus places it around
the beginning of the
Hellenistic period, when the
influence of Greek art and
culture spread through the
Mediterranean, into the Near
East, Asia, northern Egypt and
western Turkey. It is thought
to have been made for a
Middle Eastern king or
governor who owed his
appointment to Alexander.

It is a predictable corollary of such attitudes that, while 'grotesques' in the classical manner may be admitted, little sympathy will generally be shown for any kind of art that finds its subject matter among the actually imperfect, the everyday and the idiosyncratic. This was indeed the case as regards the painting of low life in the seventeenth and eighteenth centuries and the Realist art of the nineteenth. Such works might be allowed to be well executed and ingenious but, where classical aesthetics held sway, they were excluded from the canon of high art – the art that appealed to a refined and educated taste nourished on the cultures of Greece and Rome, particularly on what survived of their sculpture. In the case of artists like Donatello and Michelangelo, whose works at different times exhibited both the kinds of expressive characteristics associated with late Gothic sculpture and the more decorous styles associated with the classical canon, it was sculptures in the latter vein that 'good taste' generally preferred, at least until early in the twentieth century. It is significant that while various kinds of genre painting flourished in the Protestant countries of Europe in the seventeenth century, as we have seen, there is no strong vein of 'realist' sculpture that can be set alongside them. This absence may be explained on the one hand by the greater hold that the classical tradition exercised over sculpture and on the other by the greater relative cost of three-dimensional work, which limited its appeal to the bourgeois collector who might have been happy to pay for a small painting.

The tendency to see classical sculpture as the realisation of ideal forms was encouraged by the apparent purity of its typical material. White marble quarried in the area of the eastern Mediterranean gave a certain satisfying homogeneity to collections of statues and fragments and of course it contrasted nicely with a background of mown lawns and clipped hedges. In fact, though the Romans generally preferred their statues unpainted, we now know that the great majority of even classical Greek sculpture was once brightly coloured (as was the majority of Gothic sculpture and architecture). It was not until 1815 that the evidence for such practices was first made public, however, and it was some time before it was generally absorbed. A large carved sarcophagus of Greek origin now in the Archaeological Museum in Istanbul retains sufficient traces of pigment to allow a plausible reconstruction (pls 163 and 164). It is hard to imagine that the classical aesthetics of the eighteenth century could easily have accommodated so garish an object.

A long-term consequence of the more or less unqualified respect in which the achievements of classical artists were held in the academies of art, by the members of the ruling classes and by the artists who advised and supplied them, is that sculptures from the Roman Empire and to a lesser extent from Greece are common and still prominent in the museums

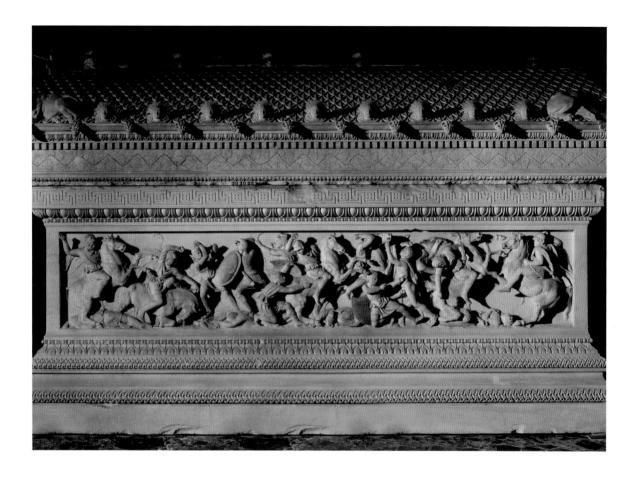

164 (*left*) Alexander Sarcophagus, relief panel, detail from a modern reconstruction, Archaeological Museum, Istanbul

The colours on this partial reconstruction are based on the analysis of pigments remaining as traces on the original sarcophagus.

of Europe and America. They are not all nowadays accorded the same level of respect, however. Such authenticated Greek works as the Parthenon marbles and the *Venus de Milo* (pl. 165) justly maintain their considerable reputations and their attraction to museum visitors, but there are many other works in both public and private collections that have been subject to a degree of redescription over the last century or so. This is hardly surprising. From the sixteenth to the nineteenth centuries, the widespread admiration for classical sculpture led to a high demand for authen-

165 *Venus de Milo*, Greek, c.150–120 BCE, marble, h. 202 cm, Musée du Louvre, Paris

This famous statue was excavated in 1820 on the island of Melos or Milos. It was acquired on behalf of a French ambassador and presented by him to Louis XVIII, who in turn donated it to the Louvre. When found it was accompanied by a block bearing the signature 'Alexandros of Antioch on the Meander'. That it was never restored is largely due to uncertainty about how the missing arms would originally have been disposed. It is generally thought to be a Greek work from the Hellenistic period.

167 (*facing page bottom*) *Sleeping Hermaphrodite*, Roman replica, probably of a Greek original of the 2nd century BCE; mattress by Gianlorenzo Bernini, 1620, marble, l. 169 cm, Musée du Louvre, Paris

The reclining figure was discovered early in the seventeenth century and entered the Borghese collection. It was restored and the mattress added soon after. In 1807 it was bought by Napoleon. A bronze copy was made for Philip IV of Spain after 1650 (now in the Prado, Madrid). Other marble versions of the figure exist in the Uffizi in Florence and the Villa Borghese in Rome.

tic-looking pieces. As the essential destination for travellers making a Grand Tour in the eighteenth and nineteenth centuries, Rome itself was the centre of a flourishing trade in excavated antiquities catering to wealthy collectors. Although the great majority of Greek and Roman statuary found in the Mediterranean area was carved in marble and was relatively fragile, and though as a consequence little of it survived intact over the ensuing centuries, large numbers of apparently whole figures were

acquired by members of the English aristocracy and others. Many of them are now to be found in stately homes and museums throughout continental Europe and in the British Isles, surprisingly complete with all their limbs, fingers and noses intact. Close examination will reveal that a high proportion of these are composites, with certain formerly missing parts supplied by the Italian craftworkers of the time, specialists in the more or less imaginative reconstruction and often 'improvement' of excavated fragments. A torso that might have started in Roman times as part of a relatively humble funerary statue dedicated to a specific individual could end up composing part of a 'Dionysus' or an 'Apollo', presented in apparent entirety with the attributes necessary to elevate it to the realm of ideas (pl. 166). Some of this work of completion or improvement was done by sculptors with considerable reputations as artists in their own right, among them Gianlorenzo Bernini, by far the most successful sculptor working in Rome in the seventeenth century (pl. 167).

There is one further point to be made. By the middle of the seventeenth century, the language of classical taste had become firmly established as the dominant discourse about art. Although challenged by artists and writers associated with the Romanticism of the late eighteenth and early nineteenth centuries, it remained the language of a kind of high-cultural authority until the middle of the nineteenth century. That authority was significantly secular. Yet respect for the classical tradition generally proved reconcilable with the ecclesiastical and temporal authority in Europe that wielded the weight of the Bible and the doctrines of the church. During the fifteenth and sixteenth centuries the Catholic Church had proved adept at Christianising certain classical myths and archetypes. It is also of note that among the collections of antique sculpture available to view in Italy

166 (*above*) *Dionysus*, Roman, first half of 2nd century, with 18th-century additions, marble, Ashmolean Museum, Oxford

This statue was acquired in Rome as a figure of Dionysus, the god of wine. In fact the ancient parts consist solely of a portrait head on a naked youthful torso, a combination associated with private funerary statues. The arms and lower legs were added in the eighteenth century. Originally in the Arundel collection, the statue was presented to the museum by the Dowager Countess of Pomfret.

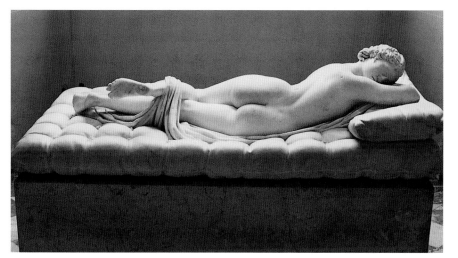

168 Unknown Italo-Flemish artist, *Adoration of the Shepherds*, c.1560–70, oil on oak panel, 119 × 111.3 cm, Ashmolean Museum, Oxford

This recently restored altarpiece is thought to have been produced by a northern European artist familiar with the art of Tintoretto and of Central Italy.

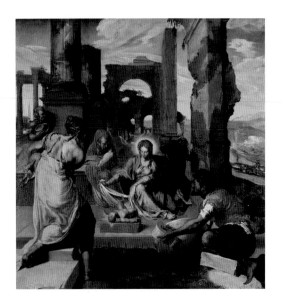

169 *(facing page)* Gianlorenzo Bernini, *Ecstasy of St Teresa*, 1647–52, marble, figures life-size, Cornaro Chapel, Santa Maria della Vittoria, Rome

Bernini here represents physical ecstasy as a means of expression of the spiritual ecstasy of the saint. In their setting in the church, the figures of St Teresa and the angel appear to hover on a cloud above the main altar, with descending rays of light represented in gilded bronze. Coupled with the use of diverse materials, such conspicuous technical virtuosity is typical of Baroque sculpture at its most ambitious and inventive. (For Bernini see also pls 167 and 218.)

in the early sixteenth century, none was more prestigious or influential than that assembled by Pope Julius II which was displayed in a specially designed courtyard in the Vatican in Rome. During the period of the Renaissance, painters had sometimes employed expedients to suggest the victory of a new religious order over the pagan classical world, such as setting the Christian subject of the Nativity in the ruins of Roman buildings (pl. 168), but the tendency of artists working under the aegis of the Catholic Church in the seventeenth and eighteenth centuries – painters and sculptors alike – was to combine the two sources of authority by treating religious subjects with a classical decorum. One way to conceive of the Baroque style that emerged in Italy late in the sixteenth century and spread throughout Europe in the seventeenth is as a bringing together of the idealism of the classical tradition with a heightened expressiveness partly driven by the emotional content of religious themes. This was consistent with the demand made by the Catholic Church during the Counter-Reformation that greater emotional expression should be pursued in art as a means to inspire religious devotion (pl. 169). From that point on the two types of authority were effectively reconciled, at least where the management of public culture was at issue.

At the end of the eighteenth century, however, art on Christian themes tended to become increasingly rhetorical and sentimental. At that point a revived and repurified classicism became the dominant stylistic mode in painting (see pl. 79), impelled in part by revolutionary anti-clericalism and by admiration for what were seen as the virtues of the Roman Republic. This direction was largely followed by sculptors in France, and in the early

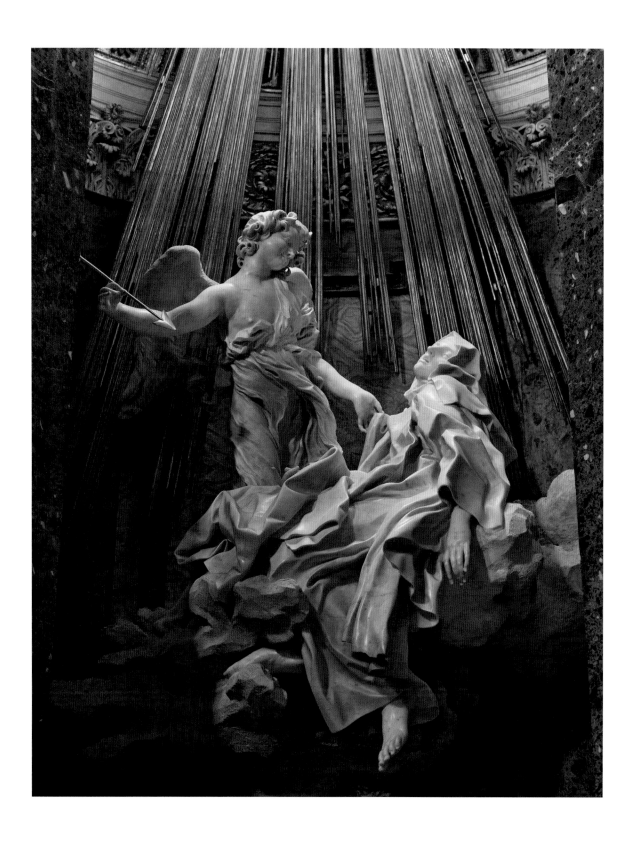

170 Antonio Canova, *The Three Graces*, 1814–17, marble, 173 × 97.2 × 57 cm, Victoria and Albert Museum, London, and National Gallery of Scotland, Edinburgh

This sculpture was commissioned from the artist in Rome by the 6th Duke of Bedford, who had admired a previous version carved for the Empress Josephine (now in the Hermitage Museum, St Petersburg). It was installed in a special Temple of the Graces in the sculpture gallery at Woburn Abbey, Bedfordshire, where it remained until 1990. Preliminary stages included a terracotta sketch model and a full-size plaster version, on the basis of which the rough carving of the marble was done by assistants before finishing by Canova. In classical mythology the Graces were daughters of Jupiter and attendants to Venus: Thalia (youth and beauty), Euphrosyne (mirth) and Aglaia (elegance).

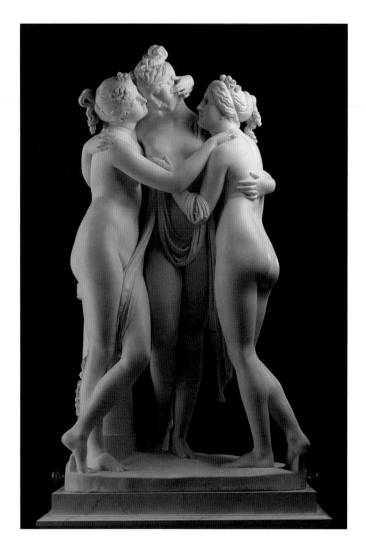

years of the nineteenth century an increasingly bureaucratic neo-classicism was sustained by the pretensions of the Bonapartist state in France and by the enthusiasm of its supporters. The notion that the post-revolutionary Louvre was the rightful home of canonical works of classical art led to the transportation of a large number of works from conquered Italy, among them the *Apollo Belvedere*, the *Capitoline Venus* and the *Belvedere Torso* (see pls 153–5). Once in Paris they were paraded through the streets in Roman-style triumph under a banner that read: 'Yielded up by Greece, lost by Rome, their fate has changed twice and will not change again.' The implication was that the new French state was the rightful guardian of the classical canon. In 1815, however, following the final defeat of Napoleon at Waterloo, the great majority of the appropriated paintings and sculp-

171 British Museum, front facade, designed by Robert Smirke, 1823–52

The British Museum was established by Act of Parliament in 1753, following the bequest and acquisition of Sir Hans Sloane's collection. It opened in 1759. The donation of the King's Library by George IV led in 1823 to the commission of a design for larger premises. Robert Smirke's quadrilateral plan was completed in 1852. Here we see the colonnaded south front.

tures were returned. Prominent among those who worked for their restoration was the Italian sculptor Antonio Canova, who had previously discharged commissions from Napoleon and had carved his portrait. Besides being by far the most highly rewarded artist of his generation, Canova was also perhaps the last sculptor successfully to exploit the icy sensuality that the classical tradition of marble carving had come to encourage before it descended rapidly into bombast and kitsch (pl. 170). (In modernist theory, kitsch refers to the garish, pretentious and sentimental forms in which the mere appearances of art are offered.) The rapid decline of neo-classical sculpture was to some extent the consequence of its massive popularity, as successful masters became increasingly reliant on assistants and copyists to satisfy the demand for new figures and versions.

In sculpture as in painting, the modernist reaction against academic traditions and values marked an end to the effectiveness of both the various denominations of Christianity and the classical tradition as practical regulating forces on the appearance of new works of art. It did not altogether extinguish the authority that classical aesthetics represented, however. The association of the classical tradition with civilisation – and its effective reconciliation with the moral authority of the church – can be read particularly clearly from the outward appearances of those museums in Europe and America that often had Greek and Roman sculptures at the heart of their collections. To approach almost any major museum in the west built in the eighteenth or nineteenth centuries is to be confronted with a broad flight of steps leading up to an entrance between fluted columns supporting a triangular pediment (pl. 171). This is the language of classical architecture. To be more specific, the reference is to the design of Greek temples

and to the Roman temples and other public buildings in which that design was continued. The implication is that the museum is a place in which a tradition of public and spiritual values is upheld and continued. Its classical facade conveys a sense of responsible authority and of proper guardianship, as it does when applied to such other institutions as schools, colleges, offices of public administration and, indeed, many of the churches built throughout Europe and America between the seventeenth and nineteenth centuries, from the new St Paul's cathedral designed in London by Christopher Wren to the Napoleonic church of La Madeleine in Paris. In the view of those who implemented such designs until as late as the very end of the nineteenth century, there could be no questioning the appropriateness of a classical style to an institution devoted to the civilised purposes of instruction, enlightenment, religious devotion or the maintenance of civil order, for it was by reference to a classical tradition that civilisation itself was still largely defined. In the twentieth century such beliefs were associated with the more extreme forms of political conservatism, particularly with Fascism.

4.4 THE VARIOUS HUMAN IMAGE

The second principle on which sculpture might be conceived and classified in thought and in practice takes a different direction from the first. Indeed, what is now proposed offers a kind of counter to the idea that the classical tradition is central. From this alternative perspective that tradition may be regarded as merely one strand drawn out of a rich and complex geographical and historical texture. What this second principle has in common with the first is the observation, already made, that of all the subjects represented over the ages in the various sculptural media, by far the most prevalent has been the human figure. Yet what we are now imagining is that it is this figure itself which provides the organising principle, not as conceived in terms of any particular stylistic canon but in all its modes of representation. In this case, it is not adherence to a classical style that provides the parameters for a notional survey of sculpture but rather the range and variety that sculpture of the human figure has to offer, whether conceived in the guise of a god or goddess or as an ancestor, as an idealised type of the male or female, as a personification of some natural force or as a portrait.

While there are many cultures without a continuous tradition of painting, there are few that have not produced some significant three-dimensional images based on the human figure – whatever function they may originally have been intended to satisfy. For all the extraordinary variety with which the human image has been interpreted and adapted, the

making of such an image serves as well as any other indication to suggest that some special demands have been confronted or that some species of aesthetic intention has been at work, however far we may be from a secure understanding of what that intention may have been (pl. 172). Clearly, a museum of sculpture that we might try to imagine on this basis would have the potential to range far more widely than any museum of painting could do across the ages, traditions, cultures and religions of the species as a whole. It would also embrace a far greater variety of materials: stones of widely differing degrees of hardness, metals and alloys, wood of many types, malleable materials including wax, clay and plaster, and ivory, bone and horn, each of them made in various ways to represent the different substances and surfaces of the human frame, both clothed and unclothed.

To conceive a fully representative collection of sculpture of the human figure is evidently to engage in a long and complicated exercise in thought. To realise such a dream would be a task requiring huge practical and financial resources. Far from sculpture being rarer than painting, as was previously suggested, it turns out that the potential field is unmanageably vast and diverse. It might be said that sufficient examples for a comprehensive or highly representative survey are indeed present in a few of the world's great museums, such as the British Museum, the Victoria and Albert Museum and the Metropolitan Museum of Art, but in fact it would take the visitor many hours and much concentration to unweave a comprehensive selection from among the other items on display, while it would take even longer to assemble a comparable survey from among the various museums of Paris or Berlin.

So where sculpture is concerned, there have been certain advantages to a restricted concentration on the classical canon. It allows for a clear art-historical narrative, though one largely confined to western Europe, with stylistic developments measurable in terms of a relatively limited range of typical materials and techniques and with an iconography on the whole reconciled with, and sometimes adapted to, the Christian faith. In fact the long authority of the classical canon helps to explain why it is only within encyclopaedic institutions or 'universal survey museums' such as the British Museum that comprehensive representations of sculpture are to be found. For much of the period when the major collections of painting were being assembled, sculpture that failed to conform to a classical or Christian canon was liable to be regarded as primitive, barbaric and virtually

172 Paleolithic *Venus*, c.20,000 BCE, from the Caves of La Mouthe, south-west France, sandstone, 13.3 × 5.7 cm, Minneapolis Institute of the Arts

In naming such prehistoric figures after the Greek goddess of love, we do no more than acknowledge a perennial human interest in making images of the female. It has been frequently suggested that they were associated with the promotion of fertility. While this may be true in a general sense, there is no surviving evidence to connect them to specific rituals or other practices. (See also pl. 150.)

173 James Stephanoff, *An Assemblage of Works of Art in Sculpture and Painting from the earliest Period to the Time of Phydias*, 1845, watercolour, 74.3 × 62.2 cm, British Museum, London

The son of a Russian stage designer who settled in London, Stephanoff earned the title of official Historical Painter in Watercolours to William IV. Most of the sculptures shown in his picture were in the collections of the British Museum.

174 *(facing page)*
The Goddess Tara, Sri Lanka, 7th–8th century, gilt bronze, h. 143 cm, British Museum, London

Buddhism reached Sri Lanka in the third century BCE. Tara came to be revered as the consort of Avalokiteshvara, the Bodhisattva of Compassion (see pl. 184). Her right hand is raised in a gesture of giving. The empty left hand would probably once have held a lotus flower, while the eyes and hair would have been inlaid with precious stones. The figure is cast in one piece in solid bronze.

beneath notice by the majority of those who saw themselves as cultured. There were those in the late eighteenth and early nineteenth centuries who viewed what they saw of Indian sculpture with a degree of interest and sympathy, the philosopher Hegel among them. Yet even they tended mistakenly to assume that it represented a primitive state of the art, pre-dating the classical works from Greece.

A watercolour preserved in the British Museum serves to illustrate the power that the idea of the classical canon still exercised as late as the mid-nineteenth century over those who subscribed to it. Made by James Stephanoff in 1845, it shows 'An Assemblage of Works of Art in Sculpture and Painting from the earliest Period to the Time of Phydias' (pl. 173).

Phydias or Pheidias, you may recall, was the Greek artist thought at the time to have been the author of the Parthenon sculptures. These are depicted at the top of Stephanoff's picture. Shown in descending order below them are Roman, Egyptian and Assyrian works. The lowest rank is occupied by Mayan, Buddhist and Hindu sculpture. The standing female figure at the bottom centre represents a near life-size gilt bronze statue of Tara, who was venerated in a variant of Buddhism in the seventh and eighth centuries CE. This is the date at which the statue was made, more than a thousand years after the Parthenon marbles (pl. 174). It was found near a temple complex in Sri Lanka in the early nineteenth century, brought back to England by Sir Robert Brownrigg, the British Governor of what was then known as Ceylon, and in 1830 donated by him to the British Museum, where it remains, now one of the most highly regarded works in the entire collection.

There are two points to be made in the light of this example. The first concerns the circumstances under which the earliest museums established their collections and the nature of the materials that were included. It is actually far from the case that only classical works were collected in the museums of the eighteenth and nineteenth centuries. On the contrary. However, it was not generally for their aesthetic virtues but as anthropological or ethnographical curiosities that non-classical works were acquired. This is largely why it is principally in the encyclopaedic museums, rather than those restricted to the fine arts, that they are now to be found. The oldest public museum in Britain, the Ashmolean Museum in Oxford, was founded in 1683. Although it is a far smaller institution than, say, the British Museum, its collection is impressively encyclopaedic, extending from

175 Johann Georg Hinz,
Kunstkammerregal
(*Royal Cabinet of Curiosities*),
1666, oil on canvas,
114 × 93 cm, Kunsthalle,
Hamburg

This picture represents a kind
of miniature prototype of the
encyclopaedic museum, a
typical princely collection of
rarities, curiosities and objects
of value. Among the objects
are items of jewellery, ivory
carvings, shells, a crystal
goblet, medallions and a
monkey skull.

the findings of archaeology at prehistoric sites to virtually contemporary painting and sculpture and including artefacts of one kind and another from all over the world. The museum was established when Elias Ashmole donated to the university the 'Closett of Rarities' he had inherited from John Tradescant the younger. Father and son of the same name, the Tradescants had travelled as gardeners collecting plants for wealthy clients and acquiring curiosities. As their collection grew and attracted attention, it was enhanced by gifts from aristocratic patrons. The *Musaeum Tradescantianum*, published in 1656, provided the first printed catalogue of a British museum.

It is of significant interest that though the idea of the encyclopaedic museum owed much to the 'cabinets of curiosities' accumulated by princes

throughout Europe during the seventeenth and early eighteenth centuries (pl. 175), the first public foundations derived considerable benefit from the enterprise of collectors like the Tradescants, who were professional men rather than aristocrats and who were not necessarily educated in the classical tradition. The impetus for the foundation of the British Museum in 1753 came in a fashion similar to that of the Ashmolean, when the vast collection of the physician and botanist Sir Hans Sloane was purchased for the nation. Like many such collections formed by the wealthy amateurs of the time, this included a quantity of minerals, gems and natural specimens (relocated in 1881 to form the basis of London's Natural History and Geological Museums), as well as coins, medals, books and manuscripts, but only a minority of items that had actually been acquired as works of art. The greater part of these last were listed as classical antiquities.

Before the early nineteenth century, therefore, the category of 'art' may have been applied confidently to paintings in the western tradition and to such three-dimensional objects as conformed to the classical canon – such as the collection of Greek and Roman sculpture given to the British Museum by Charles Towneley in 1824 – but it was used with increasing uncertainty the further from that canon any specific object appeared to be located, even if that object was recognisably a representation of the human figure. The Parthenon marbles were generally agreed to be 'in the first class of art'. In contrast, at the time when the statue of Tara was donated to the British Museum, while its craftsmanship might have been acknowledged by anyone with an understanding of metal casting, the majority of interested viewers were more likely to view it as a curious and unseemly idol than as a proper work of art.

The second point about Stephanoff's watercolour goes some way to moderate the first, however, and thus to draw attention to a growing conflict of assumptions and priorities regarding the world's repertoire of sculpture, the effects of which can still be felt today. At the time Stephanoff made his little picture, the viewpoint it represented may have been prevalent but it was also conservative and exclusive. The authority of classical aesthetics had not been entirely unopposed, even before the time of the Romantics. It had been subject to challenge on various grounds and from various quarters more or less from the point at which it was first established. Although the Renaissance of the fifteenth century had spread throughout mainland Europe, elements of the pre-Renaissance tradition of expressive carving (see pl. 149) persisted in the north in the face of the growing taste for classical sculpture. This persistence was due in part to the Protestant Reformation in the early sixteenth century and in part to the strength of the artisanal guilds and of traditions of carving developed

AN INTRODUCTION TO ART

176 Tilman
Riemenschneider, *Unidentified
Female Saint*, c.1515–20,
limewood, 106.7 × 33 ×
16.8 cm, Compton Verney,
Warwickshire

Riemenschneider's workshop
in Würzburg was one of the
most successful of the time,
employing as many as forty
assistants. Although he was
responsible for work in
alabaster, sandstone and
marble, limewood was a
favoured material for statues
such as this that were
intended for an indoor
setting. The figure would
originally have formed part of
a larger complex. It is likely
that the missing right hand
once held an attribute – an
instrument of martyrdom or
some other element from the
narrative of the saint's life –
that would have indicated her
identity. The great majority of
such figures were painted and
gilded but in this case
Riemenschneider merely
varnished the pale wood,
giving a satisfying
homogeneity to the forms of
the sculpture.

for work in wood, by far the most prevalent material in northern Europe (pl. 176). Furthermore, during the seventeenth century, even as a number of publications extolled the supreme virtues of classical art, there was increasing recognition that the Italian art of Leonardo, Raphael, Michelangelo and Titian represented an independent and matching level of achievement. In 1637, receiving with gratitude a copy of Franciscus Junius's book *The Painting of the Ancients*, the painter Peter Paul Rubens wrote that he would now appreciate a companion treatise on the paintings of the Italians. Even in largely Catholic France a debate on the relative merits of the Ancients and the Moderns was conducted through various publications in the last quarter of the seventeenth century, with arguments being advanced for the superior achievements of modern literature, painting and sculpture.

A further source of moderation of the authority of the classical canon came from the considerable enlargement of the field of curiosities that occurred as a consequence both of voyages of discovery and of the fruits of colonisation and trade, particularly trade with the east. At the time of the Roman Empire, a trade route had been open to convey valued silks from eastern China across northern India through the Bosphorus into Europe. Porcelain and other goods had subsequently been carried into Persia and the Ottoman Empire along the same route for centuries before direct trade with China was established by the Portuguese in 1554. We have already seen

177 (*far left*) Dish made for export, China, Ming Dynasty, Wan-li period, 1573–1620, porcelain with cobalt blue underglaze painting, British Museum, London

Items of blue-and-white porcelain such as this were exported from China in their millions from the seventeenth century onwards, selling in Europe for much higher prices than could be commanded by locally made ceramics.

178 (*left*) Dish made in imitation of Chinese export ware, (?)Frankfurt, c.1680, pottery with tin glaze, d. 33.2 cm, author's collection

Tin-glazed pottery items such as this were unlikely to be confused with the porcelain dishes on which they were based but they provided an affordable version for those who were attracted to the appearance and motifs of expensive Chinese and Japanese ceramics.

the appearance of Chinese porcelain and a Japanese sword in still-life paintings made by Protestant painters in the seventeenth century. One clear effect of the flourishing trade in imported Chinese and subsequently Japanese porcelain was the emergence of a number of European factories producing cheaper imitations in tin-glazed earthenware. Large quantities of plates, bowls and vases survive that were made in Delft, Nevers, Frankfurt and elsewhere in the late seventeenth and early eighteenth centuries, their decorations copied from Chinese and Japanese motifs by European craftworkers who must often have had little idea of what it was they were supposed to represent (pls 177 and 178). During the eighteenth century a widespread fashion developed for ornaments, decorations, furniture and textiles that evoked a fantasy oriental world. 'Chinoiserie', as it came to be known, contributed a distinctly playful – and thoroughly unclassical – element to the highly ornamented late Baroque style known as Rococo. After 1710, when a form of hard-paste porcelain was first made at Meissen, small ornamental figures were made in a number of European factories, some painted in bright colours, others simply glazed over the white ceramic body. Although they were generally conceived as domestic ornaments, the best of these deserve consideration alongside the more expensive examples of late Baroque sculpture in stone and bronze (pl. 179).

As the expansion of the world proceeded in both geographical and chronological terms, and as knowledge of pre-classical cultures was disseminated through archaeological appropriation and publication, information spread about civilisations increasingly remote from western Europe. In the 1780s, Sir Joshua Reynolds had lectured the assembled students of the British Royal Academy from a viewpoint that connected the academic artists of the time firmly back through the Italian Renaissance

179 *Harlequin with Tankard*,
modelled by J. J. Kaendler,
Meissen factory, *c.*1738,
porcelain, h. 15.3 cm,
Staatliche Porzellanmanufaktur,
Meissen

There was great competition
in Europe to achieve the
combination of materials and
high firing temperatures
required for making porcelain
and thus to compete with
products from China and
Japan. The Meissen factory
where the first true European
porcelain was made was
guarded like a military
installation. Kaendler was
among the most inventive
artists employed to provide
models for the figures that
were produced in the factory.

masters to the painters and sculptors of Greece
and Rome. In his inaugural address in 1792,
however, Reynolds's successor as President
took a different line. Admitting 'the earlier
days of the world' into his history of art, Benjamin
West drew the attention of his audience
to the antiquity of the monuments of India,
Persia and Egypt and to the role of sculpture
in serving religious instincts that were both
pre-classical and pre-Christian.

So far as sculpture was concerned, it was the
Hindu art of the Indian sub-continent – with
its many-armed and animal-headed gods, its
often overt sensuality, its abrupt changes of
scale, its mobile poses redolent of the dance –
that then offered the most dramatic of contrasts
to the more decorous and more static
classical canon as it was understood in Europe
(pl. 180). Those who first became acquainted
with such things were not artists or connoisseurs,
however, but men who travelled east in
the interests of commerce. The first East India
Company had been established in 1600 by a
group of English merchants, and trading posts had been set up within the
decade. Dutch and Portuguese equivalents followed soon after. While the
English company came to function as the effective spearhead for control
and colonisation of India, a minority of the more open-minded of its representatives
identified with the relative tolerance of the Mughal regime in
Delhi and learned to see local works of art as expressions of ideas and
systems of belief that were supported by traditions and literatures far more
venerable than those associated with Christian doctrine.

In fact, of all the world's religions still widely practised, Hinduism is by
far the most ancient. The oldest Hindu texts, the *Vedas*, were transcribed
in Sanskrit around 1400 BCE from an older oral tradition in the area of
the Indus valley. Further sacred texts include guides to worship and
conduct and epic poems in which the struggle between good and evil is
played out by a cast of divine and mythical characters. In Hindu mythology
Brahman is the origin and creator of all things, more an abstract
principle than a personified god. The principal triumvirate of deities is
composed of a mother goddess, primarily associated with fertility and with
roots stretching back several millennia, and two male divinities, Shiva and
Vishnu. Shiva is the next most ancient of the three. He controls the begin-

180 *Vishnu*, India, West Bengal, Pala period, c.1050, stiltstone, h. 89 cm, Ashmolean Museum, Oxford

Vishnu is shown as a four-armed figure, holding his conventional attributes: a mace (to signify authority), a conch shell (an ancient war trumpet but also a symbol of creative power) and a *chakra*, a sharp-edged discus. His fourth hand makes a gesture of beneficence. He is accompanied by two attendants. The small scenes carved above these show his various other incarnations.

181 *Parvati*, India, Tamil
Nadu, c.970, bronze,
h. 76.1 cm, Norton Simon Art
Foundation, Pasadena

This figure from south India
was produced during the
Chola period. The style of the
sculpture reflects Hindu texts
in which Parvati is celebrated
for her sensuous beauty. She
is shown richly ornamented
with jewellery. The patron in
this case was a woman,
Queen Sembiyan Mahadevi,
the daughter-in-law of a
Chola king.

183 (*facing page bottom*)
*Ganesh seated on his Rat
Vehicle*, India, southern
Deccan, 18th century, bronze,
h. 20.5 cm, British Museum,
London, formerly Edward
Moor collection

Ganesh or Ganesha is
revered as Lord of Beginnings,
both creator and remover of
obstacles. In placing his image
at the front of his book,
Moor was adhering to the
custom of appealing to the
deity at the outset of an
enterprise. Moor's collection
was bequeathed to the British
Museum in 1940.

ning and end of cycles of time and in
his role as lord of the dance may be
represented performing the 'dance of
creation' (see pl. 8). His consort is
Parvati (pl. 181). Vishnu is appealed
to as ruler over the stability of family
life and his principal consort is
Lakshmi. His cult was established by
the fifth century CE. Each of these has
various manifestations and names
and associated narratives according
to their different attributes. Hinduism
also admits a virtually infinite number
of lesser gods to its pantheon and
encourages the making and venera-
tion of images, which are believed to
be inhabited by the gods themselves.
As a consequence Hinduism has given
rise to a wealth of figure sculpture,
much of it employed in religious
rituals that have been observed for
centuries. The relief of the deity
Vishnu illustrated in plate 180 is the
first recorded Indian sculpture of any
size to have entered a western
museum. It was donated to the newly
founded Ashmolean Museum in the
late 1660s by Sir William Hedges,
who was governor of the East India
Company in Bengal.

European interest in the produc-
tions of other cultures drew support
from the Enlightenment. This is the name given to the widespread devel-
opments that took place from the middle of the seventeenth century in sci-
entific method, in rational inquiry and in the philosophical critique of
superstition. The great significance of the Enlightenment project lay in
replacing tradition and authority with the relative and uncertain values of
reason and experience as the standards of credibility in science, religion,
philosophy and art. From the point of view of someone emancipated from
the absolute authority of the classical tradition and the Christian faith,
there was no good ground on which to assume that a representation of a
Hindu deity or of the Buddha must be any less sophisticated or any less

valid on aesthetic grounds than a figure of Apollo or of the Virgin Mary. The more a spirit of inquiry was at work in the examination of foreign artefacts, the easier it became for Europeans to see the images generated by non-Christian religions as deserving of an aesthetic regard, and the less rigid the distinction became between curiosities and works of art.

In the eighteenth and early nineteenth centuries, while Christian missionaries were working to convert the heathen and to wean them from the worship of their idols, enlightened traders and interested scholars were collecting examples of the idols in question and learning about the antiquity of the religions in which they played a part. The collections of the British Museum again furnish appropriate illustration. On the one hand is a deity figure carved in wood from Rurutu, one of the Austral Islands to the north-east of Australia (pl. 182). This was given to a missionary in 1821 as an 'act of conversion'. It is the only survivor of its type. Its uniqueness suggests that any similar sculptures were probably destroyed as part of the same process of conversion.

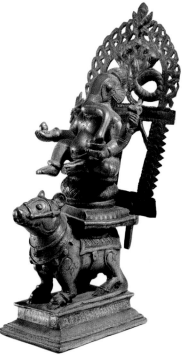

182 (left) Deity figure known as A'a, from Rurutu, Austral islands, French Polynesia, late 18th or early 19th century, hardwood, h. 111.6 cm, British Museum, London

This is the sole survivor of a group of carved figures representing their gods that a deputation from the island of Rurutu presented to a London Missionary Society station in 1821. It was brought back to London the following year and in 1911 was sold to the British Museum from the Society's collection. It is thought to represent a god creating men and other gods. A cavity in the back originally contained twenty-four small figures. These were destroyed in 1882.

On the other hand is a small cast bronze figure of Ganesh, a Hindu deity conventionally represented with a human body and the head of an elephant (pl. 183). The son of Shiva, he was mistakenly beheaded by his father and was made whole again with the head of the first live creature to be encountered. He is here represented seated on a rat or bandicoot, which forms his vehicle. This is one among a large number of items collected by Edward Moor, an employee of the East India Company in the early years of the nineteenth century. An engraving of this sculpture was used as the frontispiece to his book *The Hindu Pantheon*. Published in 1810, this remains a model of religious scholarship. A further collection of Indian sculpture was donated to the museum by Moor's colleague and contemporary

James Stuart. The purpose of his collection was to explain the Indian system of deities, in the conviction that it would demonstrate the fallacy of the idea that Europe was deserving of ascendancy over the east, either on moral grounds or in terms of the aesthetic merits of its art.

By this time, however, the relatively sympathetic early administration of the East India Company had been transformed into a vehicle for the missionary zeal of 'muscular Christianity'. Although they largely emerged from the same evangelical tendency as the anti-slavery movement, the missionaries tended to view non-Christian populations as primitive and in need of conversion. The resulting potential for conflict was further aggravated in India by the Hindu belief in progressive reincarnation and by the rigid caste system that this belief supported. In the event the East India Company was thoroughly implicated in what was called the Indian Mutiny of 1857–8 and in the terrible atrocities that followed. It was finally dissolved in the latter year, when the colonial administration of India passed to the British crown.

4.5 EMPATHY AND SPIRIT

From the previous section it is clear that a high proportion of figurative sculpture was made from earliest times for use in public rituals of one kind or another, for religious purposes as decoration integral to temples, cemeteries, shrines and churches, or as vehicles for private acts of veneration, entreaty or sacrifice. It was in part this requirement to answer to the spiritual needs of specific communities that presumably invested the making of these images with a sense of serious purpose in the first place and that helped to elevate the work involved to the highest levels of skill, concentration and often invention. There are exceptions. Both Judaism and Islam prohibit the making and worship of 'graven images'. The teaching of Buddhism, however, positively encourages it, regarding offerings to images of the Buddha and of bodhisattvas as means by which the devotee can acquire merit (pl. 184).

Different belief systems lead to different interpretations of the human figure. It is easy to feel daunted when our attention is drawn to a curious statue from an unfamiliar culture – a Tibetan group with multiple heads and arms, an African figure covered in nails, a complex ceramic figure from Mexico (pls 183–7). The distance separating us from the culture in which such things were produced can often seem too wide to bridge; as though there must be a daunting amount to learn if we are to make sense of them, while simply trying to enjoy them as art would be like papering over the gap that is left by the investment we cannot sincerely make in the relevant systems of belief.

184 *Bodhisattva Avalokiteshvara*, Japan, late 17th century, wood with traces of paint and lacquer, h. 27 cm, author's collection

This image of the compassionate bodhisattva is designed to express a state of thoughtful patience, the patience required of those who must wait until all humankind achieves the state of enlightenment before themselves becoming a Buddha.

In thinking about such matters, it is easy to find oneself paralysed by the apparently irreconcilable character of extreme positions. On the one hand there is the idea, as represented by Clive Bell, that 'aesthetic emotion' provides a sufficient access to all the world's art – except, presumably, to that which leaves the connoisseur unresponsive or indifferent. On the other there is the idea that understanding requires some knowledge of specific cultural conditions, systems of belief and so on. Taken to its conclusion, as it is in some types of anthropological theory, this latter position would imply that we can only properly appreciate the artistic and other productions of a given culture if we share the beliefs of its members. In that spirit, the ethnographer who has studied African tribal rituals might with some justice point out that the mask approached as a work of art in the gallery is altogether remote from the thing that was made to be used in the performance of a particular routine or dance at a certain time of year in the course of a ceremony to ensure the success of the harvest (see pl. 30). From

185 (*facing page top left*)
Vajrabhairava and Consort,
Tibet, 17th century, bronze
with traces of pigment,
h. 68.5 cm, Museum of Fine
Arts, Boston

The Vajrayana sect of
Buddhism spread into Nepal
and Tibet after the eighth
century, where it merged with
local beliefs to produce an
increasingly complex and
exotic religious iconography.
Central to its imagery are the
shaktis or saviouresses shown
in sexual union with
bodhisattvas in various
incarnations. Vajrabhairava is a
wrathful tantric form of
Manjushri, the Bodhisattva of
Wisdom, representing the
ability of the individual to
overcome ignorance and
death. Personifications of
ignorance are trampled under
his feet. In his principal hands
he holds an axe and a skull
cup, the remaining arms being
endowed with various other
symbolic attributes. He wears
a garland of fifty severed
heads, representing the
purification of the fifty main
veins of the body.

this point of view an aesthetic emotion may score well as a means to establish a certain desirability, and hence perhaps market value, but it offers nothing as a means to understanding.

To overcome the paralysing effects of being caught between these extreme positions, we might perhaps look to the common ground often observed between aesthetic experience and religious experience. The same theoretical resource will serve to extend our consideration of the relations between historical and aesthetic approaches to art. What is common to aesthetic and religious experience is the idea of a sense of value that transcends explanation. Those myriad artistic images that are intended to encourage religious devotion might be said to give practical form to this connection. Let us say that I am equipped with a full account of the production of the carved bodhisattva shown in plate 184. I know the date and place of its origin, the system of beliefs in which it was intended to play a part and the specific subject it represents; I know the nature of the fruitwood from which it was made, the technique involved, using separate blocks glued together, and the kinds of tools used for carving; I know about the processes of lacquering and gilding used to cover the surface and even about the kinds of exposure and handling that have led to erosion of much of that original covering over the past 350 years or so. Yet when all that information is taken into account, and although I am not a Buddhist, there seems still to be a kind of remainder – a meaning or value attached to the object that these various details have not fully accounted for.

There are many colloquial ways of referring to those things that seem to have such a remainder and that have proved resistant to philosophical explanation of their distinctiveness. We talk of things being greater than the sum of their parts, of things seeming not quite to be of their time and of the artists who made them having been inspired – that is, influenced by supernatural forces. As early as the fourteenth century the Italian author Petrarch used the phrase *non so che* – connected to the idea that loving attraction is ultimately beyond explanation – in recognition of the impossibility of giving a more precise account. The French similarly refer to a quality of *je ne sais quoi*, an expression that English speakers have adopted. In the 1930s, the German critic Walter Benjamin wrote of a certain 'aura' that attaches to the unique and original work of art, albeit he questioned its value in an age when techniques of mechanical reproduction were readily available. The implication, then, is that however exhaustive its methods may be, the historical approach is always liable to leave something further to be said about the individual work of art – even if that something further is precisely what cannot easily be put into words.

The study of aesthetics takes various forms, from philosophical systems that aim to isolate a certain qualitative aspect from consideration of social

187 (*right*)
Anthropomorphic urn, Monte
Albán, Mexico, c.500–700, clay,
h. 51.8 cm, Barbier-Mueller
Museum of Pre-Columbian
Art, Barcelona

Monte Albán was an urban
centre influenced by the
earlier Olmecs, that flourished
during the 'classic' period in
Central America (c.200–1000
CE), well before the first
contacts with Europe. It is
particularly known for
complex pottery urns such as
this, which are thought to
depict deities or deceased
persons given the features of
gods. They may originally have
been used as containers for
offerings.

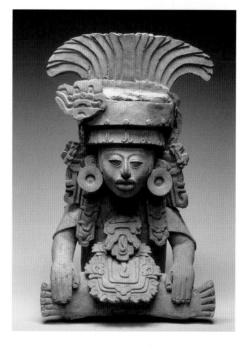

186 (*above right*) Nkisi
Nkondi, Kongo, Zaire, late
19th century, wood, metal
and pigment, h. 180 cm,
British Museum, London

The 'power objects' known as
Nkisi Nkondi are discussed
below. Nkisi refers to ritual
programmes for dealing with
problems, grievances and
ambitions. Nkondi means
'hunter', referring to the role
of the magical object in
tracking down wrongdoers.
Each metal spike or nail
driven into the wood of such
a figure represents an
occasion on which its power
was invoked for a specific
purpose.

and historical factors, to materialist theories that represent such factors as bearing inescapably on all questions of meaning and value. But in whatever direction one may lean, absolute clarity is neither to be found nor expected. The sense of an aesthetic remainder is just that – a sense or intuition; it is in the nature of intuitions, as of the kinds of experience categorised as religious, that they tend to evade logical explanation. We should certainly not confuse knowing about a given religion with sharing its beliefs. In the case of the sculptured boddhisattva, however, as of other religious objects regarded as works of art, might it be that the intuition of an aesthetic remainder will serve as the stimulus to an appropriate kind of empathy; an enlarging of sympathetic understanding; a means for the unbeliever to recover a kind of value with which the object was imbued in the process of its creation, *as though* one shared the relevant beliefs?

There are two reservations to be observed. Firstly, just because some art seems to exceed the material conditions of its production, it does not follow that all art is successful in this respect. Once the circumstances of its commission, making and installation have been explained, art made to be displayed in banks may well leave nothing else to be said. The same may be true of work that does little more than assist in the inculcation of religious sentiment. Secondly, *contra* Clive Bell, we should not assume that an aesthetic remainder somehow subsumes or renders nugatory the information that a historical approach might provide; for instance that if someone claims to appreciate the complex forms of a Hindu sculpture like the Hedges *Vishnu* (see pl. 180), then for them the connection between aesthetic and religious transcendence is somehow automatically established, without the need for any further understanding of the work's origin or function. The point is that there is little virtue in the idea of the aesthetic as a kind of remainder after all explanations are exhausted unless it allows due consideration to all that might count as understanding before that remainder is left. If we are to attach significance to the point at which the ordinary words seem to run out, we will first need to have done what we can with description and explanation, if only in thought. It is only in the light of some effort to imagine the work as a produced thing possessed of a history of a kind that it will make any sense to see it as somehow transcending the conditions of its production. Whatever aesthetic appreciation may involve, it does not require belief in the supernatural. It is not a mode of consciousness in which we become insulated from all awareness of the social, biological and historical conditions of our own and others' lives. On the contrary, it is precisely by extending and heightening our awareness of those conditions that art earns its place in our attention. The finest works of criticism are those in which that heightened awareness is given form; not, however, by means of an exhaustive rehearsal

of the historical background but rather through the effort to find words and forms of expression appropriate to the intuitive experience of art.

I do not believe that there can be anyone who will not sometimes struggle a little to make sense of some figure and to work out just what appreciating it might actually mean. Yet my enterprise commits me to the view that there is no artistic production of a human culture that need be entirely inaccessible to the interested spectator, even where little information is initially available to explain it. I could not have embarked on this book if I thought otherwise. To emphasise, far from an aesthetic regard requiring that we abstract the work of art from the conditions of its production, it serves rather as a stimulus to curiosity about the conditions in question and to empathy with the beliefs and values by which other lives have been shaped. If there is one point that distinguishes that regard, it is that it does not consider the significance or value of the image as in any way reduced when those conditions change and when the work's usefulness in a certain social function or ritual may be exhausted. Conceived in this way, the appreciation of the art of diverse cultures is an invaluable means to guard against the obstacles to more general understanding and empathy that are due to xenophobia (a fear and dislike of the foreign) and ethnocentrism (a belief in the primacy of one's own culture). To respond to a work of art, then, is not solely to be motivated to know it better; it is to open a door into the world from which it emerged.

In view of the long legacy of colonialism, a self-conscious awareness of the problems associated with partiality of viewpoint has become virtually obligatory for writers regarding non-western art from within a western cultural perspective. These problems are not entirely specific to western viewers, however, nor do they apply only to the productions of cultures other than one's own. A Muslim from Mecca, a Buddhist from Kyoto or a Hindu from Mumbai may feel distanced from a European work that seems to cater to a specifically Christian perspective. But so might a non-Christian of European origin, albeit in this case there would still be some aspects of a common culture – familiar conventions and types of setting, for instance – to help one match the appearance of the work to other familiar representations, thus reducing the sense of distance.

As I have already suggested, what is peculiar to the western perspective is the powerful effect the classical tradition has exerted, and still to some degree exerts, not only as an organising narrative of development in the art of sculpture but as a dominant resource of aesthetic standards. In fact it was largely with specific regard to the classical tradition that aesthetics was established as an academic discipline in the eighteenth century. However we may feel about it, classical art comes to the western observer already authorised and framed in aesthetic terms. The social and religious

188 (*facing page*) Plaque showing the Oba of Benin with attendants, Edo people, Benin, Nigeria, 16th century, cast brass, 51 × 37 cm, British Museum, London

The Oba or King of Benin is shown with two attendants holding up their shields to shade him. The two smallest figures are examples of 'social perspective': they are not supposed to be further away but simply less important. More than nine hundred such plaques were removed from Benin following the sacking of the city by the British, a shameful episode in the history of colonialism resulting from resistance to demands that the area be opened up to trade. Cast in the sixteenth century, after contact with Europe was first established, the plaques were originally fixed to pillars in the Oba's palace. Subsequently auctioned off by the British government, they are now largely distributed between the British Museum and museums in Germany and America.

practices that the originating art of the Greeks may in part have been made to serve are stripped of any taint of exoticism or savagery by the manner in which that art permeates the forms and ideals of later work. Values attached to classical art become inseparable on the one hand from the foundations of western philosophy in Greece and from a continuously recycled literary mythology, and on the other from a tradition of secular bureaucracy originating in the Roman state.

The effect is akin to that associated with patriarchy as characterised in feminist theories. Where the male is dominant in social and political systems, the tendency is for the female to be conceived as the Other and as lesser in relation to the male. So long as the classical tradition was dominant, and still wherever its legacy persists, the arts of cultures untouched by that tradition – whether on grounds of antecedence, of geographical distance, or of sheer indifference – have often been viewed as alien, exotic and impenetrable. They have accordingly been treated for the most part as aesthetically second-class objects: 'curiosities' rather than 'works of art'. This tendency was reinforced by the long association of the classical tradition with dominant conventions of life-likeness and by its use as a standard by which the productions of other cultures were seen to fail the test of truth to nature, a test based on the principle of one-to-one correspondence between the forms of art and those of life. However much a limb might be extended for expressive effect, or the relative proportions of head to torso diminished or enlarged, a classical figure was one in which an ideally proportioned human body was always born in mind. Where such standards prevailed, the 'distortions' of the Other and the modern were alike liable to be dismissed as outlandish and incompetent. It was symptomatic that the late revival of classical principles associated with the rise of Fascism during the 1920s and 1930s was accompanied by condemnation of modernist art on the grounds of its barbarity, primitivism and decadence.

Such reactions notwithstanding, it remains the case that with the modernist developments of the late nineteenth century both the classical tradition and the Christian religion finally lost their real authority over the content and appearance of new art. It was no mere coincidence that this was also the period when knowledge of the world's art was hugely enlarged by western imperialist expansion into the south, by increases in facilities for travel, by advances in photography and in pictorial reproduction and distribution and by a succession of international exhibitions and so-called World's Fairs. In section 2.11, I also referred to the impact made by African art on avant-garde artists in Europe in the early twentieth century. As might be imagined, the masks and carvings from Africa were of particular interest to those sculptors at the time who had already

turned away from the principles of academic practice, based as these still were on the assumption that study from canonical works of classical art was essential to professional development.

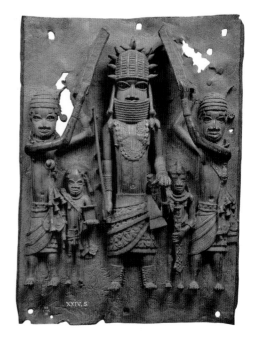

In fact the objects admired and collected by these artists were by no means the first African artefacts to be seen in Europe. As early as the late fifteenth century traders had brought back carved ivories from West Africa, where a sophisticated tradition of casting in bronze and copper had been maintained for some centuries before that (see pl. 208). There are wooden statues in European museums that were collected as early as the middle of the nineteenth century, while a vast quantity of cast brass heads, figures and plaques were removed by the British in 1897 following the punitive sacking of the ancient palace of Benin (pl. 188). Yet what distinguished the moment of the early part of the twentieth century was the treatment of African artefacts not simply as ethnographical curiosities but as original works of art of immediate relevance to the concerns of contemporary European artists (pls 189 and 190). As suggested earlier, the apparent vitality of those styles of art seen as 'primitive' served as a kind of demonstration by contrast. At the turn of the century, public commissions for sculpture throughout Europe and America were still liable to be filled by figures whose stuffy life-likeness was propped up by the last vestiges of classical formality. The suggestion the modernists took from African sculpture was that with the abandonment of classical canons of life-likeness as criteria in the traditional sense, it would be possible for the object to acquire a different sense of animation: one based on the idea of its possessing a life of its own.

I should be clear about what is at issue here. Where sculptures have been conceived as possibly animate things it has generally been for one of two reasons: because they have appeared so life-like as to be accorded real human powers and feelings – to be taken literally for 'speaking likenesses' – or because some framework of beliefs surrounding their making and use has required their being invested with a spirit, whether benign or potentially malign. Conventions of life-likeness are relative to local traditions, economies, modes of life and so on, and these two reasons may coincide. On the one hand there are examples of statues of the Virgin Mary believed by devotees to shed tears or to smile. On the other some degree of likeness to an actual person – an ancestor for instance – may be required before that person's spirit can be thought to occupy an otherwise non-naturalistic work and their power be channelled through it. In some cases

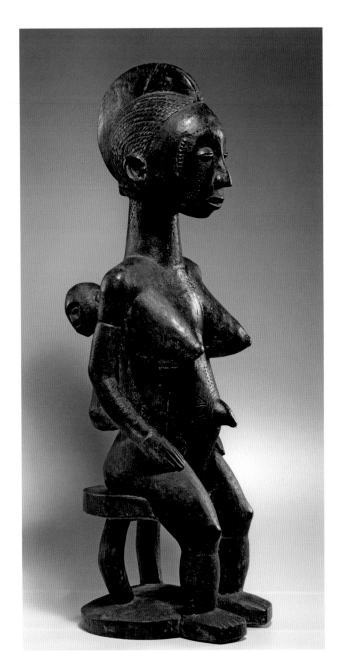

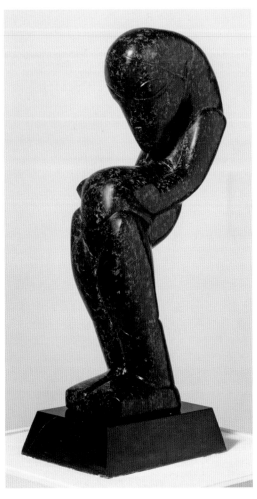

the likeness that is required may not be to an actual person but to a type
of image – to the style of representation in which an ancestor, a teacher or
a god is traditionally imagined and revered (pl. 191). There may be a del-
icate balance to be struck. While too marked a departure from the type
may prevent the sculpture from serving as a vehicle, a merely slavish copy

189 (*facing page left*)
Female figure with child,
Idoma or Tiv people, Nigeria,
19th century, wood,
h. 68.5 cm, Dr Laurence R.
Goldman, Brisbane

This figure formerly belonged
to the sculptor Jacob Epstein.
It is one of a small group of
figures in similar style that
survive from an area inland
from the city of Benin.

190 (*facing page right*) Jacob
Epstein, *Female Figure in
Flenite*, 1913, serpentine stone,
h. 45.7 cm, Tate Britain,
London

Epstein was born in New
York in 1880 and studied in
Paris. In 1905 he moved to
London, remaining in England
for the rest of his life. The
deliberately 'primitive' aspect
of this figure was prompted
in part by the sculptor's
studies in the British Museum.
It was also encouraged by a
recent stay in Paris and by
the interest in non-western
art then shown by members
of the European avant-garde.
The sculpture shown in pl.
189 was part of Epstein's
considerable collection of
works from different cultures.

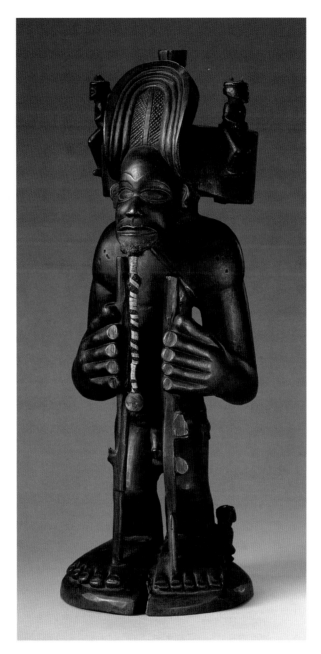

191 *Chibinda Ilunga*, Chokwe
people, north-eastern Angola,
c.1850, wood, hair and hide,
40.6 × 15.2 × 15.2 cm,
Kimbell Art Mseum, Fort
Worth

The hero Chibinda Ilunga
features in a number of
carvings from the court art of
the Chokwe people. He is
the central figure in a dynastic
epic maintained in an oral
tradition. A princely hunter, he
is credited with the successful
establishment of the Chokwe
people in a fertile land rich in
game. He is customarily
shown with a hunter's staff –
symbolic of pasage through
both distance and time – and
a chief's coiffeur. Here, the
horn held in the figure's left
hand suggests a container for
magical substances.

might be thought lacking in animation. Alternatively the force supposed
to animate the figure may be relatively independent of any resemblance to
an actual or imagined person. In the broad category of African sculptures
known as fetishes a simple generic likeness to a human or animal figure
is sufficient. The object is then invested with power by a package of potent

material – earth from a grave, blood, bones, excrement – that is inserted into its body or attached to it in some manner.

This is the case with those Congolese figures known as Nkisi Nkondi (see pl. 186). Once invested, the spirit of the figure is aroused by driving a nail, blade or spike into its wooden body, so that it can then be set to work on behalf of a petitioner for purposes such as retribution or revenge. To make such a thing the subject of an exercise in art appreciation might well appear a kind of offence against its true nature. In the cultural transactions involved, the traffic was not all in one direction, however. For the modernist artists such as Picasso who were fascinated by African fetishes, a large part of their appeal lay in suggesting a means by which a certain potential for aggression and offence could be restored to a European culture of art that had become complacent and effete, where that complacency and effeteness were associated specifically with academic forms of naturalism.

With the assimilation of so-called primitive art to a modernist aesthetic, there was thus a major shift away from the association of animation with achieved life-likeness towards the idea that it depended on a kind of creative investment. There was a consequent shift of emphasis in the ways in which responses to the art of sculpture were typically described and explained in the west. Where previously spectators' responses had been seen as elicited largely by the naturalistic life-likeness of sculptured figures, and perhaps by the theatrical modes of their animation, now a greater stress was placed on the work's possession of a 'life' or 'spirit' with which it came to be endowed in the process of its making. The idea that what the carving sculptor does is to liberate a kind of being residing in the block of material had actually been familiar at least from the sixteenth century, when Michelangelo was adopted as the type of the artist hero. But during the early years of the twentieth century that idea came to occupy the forefront of thought about the art, now shorn of its previous dependence on a naturalistic final result. A new emphasis was placed on the materials and forming processes of sculpture and on the signs of the artist's involvement with both.

Life-like or not, fetish or saint, celebrity or deity, it is clear that sculptures are material things produced by human agency. They encompass a wide range of materials and techniques. It is time, then, to return to the larger view of the art and to turn our attention to the principal kinds of materials from which sculptures have been made and to the processes and tools by which they have been worked.

❏ ❏ ❏

4.6 MODELLING AND MOULDING

In stressing the importance of materials and processes in the study of sculpture, I certainly do not mean to suggest that such considerations are irrelevant where painting is concerned. Yet it remains the case, as remarked earlier, that a painting reproduced in a print or a photograph will generally retain far more of its identity than will a sculpture. In a description of a painting, that it is made of tempera on panel or of oil or acrylic paint on canvas will often be added as an afterthought once its subject matter and compositional design have been dealt with. A description of a sculpture, however, will normally need to accord priority to such questions as whether it has been modelled in clay or wax, whether it is carved in stone or wood, whether it has been cast in bronze or welded in steel, and so on. This is not merely because there are many more possible materials to take into account. It is also because the very character of the image is likely to have been largely decided by the material chosen and the technical process applied.

Modelling involves the use of materials that are to some degree malleable, generally clay, stucco, plaster or wax. A lump of such material may be worked into shape by removing parts and by shaping with tools, but a figure that has been modelled has normally been gradually built up, with a supportive core of wood or metal if required. For this reason modelling tends to be characterised as an additive technique, in contrast to the subtractive techniques of carving. The distinction between the two types of process was clearly made in the early fifteenth century by Alberti, encountered in section 2.3 as the author of a treatise on painting. In an earlier short treatise titled *De Statua* he differentiated between modellers in wax or clay and 'sculptors', whose task it is to reveal the figure contained within the marble block.

From classical times, however, the two processes had been closely connected in practice. The reputation of the classical Greek sculptor Praxiteles is based largely on the carved marble figures for which he is supposed to have made the prototypes. Yet if the testimony of Pliny's *Natural History* is to be believed, it was modelling that he considered the mother of all other forms of sculpture. Not only was modelling generally preliminary to casting in bronze but, at least from the classical period onwards, the great majority of statues carved in stone are likely to have been based not only on drawings made on the surface of the block but on preliminary models worked out in the far less expensive material of clay. A clear advantage of such a procedure was to reduce the risk of costly wastage by allowing an accurate gauging of the block of stone required for the final work.

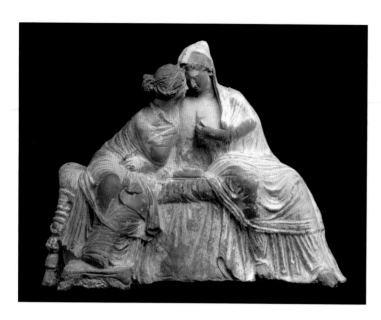

192 *Group of Two Women Talking*, Greece, Myrina, c.100 BCE, terracotta, h. 20.4 cm, British Museum, London

Small moulded terracotta figures were made in Greece from at least the seventh century BCE, by artisans known as *koroplasts* ('modellers of girls'). Later statuettes such as this belong to a type widely known as 'Tanagras', after a site near Thebes in central Greece, though this is only one of the many places where they have been found. The practice of making miniature figures in the style of Praxiteles started in Athens late in the fourth century and was subsequently imitated throughout the Hellenistic Greek world.

Malleability tends to mean fragility. If modelled work is to be preserved it will usually need to be hardened or to be cast into another and more durable material such as bronze. (I shall deal with casting in the following section.) Stucco is based on lime, plaster on gypsum, though the terms tend to be used more or less interchangeably. Both are readily obtained in a powdered state and can be mixed to a smooth consistency with water. Both will set hard after this mixing, plaster quicker than stucco. Plaster is easily worked even in fairly large amounts and will retain the finest marks of the hand or of tooling. These are the qualities that have made it the favoured material for models to be cast in bronze. Stucco and plaster have also been widely used in interiors for various types of sculpted decorations and applied reliefs. In both cases, however, the resulting surface can be dry and unappealing if left untreated, while any projecting elements will remain vulnerable to breakage.

Clay is a natural sticky earth. It remains absorbent and thus potentially soluble if left unfired. If left to dry out it will harden and can be baked in the sun, but if it is to be rendered impermeable and more durable it requires heating at high temperatures in an oven or kiln. In Europe, fired clay is usually known by the Italian term terracotta (literally 'cooked earth'). The sculptures modelled in clay that have survived in quantity from ancient Greece are not preliminaries for sculpture, which are unlikely to have been fired, but small, fired and generally painted statuettes, mostly of women, which were made during the Hellenistic period. Although some of these offer popular versions of the styles of classical sculpture, many of the most appealing capture moments of apparent informality and intimacy in the life of the time (pl. 192).

The oldest modelled sculptures so far discovered are clay reliefs made in caves in the Pyrenees. These include a pair of bison dated to about 18,000–10,000 years BCE. Although few free-standing modelled figures have survived that are as old as the oldest carvings, such as the 'Venus' from Willendorf (see pl. 150), it is reasonable to assume that clay would have been widely used from the earliest time when figures were made. The results would generally have been too fragile to have lasted over such a

period. Among the oldest modelled figures that have been unearthed in some quantity are small statuettes of seated women from northern Mesopotamia, thought to be some seven thousand years old. Evidently made in the hand without recourse to tools of any kind, these are objects that convey across the millennia a kind of endearing practical wit in the act of representation (pl. 193). A typical example shows two simple units of thigh-plus-leg composed of cushion-shaped lumps of clay. The straight-backed upright trunk to which these are joined is pinched into two narrow opposed planes to make a head. Its arms are drawn out from the shoulders and wrapped round under the applied hemi-spheres that compose the breasts, ensuring that vulnerable projections are minimised. The elements composing legs and arms are simply tapered into points with no attempt to model hands or feet. Nor are the figures given modelled features, though some of them retain striped decorations in reddish pigment, with dots for the eyes.

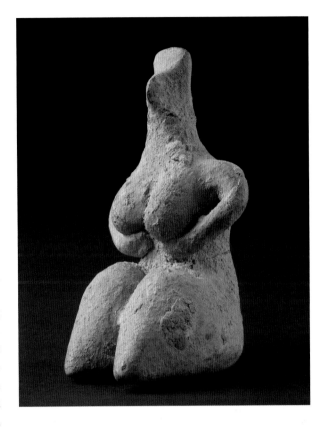

193 Seated female figure, baked clay, 'Tel Halaf' type, northern Mesopotamia, c.5000 BCE, h. 7.6 cm, author's collection

Figures of this type are named after the mound of Tel Halaf in north-eastern Syria, which marks the site of a culture that was established in Neolithic times. They are assumed to have been associated with fertility and perhaps with worship of a mother goddess.

Figures such as these, because they are small, could be modelled in solid form and dried out or fired without too great a risk of breakage. But the principal problem with clay as a medium for sculpture is that firing a body of any considerable size normally leads to shrinkage and thus to the risk of cracking and distortion. The basic technical problems involved in the making of figures in fired clay are similar to those that the potter faces in making earthenware bowls and ewers. (It is perhaps partly because of this common investment in the materials and processes of modelled sculpture and pottery respectively that certain ceramic jars and vases – however plainly they may be glazed or even where they are left unglazed altogether – seem possessed of a surprising kind of resonance and content such as we normally associate not with utilitarian objects or even with the most appealing of decorations but with refined sculptures of the human figure; pl. 194). In the case of a solid figure there is an added risk of breakage when moisture is expelled as steam during heating. A large sculpture in clay that is to be fired or otherwise dried out will need either to be hollow or to be composed of separate small parts that can be joined together after firing, or both.

194 (*right*) Vase in red-polished pottery, pre-dynastic Egypt, Naqada I period, 4000–3600 BCE, British Museum, London

Evidence of the making of pottery is a clear sign of the establishment of communities and of civilisation. Such basic needs as the carrying and storage of water combine with the simple technologies involved in moulding clay – whether on a wheel, as here, or by coiling – to produce a range of common shapes. Within that range, however, there may be considerable variations in type and refinement. Glazes develop from the need to counter the porosity of pottery.

195 (*far right*) 'Stick figure', China, Western Han dynasty, 2nd or 1st century BCE, fired clay with traces of paint, h. 58.5 cm, author's collection

Many figures of this type have been found in tombs dating from the Han dynasty, where they represented attendants for the afterlife. The generally grey clay body is covered with a lighter-coloured slip (a coating of fine clay mixed with water to a creamy consistency). Movable arms, perhaps in wood, were originally attached to holes in the shoulders and the figures would have been clothed and brightly painted. It may be asked why such careful attention should have been given to the torsos if they were to be covered up. The answer may be that the artisans were enacting the process of giving life, as represented in a contemporary Chinese creation myth according to which the goddess Nü Wa fashioned beings by kneading them out of earth.

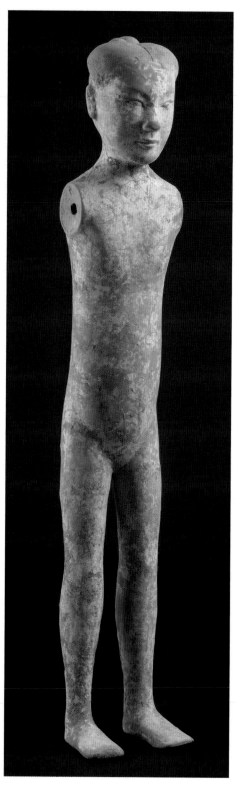

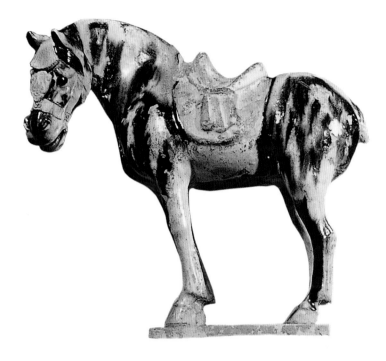

Images in clay or plaster can also be made by pressing material into a mould. For a simple figure in the round a two-part mould will be required. More complicated figures can be constructed by using a number of moulds and then joining the resulting parts. In ancient China, clay was used not only to make some of the most sophisticated of all ceramic vessels but also for a wide range of moulded figures, from the relatively simple 'stick figures' found in tombs of the Han dynasty (pl. 195) to the more complex horses, camels and attendants of the Tang (pl. 196). These latter were assembled from piece moulds, then further worked on to add detail before being fired with glazes that produced rich colours of ochre, brown, green and sometimes deep blue. The use of detailed moulds in China was greatly assisted by the particularly fine clay that is widespread in the north of the country. This material is unusually resistant to shrinkage and distortion when dried out and when fired.

That quantities of such ceramic sculptures have survived is a consequence of the practice of interring the powerful and wealthy with representations of all they might need in the afterlife. This practice was common in the ancient world. It is responsible for much of what we know of the civilisation of ancient Egypt, where some tombs of important persons have been found to contain miniature representations of a complete way of life. In China, the making and interment of grave goods was prevalent from early times until the end of the Ming dynasty in the seventeenth century. The most extensive burial site so far known is that of the first Emperor of

196 Statuette of a horse, China, Tang dynasty, 618–960, moulded, glazed and fired clay, h. 60.5 cm, l. 79 cm, British Museum, London

During the Tang dynasty, figures such as this were exhibited at the funerals of the wealthy and were then interred with them as requirements for the afterlife. The finer examples were coated with translucent lead glazes. Different colours could be given to the glaze through the addition of iron, copper or cobalt.

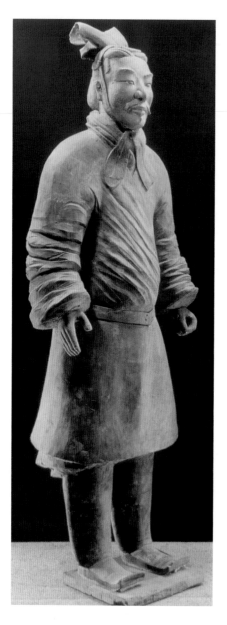

197 *Military officer*, China, Qin, 3rd century BCE, brown and grey clay, originally painted, h. 191 cm, excavated 1976–77 from Pit 1, mausoleum of the First Emperor of Qin, Museum of Terracotta Warriors and Horses, Lintong County, Xian

Figures such as this were for the most part made by assembling torso, head and hands from separate moulds, using a coarse sandy clay. When partly dry, this was then covered with layers of finer clay, into which all the individualising details of uniforms, musculature, hair and features were carved. The figure was then mounted on a base and fired, before being painted and equipped with real weapons or other trappings.

Qin, who is credited with the unification of China in the third century BCE. Discovered in 1974, this huge complex is still in the process of excavation at the time of writing. It includes more than eight thousand life-sized sculptures of warriors and horses modelled in clay – the so-called Terracotta Army – together with other figures representing servants, musicians, acrobats and administrators (pl. 197). These were made with the use of numbers of moulds, but with different details added by hand so that each figure was individualised. Surviving traces of pigment indicate that they were originally brightly painted.

At a later date, between the fourth and ninth centuries CE, unfired clay was widely used in China in inhabited cave complexes on the northern Silk Road along which Buddhist teachings were carried from India into China. At Dunhuang, the most important Buddhist site in China, almost five hundred such caves were used as monasteries and temples, many of them richly decorated with both paintings and painted sculptures. Complex reliefs were attached to the cave walls while large figures were built up over wooden armatures or stone cores. That many of these have survived in remarkably good condition is due to the particular properties of the local clay and the stable atmospheric conditions in the caves (pl. 198 and see pl. 143).

Clay was also used for some of the oldest surviving sculpture from sub-Saharan Africa. The village of Nok north of the Niger delta has given its name to a number of refined heads and broken figures in a coarse red pottery that can be dated to between 500 BCE and 200 CE (pl. 199). In the typical example shown, the manner in which the stylised features are

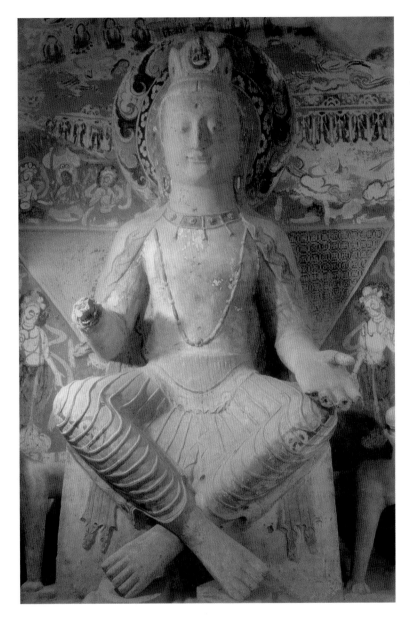

198 *Seated Bodhisattva*, Tang dynasty, 893–4, painted clay, h. 2.65 m, Dunhuang, cave 196, Gansu Province, China

This bodhisattva sits with one foot supported on a lotus blossom, in the posture of 'relaxation' particularly associated with Avalokiteshvara (known as Guanyin in China). The wooden armature projecting from the right wrist shows how the missing hand would have been attached.
A bracelet similar to the one on the left wrist would have covered the join.
(For Dunhuang see also pl. 143.)

carved into the cylindrical form of the head serves to maximise their potential as decorative motifs. Much more naturalistic terracotta heads and broken figures have been found at the Yoruba capital of Ife to the southwest, the site of an ancient and considerable court culture (pl. 200). When these were first seen by Europeans early in the twentieth century it was assumed that their naturalism could only be explained if the African artists had been working under the direction of Europeans. It was subsequently

199 (*right*) Head from a figure, northern Nigeria, Nok culture, c.285 BCE–515 CE, terracotta, 32.4 × 17.2 × 17.8 cm, Kimbell Art Museum, Fort Worth, Texas

This head probably once surmounted a complete figure of well over a metre in height. Evidence of iron working has been found at many of the same sites as similar pottery sculptures. Given a strong tradition in sub-Saharan Africa that pottery is the work of the smith's wife, it may be that the Nok figures were the work of women artists. They were fired not with kilns but by immersion in open bonfires.

200 (*far right*) Head of a queen, Nigeria, Yoruba culture, Ita Yemoo, 12th–13th century, terracotta, h. 25 cm, National Commission for Museums and Monuments, Ife, Nigeria

This head was excavated at the remains of a shrine late in the 1950s. It may once have formed part of an entire figure some three-quarters life size. Bronze heads in a similar style have been found in the same area. (See also pl. 208.)

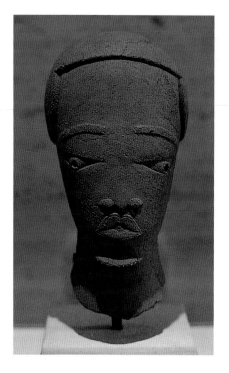

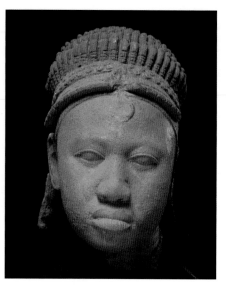

established that the earliest of them were made no later than the twelfth century, long before any Europeans had landed on the Guinea Coast. A third group of African sculptures in fired clay is associated with the culture of Djenne, a city on the upper waters of the Niger that is estimated to have had a population of some 10,000 by as early as 800 CE. They include a number of complete figures expressively modelled in seated and kneeling poses (pl. 201). The evidence suggests that these were made over a period of several hundred years, probably ending in the sixteenth century. A wealth of pottery made from the same material has been found in the same region. Given the persistent local tradition that pottery is women's work, it seems probable that these remarkable sculptures are the work of women artists.

In the very different circumstances of Renaissance Italy various attempts were made to produce large-scale sculpture in clay, while both wax and terracotta were widely used to make preliminary models for carved figures. One of the most complete early terracottas to have survived is a Virgin and Child attributed to Antonio Rossellino (pl. 202). Although no corresponding carved figure is known, the relatively spontaneous appearance of the work and the inconsistency of its detailing suggests that this was indeed made as a preliminary model. Small studies in wax also survive from the hands of Michelangelo and Giambologna, their preservation

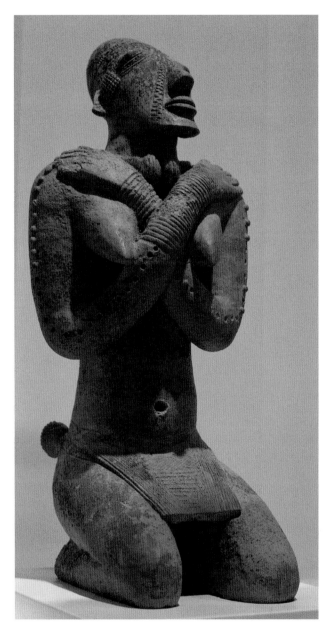

202 (*above*) Antonio Rossellino, *Virgin and Child*, sketch model for a statue, earthenware, *c.*1465, h. 48.3 cm, Victoria and Albert Museum, London

Rossellino spent his entire career in Florence, where he received a succession of commissions for tomb sculptures and reliefs, working mainly in marble.

201 (*above left*) *Kneeling Woman*, Mali, Djenne culture, inland delta of River Niger, 11th–16th century, terracotta with traces of red slip, h. 50.6 cm, Menil Foundation, Houston, Texas

Numerous whole and partial figures, both human and animal, have been found in the area round the ancient city of Djenne. Study of the sculpture is complicated by the fact that the same styles and materials are still used by local potters. While they may simply be working in emulation of an earlier tradition, opportunity also exists for the production of valuable fakes. These can be hard to detect, particularly where excavated fragments have been incorporated into apparently complete figures.

203 Clodion (Claude
Michel), *Bacchante supported
by Bacchus and a Faun*, 1795,
terracotta, h. 50.8 cm, Norton
Simon Art Foundation,
Pasadena

The artist studied in Paris and
in Rome, where he became
acquainted with small
terracotta studies made by
Bernini for his larger carvings.
Although Clodion executed
some monumental works in
marble, he was best known
for his small virtuoso
terracotta sculptures, typically
on antique themes
interpreted according to the
eighteenth-century taste for
Rococo caprice.

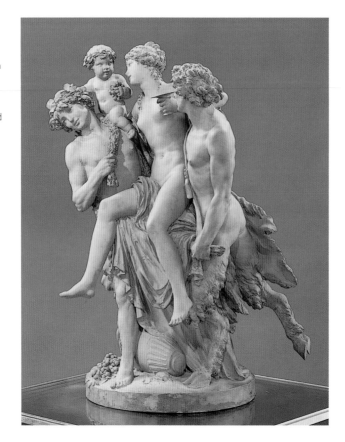

testifying to the increasing elevation of the status of sculptors from labo-
rious craftsmen to inventive artists. Just as collectors became interested in
artist's drawings as demonstrations of skill and for the insight they gave
into creative processes, so a demand became established for such prelim-
inary sketches as these. As the productions of small bronze statuettes
helped establish a market for sculpture on an intimate scale for private
enjoyment, works in terracotta offered a cheaper alternative. It was not
until the eighteenth century, however, that individual sculptors became
known for virtuoso works in unglazed terracotta that were produced and
sold as ends in themselves (pl. 203).

Of all ensembles of modelled sculpture surviving from modern times,
the most remarkable is the series of some eighty wax figures worked on
by the painter Edgar Degas between the mid-1880s and his death in 1919,
during a period when his eyesight was failing. The two principal subjects
of these are dancers and women in the process of washing and drying
themselves. These give a distinctly sculptural expression to the extraordi-
nary striving for empathy with the female form that enlivened the artist's

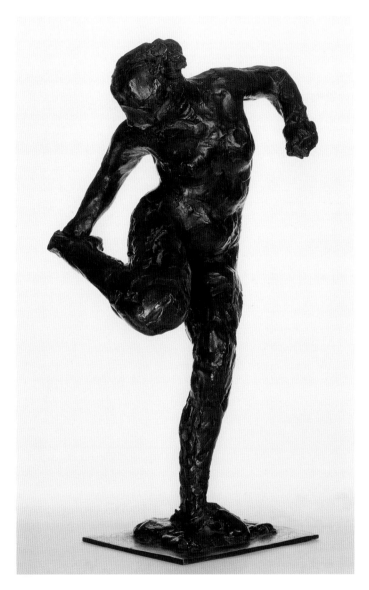

204 Edgar Degas, *Dancer looking at the Sole of her Right Foot*, c.1892–1900, bronze, h. 48 cm, cast c.1919, Ashmolean Museum, Oxford

Degas included a near-life-size wax figure of a 14-year-old dancer in the Sixth Impressionist Exhibition in 1881. This was the only one of his sculptures to be exhibited during his lifetime. The wax originals for his remaining work in three dimensions were found in his studio after his death. Rather than using posed models for these, he relied on knowledge of the figure accumulated through quantities of drawings, pastels and paintings. (For Degas see also pls 63 and 122.)

later oil paintings and pastels on the same themes. Degas's wax sculptures are now largely known through the editions of bronze casts that were made from them after his death (pl. 204). In many of these the deep cracks that opened up as the wax dried out are faithfully represented in permanent form, providing a strangely complementary effect to the vivid impression of the human body caught in delicate balance or at one moment in a continuous sequence of movements.

❏ ❏ ❏

4.7 CASTING

Casting involves the use of a process of moulding to reproduce an original model. Although this usually means translation into a more durable material, reproductive casts in plaster have been widely used to produce copies of celebrated statues in marble and bronze. The technique was known to the Greek sculptors in classical times and can be presumed to have been used to assist the imitation of their works during the Roman period. In the academies of the eighteenth and nineteenth centuries collections of casts of celebrated classical works were considered essential in the education and training of aspiring artists. A large gallery of reproductive casts was opened at the Victoria and Albert Museum in London in 1873, and has been much added to since then.

Casts in metal, in contrast, are usually made as end products from original models in clay, plaster or wax. The metals most commonly used for cast sculptures are bronze, which is an alloy of copper and tin, and brass, an alloy of copper and zinc, with copper in the majority in both cases. Adding a small amount of lead increases the fluidity of the molten metal, improving the take-up of any detail in the mould. Zinc is relatively ubiquitous, whereas tin is not found in any quantity in the Mediterranean area or the Middle East, though there were ancient sources in Afghanistan and Turkey. The two alloys are hard to tell apart once they have acquired a patina with age or through a chemical process of patination. As a consequence, both in their artistic uses have generally come to be known as bronze, while the term brass has been reserved for the bright unpatinated metal used for doorknobs and musical instruments and for the small plaques once used to decorate the harness of heavy horses, now to be found nailed over the fireplaces of English country pubs.

Bronze casting requires the making of a mould – a negative of the model – into which metal can be poured in molten form. The production of cast-metal sculpture of any size within a culture testifies to the development of appropriate technology and expertise and to a concentration of power and wealth sufficient to command both the expertise and the necessary physical resources. This tends to imply a certain concentration of population and a court culture of some kind. Bronze is a relatively costly material. A large figure cast in solid bronze will be both expensive and heavy. Small figures may be cast solid from wax models but the majority of surviving bronze figures of any size are hollow and were made by the lost-wax process. This is the most sophisticated form of casting, first discovered soon after bronze alloys were made in the fourth millennium BCE, and still used for the making of sculpture well into the late twentieth century.

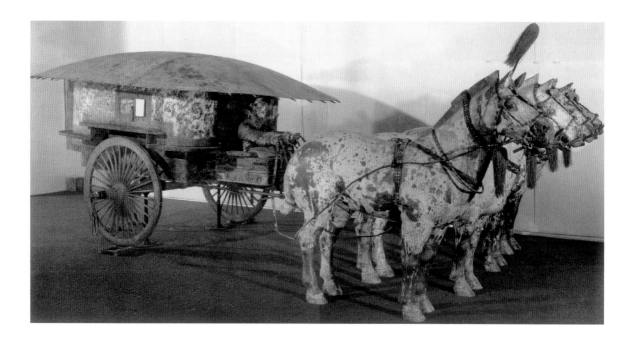

Highly decorated ritual vessels in bronze were cast from clay moulds in China from as early as 2000 BCE. Where figurative work is concerned, some of the most remarkable achievements of bronze casting and working have been excavated from the tomb of the First Emperor of Qin, where the Terracotta Army was discovered. These are two chariots, made half life-size, each harnessed to a team of four horses and complete with driver (pl. 205). They were cast from numerous small pieces – a total of 3462 in the example shown – which were then forged together before each component was painted. Details were inlaid with gold and silver. It is thought that the closed vehicle shown may have been intended to act as a 'soul carriage' for the Emperor's journey to the afterlife. Like the terracotta warriors, the bronze chariots testify to the extraordinary resources of skill, time and materials that virtually unlimited power can command.

The level of accomplishment to which bronze-casting technology had been brought in ancient Greece is vividly demonstrated by two life-sized figures discovered in 1972 in the Ionian Sea near Riace, the so-called 'Riace Warriors' (pl. 206). These were probably made in the mid-fifth century BCE, early in what is generally considered the classic period for the production of sculpture in Greece. They are virtually complete apart from the spear and shield each would originally have held. The figure shown would also have had a garland in the hair. Their bronze was cast in several parts, with separate moulds made for much of the detail. Lips and nipples are made of pure copper, the teeth of silver, the eyes of ivory.

205 Chariot (no. 2), China, from the tomb of the First Emperor of Qin, 3rd century BCE, bronze with gold and silver inlay and paint, 106.2 × 317 cm, Museum of Terracotta Warriors and Horses, Lintong County, Xian

This half-size model was excavated in 1980 from a pit near the tomb of the Emperor. The means of fabrication of the chariot exactly copied those that would have been required to make the real thing, so that for each wheel, a hub and thirty individual spokes were separately cast before being assembled together. Gold and silver were used to model and to inlay the horses' fittings.

206 Figure of a warrior,
Greece, c.450 BCE, bronze
with glass paste, silver and
copper inlay, h. 200 cm,
Museo Nazionale, Reggio,
Calabria

For life-size statues such as
this and its pair, hollow
bronze was considerably
lighter than solid marble.
Standing figures also needed
less support. The warriors are
thought to have been made
for display at a Greek temple
in Delphi or Olympia and to
have been lost in a shipwreck,
possibly when being carried
as booty to Rome. Their
remarkable state of
preservation is due to their
having lain buried in thick
mud, which delayed
corrosion.

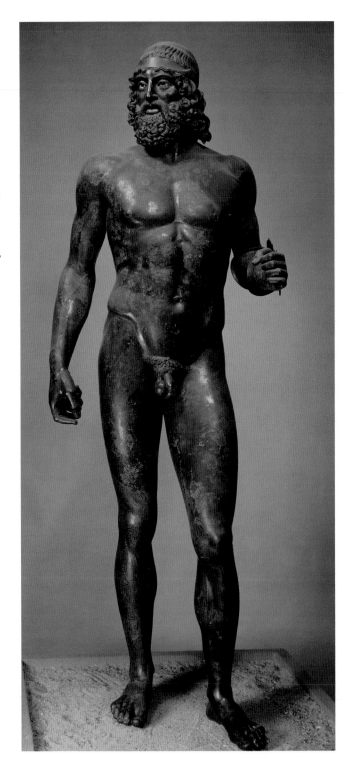

In what is called the direct-casting method, the basic stages of the lost-wax process are these. First a rough model is made in clay, to slightly smaller dimensions than are intended for the completed figure. This is then given a coating of wax, which is modelled and finished according to the intended appearance of the cast. This is coated with a slip – a fine layer of liquid clay. The whole is then encased in further layers of clay or plaster, with an aperture left, usually where the base of the sculpture will be. This forms a mould for the cast. A number of metal pins are pressed through this mould into the internal clay body to secure the one to the other. The whole is then baked so that the mould hardens and the wax runs out. Then a measured amount of molten bronze is poured into the cavity that the wax has left. If all goes well this will compose a cast of the figure, which can be exposed by breaking open the mould once the metal has cooled. The protruding ends of the metal pins can be filed away. To finish, the cast will be given sharper detail by cold-chiselling and any imperfections removed by burnishing the surface. If the design permits – for example where the figure is shown seated on a base – the clay core can be carved out, leaving the base and figure hollow. For a small standing figure the core can be left in. A large standing figure will normally be cast in several pieces, which can be hollowed out and joined together with molten bronze. The direct-cast bronzes of Hindu deities made in India during the Chola period (9th–13th centuries) were for the most part exceptions to this rule, even relatively complex figures being generally cast in one piece. Much of the fine detail of these sculptures was worked after casting, in a finishing process that might continue over several weeks (see pls 8 and 144).

With the direct-casting method the model is inevitably destroyed. An alternative method – indirect casting – involves making a piece-mould from the original model and using this to generate further models for casting. For a large statue, the model will be cut up into sections and moulds made from each – head, torso, arms and legs and any other components as required. These are first lined to the intended thickness of the bronze with strips of wax or some other malleable material, then filled with clay. When the clay has set it is removed, fitted with spacers called chaplets and, after discarding of the lining, replaced in the mould, forming a core. Molten wax is then poured into the space between the mould and the core. Wax is also used to form both the channels into which the bronze will be poured (the sprues) and those from which the air will need to escape. The entire section is then encased in clay and baked. As in the previous process, metal is poured in through the sprues where the heated wax has run out. Once the cast is removed from the mould, any metal in the sprues is cut off and the surface cleaned of blemishes. The various parts

207 Benvenuto Cellini, *Perseus and Medusa*, 1545–54, bronze with marble base, h. 5.5 m, Loggia dei Lanzi, Piazza della Signoria, Florence

In Greek mythology Perseus was the son of Zeus and Danae. He received magical gifts from the nymphs, including winged sandals and the helmet of Hades, and with their aid cut off the head of the gorgon Medusa, a monster with the power to turn all she looked on into stone. The statue was commissioned by Duke Cosimo de' Medici, who approved Cellini's design on the basis of a preliminary wax model (now in the Bargello Museum, Florence). The figure of Perseus in a small bronze version (Bargello) was based on study from a live model. Cellini also cast a small version of Perseus's hand holding the head of Medusa (now in the Victoria and Albert Museum, London).

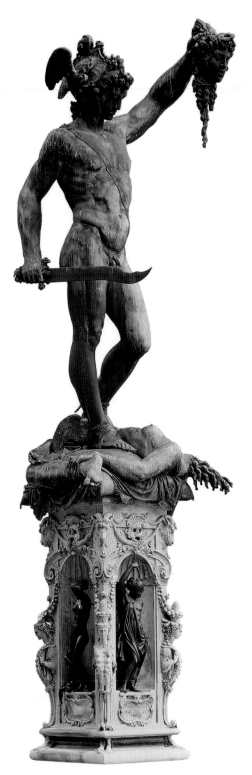

of the statue can then be assembled and joined together and finished by filing and chiselling.

One of the most notorious examples of lost-wax casting on a grand scale is the statue of Perseus and Medusa, some five and a half metres high in all, made by Benvenuto Cellini for the Piazza della Signoria in Florence, where it joined a smaller bronze group of Judith and Holofernes modelled by Donatello in 1446–60. Installed in 1554, Cellini's work shows the mythical Greek hero standing on the body of the gorgon and holding up her severed head (pl. 207). The main body of the work is supported on a carved marble base, each face of which has a niche containing a miniature figure in bronze. A full record of the various stages in the making of this remarkable work is given in Cellini's autobiography, the *Vita di Benvenuto Cellini,* first published from his manuscript in 1728. The commission occupied the artist and his several assistants over a period of nine years. He brought to the work the skills of an accomplished goldsmith, the highest ambitions of a monumental sculptor and a conviction that a successful figure must satisfy a multitude of different viewpoints. The statue was prepared with a wax model, a small bronze version, a large model in plaster over an iron armature

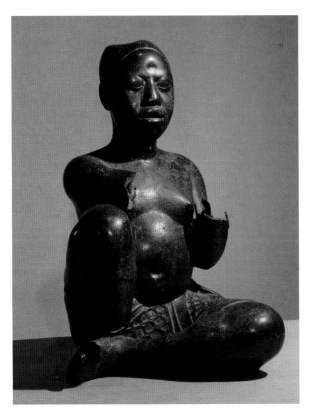

and a full-size model in clay. It required the building of a special furnace. The activity of finishing and chasing alone was spread over four years.

The best-known body of metal work from Africa is the series of cast brass plaques from the city of Benin, the majority dispersed to English and German collections following the British punitive expedition of 1897 (see pl. 188) though descriptions of the city and its artefacts had been published by travellers either side of 1700. Of these plaques the earliest are now dated to the sixteenth century, but ritual vessels and regalia excavated from a burial site in the area of the Niger delta demonstrate that a highly sophisticated bronze-casting technology was established in West Africa by no later than the tenth century. From a slightly later date there are bronze heads cast at Ife that compare with the terracottas already mentioned. The most remarkable surviving work from Ife, however, is a half-life-size figure of a seated man, hollow cast in copper probably in the thirteenth or fourteenth century (pl. 208). Given the weight of metal that would have been required for the figure in its unbroken state, it is assumed that the casting would have followed a technique also used in Europe for the making of heavy bells, with the mould partly buried in the ground and the molten

208 *Seated figure of a man*, Nigeria, Yoruba culture, Tada, 13th–14th century, copper, 53.7 × 34.3 × 36 cm, National Commission for Museums and Monuments, Lagos

The style of this figure suggests that it must have been cast at Ife (see pl. 200), though the shrine where it was found is some 200 kilometres north on the river Niger, where it was associated with the founding hero of a local dynasty of kings. It may have served to mark the northern point of a trading empire based on Ife.

metal poured in from a series of crucibles. The sculpture was kept until recently in a shrine in the village of Tada on the river Niger, some way north of Ife. Where African wooden sculpture tends to present a largely symmetrical view of the human figure, this work is remarkable for the complexity of its pose. There is no surviving European cast work of comparable date that could be said to achieve so high a degree of naturalism while establishing so thoroughly three-dimensional a presence, or one that offers such novel configurations through so great a variety of viewpoints.

At the other extreme of scale in African metal casting are the numerous brass weights made by the Akan-speaking peoples in regions of what are now Ghana and the Ivory Coast. These were used from about 1400 to 1900 for weighing gold dust in transactions both with trans-Saharan, Portuguese and Dutch trading partners and within local communities, where gold dust was the principal form of currency. The equipment required for such exchanges included a box for containing dust, a small pair of scales and a bag of weights. When a sale was made and the appropriate amount of gold dust weighed out, seller and vendor would check the parity of each others' weights. The weights are made as individual castings in clay moulds, with each composed of a measured amount of brass. Many of them are decorated with simple abstract patterns, some are formed by direct casting from such objects as seeds, fruit and crab claws, while a significant number are composed from small wax models of tools, musical instruments, birds, catfish and animals. Some are cast from miniature wax models of human figures, often illustrating sayings and proverbs of the Akan-speaking peoples. The example illustrated shows a man playing an Asante harp-lute (pl. 209).

When discussing modernism in painting I suggested that the achievement of naturalism in Europe in the nineteenth century, whether or not aided by photography, drove the inventive artist to other measures of difficulty and of the overcoming of difficulty. For sculptors working in the academic tradition, the development of increasingly reliable techniques for creating and copying life-like figures meant that much of the risk was taken out of the relevant processes. Over much of that century sculpture in the west, whether modelled or carved, seemed stuck in the stultifying manner that followed from the identification of plausible figure sculptures with a kind of habitual classicism. Increasingly prudish attitudes to-

209 Gold weight in the form of a man playing a harp-lute (*seprewa*), West Africa, Asante culture, probably 19th century, brass, h. 4.8, l. 5.1, w. 1.2 cm, author's collection

Whatever the subject, each gold-weight was made to a correct measure, corresponding to one of some sixty traditional units. When eligible for marriage a young man would be provided by his father with a small set of weights, some money and a rifle. The harp-lute on its own appears in a weight in the Museum für Völkerkunde in Berlin.

wards the exposure of the actual human body no doubt contributed to the growing tendency to prissiness that characterised nineteenth-century neo-classicism. The same was true, of course, of much academic painting, but there were two measures by which the continuation of painting as a major art form was assured, at least for the time being. The first was that even the most slavishly descriptive painting could still claim to achieve a kind of virtuality in the transposition from three dimensions into two. The second was that the naturalistic canons of academic painting were challenged throughout the century by European work that called attention to the painted surface and to those activities by which its difference from the appearances of nature were most clearly marked. Naturalistic sculpture, however, was stuck with its three-dimensionality and thus faced the possibility of a kind of collapse into literalism. Whatever the period or culture, naturalistic sculpture of the human figure needs some factor additional to its achieved life-likeness – some working of the material to ends other than those of imitation, perhaps – if it is to do more than fascinate us with the possibility of confusion. These are the grounds on which sculpture stands apart from waxworks.

In 1877 the French sculptor Auguste Rodin exhibited a life-sized figure of a young man at the French Salon, with the title *The Age of Bronze*. This was considered so naturalistic that it was assumed that the artist must have cheated by taking casts from a living body. In fact, however, what his audience was responding to was Rodin's consummate skill as a modeller; his ability to bring the surface of the sculpture alive as the expression of a complex volume. Although Rodin saw himself as working within a largely classical tradition vitalised by the work of Michelangelo and Bernini, he took his cue from the early modernist painters in emphasising the activity by which his figures were fashioned, working rapidly in clay from models often set in motion in the studio. What holds the attention in his most successful figures is an abiding tension between their weighty sculptural masses and the busy, almost painterly surfaces by which those masses are bounded. These figures are modelled in plaster. The malleability of that material is essential to the impression of continuous nervous engagement that Rodin's working method conveys. Yet it is in the bronze casts made from these models that the crucial effect is added, as the matt, light-absorbing surface of plaster is replaced by the more tensile, light-reflecting properties of the metal.

The plaster version of Rodin's figure of *Eve*, also life-size, is dated to 1881. This is when the sculptor ceased work on it, citing his model's pregnancy as the reason. Its pose pays tribute to Michelangelo by echoing his frescoed image of Eve from the Sistine Ceiling in the Vatican, which Rodin had visited five years previously. The plaster was not exhibited until 1899,

210　Auguste Rodin, *Eve*, bronze cast 1911 from a plaster of 1881, h. 175 cm, Musée Rodin, Paris

This figure was originally paired with a statue of Adam and was planned for incorporation into the *Gates of Hell*, an ambitious project that Rodin based on Dante's *Inferno*. It arose from a commission for bronze doors for a proposed museum of decorative arts that was never built. A number of separate figures such as this were generated by the project. The plaster ensemble of the *Gates* was not cast until 1925, after the sculptor's death. (For Rodin see also pl. 134.)

211 Pablo Picasso, *Baboon and Young*, 1951, plaster with pottery, steel spring, toy cars, wood, 53 × 33 × 61 cm, Musée Picasso, Paris

A pottery jar forms the animal's belly, the shoulders and ears are made from pottery handles, the tail from the spring of a car, the legs from wood and the face from two toy cars. Soon after its completion, the sculpture was cast in an edition of six bronzes. (For Picasso see also pls 31, 229 and 233.)

when it was the first large figure to be shown publicly in France without a base, and it was not cast in bronze until 1911 (pl. 210). Like many of the sculptor's works, it exists in several versions and in various editions of casts. Given the importance of the worked surfaces of his figures, much of the virtue of Rodin's sculptures is lost if the casts are not made to the highest technical standards.

For all the great acclaim that it attracted in the early twentieth century, Rodin's work represented a kind of terminus. It is significant that two artists who were primarily painters, Matisse and Picasso, were foremost among those who pursued the potential for modelled and cast sculpture that he had indicated. Picasso in particular was characteristically inventive in incorporating diverse ready-to-hand elements into figures basically modelled in plaster, in the assurance that while casting into bronze might unify the results, a certain quirky resonance would be maintained (pl. 211). Such inventions notwithstanding, beyond the first third of the twentieth century the bronze casting of modelled sculpture was a technique largely employed in the monumentalisation of conservative and largely corporate work.

4.8 CARVING STONE

Clay usable for pottery and for modelling can be found in most parts of the world. In so far as there are regional variations in composition of the material these are not so great as to require the use of very different techniques. There is also widespread distribution of copper ores suitable for smelting and for alloying with either tin or zinc. Matters are different in the case of stone suitable for carving. In any explanation of the character and development of different sculptural traditions in different areas, consideration needs to be given to the availability or lack of particular materials suitable for carving. We have already seen the close association of the classical tradition with the white marble found in certain areas around the eastern Mediterranean. Marble is also found in India but was not there as widely used for sculpture as were sandstones of various colours and the dark form of slate employed for the stele of Vishnu in the Ashmolean in Oxford (see pl. 180). In the area of Gandhara that is now in northern Pakistan a grey schist was used in the first to third centuries CE for Buddhist carvings that show the effects of contact with Greek styles channelled through the eastern Roman Empire (pl. 212). That both this and the dark slate were highly stratified rocks quarried in slabs rather than blocks helps to explain why they were generally used for steles, reliefs and relatively shallow figures set against walls rather than for figures in the round. Schist's tendency to flake also explains why piercing and undercutting are rare in sculptures from Gandhara.

The availability of diverse stones suitable for carving undoubtedly encouraged the establishment and spread of complex Hindu and Buddhist iconographies throughout the Indian subcontinent and into South-east Asia. Wherever Buddhism took root, the encouragement that its teachings gave to the use of images was in turn a great incentive to the development of sculpture. A fully fledged Buddhism first became established in the north-western part of China in the fourth century and from that point on the marble, sandstone and limestone found in the country were all widely used for religious figure sculpture (pl. 213). In Japan, however, there was no native stone suitable for carving. As a consequence, the strong tradition of Buddhist sculpture that flourished in the country from the late sixth century to the eighteenth was dominated by work in wood, with a lesser quantity of casting in bronze.

In northern Europe there is a prevalence of limestone and sandstone. As an alternative to wood, this was widely used throughout the Middle Ages for sculpture on Christian themes, particularly where carvings were to be integrated with architecture. A massive impetus came with the great period of cathedral building from the eleventh to the fourteenth centuries, especially in France, where large numbers of mostly unnamed stone carvers

212 *Bodhisattva Maitreya*, Pakistan, ancient Gandhara, 2nd–3rd century, grey schist, 84 × 28 × 11.7 cm, Musée Guimet, Paris

The halo and the water-pot held in this figure's left hand identify him as Maitreya (see also pl. 145). Its debt to Graeco-Roman art is shown in the sandals, the moustache and the style of the torso and drapery.

213 *Amitabha Buddha*, China, Sui Dynasty, dedicated Changguang Temple, Hancui village, 585 CE, marble, h. 548 cm, British Museum, London

In a strand of Buddhism pursued in eastern Asia, the historical Sakyamuni became one part – the Created Body – of the 'three bodies of the Buddha'. The others were a Body of Essence corresponding to the Hindu Brahman, and Amitabha, the Body of Bliss, who presides over the western Paradise (reserved for those who would never reach the state of nirvana). The style of this large figure was probably based on Indian bronzes brought to China by pilgrims or as trade. Its right hand would have been raised in a gesture of fearlessness, the left in a gesture of bestowal. Originally it was flanked by a smaller standing bodhisattva (now in the Tokyo National Museum). The figure was presented by the Chinese government to the British Museum in 1938 to commemorate the International Exhibition of Chinese Art of 1935–6.

214 Giselbertus, *Eve*, formerly right half of lintel on north portal of the cathedral of Saint-Lazaire, Autun, *c*.1120–40, limestone, Musée Rolin, Autun

The words *Giselbertus hoc fecit* ('Giselbertus made this') cut into the west tympanum at Autun have been widely assumed to refer to the sculptor, though it is also possible that they name the donor of the work. What is more certain is that the same craftworker had overall responsibility for carvings in the doorways of the church and on capitals surmounting the pillars of the nave, choir and transept. It has been suggested that he may also have been responsible for the architecture of the church.

found employment providing figurative decoration for facades, porches, naves and cloisters. One of the few craftworkers thought to have signed his work, a certain Giselbertus, may have been responsible for a series of sculptured capitals and a remarkable doorway made in the first part of the twelfth century for the cathedral of Saint-Lazaire at Autun in central France. A figure of Eve carved in relief was set in the centre of the doorway. She is shown lying down and reaching behind her to pluck the apple, as though to avoid the sight of her own action (pl. 214).

As previously mentioned, the materials available for the manufacture of tools also influence decisions about the materials that can be worked. It might be thought that the hardest stones would only be preferred where sculptors have access to the hardest and sharpest of tools. In fact the reverse was often the case. The more easily a stone will flake and split, the more difficult it is to work with blunt tools. Iron-hard igneous or volcanic rocks, such as the basalt and diorite used for some of the larger figures in ancient Egypt, could safely be pounded by gangs of workers armed with stones and bronze punches (see pl. 136). Finely carved sculptures in jasper and granite were made by artisans working with no tools harder than bronze and reliant on time-consuming work with wooden drills and abrasive powders for finishing and polishing. The same is true of ancient Chinese and South American work in jade, a stone so hard that steel will not scratch it (pl. 215). Where the sculptors were working to order – for an Egyptian pharaoh, say, or a Chinese emperor – we might assume that the choice of the hardest materials was made not by those sculptors them-

215 Pendant, Central America, ?Honduras, Maya culture, c.400 CE, jade, h. 10 cm, Barbier-Mueller Museum of Pre-Columbian Art, Barcelona

The Mayas occupied an area of what is now southern Mexico and Guatemala, including the Yucatán peninsula. Theirs was the greatest civilisation of pre-Columbian Central America, dating from about 200 CE until the arrival of the Spanish early in the sixteenth century, with a 'classic period' from about 300 to 900. This figurine was probably made as an item of jewellery.

216 (facing page) Cycladic figure, late Spedos variant, c.2500–2400 BCE, marble, 41.5 × 10.7 × 3.75 cm, Walters Museum, Baltimore

The majority of these early Cycladic figures have been unearthed in illegal excavations – a result of their great popularity and consequent value. This has inhibited research into their origins and function. Primitive metal tools would probably have been available by the time this example was made, though much of the finishing would have been done with the use of abrasives such as emery powder and pumice. The apparent absence of features is explained by the fact that eyes and mouth would originally have been painted on.

selves but by the persons with the power to command, who presumably looked for permanence, whether in personal possessions or in public monuments. Yet the ability to work these materials must still have been the sculptor's stock-in-trade, the guarantee of employment and of a degree of status.

In fact, of stones to be found in any quantity there is none so hard that it was not sculpted long before iron and steel tools were available. It is not so much in the choice of materials as in the complexity of sculpted forms that the influence of sharp and hardened chisels and drills is revealed. The greater the hardness of the material in relation to the available tools, the more compact the figure will tend to be to minimise the risk of breakage during the process of making. Rounded forms divided by relatively shallow indentations are characteristic of the earliest stone figures to have survived, such as the Willendorf 'Venus' in Vienna and the 'Venus' in Minneapolis (see pls 150 and 172). Those who made them were working with nothing harder than one stone against another – albeit few stones are as hard as the widely available flint from which early tools were made. It is generally assumed that the marked plumpness of these and other figures of similar age signifies a celebration or invocation of the fertility of the female. Whether or not this is the case – and there may be no secure way of telling – the compactness of these prehistoric figures makes practical and aesthetic virtue out of the limitations under which the carvers were operating, in ways quite independent of the canons of female attractiveness that are observed in the vast majority of subsequent sculpture. A marked contrast is provided by the slender marble figures, mostly female, that have been found in graves around the eastern Mediterranean (pl. 216). These date from a period far closer to modern times and are more technically ambitious in their elongation and in the elegance of their profiles. In their lack of extensive projection and undercutting, however, they remain rep-

resentative of sculpture made from relatively hard materials with simple tools and abrasives.

Once hard and sharp tools were available, the sculptor was freer to exploit the relative softness of stones such as marble and to disguise the problems of weight bearing and balance with virtuoso displays of under-cutting, perforation and detail. One of the best known of all marble sculptures – indeed one of the best known of all the world's sculptures – is the over-life-size standing figure of David carved by Michelangelo over the course of three years at the very beginning of the sixteenth century (pl. 217). It was commissioned as a symbol of the republican government of Florence and was destined for a prominent position in the Piazza della Signoria.

This is the same subject that Donatello had addressed in bronze more than half a century before (see pl. 152). The features common to the bronze and marble Davids are indicative of the structural problems that Donatello and Michelangelo each faced in constructing large standing figures from heavy materials. In both sculptures there is an element that provides additional bracing for the weight-bearing right leg – the wing from Goliath's helmet in Donatello's work, a more conventional tree-stump in Michelangelo's – while in each case the more relaxed left foot is actually planted firmly on the base. In both, though the arms are detached from the body, they are physically attached at their extremities, the right arm of Donatello's figure being supported through the long sword, the left of Michelangelo's David through the sling that rests on his shoulder. The marked differences between the two figures are largely due to the ways in which the sculptors exploited the widely different properties of their materials. In Donatello's bronze version David appears as a dreamy and sensuous adolescent, the lustrous smoothness of the polished body set off by the chiselled detail of laurel leaves and twisted tresses and by Goliath's helmeted head at the base. In Michelangelo's larger work the light-absorbing properties of the white stone are exploited to create a more homogeneous effect, with only the minimum necessary props to complement the more mature nude figure.

Thanks both to the unrealistic and ever-changing demands of his patrons and to his reluctance to delegate, Michelangelo left a considerable number of unfinished sculptures, with figures in different stages of emergence from the blocks of stone (see pl. 156). Such insights as these provide into his working procedures allow us to reconstruct the likely stages in the making of the marble David. The single block of Carrara marble provided for the sculpture was relatively shallow and had already been partially worked on by another sculptor forty years previously. This limited Michelangelo's options for the stance of his figure and for the amount of projection that

217 Michelangelo, *David*,
c.1501–4, marble, h. 409 cm,
Galleria dell'Accademia,
Florence

Now preserved indoors to
ensure its protection,
Michelangelo's statue has
been replaced in Florence's
Piazza della Signoria by a
full-size copy.

218 Gianlorenzo Bernini, *Apollo and Daphne*, 1622–5, Carrara marble, h. 243 cm, Villa Borghese, Rome

In Greek mythology, Apollo was the son of Zeus and Leto and twin brother to Artemis (the Roman Diana). He represents an ideal of male beauty (see pl. 153). The nymph Daphne was the daughter of the river god Peneus. It was he who responded to her prayer by turning her into a laurel tree when she was pursued by Apollo. Daphne is the Greek term for laurel, the tree sacred to Apollo. (For Bernini see also pls 167 and 169.)

219 (*facing page*) Berthel Thorvaldsen, *Hebe*, 1816, marble, h. 150 cm, Thorwaldsens Museum, Copenhagen

Hebe was the daughter of Zeus and Hera and was the personification of youth. She is shown performing her role among the gods, which was to serve them with their drink of nectar. The Dane Thorwaldsen was Canova's nearest rival in Rome, pursuing a neo-classical style that was closer to the spirit of pre-Hellenistic Greek sculpture. He maintained a large and productive studio, with numerous professional marble carvers and students. Each of his figures was worked up from an initial sketch, through an enlarged and then a full-size clay version, to a final model cast in plaster. From this, the marble was carved with the aid of a pointing machine. So long as the plaster 'original' was preserved, multiple marble figures could be made from it according to demand.

would be possible in the horizontal plane. Evidence suggests that the figure was worked from the front, presumably following a drawing sketched out on the block. Those portions of the figure nearest the resulting viewpoint were defined first. The back of the left hand holding the sling might be likened to the object in a painting placed nearest to the picture plane, which thus provides a point of registration for all that is set further back in the represented space. With this element established, Michelangelo must have continued to excavate the marble until he had produced an image in relief, refining the nearest surfaces as he went, with flat chisel, claw-chisel and rasp. Side views would have been created as he cut more deeply into the stone at the edges of the figure. The 'background' would have been gradually eliminated as he worked further into the block, opening up the areas between the legs and between the body and the right arm, until the reverse side of the figure was entirely exposed for shaping. Then the sculpture could be finished off in the round, with final attention given to the intricate carving of the facial features, the fingers, the genitals and the hair, to the shaping of the musculature of the torso and to the detailing of the veins on the backs of the hands.

Due in part to the extraordinary standard set by Michelangelo, the technical sophistication of marble carving in Italy continued to develop over the ensuing century, reaching a high point early in the 1600s. Bernini's group of Apollo and Daphne was completed in 1625, with some of the finest work delegated to a specialist carver (pl. 218). The subject is the moment at which the nymph is turned into a laurel tree in order to escape from the pursuing god. Here it seems unlikely that the sculptor could have proceeded far by drawing his design on a single face of the original marble block. In fact Bernini was a copious and fluent draughtsman and his figure group was surely conceived, studied and worked on in the round from the start. Although he must have attended at all stages to the problems of distribution of weight and of structural supports, he took far greater risks than Michelangelo with the possibilities of breakage, leaving the right arm and left leg of Apollo projecting totally unsupported into the surrounding space. That this highly fragile sculpture has survived in its undamaged state is due in part to the quality of the stone and in part to the fact that it has never been moved from the Villa Borghese in Rome, where it was first set up to compete with a collection of marble sculpture of ancient origins. It is fair to assume that spectators in Rome at the time would have noted Bernini's clear reference to the Apollo Belvedere (see pl. 153), then the most famous of all classical sculptures, and would have made the comparison that he thus invited between ancient and modern levels of accomplishment.

As already implied, the power of the classical tradition to generate new and significant types of sculpture appears finally to have been exhausted by the first third of the nineteenth century, when Antonio Canova and the Scandinavian Bertel Thorvaldsen were both working in Rome, each with a large studio employing assistants at virtually all stages from the interpretation of initial sketches to transfer of full-sized plasters into their marble equivalents (pl. 219). With the decline of the academic tradition in the latter part of the nineteenth century, virtuosity in stone carving of the order demonstrated by Bernini and Canova came to be associated with a now-degenerate classicism or with the conservatism of ecclesiastical commissions or both. For most of the nineteenth century, the art of stone carving was directed to such traditional ends as civic monuments, architectural decorations, portrait commissions and memorials. During the Italian Renaissance it had been in work of this kind that the most able and inventive sculptors had made their reputations. Significant developments in sculpture in the modern period, however, have generally been associated with works intended as ends in themselves, whether for display in public locations, in galleries or in private homes, even when the artists concerned have also worked on public commissions. In the nineteenth century few of these developments

were made in stone carving. Rodin was the major sculptor to emerge in Europe in the late nineteenth century. He did oversee the making of a number of portrait heads and other works in marble but it is on the type of highly expressive works already discussed that his reputation depends and these were all modelled in plaster and cast in bronze.

By the end of the nineteenth century sculpture in which the understanding of life-likeness had been mediated through the classical tradition

tended to look particularly retrograde, as though addressed to an already collapsing social order. At the same time the marked increase in awareness of the art of ancient and non-European cultures that impinged so clearly on the development of modernism in painting worked to even greater effect where carved sculpture was concerned. The great majority of the art that was newly brought to the attention of European artists was after all sculptural in character and mostly carved, whether from Africa, from the ancient Middle East, from the South Seas or from pre-Columbian South America. In a statement published in the *Architectural Association Journal* in 1930 the English sculptor Henry Moore reviewed the resources on which the modern sculptor felt free to draw:

> The world has been producing sculpture for at least some thirty thousand years. Through modern developments of communication much of this we now know and the few sculptors of a hundred years or so of Greece no longer blot our eyes to the sculptural achievements of the rest of mankind. Paleolithic and Neolithic sculpture, Sumerian, Babylonian and Egyptian, Early Greek, Chinese, Etruscan, Indian, Mayan, Mexican and Peruvian, Romanesque, Byzantine and Gothic, Negro, South Sea Island and North American Indian sculpture; actual examples or photographs of these are all available, giving us a world view of sculpture never previously possible.

These various factors combined to generate a renewed interest in stone carving in the early twentieth century. Yet this was carving that consciously eschewed the kinds of virtuosity in imitative representation that had been associated with European sculpture since the Renaissance, with the classical tradition in particular. The effects now sought were those identified with the 'purer' and more 'primitive' art of pre-classical, pre-Renaissance and non-European cultures. So far as stone sculpture is concerned, the principle contrasting tendencies of the early twentieth-century avant-gardes are illustrated by Jacob Epstein's *Female Figure in Flenite* of 1913 (see pl. 190) and Barbara Hepworth's *Three Forms* in grey alabaster of 1935 (pl. 220). The first interprets the human figure expressively by reference to examples drawn from African and Oceanic cultures, the second renders a group of abstract forms inviting to the sense of touch, in such a way as to suggest a kind of equivalent for a trio of related individuals.

220 Barbara Hepworth, *Three Forms*, 1935, grey alabaster, 26.5 × 47.3 × 21.7 cm, Barbara Hepworth Museum and Sculpture Garden, St Ives, Cornwall

In the early 1930s Barbara Hepworth and her partner, the artist Ben Nicholson, were at the forefront of a small group of English modernists, with connections to artists working in Paris. Triplets were born to them in November 1934. During this period Hepworth made a number of abstract carvings, with separate forms in marble or wood juxtaposed on a small base. In a subsequent statement she wrote of her abstract work of the mid-1930s that it 'initiated the exploration' in which she hoped 'to discover some abstract essence in sculptural terms giving the quality of human relationships'.

4.9 CARVING WOOD

Most kinds of wood are easier to carve than most kinds of stone but they are also less stable and less durable, prone to shrinkage as they dry out and vulnerable to burning, to infestation by insects and to rot. We can assume that vast quantities of wooden sculpture have been lost over the ages. A *Guide to Greece* written by Pausanias in the second century CE describes a number of earlier wooden statues with marble attachments, none of which survived into modern times. Although no positive evidence remains, it is also likely that wood was sometimes used as an alternative to clay when models were required for classical sculptures in marble and bronze. The wooden objects that have survived from ancient cultures are for the most part those that were included in burials where the atmospheric conditions favoured their preservation. These include numerous single figures and figure groups and small carved utensils from Egypt. The fine female nude from Thebes dates from the Middle Kingdom, about 2000–1700 BCE (pl. 221). Other survivals from early times are due to the continuity of religious traditions and practices. The small figure of a celestial musician was carved and painted in the late fifth or early sixth century CE (pl. 222). It derives from the library of an ancient Buddhist monastery in Kucha, situated on the Silk Road north of the Taklamakan Desert, at the western end of present-day China. In Japan, finely carved figures from as early as the eighth century CE have been preserved due to their being maintained as objects of devotion in temples. The standing figure of the healing Buddha was carved from a single block of cypress wood in the ninth century (pl. 223).

The great majority of sculpture from Africa is carved in wood. Individual figures are rarely larger than a metre high and are almost never set in a narrative or localising context. Carvers normally envisage their work three-dimensionally in relation to the block of wood without any prior drawing on its face. The resulting effect is altogether unlike the continuous surface rhythm that unifies the torso and limbs of the ideal classical figure, a rhythm that tends to preserve at least an echo from some preliminary drawing on the block. Rather, it is characteristic of African sculpture that the sense of presence and animation depends strongly on the marked relations and contrasts between different salient volumes. It can be difficult to establish when a given African sculpture was made, though a latest possible date can be established where it is known when a piece was first removed from its place of origin. On this basis there are few African wood sculptures in museum collections that can definitely be given a date before the end of the eighteenth century (pl. 224) while most tend to be ascribed to the late nineteenth or early twentieth – the later date

221 Figure of a nude female, Thebes, Middle Kingdom, c.2000–1700 BCE, wood, Metropolitan Museum of Art, New York

The woman is shown wearing a wig of a type associated with the Middle Kingdom. It is likely that the small statuette was once painted. Too finely carved to have composed one of the models of servants included in the tombs of the powerful, it may originally have been made as a gift.

222 (right) *Celestial musician tuning her lute*, oasis of Kucha, 5th–early 6th century, wood with traces of colouring, 12.3 × 4.6 × 2.6 cm, Musée Guimet, Paris

Until the late nineteenth century it was assumed in the west that the area of Central Asia threaded by the Silk Road had been occupied by Turkish Muslims. After 1900, discovery of Buddhist manuscripts from the area led to intense interest from archaeologists and collectors. Expeditions were sent from Sweden, Britain, Germany, France, Russia and Japan, with the objective of recovering manuscripts and works of art. (See the caption to pl. 143.)

223 (far right) *Yakushi Nyorai* (Healing Buddha), Early Heian period, 9th century, cypress wood, h. 157.5 cm, Gango-ji, Nara, Registered National Treasure

Buddhism arrived in Japan via Korea and China and was well established by the ninth century. Yakushi Nyorai is the Japanese name given to the Buddha of Medicine and Healing, whose cult was among the earliest to take root in the islands. He is also known as the Lord of the Land of Pure Bliss in the Eastern Quarter of Heaven.

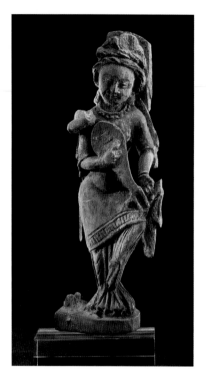 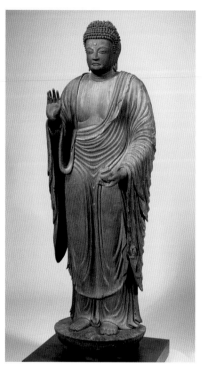

being set by the time at which the making of masks and figures ceased to be sustained by meaningful customs and traditions.

There are at least two reasons, though, why it would be wrong to assume that what survives from the nineteenth and early twentieth centuries fairly represents the various traditions of sculpture across the whole sub-Saharan area. The first is that the surviving heads and figures from Africa made in the more durable materials of terracotta and bronze testify, as we have seen, to the existence of a number of rich and sophisticated court cultures, each with a high level of artistic production, that can be dated back variously over a period of more than two millennia. It seems safe to assume that quantities of wooden sculptures were also made over this period and that their styles evolved accordingly. The second reason is that the conditions under which the great majority of African masks and figures were made, used and stored were far from conducive to their preservation. Although they were often highly valued within their communities, the functions for which they were intended generally involved some degree of exposure to wear and tear, to the elements and to damage by termites. They were never intended to be set up on reserved flat surfaces and admired as works of art but were often moved about and handled. Sculptures were generally treated as beings endowed with a certain life, but a

224 Carving of a king, Kuba-Bushoong, Republic of Congo, probably late 18th century, wood, h. 54.5 cm, British Museum, London

The Kuba occupy a territory in what was central Zaire. In the Bushoong chiefdom kings were commemorated with wooden statues, each equipped with an attribute to identify him. This statue represents the founder of the Bushoong ruling dynasty, shown with a board for the game of mancala. Although he reigned in the early 1600s, it was only in the following century that such figures were carved. This is one of the oldest examples of African wood sculpture that has survived intact. It was collected in the early twentieth century and given to the British Museum in 1909

carving might be abandoned if it was considered that it had ceased to fulfil the supernatural function for which it was made. Few of those that remained with their communities were likely to have been preserved intact over long periods, while those that were acquired by European and other collectors were a small minority. Even during the nineteenth and into the twentieth centuries, the losses must have been vast.

It is not entirely inappropriate to label the pre-twentieth-century cultures of sub-Saharan Africa as primitive, if what is meant is that those cultures were technically backward in relation to industrial Europe or that they generally had no written languages. However, it would be entirely unjustified to associate primitivism in this sense with any deficiency in aesthetic terms or even with a lack of sophistication in meeting the specific demands of the culture in question. It is cause for some ironic reflection that European observers should have labelled the art that emerged from Africa as 'primitive', meaning that its lack of naturalism was indeed due to lack of sophistication, when they were at the same time treating the comparable work of the European avant-gardes as a sophisticated reaction against academic naturalism. The assumption at work here was that the virtue of African art lay in its innocent and authentic freedom from those canons of life-likeness against which the knowing European modernists were reacting. Yet what the evidence shows is firstly that highly naturalistic – almost 'classical' – types of art had flourished in Africa, in the area of Ife at least, as early as the twelfth century, and secondly that many highly individual traditions were maintained during the later periods from which wooden sculptures have survived. Different localised cultures pursued various repertoires of figurative styles, with different degrees of life-likeness or of formal invention and development, often with complex interrelations with the styles of their neighbours, and with individual carvers excelling in their interpretation of particular types – just as in Europe.

In other respects circumstances in Europe were of course far different. To take one major factor, developments in trade and the consequent widespread growth of cities were of clear importance for the European development of sculpture from the Middle Ages onwards. It was in cities that the wealthy churches were to be found. Not only did the Catholic Church provide the principal source of patronage and employment for artists but the Bible also provided a single source of subject matter for sculpture with a religious function, which made up the great majority of all sculpture during the Middle Ages and the Renaissance. There was a consequent tendency for sculptural work across a broad area to be concentrated on a range of common subjects and thus, perhaps, to be less heterogeneous than the figurative sculpture from central and west Africa.

The subject of the Virgin and Child is a particularly telling indicator of the development of carved wooden sculpture in Europe from the early Middle Ages until the eighteenth century, presenting a distinct range of challenges and possibilities for the artist (pl. 225 and see pl. 149). Whether the Virgin is posed standing or seated, the interlocking of two figures of different sizes offers a range of complex formal problems. How are the various limbs to be disposed in relation to each other? How are the

draperies to be arranged to best effect, so that they serve both to contrast with the exposed areas of head and hands and to model the body beneath? It is significant that while a few preparatory drawings by late medieval and early Renaissance sculptors survive for ambitious carved altarpieces, these appear to have been furnished less as studies addressed to such problems than as evidence for contracts. We should remember that paper was still a rare and expensive commodity as late as the end of the fifteenth century and parchment still more so. It was with Michelangelo and his successor Bernini that sculptors' drawn studies came to occupy an important place in the invention of their works. Before then, suggestions for individual figure groups and even for more complex compositions were frequently taken from the graphic work of engravers, which was widely circulated in sculptors' studios. In interpreting these, carvers would have had to consider such factors as how the weight of the figure was to be disposed and its stability assured. Where was the balance to be struck between variety and virtuosity of carving and avoidance of the risk of damage? Could the whole sculpture be made from a single block of wood or would it be necessary to carve such elements as heads and hands from separate pieces? If the latter, how were joints to be made and secured? For the carver in wood such questions had to be addressed with a continual regard to the distinctive character of the material: to the size and character of the timber available, to the direction and closeness of the grain and to the different techniques required in cutting with and against the grain respectively.

Particularly in northern and central Europe there was a ready supply of suitable timber. Large figures could be made from single pieces of poplar, willow, limewood (see pl. 176), walnut or oak, small ones from fruitwoods or from the hard dense wood of the box tree (see pl. 225). Where African carvers were largely restricted to iron adzes and knives, with heated wires used for boring holes, European carvers were working from the early Middle Ages with a wide range of tools. Denser woods such as dry oak were worked with the heaviest gouges and chisels. As might be expected, the finer-grained woods were generally worked with the sharpest steel blades and allowed fine detail on a small scale. The small figure of the Virgin and Child by Veit Stoss is exemplary of the kind of virtuoso carving in boxwood that would have been impossible without the availability of a range of fine and sharp steel tools. This is a work that would no doubt have been intended for the private devotion of a wealthy client – someone

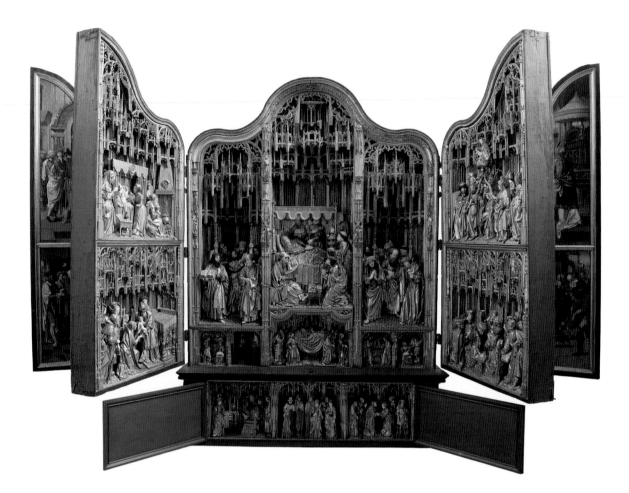

226 Complex altarpiece, Antwerp, central panel and predella, 1518–22, carved, painted and gilded oak, closed 286 × 254 cm, open, 286 × 508 cm, Marienkirche, Lübeck

In Antwerp, painters and wood carvers were members of the same guild. The altarpieces made there were in considerable demand in the early part of the sixteenth century. Paid for by a German merchant and commissioned for a church dedicated to the Virgin Mary, this ensemble is organised so as to compose a detailed narrative of her life and death. When fully closed, it displays a painted scene of the Annunciation. The first pair of wings opens to disclose four painted episodes from the life of the Virgin's parents and four connected with the Nativity. These open in turn to disclose the central section and inner wings, composed of figures with architectural settings carved in the round and in deep relief. The central scene shows the death of the Virgin attended by the twelve apostles (see also pl. 46).

Three scenes from her life are carved in the predella panel at the bottom. For much of the year the altarpiece would have been kept partially closed, the inner scenes only displayed at major festivals such as Christmas and Easter.

who would have appreciated the smooth finish and high polish that the hard, close-grained wood made possible.

Until recent times it was exceptional in northern Europe for the surfaces of wooden sculpture to be left bare like this. The great majority of carvings on religious themes were either gilded or painted or both. A particularly ambitious sequence of scenes in carved, gilded and painted wood, which has survived in something like its original condition, forms part of a large and complex altarpiece that was made in Antwerp in the early sixteenth century for the Marienkirche in Lübeck in Germany (pl. 226). Its theme is the life and death of the Virgin. The fine condition of the sculpted ensemble is largely explained by the fact that it was exposed only on special occasions, being normally protected by the two layers of painted wings that were made to fold over it. That the carved panels were reserved for the most precious inner portions of the altarpiece is a reminder that on anything like a level field of comparison, sculpture was more costly than painting, particularly when it was as heavily gilded as this.

With the type of virtuoso work achieved by Veit Stoss and the anonymous carvers of the Lübeck altarpiece a high point was reached in the technical sophistication of wood carving, at least as regards European sculpture of the human figure. Where carvings were required in the seventeenth and eighteenth centuries, marble was the material most favoured by sculptors and their clients. During that period the most remarkable work in wood was done by cabinet makers and by the carvers of architectural decorations, trophies and cartouches – a range of work associated particularly with the virtuoso English carver Grinling Gibbons. As with sculpture in stone, however, the modernist reaction against academic techniques and classical styles led around the turn of the nineteenth and twentieth centuries to a revival of interest in wood carving for the purposes of art. This was similarly driven by the deliberate pursuit of what were seen as primitive forms of expression and by a consequent rejection of just those kinds of technical virtuosity that had allowed earlier European sculptors to represent life-like figures in dramatic poses. One of the first modernist artists deliberately to cultivate a primitive appearance in carved wooden sculpture was Paul Gauguin, better known as a painter and as an exhibitor with the Impressionists in the later stages of the movement in Paris. His *Idol with Pearl* was made in 1894 following his first visit to the island of Tahiti (pl. 227). On one side it shows

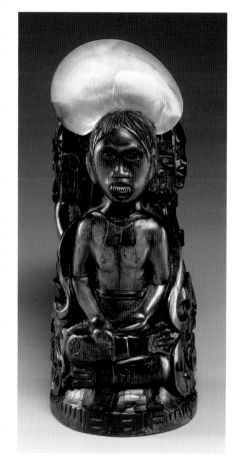

227 Paul Gauguin, *Idol with Pearl*, 1894, carved and painted wood, 23.7 × 12.6 × 11.4 cm, Musée d'Orsay, Paris

Gauguin produced a considerable number of small sculptures in wood and in ceramics. The reverse face of this work shows two figures of an Oceanic type known as Ti'i. (For Gauguin see also pl. 96.)

228 Constantin Brancusi, *Torso of a Young Man*, 1917–22, maple wood, h. 48.3 cm, Philadelphia Museum of Art, the Louise and Walter Arensburg Collection

Brancusi worked briefly in the studio of Auguste Rodin (see pls 132 and 208). Although he devoted himself exclusively to carving after about 1908, many of his carved works were also issued in cast metal versions, this *Torso* among them. There are highly polished brass versions in the Cleveland Museum and in the Hirshhorn Collection in Washington D.C.

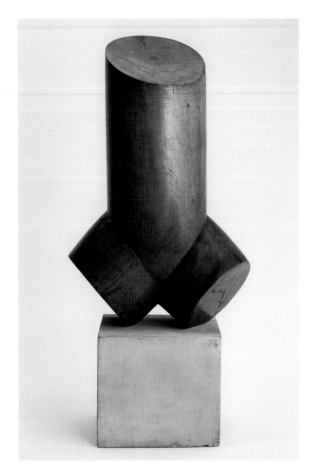

two figures of a type to be found in Oceanic carvings, on the other a Buddha-like figure which the artist derived from photographs of ninth-century reliefs from Borobodur in Java.

When discussing the work of the painter Barnett Newman in section 2.2, I mentioned the interest of modernist artists in what could be considered the first principles of creative activity. In the case of painters this involved an acknowledgement of the essential primacy of light and of drawing as an archetypal means of mark making. In the case of sculptors it meant a return to the simplest evocations of organic form. The *Torso of a Young Man* was carved in maple by the sculptor Constantin Brancusi, who arrived in Paris in 1904 (pl. 228). Born into a peasant community in Romania, he combined the practical disposition of an artisan with an interest in the mystical aspects of eastern religions. He was thus ideally qualified to contribute to the modernist 'purification' of the art of sculpture and to reinvest the European tradition with a sense of refinement that

was distinctly unclassical. With works such as these, modernist sculptors fulfilled Baudelaire's prophecy, striving for some sense of the inherent life that was supposed to invest the fetish, and for the time being at least restoring sculpture's 'isolation' from painting and architecture – not simply its separate development as an art form but also its realisation in works that are seen by their enthusiasts as entirely self-sufficient in their three-dimensionality, eschewing all colour but that of the material, and being neither simply models or representations of other things nor components of other structures.

4.10 CONSTRUCTION

During the twentieth century a range of sculpture developed in Europe and America that owed less to the long European traditions of figurative work in either modelling or carving than it did on the one hand to developments in painting and on the other to metal-working techniques and practices not previously associated with the making of fine art. Cubism provided the principal point of departure. In section 2.4 I mentioned how Braque and Picasso stuck pieces of paper to the surfaces of their paintings and then drew further shapes on top of them, thus calling into question the convention according to which the entire represented content of pictorial art was safely contained behind both the picture plane and the picture surface. Other artists were quick to respond. Among the technical developments that ensued was photomontage, rapidly exploited not only for the purposes of art but for propaganda and for advertising. In 1912–13 Picasso himself went one step further than collage, building out into three dimensions what had formerly been the still-life content of his paintings (pl. 229). The effect was to combine the virtuality associated with pictorial art with sculpture's capacity to establish representation through transformation of materials. In one way the work illustrated reads as a kind of picture of a guitar, in which the relations between planes and voids and silhouettes have been treated with a freedom that derives from Cubist painting. Yet it is also a kind of sculpture in which a real instrument made of wood has been represented by a space-occupying structure of sheet metal.

Works such as this had an immediate effect on the Russian artist Vladimir Tatlin, who visited Picasso in Paris in 1914 and who made a series of abstract reliefs on his return to St Petersburg, the most radical strung across corners using ropes together with a selection of other materials not normally associated with the making of fine art (pl. 230). Following the Russian Revolution of 1917 Tatlin became the leader of a

229 Pablo Picasso, *Guitar*, (?)1912–13, sheet metal and wire, 77.5 × 35 × 19.3 cm, Museum of Modern Art, New York

This is one of a number of Cubist constructions that Picasso made in the two years before the First World War. It is based on a maquette in cardboard, string and wire datable to October 1912 (also in the Museum of Modern Art, New York). (For Picasso see also pls 31, 211, 233.)

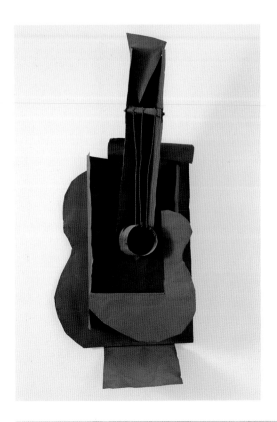

230 Vladimir Tatlin, *Corner Counter-Relief*, reconstruction of work of 1914–15, iron, copper, wood, rope, h. 78.8, w. 152.4, d. 76.2 cm, National Gallery of Australia, Canberra

Before visiting Paris, Tatlin had already been exposed to Cubist work through publications and private collections in Moscow. His first 'counter-reliefs' were exhibited in St Petersburg in December 1915, in the same exhibition as Malevich's first *Black Square* (see pl. 102). The two artists came to represent alternative tendencies in the Russian avant-garde, with Tatlin's supporters accusing Malevich of idealism and individualism.

231 Vladimir Tatlin, model for the *Monument to the Third International*, 1921, from a contemporary photograph

After 1917 Tatlin took a leading role in the implementation of Lenin's Plan for Monumental Propaganda. First proposed in 1919–20, the *Monument to the Third International* was an ambitious project for a huge tower spanning the River Neva. Glass-walled halls of geometrical shapes were to be enclosed within a spiral of steel. While it was inconceivable that such a structure could be built at the time in Russia, the various versions of Tatlin's model were widely seen as expressing the positive

'Constructivist' faction committed to the development of a practice consistent with the materialist principles of Communism. What this meant in effect was a positive abandonment of the distinction between fine art and design, and the recasting of the artist as a kind of laboratory worker, exploring the potential of different techniques and structures for the practical task of building a new society. There was a consequent tendency to avoid materials and processes that were explicitly associated with making

fine art and to concentrate rather on those employed in modern building and manufacture, steel, glass and early types of plastics among them.

Tatlin and his fellow Constructivists were responsible for some remarkable models and proposals. The reality, however, was that under the circumstances of post-revolutionary and post-war Russia neither the resources nor the necessary political support were generally available for their implementation. Tatlin's model for an ambitious *Monument to the Third International* remains indicative both of the idealism of its moment and of the wide gap that came rapidly to exist between Constructivist projects and the political and economic conditions of the time (pl. 231).

The optimistic strain of modernism that Constructivism represented nevertheless persisted during the 1920s and early 1930s, not only in Russia but also among small groups of avant-garde artists throughout eastern Europe and beyond. They were united by their continuing faith in the Revolution and in the idea that a new world required a new art – an art that would combine modernist ideals with a potential for progressive social effects (pl. 232). For a while, abstract artists, Constructivists and architects found common cause in a broad European Modern Movement, envisaging the unification of all the arts in the design of a largely urban world. The assumption underlying their proposals were that if planning and implementation were done on egalitarian if not explicitly socialist principles, aesthetic and utilitarian considerations would be entirely reconcilable, to the extent that art and planning would become effectively one function.

This first phase of constructive art was brought to an end by the outbreak of the Second World War, though the realisation of its practical aspirations had already been effectively ruled out, not only by the Stalinist counter-revolution in Russia and by the consequent betrayal of the promise to internationalise the Revolution, but by the rise of Fascism in Italy and Germany and subsequently in Spain. While new proponents of a kind of constructive art continued to emerge as late as the 1950s, it was to a western art world largely uninterested in political struggle that their works were addressed. The Constructivism that had been committed to the building of communism was virtually forgotten until the late 1960s. Meanwhile in the dominant discourses of art criticism, modernism was divested of its utopian connotations and re-identified as an individualistic art, justified by its critical independence from the commercial values of a bourgeois social world.

Late in the 1920s a new form of constructed sculpture had emerged from the legacy of Picasso's Cubism. Its early practitioners were Picasso himself and his fellow Spaniard and collaborator Julio González, an artist trained in metal-working. The most remarkable outcomes of this period

232 Katarzyna Kobro, *Sculpture of Space*, 1928, painted steel, 44.8 × 44.8 × 46.7 cm, Musée National d'Art Moderne, Centre Pompidou, Paris

Kobro was of Latvian origin and studied in Moscow in 1917–20 before settling in Poland, where she belonged to a number of Constructivist groups, together with her husband, the artist Wladyslaw Strzeminski. At the time this work was made she was concerned with the idea that sculpture should serve as a 'laboratory' for developments in architecture. A quantity of her work was destroyed by the Nazis during the Second World War. Most of what remains is preserved in the Museum of Art in Lódź.

of work were a series of open structures made in wire and in welded and bolted iron (pl. 233). Photographs of these published in a French journal led the American artist David Smith to conceive that he could use the industrial procedures of which he had experience in order to make art. Between 1933 and 1965 he produced a large number of highly original sculptures in iron and steel, some using found elements (pl. 234). Smith drew a particular advantage from the grounding of constructed sculpture in Cubist painting and collage and from the freedom from traditional preoccupations with density and mass that came with work in steel. For all their real weight, his works have a consistently picturesque quality, whether as self-contained scenarios in interior spaces or as individualised presences that invite a landscape setting. From the late 1940s onwards his work appears highly compatible with the large-scale abstract paintings that his American contemporaries – notably Clyfford Still, Newman, Rothko and Pollock – were making at the same time. In particular, works such as the one illustrated seem to propose that, in so far as the work of art serves as a representation of the human, it does so not through resemblance but rather through a kind of equivalence or parity, through its ability to arouse in the spectator the intuition of a presence met on equal terms. This effect is achieved not simply by constructing the work to an

233 Pablo Picasso and Julio
González, *Project for a
Monument to Apollinaire*,
October 1928, wire,
h. *c*.60 cm, Musée Picasso,
Paris

The poet and critic Guillaume
Apollinaire had been a central
figure in the Parisian avant-
garde until his death in 1918.
A commission to design a
monument prompted Picasso
to try out a series of different
ideas for sculpture, many of
them recorded in a
sketchbook of 1928. An
enlarged version of this
project is in the collection of
the Museum of Modern Art,
New York. (For Picasso see
also pls 31, 211, 229.)

approximately human height but by eliciting in the spectator a sympa-
thetic response to the different inflections, projections and types of contact
of which the barely balanced whole is composed.

Besides rendering it compatible with the work of his contemporaries
among the American painters, the relatively pictorial content of Smith's
work also assures it some of the self-containing power that I have attrib-
uted to painting. It is thus insulated to a degree against a problem pecu-
liar to abstract sculpture. Differences between paintings – even abstract
paintings – can be understood as differences between like things; even a
small mark on the surface can be significant in this respect. Each sculp-
ture, however, is a different object and it invites comparison with other
objects. Once cast adrift from the security of reference to the human figure,
or to animals or deities, sculpture is in danger of a degree of arbitrariness
in its relation to the rest of the world. Hepworth's *Three Forms* (see
pl. 220) are as likely to invite comparison with three pebbles as with
another sculpture. Duchamp's solution to the problem – or rather his mode
of acknowledgement of it – was simply to put a piece of the world on a
pedestal, as it were to put the literal in place of the virtual (see pl. 25).
But for one strand within the 'high' modernism of the mid-twentieth
century, descent to the literal was precisely what art had somehow to avoid
if the all-important distinctiveness of its presence was to be maintained.

234 David Smith, *Sentinel I*,
1956, steel, 227.5 × 43 ×
57.5 cm, National Gallery of
Art, Washington D.C.

Smith originally trained in
New York as a painter. In his
move to sculpture he drew
on the experience of
occasional employment in a
car factory and of working
alongside commercial welders
in his first studio in Brooklyn.
He envisaged an art form
that would combine the
effects of painting and
sculpture.

235 Anthony Caro, *Source*, 1967, steel and aluminium painted green, 185.5 × 135 × 358 cm, Museum of Modern Art, New York

Caro's first abstract welded sculpture was made in 1960 following a visit to America during which he met David Smith and the painter Kenneth Noland, and was encouraged by the modernist critic Clement Greenberg.

During the 1960s the major transatlantic tendencies of sculpture diverged on this issue, in accordance with a wider schism in the understanding of modernism as a quality to be pursued in art. One direction was represented by the work that the English artist Anthony Caro produced during the 1960s and 1970s. Following a period as assistant to Henry Moore and a phase of work during which he made plaster figures for casting into bronze, he adopted a constructive technique using standard and found steel components welded and bolted together into abstract configurations. Smith's example was crucial in motivating this change of direction, as was the example of contemporary American abstract painting. The resulting work was distinguished by the complete absence of any kind of separating plinth or base and by the treatment of the ground as a compositional plane – shared with the spectator – from which the various elements of the structure were projected into space (pl. 235). Antecedents in Cubist collage are clear and are indicative of Caro's ambition somehow to distract attention from the physical substance of these sculptures. For all the weight and durability of their components, the intended effect is to compose a kind of 'syntactic' whole in the mind of the spectator, analogous to the impression made by a lyric poem or piece of music. In this

case, however, the work is apprehended not through attention to the unfolding of a sequence but through an intuitive psycho-motor response to the distinctive manner in which the variously inflected components are related to one another and by the way in which the sculpture as a whole qualifies the occupation of a shared physical space. For the supporters of such work, its merits lay in the sense of an infinitely extended 'present-ness' that it offered to the spectator and in the beneficial contrast that was thereby maintained *vis-à-vis* the commercial and utilitarian values of everyday life.

To those who dissented from the strand of high modernism that such work represented, however, its weakness lay precisely in the abstraction from the everyday that was required for its effects to be registered. Seen from this point of view, the sculpture pretended to a kind of transcendental independence not only from the practically significant virtues of its materials but also from just those specialised social and physical circumstances that were the necessary conditions of its cultural success. From this second position, if abstraction in sculpture was to remain a feasible proposition, it could only be through some kind of explicit negotiation with the modern environment that allowed for a degree of reference on different terms. An alternative tendency in the modernist art of the 1960s was represented by a generation of American artists known – somewhat inappropriately – as Minimalists. These included Donald Judd (see pl. 107), Robert Morris (see pl. 26) and Carl Andre. It was a common feature of their work that it took explicit account of the conditions of its own display, generally those presented by the art gallery and the museum, though both Morris and Andre made work for specific outdoor locations. Under the patronage of the De Menil family, Judd went so far as to convert a series of buildings in the town of Marfa in Texas in order that they might serve as congenial permanent settings for his own work and that of his associates (see pl. 15). Where Caro's work of the 1960s was generally painted (as was a good deal of Judd's), the differences between the various metals that might be employed being concealed beneath a skin of colour, Andre's presented the different literal properties of various metals, and of other materials like timber and fire-bricks, as deciding factors in the effects of his work (pl. 236).

While Andre continued to refer to his art as sculpture, Judd preferred the term 'three-dimensional work', as mentioned at the close of section 2.12. His implication was that the basically European tradition of fine art was now redundant, defined as it was in terms of painting and sculpture conceived as media developing along distinct lines of development, with sculpture preserving its distance on the one hand from architecture and on the other from 'objects'. It has certainly been the case that since the

236 (*right*) Carl Andre,
Lead-Aluminium Plain, 1969,
lead and aluminium,
183 × 183 cm, Seattle Art
Museum

In some early works, Andre
used wood in a manner
reminiscent of Brancusi. After
a period working on the
railways he began using
simple units of building and
manufacturing materials laid
together on the ground.
Visitors to his exhibitions
were free to walk on metal
pieces such as this one.

late 1960s much avant-garde art has been concerned either with explicit modes of interaction with architectural and other contexts or with the possibilities for constructive confusion with middle-sized dry goods of no artistic standing, or both.

No such confusion is conceivable in the case of the sculpture made in steel by the American artist Richard Serra (pl. 237). This is work that employs the materials and techniques of heavy industry to produce components of architectural scale. While these works are generally so designed as to take account of particular environments and conditions of display, they are not so much intended to complement their settings as to compete with them, as it were to force attention away from the framing context by compelling the spectator to respond to the size, weight, substance and presence of the materials that are installed as art. However inflated or extensive the site proposed, the strategy of Serra's work is to increase the stakes, not simply in order to preserve the autonomy of each individual sculpture, but so as to confront the proclaimed necessities of planning with the priority of the experience of art – albeit an art reduced to extremes of size, weight, substance and presence.

237 (*facing page bottom*) Richard Serra, *The Matter of Time*, 2005, sheet steel, thickness 5 cm, h. 427 cm, weight 1034 tons, Guggenheim Museum, Bilbao

This massive work in eight separate pieces was commissioned as a permanent site-specific installation for the museum designed by the American architect Frank Gehry. Its steel plates were curved in a rolling mill in Germany and joined by spot welds. The sculpture fills a gallery some 130 metres long by 24 wide.

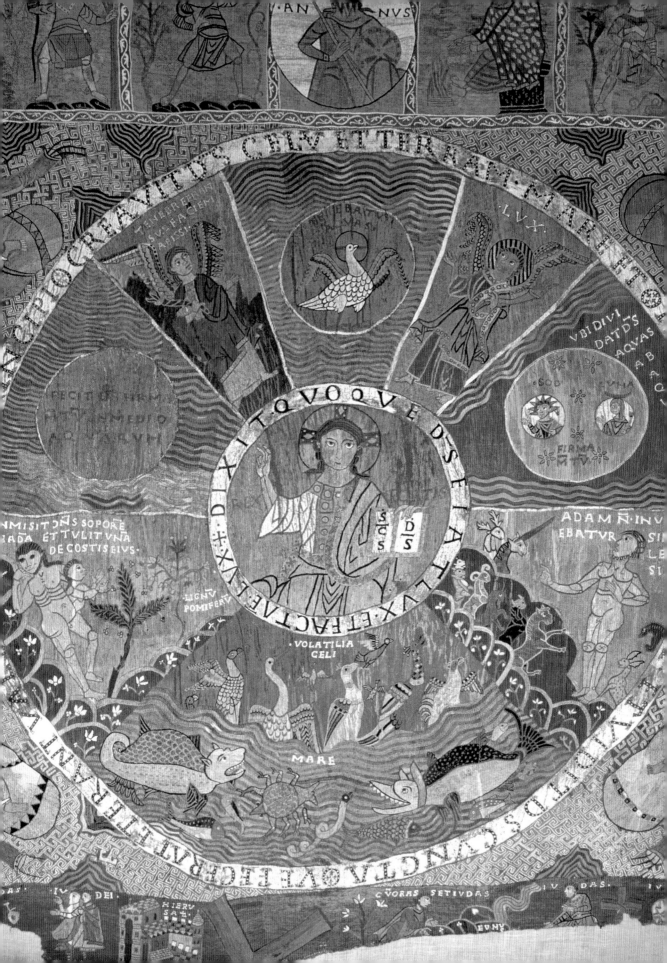

IN PRINCIPIO CREAVIT DS CELV ET TERRAM MARE ET

TENEBRE ERANT SVP FACIEM ABISSI

DS FEREBAT AQVAS

LVX

FECIT DS FIRMA ET IN MEDIO AQVARVM

UBI DIVI DAT DS AQVAS AB AQ

SOL

LVNA

FIRMA MENTV

DIXIT QVOQVE DS FIAT LVX ET FACTA E LVX

SCS DS SCS

IMMISIT DNS SOPORE IADA ET TULIT VNA DE COSTIS EIVS

LIGNV POMIFERV

VOLATILIA CELI

ADAM Ñ INV EBATVR

SI LE SI

MARE

IN VO

CVORAS SETIVDAS

IV DAS IV

DEI

HIERV SAL

EV NV

PART 5

OBJECTS IN TRANSITION

5.1 FROM DADA TO CONCEPTUAL ART

By objects in transition I mean those various artefacts that tend to evade inclusion among the established genres and media of art, that thus effect a degree of transition between categories or that may seem to change status and value according to the cultural perspective from which they are viewed. This may be because they have so far extended the normal boundaries of genres and media as to invite re-categorisation, or because they belong to categories that for one reason or another invite reconsideration and revaluation as kinds of art. In this first section I am concerned with the activities of modern artists, those working self-consciously within a tradition of fine art but tending to avoid the media of painting and sculpture. The avoidance may be strategic, as a means of circumventing the associations these media have with particular cultures and value systems; it may alternatively follow from a sense that the potentials of both painting and sculpture are exhausted and that there is therefore an imperative to work in some other fashion; or it may be due to a combination of these factors. To talk of transitional objects is in a sense to imply a movement away from the established categories of fine art and thus to associate them with opposition to a status quo. The transitional objects produced during much of the twentieth century were intentionally oppositional in this sense. It could be said of the early twenty-first century, however, that it is the transitional objects themselves – the quirky Surrealist objects, the artists' videos, the performances, even the curators' shows-as-artworks – that have come to occupy centre stage.

The category of fine art as I have applied it is to a large extent the contingent product of western modes of specialisation and of a self-conscious history of art that first emerged in Italy in the sixteenth century, at a time when the social and intellectual status of the artist was rising. From that point on painting was increasingly promoted as the visual art form that promised a depth and range of content comparable with the established genres of literature, while sculpture was bolstered both by its grounding in the classical cultures of Greece and Rome and by its potential for public

facing page Damien Hirst, *For the Love of God* (detail of pl. 245)

commemoration and display. The gradual separation of 'art' from 'craft', and the elevation of the former over the latter, gained impetus from the Romantic promotion of the artist as an exceptional individual – a kind of free spirit or genius, whose insights are of value not only because they are unconstrained by practical and utilitarian considerations but also because they defy or exceed the ordinary. During the early part of the twentieth century both painting and sculpture came to be widely seen as paradigmatically modernist art forms, the one secured in its autonomy by the tendency to abstraction that cut the medium loose from any explicit reference to other things in the world, the other achieving the isolation that Baudelaire had foretold by briefly abandoning its association with the architectural and the monumental, establishing its identity rather through a 'life' internal to its processes and materials.

Yet the modernist affirmation of painting's and sculpture's central status was open to challenge in two principal phases. The first was when a dissenting Dadaist faction emerged within the early twentieth-century avant-garde. ('Avant-garde' was originally taken from French military terminology. When applied to the discussion of art and culture it refers to a group of individuals working at the most forward point of development in new techniques and modes of expression. Use of the term tends to imply that there is a degree of common ground between technical innovation and political radicalism.) The second phase came at a point in the 1960s when modernism was centrally identified with American modes of abstract art and with their critical support, when there was widespread opposition to American conduct of the war in Vietnam and when modernism itself came to be identified by many as the failing critical apparatus of an oppressive cultural and material power. Until that point modernism in art had generally been associated with dissent from a prevailing social and moral order. This idea had its origins in the Romanticism of the late eighteenth century and was at the heart of Gustave Courbet's Realist painting in the mid-nineteenth. At that time, however, in so far as dissent was a kind of content recoverable from the relevant artistic work, it was in terms of its style and subject matter. The radicalism of Courbet and later of Manet lay largely in their use of established genres to introduce kinds of content and effect that were troubling to the business-as-normal of art appreciation at the time. This process left the more basic distinctions between the principal artistic media mainly intact: a painting was a painting and a sculpture a sculpture and so on. In the wake of Cubism, however, modernist art in the west tended to separate into a traditional and a radical strain, the former pursuing a range of both abstract and figurative styles in sculpture and in easel painting, the latter distinguished not simply in terms of its

more pronounced opposition to the culture of the dominant order but by
its sceptical attitude to art's traditional technical categories.

The artists involved with Constructivism and the European Modern
Movement were generally radical in their approach to technique and par-
ticularly in Russia tended to see easel painting as a redundant medium.
Except where Fascism prevailed, however, they were not dissenters from
the governing social order. Rather they identified with the Revolution in
Russia and looked to an expected spread of socialism beyond its borders.
Their assumption was that a coming new world would require new modes
of expression. There were others, though, who responded in a more pes-
simistic spirit to the events of the First World War and to the widespread
repression that actually greeted the revolutionary movements in western
Europe. Under the name of Dada, a number of artists and writers gath-
ered first in Zurich, then in Berlin, Cologne, New York and Paris, less con-
cerned to inject an aesthetic content into social reorganisation than to
address the violence and absurdity of the bourgeois regimes and military
castes they held accountable for the war. Where the artists of the Modern
Movement may have seen painting and sculpture as rightly subsumed into
the progressive schemes of design and architecture, the strategies of the
Dadas were those of negation: if art was sup-
posed to be ordered, rational and deliberate, they
would promote disorder, irrationality and ran-
domness; in place of the traditional media of
painting and sculpture they offered montages,
assemblages of one kind or another, and every-
day objects rendered bizarre or menacing (pl.
238) or simply left untransformed in the manner
of Duchamp's ready-mades (see pl. 25).

Dada's fascination with the potentially subver-
sive power of assemblages and domestic objects
was carried forward into the Surrealist movement
during the 1920s and 30s, with some of the same
artists involved and with André Breton as princi-
pal theorist. In so far as there was a coherent
theory that sustained the movement, it was pro-
duced by combining aspects of Karl Marx's cri-
tique of capitalism with Sigmund Freud's account
of the unconscious. What followed was a diag-
nosis of bourgeois society as doubly repressive,
not only of the lives and potential of those it
exploits but also of its own buried fears, fantasies

238 Man Ray, *Cadeau*, 1921,
replica c.1958, painted
flat-iron with tacks,
15.3 × 9 × 11.5 cm,
Museum of Modern Art,
New York

Man Ray was involved with
Marcel Duchamp in the
origins of the Dada group in
New York. In 1921 he left for
Paris where he spent the
next twenty years, becoming
associated with the Surrealist
movement. In his principal
career as a photographer he
introduced a number of
exploratory techniques to the
medium.

239 Salvador Dalí,
*Retrospective Bust of a
Woman*, 1933, painted
porcelain, bread, corn,
feathers, paint on paper,
beads, ink stand and two
pens, 73.9 × 69.2 × 32 cm,
Nellens Collection, Knokke le
Zoute

Dalí was central to the
Surrealist movement until his
expulsion on political grounds
in 1940. This assemblage was
prompted by Dalí's discovery
of an inkwell based on Jean-
François Millet's painting *The
Angelus* – a work by which he
was fascinated. In the year
during which the assemblage
was made he held an
exhibition entirely of paintings
referring to the *Angelus*. Some
elements of the assemblage
were reconstructed in 1970.

and desires. It is in acts of censorship that this repressive character is most
nakedly revealed. The avowed aim of the Surrealist artists and writers was
to work at the limits of the acceptable, to haunt the culture of the status
quo with the evidence of its own suppressed material and by this means
to effect a 'revolution in consciousness' (the phrase is Salvador Dalí's).

Various strategies were adopted to subvert the control of the conscious
mind over the generation and ordering of material, including sleep depri-
vation, starvation and the use of narcotics. Randomising procedures were
employed to frustrate normal processes of composition. One of the Sur-
realists' favoured devices was to set up improbable juxtapositions, by using
techniques derived from collage to create images suggestive of the content
of dreams. While many of their best-known works are paintings, an ade-
quate survey of the movement would pay at least as much attention to the
practice of combining disparate materials into pseudo-primitive fetishes
for an over-sophisticated world (pl. 239), to the collection of found or
altered objects and to the contribution made by artists associated with the

240 Jacques-André Boiffard, *Renée Jacobi*, c.1930, silver gelatine print, 23.8 × 18.8 cm, Musée National d'Art Moderne, Centre Pompidou, Paris

Boiffard worked as an apprentice to Man Ray in the late 1920s. Adopted into the Surrealist movement, he broke with its principal theorist André Breton and after 1928 worked with Georges Bataille, Breton's adversary and competitor and the editor of the journal *Documents*.

movement to developments in still photography and film, both directly through their own work in photographic media and indirectly through generation of an exploitable imagery for dreaming and the unconscious (pl. 240). The influence of the movement has been massive and persisting. That influence has not necessarily been to the benefit of subsequent developments, however. While the idea of working at the limits of the acceptable has persisted as a kind of avant-gardist fixation, the resulting enterprises have all too often been rendered bathetic by the lack of any substantial resistance in legal, social or political terms.

In section 1.5 I mentioned that renewed interest in Duchamp's work was shown by certain artists during the 1950s and 1960s. The latter decade also saw increased scepticism regarding the continuing viability of painting, pronounced on the part of a new international avant-garde and noticeable even among the adherents to a weakening strain of traditional modernism. Sculpture seemed to have a slightly longer lease of life as a modernist medium but only by virtue of a considerable expansion in the kinds of objects that the term was used to cover. By virtue of the inescapable implication in its own physical surroundings, sculpture is open to a kind of 'networking' that painting generally is not. If it was still generally clear what was and was not a painting, the much more elastic category of sculpture was extended to include a host of other artistic enterprises – from various types of installation to presentations involving real bodies and paths walked across the landscape.

By the mid-1960s, art-world institutions were becoming troubled by the problems of curating 'other media' and of absorbing them into the world of fine art. Several developments during the decade testified to a great expansion in the number of categories by which works of modern art were claimed and recognised as such. In 1959 the term 'Happening' was first used by the American artist Allan Kaprow. Three years later the first festival of the international 'Fluxus' movement was staged in Germany, involving assemblages, tableaux, actions, readings, musical performances and so forth, with clear links back to the Surrealist movement. 'Performance pieces' – intended as art rather than music or theatre – began to be explicitly so described in the late 1960s. The German film maker Gerry Schum produced *Land Art* in 1968, a compilation of works made specifically for television by artists using the landscape as a kind of medium in itself. A year later an exhibition, *TV as a Creative Medium*, was staged at a gallery in New York, anticipating artists' widespread use of video formats after equipment became readily accessible in the mid-1970s. The effect that advances in computing programmes and technologies would have on artistic work during the 1980s and 1990s was similarly anticipated in the exhibitions *Cybernetic Serendipity*, staged at the Institute of Contemporary Arts in London in 1968, and *Software* held two years later at the Jewish Museum in New York.

What appeared at the time as the most determined assault on the priority of painting and sculpture came in the late 1960s with the advent of Conceptual Art, a movement that emerged neither from the post-war legacy of Surrealism nor from an engagement with new media but rather from a preoccupation with the inherited problems of painting and sculpture themselves. In a text published in 1967, the American artist Sol LeWitt offered a set of guidelines for a new approach to art – one in which phys-

ical materials might be dispensed with altogether. 'In conceptual art,' he wrote, 'the idea or concept is the most important aspect of the work ... What the work of art looks like isn't too important.' Much was made at the time of the idea that art had become subject to a process of 'dematerialisation'. In fact it was only in its most trivial aspects that Conceptual Art could be seen in this light – as though it were the end-game in a gradual process of reduction that had begun with modernism. It was more to the point that the movement addressed a kind of crisis of modernism as primary material for inquiry and analysis.

So long as development in modern art was largely conceived by reference to the changing appearances of painting and sculpture, it had seemed easy enough to distinguish between a given work of art and a body of written or spoken discourse about it. The work on the wall or on the floor was the primary object of attention; an accompanying text might be 'about' the work but was not to be confused with the work itself. However, if a 'ready-made' or a 'found object' was to be singled out as a work of art, its status as such could hardly be established by examining its formal and technical characteristics alone, since these were shared with other objects that were not works of art (see pl. 25). That status would presumably depend on the validity of a claim implied in some title, description or specification that was thus inseparable from the enterprise itself and that would necessarily take the form of a linguistic statement. 'I propose this as a work of art' is one of the simplest forms such a statement might take. In any critical assessment of the enterprise, that statement would come up for scrutiny. Rather than questions of whether or not arrangements of forms and colours were pleasing to the eye, the work of criticism would be to consider the implications of considering x as a work of art.

In common with the institutional theory of art discussed in section 1.5, the position represented here is one that recognises the inadequacy of any means of defining art which is dependent on visual discrimination or emotional response alone. It departs from that theory, however, in regarding the claim to artistic status not as one made on behalf of the work by some agency of the art world but rather as an integral and examinable component of the work itself. In the case of Happenings, Actions and Performances the claim to artistic status must also rest on some kind of script or definition – or at the least on exploitation of a permissive attitude towards specific kinds of real-world objects and events already established within the art world – since there could be no other secure means of distinguishing what is and is not to be seen as comprising 'the work'.

While characteristic works of Conceptual Art took linguistic form and tended to raise problems of definition and analysis, it was not in the

margins of literature or of philosophy that the origins of the movement were to be found but in the tradition of fine art and in the problems encountered by anyone who wanted to maintain that tradition – and the possibility of some kind of integrity and self-sufficiency for new works of art – without being forced into technical conservatism. It is often argued that a kind of 'crisis of the object' occurred during the 1960s. Yet the crisis in question might more appropriately be thought of as a problem in the critical relations between 'art' and 'language' – a crisis brought on by the collapse of those protocols, symbolised in the frame and the pedestal, that had previously served to keep the two apart. It had been an item of faith in modernist criticism that theory was something by which the work of the authentic artist was explained after the fact, rather than a body of ideas that preceded or guided it. That was by no means a secure position even where painting and sculpture were concerned and it was certainly not sustainable in the face of work that had no fixed physical form. In 1969 the English group Art & Language published the first issue of their journal, *Art-Language*. The editorial proposed that inside the framework of Conceptual Art the making of art and the making of theory might now have to be seen as indistinguishable. Rather than something primarily to be looked at, the work of art should be conceived of as something to be thought about.

During 1969 and 1970 there were several major exhibitions of new art in which there was little work that could usefully be described as either painting or sculpture or that fitted comfortably into any established genre (pl. 241). A number of critics and curators (myself among them) were staging shows specifically addressed to 'Conceptual Art' or 'Concept Art' or 'Idea Art'. Certain common features could be observed. There was not much colour and there was not much stuff: no expressive brushwork on the walls, no accumulations of three-dimensional form on the floors. Instead, there were diagrams and texts, the latter varying in length from a few words to many pages. There were objects – books, pamphlets, pieces of paper – but their typical function was not so much to call attention to themselves as 'art' as to invoke the imaginary or theoretical existence of other kinds of objects, processes or events. It was to these secondary and sometimes unstable objects of thought – concepts of one kind or another – that the attention of those attending the gallery was directed (pl. 242 and see pls 27 and 126). The viewer or spectator had thus been transformed into something rather less than a spectator or viewer and at the same time made something rather more – a reader, researcher or thinker.

It might be asked why reading a work in linguistic form should be thought of as an experience of art rather than, say, of literature. The answer, I think, is that it is clearly from artistic rather than literary tradi-

tions and concerns that such work emerges. One clear symptom of this is that Conceptual Art remains concerned with objects and phenomena and with the manner in which they are differentiated, represented and experienced. What is distinctive is that the objects in question are constructed not from paint and canvas, clay or metal but from verbal descriptions. While some of these descriptions, like Lawrence Weiner's (see pl. 242), refer to objects and physical states that can be realised, others propose forms that can only be sketched out in thought (see pls 27 and 126). With the benefit of hindsight, such works may be seen as pursuing some implications of art's twentieth-century engagement with abstraction. It was perhaps inevitable that once the appearances of the world ceased to be binding on painting or sculpture, the possibility of an art of imagined objects would have to be confronted sooner or later.

The audience for this art faces a new demand – or perhaps it is really a traditional demand under a new aspect: that one should imagine the objects in question according to the formal constraints of the work (the rules of its game, as it were) and not merely invent them for oneself accord-

241 *When Attitudes become Form*, Institute of Contemporary Arts, London, 1969, view of installation

Organised by the curator Harold Szeeman as a survey of a new international avant-garde, the exhibition *When Attitudes become Form* opened at the Kunsthalle in Berne in the spring of 1969. The illustration shows a revised version installed under my supervision in London the following autumn. The 'photopath' in the foreground is a work by Victor Burgin (see pl. 126).

242 Lawrence Weiner,
A square removal from a rug in use (statement 054), 1969

The purchaser or exhibitor of such a work by Weiner is presented with the statement that defines it, together with a declaration from the artist to the effect that the work may be made by the artist or may be made by the receiver or may be left unmade: 'each being equal and consistent with the intention of the artist the decision as to condition rests with the receiver upon the occasion of receivership'. The question such work raises is how far its effect is dependent on, or restricted to, a given material realisation.

A SQUARE REMOVAL FROM A RUG IN USE

ing to the promptings of personal fantasy and preference. When I referred above to the spectator becoming 'something more', what I had in mind was the kind of engagement with the work of art that has perhaps always come from meeting this demand. To recall the work introduced at the outset of this book, Rembrandt's painting of the artist in his studio invites us to imagine what might be represented in the hidden picture on which the artist is working (see pl. 1). That act of imagination will be most rewarding if it is done in accordance with the formal structure of the painting. For example, if we follow the cue provided by the painter's outward glance we might imagine that what he is studying is a reflection of the picture we are actually seeing – in other words that the painting of the artist in the studio is the work on which he is actually engaged. Alternatively, if we respond to that outward glance by adopting the answering position of an imaginary spectator, then we might imagine that it is our 'own' image – that of the sitter or model posed in the studio – that is being formed on the hidden surface. Although these are alternative imaginative scenarios, we remain in each case within the practical perimeters of the

painting's represented world. I suggest that the work in textual form, such as plate 126, both invites a similar kind of adherence to its formal structure and offers a similar degree of latitude in what may be imagined in response.

5.2 THE LATE TWENTIETH CENTURY

As I understand it, Conceptual Art was itself a transitional movement, the outcome of a specific moment in the development of modern art and of the attempt by certain artists and others caught up in that moment to imagine a different kind of practice within the framework of fine art. As implied earlier, there are echoes of the early experimental phase of abstract art in the second decade of the twentieth century, discussed in section 2.12. In the earlier case, 'abstract art' was used for much of the rest of the century as a label for work that failed to exhibit traditional pictorial forms, but with no strong sense of connection to the matters that Malevich, Mondrian, Kandinsky and others had addressed. Since the 1980s 'Conceptual Art' has similarly been adopted as the professional label for more or less any work that is not evidently painting or sculpture, with a comparable disregard for the character of the original movement and for the problems it addressed. There is particular irony in the use of the term to categorise the highly spectacular work to be seen in massive museum installations such as those staged in the Turbine Hall of Tate Modern in London, since the original Conceptual Art movement had been strongly opposed to the tendency to identify ambition in art with over-inflated spectacle and escalation in material terms (pl. 243).

As this case suggests, where the art of the late twentieth and early twenty-first centuries is concerned, we should not expect an easy consensus as to which are the enterprises most deserving of attention and which the overall developments of most significance. I therefore offer two alternative ways in which the art of this recent period might be regarded. The first version goes as follows. A traditional form of modernist theory had tended to associate aesthetic quality with the maintenance of boundaries between media and with specialisation within those boundaries. It had also insisted on hierarchical distinctions between art and fashion, between high art and popular culture and between avant-garde art and kitsch. It had tended to deprecate all types of radical modernist practice, in the process consigning to the margins a quantity of works of art in which the interests of minorities were expressed, whether the constituencies in question were defined by sex, by class or by ethnic origin. During the late twenti-

eth century, however, there was a significant relaxation of those constraints on artistic practices that had been associated with the privileging of painting and sculpture and with the divisive notion of 'fine art'. Over the late 1950s and the 1960s, the imagery of mass and popular culture was enthusiastically embraced by artists of the Pop Art movement, principally in London and New York. Subsequently, in the face of *Global Conceptualism* (the title of a retrospective exhibition staged in New York in 1999), avant-gardism in art became clearly associated with a final breakdown of the special status accorded painting and sculpture and in due course, during the 1980s and 1990s, with widespread impatience with those modes of discrimination that had served to keep a culture of fine art separate from – and elevated above – the world of fashion, mass media and popular culture.

As the male-dominated painting or sculpture studio ceased to be the principal site of artistic production and as the hybridisation of artistic media became increasingly accepted, women artists became conspicuous in exploiting new technical possibilities, while members of ethnic and other minorities were able to find outlets for diverse kinds of practical work in which their distinctive concerns could be given expression. A positive consequence was that the appeal of avant-garde art was extended to a new and far larger audience than it had previously enjoyed, that it appealed to a generation of dealers, entrepreneurs and collectors who were in a position to profit from the boom economies of the time and that its curating institutions attracted sponsorship on a large scale from international businesses and brands, eager to associate themselves with the imagery of a dynamic, liberal and expansionist culture.

For the first time a significant number of women artists occupied positions at the forefront of the avant-garde. One of the success stories of the 1980s was the recognition accorded the art of Cindy Sherman, whose work consisted of photographs of herself, variously situated, dressed, made up and posed, in each case playing out a different woman's role from an imagined narrative of modern life. The works are given the generic title of *Untitled Film Stills* (pl. 244). Another success story was the career of the male artist Jeff Koons, whose work took the Duchampian concept of the ready-made into the territory of popular consumer goods and who with knowing and flagrant aplomb mapped out an area of common ground between high art and kitsch (pl. 246). But if there is a single career that epitomises the changed field of practice opened up to the ambitious artist by the end of the twentieth century, it is that of Damien Hirst, whose diamond-covered skull *For the Love of God* was sold in 2008, reportedly for a sum in excess of £50,000,000, to an investment consortium in which the artist himself is said to have a stake (pl. 245).

243 (*facing page*) Anish Kapoor, *Marsyas*, installation in the Turbine Hall, Tate Modern, London, 2002, steel rings and PVC membrane, l. 150 m, h. 35 m

Tate Modern opened in 2000 in a former power station on London's Bankside. While much of the building has been converted into conventional galleries, the dimensions of the former Turbine Hall have been maintained to provide a cavernous exhibition space that individual artists are commissioned to use for ambitious projects. *Marsyas* was the third in the series. Kapoor was born in Bombay and lives in London. His work was designed and made with the assistance of a structural engineer. The title refers to the satyr who was flayed alive for daring to challenge Apollo to a musical contest (see pl. 95)

244 (*right, top*) Cindy
Sherman, *Untitled Film Still No.
96*, 1981, colour photograph,
61 × 122 cm, Metro Pictures,
New York

Sherman belongs to a
generation of American
artists whose work is based
on the assumption that there
can be no access to a 'reality'
that is unmediated by the
images and stereotypes in
which the world is
represented.

245 (*right, bottom*) Damien
Hirst, *For the Love of God*,
2007, platinum skull covered
in 8601 diamonds, human
teeth, 17.1 × 12.7 × 19.1 cm,
private collection

Identified as the leader of a
generation of British artists
that first emerged to public
attention in the late 1980s,
Hirst came to wide
prominence with a work
consisting of a great white
shark suspended in a tank of
formaldehyde. In purely
financial terms he is probably
the most successful artist
ever to have worked in
Britain. The setting of the
diamonds was done by a
professional jeweller to Hirst's
instructions.

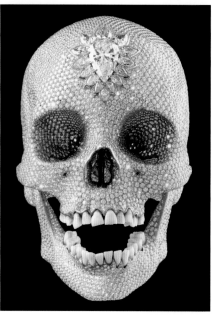

From a second point of view on the period the same material might be
surveyed with a more sceptical regard. In this version, the demise of the
authority of traditional modernism is considered in a less triumphal spirit
and with less certainty about the advantages of the outcome. There can
be no questioning the fact that the moment of the late 1960s initiated pow-
erful liberalising tendencies in artistic practices and in their reception. Yet
it does not follow that the ensuing effects have been entirely beneficial.
Since that time there has been a massive expansion in the international art

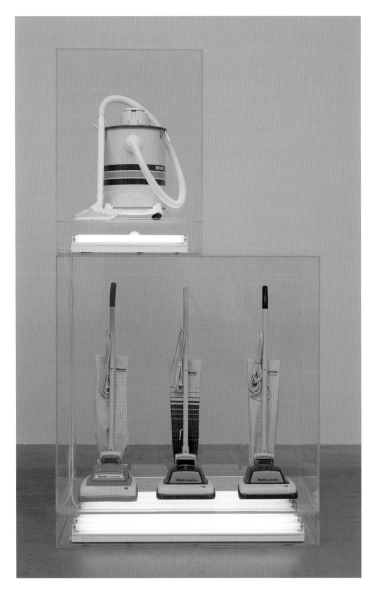

246 Jeff Koons, *New Hoover Covertibles; Green, Red, Brown, New Shelton Wet/Dry 10 Gallon Displaced Doubledecker*, 1981–7, vacuum cleaners, Plexiglas and fluorescent lights, 251 × 137 × 71 cm, Tate Modern, London (Anthony d'Offay Gift)

Koons followed study at a college of art with a period of work as a commodities broker on Wall Street, New York. The dominant modernist theory of the mid-twentieth century insisted on a critical distinction between commodities and works of art and between kitsch and avant-gardism. Koons's strategy in works such as this is to render these distinctions ineffective or irrelevant.

world and in the turnover of its various forms of business, including those businesses that even publicly owned museums have now become. This expansion has certainly been facilitated by the erosion of boundaries between media and disciplines. It has led in turn to further pressure on those boundaries, whether in pursuit of new spectacular types of artistic installation or through the replacement of scholar curators by persons equipped with the supposedly broader competences of media and cultural management. However, where art is concerned there is no reason to

assume that increases in sheer quantity must mean gains in aesthetic terms. Nor should we assume that the modernist distrust of commercial motivation was altogether unjustified.

Concentration on individual media, genres and disciplines normally means specialisation, whether practical or intellectual or both. Specialisation may lead to isolation, to conservatism and to the indefensible protection of critical and professional privilege. Nevertheless, it is also enabling of the development of skills and of certain kinds of depth and intensity of work. It may or may not be the case that the depth and intensity traditionally associated with painting and sculpture are no longer to be achieved within the practical limits of those media. However, the case against them is not made merely by asserting their redundancy in face of a generic category of 'art' – one in which nothing counts for critical purposes so much as extending the range of objects that the category can be made to include (an activity dependent as much on public relations as on artistic initiative) – and then inflating the results to gigantic scale. By the same token, it is a positive measure of vigilance in scholarship that regular and sceptical attention is paid both to the usefulness of disciplinary boundaries and to the mechanisms by which certain works and artists are accorded canonical status. Yet it does not follow that interdisciplinary work is never shallow, or that depreciating an artistic canon in the eyes of students and others may not be at least as damaging a means of indoctrination as recommending it uncritically.

I do not mean to suggest that these two points of view are mutually exclusive. It is both normal and appropriate to approach the art of one's own time with a mixture of enthusiasm and scepticism. An important aim of this book is that it should allow readers to take pleasure in the experience of art and to feel confident in their own responses, whether the works in view are from ancient and distant cultures or from the present. But confidence comes with critical ability, that is, with an informed awareness of those social, economic and other factors by which both works of art and spectators' responses are always liable to be affected.

5.3 REVISIONS AND REVALUATIONS

What remains indisputable is that throughout what came to be called the post-modernist world of art from the 1960s onwards there was widespread pursuit of media that evaded categorisation as painting or sculpture, whether through extension into the time-based forms previously associated with theatre, music and film, through employment of linguistic text

or through deliberate involvement with techniques and materials generally associated with craft rather than art. It was not only through changes in artistic practice, however, that revisions were made in the relevant categories. Over the same period a converging tendency gathered force in the fields of art history, art criticism, artistic curatorship and cultural studies. Critical examination of the authority of established artistic disciplines and canons was variously driven by work in the Marxist intellectual tradition, by feminist scholarship, by the growth of cultural studies as an academic area and by the newly enfranchised views of the formerly colonised. As a consequence, the proliferation of various new kinds of artistic work coincided with a considerable redirection of interests regarding the various objects already stored in the world's galleries and museums, with a reorganisation of methods for their display and with a revision of priorities concerning new acquisitions.

This last tendency serves to introduce a second category of transitional objects – those on which this liberalisation of scholarship has caused a slightly different light to fall, in some cases introducing works known principally to specialist curators into the context of wider debates about the making and appreciation of art. The majority of this book has been concerned with those works of art from various periods and cultures that fall readily within established categories of the so-called fine arts as conceived from a modern western perspective – painting, prints and sculpture. (While in the case of sculpture I have drawn attention to the potential for confusion and overlap with such things as architectural decorations, utensils, grave markers and so on, I have deliberately reduced that potential by concentrating on sculpture of the human figure.) For a visitor to any encyclopaedic museum, however, it will immediately be clear that items in these established categories compose only a proportion of the material presented to view. It will also be clear that the borders are nothing if not fuzzy between the kinds of objects that are preserved for their appeal as fine art and a host of other exhibits, such as those categorised as decorative or those collected for their value as evidence on historical, archaeological or ethnographical grounds.

There are certain art forms that are not paintings or prints or sculptures that have nevertheless been widely regarded over the centuries with the kind of concentrated aesthetic attention we associate with works of fine art. The blue-and-white porcelain produced in China from the thirteenth to the eighteen centuries is one example (pl. 247). Another is bonsai – the cultivation, shaping and tending of miniature trees – which the Japanese have long regarded as an art form, with some of its most venerable examples categorised as national treasures (pl. 248) Yet there are also objects and materials of different kinds that have been worked by those artisans

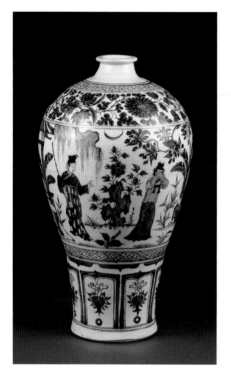

247 (*above left*) Meiping vase, China, Yuan dynasty, 13th century, porcelain with cobalt blue underglaze painting, h. 35.6 cm, Victoria and Albert Museum, London

The technique of underglaze painting on porcelain was developed in China in the Yuan and early Ming dynasties and brought to a high degree of sophistication in imperial kilns. While export of the finest porcelain was generally prohibited, objects such as this were highly valued as gifts and items of trade in the Middle East and subsequently in Europe.

we tend to designate as 'craftsmen' rather than 'artists' – as though craft were securely distinguishable from art and as though the achievements of art have not generally been based on craft skills. (In the west, the most accomplished studio pottery is generally designated as 'craft', while the most hapless of avant-garde installations and performances are categorised as 'art'.) Together with these there are the many and varied kinds of production that result from work allocated to women, who for one reason or another and in many cultures and periods have generally been excluded from consideration as 'fine artists'. The second category of transitional objects, then, is one that embraces the productions of people who have not consciously been working to make works of 'fine art' according to the principal point of view from which this book is written, whether because no such hierarchical distinction has been made among the artefacts of their period or culture, because they have had other purposes in mind or because they have had no access to the appropriate training and opportunities, or all three.

It is this last varied type of transitional objects that needs finally to be acknowledged. To give an adequate account of the various types of work that would qualify is well beyond the scope of this book. I will therefore restrict myself to indicating one broad category in which items of extra-

ordinary ingenuity, industry and appeal are to be found but which is generally excluded from consideration in western accounts of the fine arts. The category in question is textiles, a field of work that ranges over such distinct media as tapestries, carpets and embroideries, each fully deserving a substantial study to itself. The first of these is the one most likely to be referred to in western accounts of the fine arts, for two principal reasons: because the weaving of tapestries was a flourishing European industry from the late Middle Ages through the period of the Renaissance and beyond and because the products generally have a high pictorial content for which named and otherwise celebrated artists were often responsible – Raphael and Goya notable among them. For the walls of the wealthy from the Renaissance to early in the eighteenth century, tapestries formed at least as prevalent a form of decoration as paintings.

Carpets have similarly been woven in Europe since the Middle Ages but the finest examples since earliest times have been those that came from a swathe of territory across the Middle East and southern Asia, including Turkey, Persia (Iran), the Caucasus and India. While workshops were organised in courts throughout these areas, carpet weaving has also flourished among nomadic and tribal groups wherever sheep have been widely grazed to provide supplies of wool. Carpets have been a major form of aesthetic product in Islamic cultures. This last observation serves to remind us that a medium that gains no place among the 'fine arts' in one culture may be central to the aesthetic world of another. The artistic work of the Muslim world is of particular significance in this context, including as it does not just the weaving of textiles but also tiling and calligraphy. (This last is considered a major art form also in China and Japan. The cursive scripts of Islamic, Chinese and Japanese cultures have in common a potential to convey expressive and pictorial content of a kind largely lacking in the letter forms that are ordinarily used in Europe and America, where 'concrete poetry' offers a poor substitute.)

Early in the seventh century the Prophet Muhammed received his revelations and within the next hundred years Islam had spread through the southern Mediterranean area and up into Spain. In the latter context, during the long process of the so-called Reconquista (the Christian recovery from Muslim rule), Christian and Muslim architects and craftsmen collaborated to create the Mudejar style, in which Islamic motifs are configured to the taste of Christian princes. Where Christianity, Hinduism and Buddhism encourage the making of religious images, Islam follows Judaism in forbidding any representations that might encourage believers to mistake the material for the divine. There is virtually no tradition of figurative sculpture associated with any Islamic culture. Where there is picture making it largely takes the form of miniature illustrations to non-

248 (*facing pae, right*) Bonsai, Japanese White Pine (*Pinus parviflora*), in training since 1625, donated by Masura Yamaki to the National Bonsai & Penjing Museum, US National Arboretum, Washington D.C.

Bonsai are natural varieties of tree that have been miniaturised by growth in restricted containers, by pruning their root systems and by pinching buds and shoots. The aim is to acquire an aesthetically pleasing shape suggestive of a real tree of great age. Wires may be used to train both trunk and branches. Examples such as this have been tended over generations.

249　Garden carpet (detail),
north-west Iran, c.1700, wool,
6.7 × 2.4 m, Fogg Art
Museum, Harvard University,
Cambridge, Mass.
(ex collection Joseph V.
McMullan)

This fine carpet, of which the
central detail is illustrated
here, represents a bird's-eye
view of the layout of a formal
Persian garden, with water
courses, trees and flowers.

religious stories (see pl. 101). While Islamic texts thus remain devoid of illustration, highly accomplished Muslim artists were among those who worked on the illumination of Hindu texts in India in the sixteenth and seventeenth centuries.

The other main pictorial content of Islamic art is to be found in the designs of certain old Persian and Turkish carpets. Many of these include stylised representations of gardens or of mosques and are otherwise rich in symbolic motifs that have been subject to a high degree of formalisation. They cannot be read as pictures in the way that most European tapestries can, however, being generally organised as flat patterns without spatial depth (pl. 249). As though to compensate for this absence of engagement with the dominant representational art forms, types of work that in western cultures tend to be relegated to the subsidiary status of decorative arts and furnishings are invested in Islamic cultures with qualities easily equal to those of the most demanding figurative art. In the case of carpets, these result from the richness of the vegetable dyes, from the continuous skilful care and imaginative concentration of the weavers and from the ways in which invention and improvisation are schooled by particular traditions.

Tapestries and embroideries are easily confused. One of the best known of all embroideries is the so-called Bayeux Tapestry, which is actually not a tapestry but a series of long strips of linen embroidered with wool (pl. 250). It was made, probably in England, following the Norman Conquest of the country in 1066 and is now preserved in a special museum in the Normandy town of Bayeux in France. I can never divorce this work from a moment of intense frustration I experienced as an undergraduate student at a time when I was beginning a course of study on medieval art. I had arrived fresh from a tour of French Romanesque churches, in a state

250 *Bayeux Tapestry* (detail), late 11th century, wool embroidery on linen, h. 45.7–53.6 cm × l. 68.38 m, Tapestry Museum, Bayeux

The origins of the 'tapestry' are matters for conjecture. There is no recorded mention of it before an entry in the accounts of Bayeux cathedral in 1463. It was not put on permanent display until 1842. This detail shows the Anglo-Saxon Harold taking the oath which was the supposed justification for William of Normandy's claim to the English throne.

251 (*facing page*) Tapestry of the Creation, late 11th century, wool and linen on wool twill ground, 365 × 470 cm, Museum of Gerona Cathedral, Catalonia

The images on this giant embroidery refer to the Creation myths of the Bible. At the centre the Pantocrator is surrounded by scenes relating to the book of Genesis. The four winds are represented as winged figures riding on bladders. Activities relating to the months of the year are shown round the outside.

of enthusiasm for the sculpture I had seen, and most of all for the carvings attributed to Giselbertus in Autun (see pl. 214) – works that have provided a kind of standard for me against which I have measured other and widely different experiences of art ever since. This was what I had expected to start working on. What my tutor required, however, was an essay on 'Historical prejudice in the Bayeux Tapestry'. Not only was I being asked to write about a work I had never seen, the requirement was that I should treat it not as art but as a piece of documentary evidence. I can still recall the sense of outrage I felt. What now seems clear in the context of this book, however, and with the benefit of long hindsight, is not how justified I was in my frustration, but rather how damaging was the polarisation by which that moment was marked. I would not seek to defend my tutor's apparent commitment to a history with no sense of art, but at least as great a fault lay in my idealisation of an art abstracted from history. If the Bayeux Tapestry is a work of art, it is art of a clearly political kind, providing illustrative justification of William's claim to the English throne.

I know that much now, though I never did see the Bayeux Tapestry. Roughly contemporary with it, however, if by no means as well known, is the marvellous embroidery on the theme of the Creation that is preserved in the cathedral of Gerona in Catalonia (pl. 251). Were a painting of comparable, skill, subject and size to have survived from this period it would be known as one of the great masterpieces of medieval art. The tendency to classify embroidery as women's work has led to the common assumption that both the Bayeux Tapestry and the Tapestry of the Creation were made by women – though probably working to designs by men. However, that assumption may simply be the product of a modern prejudice, fuelled by the unquestionable truth that most of all work in textiles is done by women and that, particularly for middle-class women stuck at home in eighteenth and nineteenth-century Europe and America, embroidery was a common if not obligatory occupation. We do not definitely know who worked on either of these two early medieval embroideries, though there are motifs in the Creation tapestry to suggest that it was the work of craftworkers with Jewish cultural experience. What we can say of both is that they would certainly have required organisation and collaboration among considerable communities and that this was work in which women may well have played a major role.

It is more to the point that the developments in art-historical study that have been made since the 1960s have led to an increased emphasis on inquiries of two related kinds: on the one hand into assumptions about the authorship of works of art and into the widespread tendency to subordinate work by women; on the other into the sometimes disadvantageous effects of treating traditions of painting and sculpture as central to

the definition and valuation of artistic work in general. I mentioned that there has been a coincidence since the 1960s between the exploration of new media in avant-garde artistic work and the growth of revisionist tendencies in art history and cultural studies. Symptoms of this coincidence are prevalent in art from that time to the present. There are artists from formerly colonial backgrounds working in the transatlantic avant-garde who employ techniques and materials associated with the cultures they or their parents have left behind, often with ironic intent (pl. 252). And there are women artists with evident high-art ambitions who employ traditional types of 'women's work', such as embroidery, so as to establish a critical distance from the norms of painting and sculpture (pl. 253). Such types of work testify to a widespread relaxation in the technical categories and demands associated with the concept of art – a relaxation initiated in the early twentieth century and gathering pace rapidly after the 1960s.

252 Yinka Shonibare, *Gay Victorians*, 1999, wax-printed cotton textiles, 165 × 64 × 107 cm and 165 × 74 × 109 cm, Collection of Kent and Vicki Logan. Fractional and promised gift to the San Francisco Museum of Modern Art (Courtesy Stephen Friedman Gallery)

Shonibare was born in England to Nigerian parents but spent his childhood in Lagos, returning to London to study art in the 1980s. The 'African' textiles on which much of his work is based are bought in Brixton market in London. The batik-printed cottons are of a type made in Indonesia in the 19th century, imported to Europe by Dutch colonisers, and then exported to Africa, much of it from bases in Manchester. They serve the artist as signifiers for the processes of cross-cultural appropriation and exchange.

As I have suggested, that relaxation brought commercial advantage. In the first years of the twenty-first century the mushrooming art fairs of an expanding globalised art world conducted a brisk trade in would-be avant-garde work of all kinds. Yet, as I have also observed, there are now more paintings to be seen in more galleries throughout the world than at any previous period of history. As to sculpture, in so far as the traditional techniques of carving and modelling are in evidence in the kinds of work that are promoted as avant-garde, it is because artists such as Jeff Koons, Louise Bourgeois and Marc Quinn have been able to employ craftsmen and women trained in commercial forms of vernacular and classical traditions. Even when such work is discounted, however, there are no doubt

253 Tracey Emin, *Everyone I have ever slept with 1963–95* (interior view), 1995, appliquéd tent, mattress, fluorescent light, 122 × 245 × 214 cm, destroyed

Emin belongs to the generation of British artists that emerged to prominence in the late 1980s. The majority of her work is explicitly autobiographical and personal. Formerly in the collection of Charles Saatchi, the embroidered tent was destroyed in a fire at the Momart Warehouse in London.

also more figurative sculptures in the world's commercial galleries than there have ever been before. It can be safely assumed that much of this sculpture, like the painting, is of a kind that modernist theory would dismiss as kitsch. In the highly commercialised post-modern world of art, however, such robust forms of dismissal have generally fallen from favour. The difficult and always open question is where the art is now to be found on which the traditions of the future will draw.

RECOMMENDATIONS FOR FURTHER READING

PART I WHERE IS ART?

Bell, Clive, *Art* (1914), ed. J. Bullen, Oxford: Oxford University Press, 1987

Danto, Arthur, 'The Artworld', *Journal of Philosophy*, vol. 61, no. 19, 15 Oct. 1964, American Philosophical Association Eastern Division 61st Annual Meeting

Goodman, Nelson, *Languages of Art: An Approach to a Theory of Symbols* (1968), 2nd edn, Indianapolis: Hackett, 1976

Turner, Jane, ed., *The Grove Dictionary of Art* (1996), 34 vols, Oxford: Oxford University Press, 2003; see also Oxford Art Online

PART II SEEING PAINTINGS

Baxandall, Michael, *Painting and Experience in Fifteenth-Century Italy*, Oxford: Oxford University Press, 1988

Gaiger, Jason, *Aesthetics and Painting*, London and New York: Continuum, 2008

Gombrich, Ernst, *Art and Illusion* (1960), London: Phaidon, 2000

Greenberg, Clement, 'Avant-Garde and Kitsch' (1939), 'Towards a Newer Laocoon' (1940) and 'Modernist Painting' (1960), in Clement Greenberg, *The Collected Essays and Criticism*, ed. J. O'Brien, 4 vols, Chicago and London: University of Chicago Press, 1986 and 1993

Harrison, Charles, *Modernism*, London and Cambridge, Mass: Tate Publishing and Cambridge University Press, 1997

Podro, Michael, *Depiction*, New Haven and London: Yale University Press, 1998

Wollheim, Richard, *Painting as an Art*, London: Thames and Hudson, 1987

PART III PRINTED PICTURES

Calza, Gian Carlo, *Ukiyo-e*, New York and London: Phaidon, 2005

Hyatt Major, A., *Prints and People: A Social History of Printed Pictures* (1971), Princeton, N.J: Princeton University Press, 1980

Ivins, William M., Jr, *Prints and Visual Communication* (1953), Cambridge, Mass., and London: MIT Press, 1978

Landau, David, and Peter Parshall, *The Italian Renaissance Print 1470–1550*, New Haven and London: Yale University Press, 1994

PART IV SEEING SCULPTURE

Haskell, Francis, and Nicholas Penny, *Taste and the Antique: The Lure of Classical Sculpture 1500–1900*, New Haven and London: Yale University Press, 1982

Penny, Nicholas, *The Materials of Sculpture*, New Haven and London: Yale University Press, 1996

Phillips, Tom, ed., *Africa: The Art of a Continent*, London: Royal Academy of Arts, 1994

Potts, Alex, *The Sculptural Imagination: Figurative, Modernist, Minimalist*, New Haven and London: Yale University Press, 2001

Tucker, William, *The Language of Sculpture*, London: Thames and Hudson, 1974; also published as *Early Modern Sculpture*, New York: Oxford University Press, 1978

Wittkower, Rudolf (with Margot Wittkower), *Sculpture: Processes and Principles* (1977), London: Peregrine, 1991

PART V OBJECTS IN TRANSITION

Foster, Hal, Rosalind Krauss, Yve-Alain Bois and Benjamin H. D. Buchloh, *Art since 1900*, London: Thames and Hudson, 2004

Harrison, Charles, and Paul Wood, *Art in Theory 1900–2000: An Anthology of Changing Ideas*, Oxford: Blackwell, 2003

Perry, G., and Paul Wood, eds, *Themes in Contemporary Art*, New Haven and London: Yale University Press, 2004

NOTE: Page numbers in *italic* refer to an illustration and/or a caption (which may appear on the page facing the relevant illustration).

Illustrations are listed by plate number. Unless otherwise indicated, photographic material has been supplied by the owners or custodians of the works. Where applicable, copyright acknowledgements precede photograph credits.

Museum of Fine Arts, Boston, Massachusetts / Zoe Oliver Sherman Collection Given in memory of Lillie Oliver Poor / The Bridgeman Art Library: 1 and detail on p. 8; © 1998 Kate Rothko Prizel & Christopher Rothko ARS, NY and DACS, London / James Goodman Gallery, New York / The Bridgeman Art Library: 2; © V&A Images: 3, 170, 202; The Bridgeman Art Library: 4, 14, 38, 42, 45, 46, 48, 50, 51, 53, 54, 62, 66, 69, 72, 73, 74, 75, 79, 81, 83, 88, 89, 93, 118, 120 and detail on p. 152, 144, 231; Alinari / The Bridgeman Art Library: 5, 138, 206; Giraudon / The Bridgeman Art Library: 6, 79, 90; Charles Harrison: 9, 11, 12, 115, 116, 117, 123, 124, 126, 158, 159, 178, 184, 193, 195, 209, 241; Eye Ubiquitous / Robert Harding Picture Library: 10; DeAgostini Picture Library, licensed by Alinari: 13; © Judd Foundation. Licensed by VAGA, New York / DACS, London 2009: 15; © akg-images / Erich Lessing: 16, 95, 154, 163, 165, 169; © V&A Images / Derry Moore: 17, 225, 247; © NTPL / Christopher Hurst: 18; Photograph reproduced with the permission of The Barnes Foundation™ all rights reserved: 19; © akg-images: 22, 68, 91, 99, 179; © ADAGP, Paris and DACS, London 2009 / The Bridgeman Art Library: 23; © Succession Marcel Duchamp / ADAGP, Paris and DACS, London 2009: 25; © ARS, NY and DACS, London 2009: 26; © RMN / Béatrice Hatala: 30; © Succession Picasso / DACS 2009 / Lauros / Giraudon / The Bridgeman Art Library: 31; Scala Archives: 32, 87, 92, 102, 131, 153, 155, 238; The Art Archive / National Gallery London / John Webb: 35; © RMN / René-Gabriel Ojéda: 37, 222; © ADAGP, Paris and DACS, London 2009 / The Bridgeman Art Library / Peter Willi: 39; © ARS, NY and DACS, London 2009: 44; bpk / Jörg P. Anders: 47; Gianni Dagli Orti / The Art Archive: 52, 136, 161; Art Resource / Scala Archives: 55; © The estate of Arthur Wallis / Tate, London 2009: 56; © 2009 Board of Trustees, National Gallery of Art, Washington, DC: 57; © ADAGP, Paris and DACS, London

2009: 59; SMPK / akg-images: 60; © Succession H. Matisse / DACS 2009: 61; akg-images / Andre Held: 64; 2009 Image © The Metropolitan Museum of Art / Art Resource / Scala Archives: 67; © RMN: 70; bpk / Scala Archives: 80, 175, 191; © Succession H. Matisse / DACS 2009 / © RMN / René-Gabriel Ojéda: 85; © RMN: 97, 122; © The Trustees of the British Museum: 98, 110, 112, 113, 114, 119, 130, 133, 137, 140, 147, 148, 151, 157, 160, 173, 174, 177, 182, 183, 186, 188, 192, 194, 196, 213, 224; The Art Archive: 96, 101; © Succession H. Matisse / DACS 2009: 100; © The Pollock-Krasner Foundation ARS, NY and DACS, London 2009 / Scala Archives: 104; © 1998 Kate Rothko Prizel & Christopher Rothko ARS, NY and DACS, London / Tate, London 2009: 105; © ADAGP, Paris and DACS, London 2009: 106; © Judd Foundation. Licensed by VAGA, New York / DACS, London 2009 / Scala Archives: 107; © The Andy Warhol Foundation for the Visual Arts / Artists Rights Society (ARS), New York / DACS, London 2009 / Scala Archives: 108; © RMN / Philippe Migeat: 109; © 2009 Museum of Fine Arts, Boston: 121; © The Andy Warhol Foundation for the Visual Arts / Artists Rights Society (ARS), New York / DACS, London 2009: 125; © ADAGP / FAAG, Paris and DACS, London 2009 / Tate, London 2009: 128; Angelo Hornak, London / Corbis: 129; © RMN / Hervé Lewandowski: 132; Corbis: 134, 210; ullstein bild / akg-images: 142; akg-images / Gerard Degeorge: 146; The Bridgeman Art Library / Ali Meyer : 150; Alfredo Dagli Orti / The Art Archive: 152; Angelo Hornak, London: 171; Photograph by Prudence Cumming Associates Ltd: 176; Museum of Fine Arts, Boston / William Sturgis Bigelow Collection / The Bridgeman Art Library: 185; © abm – archives Barbier-Mueller / Studio Ferrazzini-Bouchet, Geneva: 187, 215; The Bridgeman Art Library / Heini Schneebeli : 189, 200; © The estate of Sir Jacob Epstein / Tate, London 2009: 190; Werner Forman Archive: 208; © Succession Picasso / DACS 2009 / © RMN / Béatrice Hatala: 211; © RMN / Thierry Olivier: 212; Pirozzi / akg-images: 218; Michael Dam: 219; Helge Schenk: 226; © RMN / Gérard Blot: 227; © ADAGP, Paris and DACS, London 2009 / Scala Archives: 228; © Succession Picasso / DACS 2009 / Scala Archives: 229; © RMN / Adam Rzepka: